POSTER TO POSTER

Railway Journeys in Art Volume 1 SCOTLAND

Dr. Richard Furness

Published by JDF & Associates Ltd,
Rydal Water, The Old Pitch
Tirley Gloucestershire
GL19 4ET UK

First Published MMIX

ISBN Number: 978-0-9562092-0-7

A catalogue record for this book is available from the British Library

Layout/graphics design: Amadeus Press/Richard Furness

Printed in the UK by
Amadeus Press, Cleckheaton, West Yorkshire, BD19 4TQ

Bound in Scotland by
Hunter & Foulis, Haddington

Dedicated to the Memory of Norman Elford (1931-2007)

Railway Artist Supreme

The National Railway Museum, York is the largest railway museum in the world. Its permanent displays and collections illustrate more than two centuries of British railway history, from the Industrial Revolution to the present day. The vast NRM archives also include a fabulous collection of railway advertising posters, charting the history of rail. Visit www.nrm.org.uk to find out more.

The Map of Scotland by Alan Young

Contents page i

Abbreviations page ii

Maps Indicating Poster Locations page ii

The Posters and Prints pages iii

Acknowledgements page viii

Foreword by Patrick Bogue, Onslows page ix

Introduction **Page 1**

My Golden Age of Railway Posters page 6
The Layout of this Book page 8

Chapter 1 The Journey Begins at Berwick upon Tweed Page 11

Opening Remarks page 12
Our Arrival in Berwick page 14
Across the Border and into Scotland page 17
The Border Abbeys: a History of Peace and Violence page 20
Back Along the Coast and into Dunbar page 25

Chapter 2 The Lothians & Edinburgh – Culture, Golf & History Page 29

History and Golf page 30
Into Historic Edinburgh page 33
Edinburgh Princes Street Area page 41
Out of Edinburgh page 45

Chapter 3 Across the Forth to the 'Granite City' Page 49

The Firth of Forth page 50
Into Historic Dunfermline page 53

The Home of Golf page 56
Across the River Tay page 59
We Arrive in Perthshire page 60
Royal Angus page 66
Northwards Along the Coast page 68
And So to the Granite City page 70

Chapter 4 The Land of Kings, Queens and Malts Page 75

In the Valley of the Dee page 76
Royal Deeside page 78
Arrival in Braemar page 81
A Glimpse of the Mountains page 83
Back to the Coast page 84
North Again to Fraserburgh page 87
Whisky Country Beckons page 88

Chapter 5 The Northern & Western Highlands & Islands Page 95

The Capital of the North page 96
The Northern Outposts page 102
Down to the Kyle of Lochalsh page 105
Across to the Islands page 109

Chapter 6 Southwards in Historic Railway Country Page 117

The Start of a Famous Journey page 118
The Splendour of Glenfinnan and Loch Shiel page 120
Arrival at Fort William page 123
Highland Wilderness page 125
Oban to Crianlarach page 129
Central Argyll page 135
Into Dunoon page 138

Chapter 7 **Beauty, History and Industry – Strange Bedfellows** **Page 141**

The Gateway to the Trossachs page 142
On the Bonnie, Bonnie Banks page 147
History Beckons Again page 150
And Now for Something Completely Different page 154
A Return to Tranquillity page 159
Across to Bute page 163
Cruising *'Doon the Clyde'* page 164

Chapter 8 **The Tranquil South West** **Page 167**

To the Ayrshire Coast page 168
Beaches and More Golf page 172
The Land of a Great Scottish Poet page 175
Back to the Coast and into Wigtownshire page 178
Tranquil Dumfries and Galloway page 180
Back into England page 185

Chapter 9 **Will Ye no Come Back Again** **Page 187**

Imagery and Inducement page 187
The Marketing of Scotland page 190
Advertising Scotland in an Unusual Way page 197
Speed to the North in Comfort page 202
Closing Remarks page 205

Appendix A Artists Portraits page 207

Appendix B Poster Database Arranged in County Order page 214
 (By the Author with Valerie and Simon Kilvington)

Appendix C Further Reading and References page 234

The Travelling Art Gallery page 237

Abbreviations

Through this book abbreviations are used aplenty. The railway fraternity are well versed with these, the art market maybe less so. The short list that follows explains these, with only those relevant to this Scottish Book being included.

BR	British Railways	(Formed January 1st 1948)
CR	Caledonian Railway	(Pre-1923)
ECML	East Coast Main Line	(Kings Cross to Edinburgh)
ER	Eastern Region (of British Railways)	(Post 1948)
GNR	Great Northern Railway Company	(Pre-1923)
GNSR	Great North of Scotland Railway	(Pre-1923)
GWSR	Glasgow & South Western Railway	(Pre-1923)
HR	Highland Railway Company	(Pre-1923)
LMR	London Midland Region (of British Railways)	
LMS	London Midland & Scottish Railway	(1923-1947)
LNER	London North Eastern Railway	(1923-1947)
MR	Midland Railway	(Pre-1923)
NBR	North British Railway	(Pre-1923)
NRM	National Railway Museum, York	
SECR	South East & Chatham Railway	(Pre-1923)
ScR	Scottish Region (of British Railways)	
SSPL	Science and Society Picture Library, London	
WCML	West Coast Main Line	(Euston to Glasgow Central)

Maps Indicating the Poster Locations

At the start of each of the first eight chapters readers will find a poster location map to help to guide us on the route. The red stars on each map refer to posters included in this part of the journey: **black stars** refer to posters used in other chapters. The aim is to try to cover the entire country in art, as summarized by Alan Young's hand-drawn map of the whole country found at the start of this volume.

> **Posters are Quad Royal (50" x 40") = QR Double Royal (24" x 40") = DR**

Covers

| Front | MERRIOTT, Jack: Loch Etive, Argyll | BR (ScR) QR: 1950 |
| Rear | ANON: Stirling Castle | ScotRail DC: 1996 |

Frontispiece

| | PATRICK, J. McIntosh: Loch Lomond | LNER/LMS QR: 1930s |

Introduction

1	WAY. R. Bernard: Richard Trevithick 1804	1950s Original Drawing
2	ANON: Caledonian Railway and its Connections	Caledonian Rly DR: 1900s
3	ANON: The Highland Railway	Highland Rly.DR: 1910s
4	ANON: Mid Scotland Route Map	Caledonian Rly DR: 1900s
5	ANON: Timetable	Caledonian Rly DR: 1900s
6	ANON: Route to the Highlands	Highland Rly DR: 1905
7	CHERET, Jules: Folies Bergere	French Poster 1898
8	CHERET, Jules: Vin Marian	French Poster 1898
9	WILKINSON, Norman: Dublin-Holyhead	LNWR QR: 1905
10	HASSALL, John: To the Summer Seas by the East Coast	North British QR: 1908
11	ANON: Crieff, On the Threshold of the Highlands	Caledonian Rly DR: 1910
12	HASSALL, John: Skegness is so Bracing	GNR DR: 1908
13	ANON: Old and Young find Skegness so Bracing	BR ER) DR: 1961
14	Wright, John: Troon	Midland Rly DR: 1910
15	ROWNTREE, Harry: Fore! Gleneagles	Caledonian Rly. DR: 1910
16	MAYO, Charles: Speed to the West	GWR QR: 1939
17	SCOTT, Septimus: Your Friends on the LMS	LMS QR: 1946
18	PURVIS, East Coast Route by LMNER	LNER QR: 1946
19	PEARS, Charles: Summer Services for Winter Visitors	SR QR: 1937
20	BUCKLE, Claude: Worcester Cathedral	GWR/DR: 1935
21	BUCKLE, Claude: Worcester Cathedral	BR (LMR) DR: 1948
22	ANON: Crossing the Border	Virgin Rail: 2005
23	ANON: The West Highland Line	BR Exec. DR: 1983
24	MAYES, Reginald: The Queen of Scots	BR (ER) DR: 1950s
25	COOK, Brian: The Face of Scotland	LMS/LNER QR: 1935
26	ANON: Come to Scotland for Your Holidays	LNWR/CR DR: 1910

Chapter 1 Berwick and the Border Region

Poster	Artist and Title	Vintage
27	COOPER, Austin: Kings Cross for Scotland	LNER QR: 1920s
28	BLACK, Montague B: Explore Scotland	LNER QR: 1930s
29	RUSHBURY, Henry: Berwick-Upon-Tweed	LNER DR: 1930s
30	CUNEO, Terence: The Royal Border Bridge	BR (ScR) QR: 1950s
31	ANON: The Golden Age is Arriving	GNER Long: 1980s
32	BADMIN, Stanley R: Berwick-upon-Tweed	Carriage Print Artwork
33	ANON: Berwick-upon-Tweed	BR (NER) DR: 1948
34	JONES, Van: Berwick-upon-Tweed	LNER DR: 1930s
35	MASON, Frank: The Coronation entering Scotland	LNER QR: 1938
36	MERRIOTT, Jack: River Tweed at Neidpath	BR (ScR) DR: 1950s
37	BADMIN, Stanley R: Kelso	Carriage Print Artwork
38	TITTENSOR, H: Kelso: Its quicker by Rail	LNER DR: 1930s
39	TAYLOR, Fred: Jedburgh Abbey: Its Quicker by Rail	LMS/LNER QR: 1930s
40	HASLEHUST: Sir Walter Scott's Tomb, Dryburgh Abbey	Original Artwork
41	PATRICK, J. McIntosh: Dryburgh Abbey, Roxburghshire	BR (ScR) QR: 1950s
42	TAYLOR, Fred: Melrose Abbey: Its Quicker by Rail	LMS/LNER QR: 1930s
43	NEWBOULD, Frank: Melrose Abbey	LNER DR: 1930s
44	SPRADBERY, Walter E: Abbotsford: East Coast for Borders	LNER QR: 1930
45	AYLING, George: Peebles for Pleasure; Its Quicker by Rail	LMS/LNER DR: 1930s
46	LANDER, E: Dunbar: Largest Swimming Pool	LNER DR: 1920s
47	NEWBOULD, Frank: Dunbar, East Lothian	LNER DR: 1920s
48	AITKEN, John: Linton East Lothian	Carriage Print Artwork
49	WESSON, Edward: Jedburgh Abbey	BR (ScR) DR: 1950s
50	ZINKEISEN, Doris: The Coronation	LNER QR: 1937

Chapter 2 Edinburgh and The Lothians

Poster	Artist and Title	Vintage
51	BRANGWYN, Frank: Scotland by East Coast	LNER QR: 1932
52	JOHNSON, Andrew: North Berwick: It's Quicker by Rail	LNER QR: 1930s
53	JOHNSON, Andrew: North Berwick	LNER QR: 1930
54	NEWBOULD, Frank: North Berwick	LNER QR: 1920s
55	LEE, Kerry: Edinburgh; Travel by Train	BR (ScR) QR: 1950s
56	RUSHBURY, Henry: Edinburgh; its Quicker by Rail	LMS/LNER QR: 1930s
57	PATRICK, J. McIntosh: Edinburgh Travel by Train	BR (ScR) DR: 1960

58	van ANROOY, Anton: Edinburgh by East Coast Route	LNER QR: 1920s
59	BERRY, J.: Edinburgh; See Scotland by Rail	BR (ScR) DR: 1950s
60	NEWBOULD, Frank: Edinburgh; Travel by LNER: Mons Meg	LNER QR: 1930s
61	STEEL, Kenneth: Edinburgh: See Scotland by Rail	BR (ScR) DR: 1950s
62	TAYLOR, Fred: Edinburgh; Chapel of the Thistle	LNER QR: 1930s
63	WOLLEN, W.B: Edinburgh; The Royal Mile	LNER DR: 1920s
64	TAYLOR, Fred: John Knox House, The Royal Mile	Carriage Print Artwork
65	RUSHBURY, Henry: The Palace of Holyroodhouse	Carriage Print Artwork
66	BUCKLE, Claude: The Palace of Holyroodhouse	BR (ScR) QR: 1950s
67	HOHLWEIN, Ludwig: Edinburgh; Its Quicker by Rail	LNER/LMS QR: 1930s
68	MICHAEL, Arthur: Edinburgh: Princes Street	LNER/LMS QR: 1933
69	CATTERMOLE, Lance: Edinburgh: See Britain by Train	BR (ScR) QR: 1960s
70	BUCKLE, Claude: Edinburgh; Scott Memorial	BR (ScR) DR: 1950s
71	NEILLAND, Brendan: Edinburgh Waverley	BR Intercity DR: 1991
72	TAYLOR, Fred: Edinburgh North British Hotel	LNER QR: 1924
73	NICOLL, Gordon: North British Station Hotel Edinburgh	LNER DR: 1932
74	WILKINSON, Norman: Fettes College	LMS DR: 1931
75	BUCKLE, Claude: Linlithgow Palace	BR (ScR) DR: 1963
76	MASON, Frank: The Forth Bridge: East Coast Route	LNER DR: 1920s
77	WILKINSON, Norman: The Silver Forth	LNER QR: 1935
78	HENRY, George: Edinburgh View from Calton Hill	LMS QR: 1934
94	FRAZER, William, M: Perth, The Fair City	LMS QR: 1920s
95	WILKINSON, Norman: Gleneagles Hotel, Perthshire	LMS QR: 1930
96	BIRTWHISTLE, C.H: Crieff, Perthshire	BR (ScR) DR 1950s
97	PATRICK, J. McIntosh: Crieff from Cullum's Hill	BR (ScR) DR: 1957
98	WILKINSON, Norman: Dunkeld Cathedral	LNER QR: 1930s
99	MERRIOTT, Jack: The River Tay	BR (ScR) DR: 1950
100	ANON: Loch Tay The Loch of Loveliness	Caledonian Rly: 1910
101	CUNEO, Terence: Glen Ogle, Perthshire: Scotland by Rail	BR (ScR) DR: 1950s
102	MERRIOTT, Jack: See the Central Highlands	BR (ScR) DR: 1960s
103	KING, Cecil: Glamis Castle, Kirriemuir	LMS/LNER DR: 1930
104	ANON: Gleneagles Hotel, Perthshire	LMS QR: 1920s
105	ANON: Arbroath	BR (ScR) DR: 1950s
106	COOPER, Austin: Montrose, Angus	LNER DR: 1925
107	PATRICK, J. McIntosh: Dunnottar Castle Stonehaven	LMS/LNER QR: 1939
108	WILKINSON, Norman: Highlander approaches Aberdeen	LMS QR: 1930s
109	McCLELLAN, Alexander: Aberdeen – Silver city by the Sea	LMS/LNER QR: 1935
110	TRAIN, Thomas: Aberdeen	BR (ScR) DR: 1948
111	MASON, Frank: Havens and Harbours 5: Aberdeen	LNER DR: 1931
112	MASON, Frank: Aberdeen: LNER tourist tickets	LNER QR: 1928
113	TALMAGE, Algernon: Aberdeen Brig o' Balgownie	LMS QR: 1924
114	MASON, Frank: Aberdeen and Royal Deeside	GNR QR: 1914
115	MASON, Frank: Aberdeen Gateway to Royal Deeside	LMS/LNER QR: 1935

Chapter 3 Across the Forth to the Granite City

Poster	Artist and Title	Vintage
79	GAWTHORN, Henry: The Track of the Flying Scotsman	LNER DR: 1920s
80	CUNEO, Terence: Scotland: Forth Bridge	BR (ScR) QR: 1952
81	WILKINSON, Norman: Grangemouth Docks, Stirlingshire	LMS QR: 1930s
82	STEEL, Kenneth: Dunfermline	BR (ScR) DR: 1952
83	PRAILL, R.G: Dunfermline	LNER DR: 1932
84	TAYLOR, Fred: Dunfermline Abbey	LNER QR: 1930s
85	MASON, Frank: Burntisland, Fife	LNER DR: 1923
86	PATRICK, J. McIntosh: St. Monance, Fife	Carriage Print Artwork
87	BUCKLE, Claude: Falkland Palace, Fife	BR (ScR) DR 1955
88	GAWTHORNE, Henry: St. Andrews	LNER QR: 1930s
89	MASON, Frank: St. Andrews	BR (ScR) DR: 1950s
90	TAYLOR, Fred: St. Andrews: Its Quicker by Rail: The Castle	LNER DR: 1930s
91	McKENZIE, Alison: St. Andrews	BR (ScR) DR: 1950
92	MICHAEL, Arthur C: St. Andrews The Home of R+A	LNER QR: 1939
93	CUNEO, Terence: The Tay Bridge	BR (ScR) QR: 1960

Chapter 4 The Land of Kings, Queens and Malts

Poster	Artist and Title	Vintage
116	NEWBOULD, Frank: Eastern Scotland	LMS/LNER QR: 1935
117	CATTERMOLE, Lance: Glen Tanner, Aberdeenshire	Carriage Print Artwork
118	CATTERMOLE, Lance: Aboyne Games, Aberdeenshire	BR (ScR) DR: 1950s
119	BUCHEL, Charles: Ballater, Royal Deeside	LNER DR: 1920s
120	LAWSON, Edward: Crathie Church, Aberdeenshire	Carriage Print Artwork
121	STEEL, Kenneth: Royal Deeside	BR (ScR) DR: 1950s
122	PATRICK, J. McIntosh: Royal Deeside: Braemar Castle	LNER QR: 1930s
123	CATTERMOLE, Lance: Highland Games at Braemar	BR (ScR) DR: 1950s
124	CATTERMOLE, Lance: Highland Games	BR (ScR) DR: 1950s
125	NEWBOULD, Frank: The Dee by East Coast Route	LNER QR: 1920s
126	TRAIN, Thomas: The Cairngorm Mountains	BR (ScR) DR: 1948
127	MASON, Frank: Cruden Bay: Travel by LNER	LNER QR: 1928
128	PURVIS, Tom: Cruden Bay by the East Coast Route	LNER QR: 1928

129	NICHOLL, Gordon: Cruden Bay Hotel, Aberdeenshire	LNER DR: 1926
130	WARREN, F.H: Cruden Bay: Seekers of Good Spirits	LNER QR: 1935
131	GAWTHORN, Henry G: Fraserburgh	LNER DR: 1934
132	MASON, Frank: Banff	LNER DR: 1926
133	LAWSON, Edward: Craigellachie, Spey Valley	Carriage Print Artwork
134	WILKINSON, Norman: Scotland by LMS: Strathspey	LMS QR: 1930s
135	LAWSON, Edward: The River Spey	BR (ScR) DR: 1950s
136	MERRIOTT, Jack: Elgin Cathedral	BR (ScR) DR: 1950s
137	DNA: Moray Firth Coast (2 posters as panorama)	GNSR QRs: 1910
138	MASON, Frank: Lossiemouth	LNER DR: 1920s
139	MASON, Frank: The Moray Coast: Findhorn Bay	BR (ScR) DR: 1954
140	BLAKE, Frederick: The Castle Inverness	Carriage Print Artwork
141	MERRIOTT, Jack: River Findhorn near Forres, Morayshire	BR (ScR) DR: 1950s
142	LITTLEJOHNS, J: The Moray Firth	LNER DR: 1912

Chapter 5 The Northern & Western Highlands and Islands

Poster	Artist and Title	Vintage
143	WILKINSON, Norman: Inverness	LMS/LNER QR: 1930s
144	CATTERMOLE, Lance: Inverness, The Castle	BR (ScR) QR: 1950s
145	DUNDAS, Gill: Inverness, The Capital of the Highlands	LMS DR: 1924
146	STEELE, Kenneth: Invermoriston Falls, Inverness-shire	Carriage Print Artwork
147	RUSHBURY, Henry: Fort Augustus, Inverness-shire	Carriage Print Artwork
148	RODMELL, Harry: The Western Highlands of Scotland:	LMS DR: 1920s
149	ANON: Travel LMS on the Caledonian Canal	LMS DR: 1920s
150	HALLIDAY, Edward I: The Western Highlands	BR (ScR) QR: 1948
151	HENDERSON, Keith: Western Highlands: It's quicker by Rail	LNER/LMS QR: 1930s
152	NEILLAND, Brendan: Tain by Train	Scotrail Poster 1970s
153	MACLEOD, Douglas: Ben Loyal, Sutherland	Carriage Print Artwork
154	MERRIOTT, Jack: Northern Scotland: Invershin Sutherland	BR (ScR) DR: 1950s
155	BROADHEAD, W. Smithson: Scotland for Holidays	LMS/LNER QR: 1930s
156	REYNOLDS, Warwick: Sweet Strathpeffer Spa	LMS QR: 1920s
157	MALET, Guy: Western Highlands: It's Quicker by Rail	LNER/LMS QR: 1930s
158	WILKINSON, Norman: Western Scotland	LMS/LNER QR: 1930s
159	MACLEOD, Douglas: Torridon Hills, Wester Ross	Carriage Print Artwork
160	STEEL, Kenneth: Eilean Donan Castle, Loch Duich	BR (ScR) DR: 1950s
161	WILKINSON, Norman: Kyle of Lochalsh	LMS QR: 1930
162	STEEL, Kenneth: Over the Sea to Skye	BR (ScR) DR: 1960s
163	WILKINSON, Norman: The Isle Of Skye	LMS QR: 1930s
164	CLEGG: The Isle of Skye: Travel by Rail	BR (ScR) DR: 1960
165	COOPER, Austin: Isle of Skye: Travel LNER via Mallaig	LNER QR: c1924
166	LINGSTROM, Freda: Flora MacDonald and the Prince	LNER DR: 1932
167	NEILAND, Brendan: Isle of Skye by Train	Scotrail DR: 1996
168	SCHABELSKY: Isle of Skye: Travel LNER via Mallaig	LNER DR: 1923
169	BELL, J. Torrington: The Isle of Skye: Its Quicker by Rail	LNER/LMS DR: 1939
170	GILFILLAN, Tom: Scotland's Highlands & Islands: Of Staffa	MacBrayne QR 1930s
171	GILFILLAN, Tom: Treshnish Isles from Mull	MacBrayne QR 1930s
172	GILFILLAN, Tom: Kishmul Castle, Barra	MacBrayne DR 1930s
173	GILFILLAN, Tom: Iona, See this Scotland by MacBrayne	LMS/MacBrayne DR 1932
174	ANON: Scotland's Western Highlands and Islands	MacBrayne DR 1930s
175	WILKINSON, Norman: Tobermory in the Western Isles	LMS/LNER QR: 1930s

Chapter 6 Southwards in historic Railway Country

Poster	Artist and Title	Vintage
176	MASON, Frank: Havens and Harbours No. 6: Mallaig	LNER DR: 1930s
177	MACLEOD, William: West Highland Line near Arisaig	BR (ScR) DR: 1950s
178	MASON, Frank: Western Highlands by East Coast Route	LNER QR: 1939
179	MACLEOD, William: Loch Shiel	BR (ScR) DR: 1950s
180	NRM Photo: Glenfinnan Viaduct and Loch Shiel	NRM Picture Library
181	NEILAND, Brendan: Loch Shiel by Train	Scotrail DR: 1996
182	NEILAND, Brendan: Glenfinnan by Train	Scotrail DR: 1996
183	MERRIOTT, Jack: The West Highland Line: Lochy Viaduct	BR (ScR) QR: 1950s
184	JOHNSON, Granger: Fort William	LNER QR: 1923
185	CLEGG: Ben Nevis; See Scotland by Rail	BR (ScR) QR: 1955
186	MERRIOTT, Jack: Ben Nevis; Western Highlands	BR (ScR) DR: 1950s
187	ANON: Corrour; You Can't Sail, Fly or Drive There	ScotRail; small size: 1996
188	CUNEO, Terence: Monessie Gorge, Argyllshire	BR (ScR) DR: 1950s
189	YOUNG, Sir David: The Scottish Highlands	LMS QR: 1924
190	MACE, John: The Western Highlands: Travel by LNER	LNER QR: 1930
191	WILKINSON, Norman: Glencoe: Scotland for Holidays	LMS/LNER QR: 1930s
192	McCULLOCH, Horatio: Glencoe, Argyllshire	LMS QR: 1940s
193	SHERWIN, Frank: Pass of Glencoe: Western Highlands	BR (ScR QR: 1950s
194	NICHOLS, George: Scotland by LMS: Highlands in Winter	LMS QR: 1924
195	GRIEFFENHAGEN, Maurice: The Western Highlands	LNER QR: 1930s
196	LAMORNA BIRCH, S.J: Western Highlands	LNER/LMS QR: 1930s
197	MacFARLANE, Alasdair: See Scotland: Oban	BR (ScR) QR: 1950s
198	ANON: Oban: Callander & Oban Railway	C&OR DR: 1910s
199	MERROITT, Jack: The Western Highlands: Ballachulish	BR (ScR) DR: 1950s
200	MERRIOTT, Jack: Loch Etive: Western Highlands	BR (ScR) QR: 1960
201	BURGESS, Arthur: Western Highlands: Fishing	LNER/LMS QR: 1935

202	PATRICK, J. McIntosh: Loch Awe	Carriage Print Artwork
203	ANON: In the Land of the Gael: Loch Awe	Cal.Rly. DR: 1910s
204	WILKINSON, Norman: Loch Awe	LMS/LNER QR: 1930s
205	GILFILLAN, Tom: Loch Awe, Argyll	BR (ScR) DR: 1950s
206	ANON: Campeltown & Inveraray	SE&CR DR: 1910s
207	ANON: The Famed Loch Eck Coaching Route	GNR DR: 1905
208	SHERWIN, Frank: Loch Eck, Argyll	BR (ScR) DR: 1955
209	HASLEHUST, Ernest: Western Highlands: Loch Long	LNER/LMS QR 1930s
210	LEE-HANKEY, William: Dunoon	LNER/LMS QR: 1930s
211	CATTERMOLE, Lance: Dunoon on Firth of Clyde	BR (ScR) DR: 1960
212	BUCKLE, Claude: Dunoon on the Firth of Clyde	BR (ScR) DR: 1957
213	CLARKE, Christopher: The Highland Games	LMS/LNER QR: 1930s

239	SMITH, John S.: The Firth of Clyde	BR (ScR) DR: 1960
240	WILKINSON, Norma: The Clyde: Entrance to Loch Long	BR (ScR) QR: 1948
241	TEMPLETON: Helensburgh Attractive Clyde Coast Resort	LNER DR: 1920s
242	MASON, Frank: Helensburgh: It's Quicker by Rail	LNER DR: 1946
243	MacFARLANE, Alasdair: The Clyde Coast: Kyles of Bute	BR (ScR) QR: 1950s
244	ANON: The Clyde Coast for Holidays	LMS DR: 1920s
245	TAYLOR, Fred: Rothesay via LNER Clyde Steamers	LNER QR: 1926
246	SHERWIN, Frank: Rothesay Isle of Bute	BR (ScR) DR: 1950s
247	ANON: Sweet Rothesay Bay	LMS QR: 1920s
248	MASON, Frank: Holiday on the Clyde Coast	LNER QR: 1920s
249	MASON, Frank: Clyde Coast via Craigendoran	LMS QR: 1924
250	WILKINSON, Norman: Firth of Clyde Cruises	LMS DR: 1930s
251	WILKINSON, Norman: The Firth of Clyde	LMS QR: 1925

Chapter 7 Beauty, History & Industry: Strange Bedfellows

Poster	Artist and Title	Vintage
214	KAY, Archibald: Callander, Trossachs Gateway	LMS QR: 1930s
215	ZINKEISEN, Doris: Rob Roy; West'n Highlands	LNER/LMS QR: 1934
216	MERRIOTT, Jack: Route of the Trossachs Tour	BR (ScR) DR: 1950s
217	'RTR': Loch Katrine via west Coast Route	LNWR/CR DR: 1910
218	PURVIS, Tom: The Trossachs by East Coast Route	LNER QR: 1926
219	LITTLEJOHNS, John: The Trossachs	LNER QR: 1930s
220	'DNA': The Tarbet Hotel, Loch Lomond	Cal Rly DR: 1910
221	PATRICK, J. McIntosh: Loch Lomond	LNER/LMS QR: 1930s
222	WILKINSON, Norman: Loch Lomond	LMS/LNER QR: 1928
223	NICOLSON, W.C: Bonnie Banks of Loch Lomond	BR (ScR) DR: 1954
224	MERRIOTT, Jack: Wallace Memorial Stirlingshire	Carriage Print Artwork
225	ANON: Scotland for Holidays: Stirling	LMS/LNER DR: 1930s
226	GRIEFFENHAGEN, Maurice: Stirling	LMS QR: 1924
227	MERRIOTT, Jack: The River Forth from Stirling	BR (ScR) DR: 1950
228	ANON: Stirling Castle; People Still Flee There	ScotRail small.: 1996
229	CLARK, Christopher: Stirling Castle	LMS QR: 1930s
230	ANON: Bridge of Allan, Stirlingshire	Cal. Rly DR: 1910
231	ANON: Seeing Glasgow by Bus and Tram	Glasgow Corp. DR: 1938
232	WILKINSON, Norman: Shipbuilding on the Clyde	LMS/LNER QR: 1930s
233	HEPPLE, Robert: Service to Industry: Shipbuilding	BR (ScR) QR: 1950s
234	MacFARLANE, Alasdair: Service to Industry	BR (ScR) QR: 1954
235	WILKINSON, Norman: Lanarkshire Steelworks	LMS/LNER QR: 1935
236	WCN: The George Bennie Railplane Transport System	LNER QR: 1930s
237	CUNEO, Terence: Glasgow Electric; Modern Railway	BR (ScR) QR: 1960
238	MASON, Frank: Dalmuir Shipping Basin, Glasgow	Original Artwork: 1930s

Chapter 8 The Tranquil Southwest and Across the Border

Poster	Artist and Title	Vintage
252	GILFILLAN, Tom: Saltcoats: The Finest Tidal Lake	LMS QR: 1935
253	BLACK, Montague B: Largs, Ayrshire	BR (ScR) DR: 1950s
254	MEADOWS, Chris: Lively Largs; Centre for Pleasure Sailings	LMS DR: 1930s
255	FRYER, William M: Largs Ayrshire; The Gem of the Clyde	BR (ScR) DR: 1954
256	UNKNOWN: Troon; Ideal Holiday Resort	MR/GWSR DR; 1910s
257	EADIE, Robert: Ayr; The Scottish Seaside Resort	LMS/QR: 1930s
258	SILAS, Ellis: Ayr	BR (ScR) DR: 1950s
259	FISH, Laurence: Ayr for Happy Holidays	BR (ScR) DR: 1950s
260	MERRIOTT, Jack: Culzean Castle; Eisenhower's Scottish Home	BR (ScR) DR: 1953
261	UNKNOWN: Turnberry on the Ayrshire Coast	LMS QR: 1920s
262	UNKNOWN: Turnberry Hotel and Golf Courses	GSWR QR: 1910
263	SLOANE, James: Girvan on the Ayrshire Coast	LMS QR: 1920s
264	UNKNOWN: To See the Land O' Burns	MR/GWSR DR: 1910
265	WILKINSON, Norman: The Birthplace of Robert Burns	LMS/LNER QR: 1930
266	NICOLSON, W.C: Bicentenary of the Birth of Robert Burns	BR (ScR) QR: 1959
267	MERRIOTT, Jack: Brig O'Doon, Alloway Near Ayr	BR (ScR) DR: 1952
268	JOHNSON: TSS Caledonian Princess via Stranraer + Larne	BR/Cal Steam QR: 1964
269	WILKINSON, Norman: Scotland for Holidays: Fishing	LMS/LNER QR: 1927
270	OPPENHEIMER, Charles: South West Scotland	BR (ScR) QR: 1950
271	WILKINSON, Norman: Galloway, Southern Highlands	LMS QR: 1924
272	OPPENHEIMER, Charles: The Solway Coast, Kippford	BR (ScR) QR: 1948
273	WILKINSON, Norman: Sweetheart Abbey	LMS QR: 1930
274	MOTT, Ralph: Moffat, Dumfries-shire Resort and Spa	LMS DR: 1930
275	GAWTHORNE, Henry: Silloth on the Solway: Quicker by Rail	LNER DR: 1930s

276	GRIEFFENHAGEN, Maurice: Carlisle Gateway to Scotland	Original Artwork 1924
277	ANON: North British Station Hotel, Glasgow	LNER DR: 1930s
278	WILKINSON, Norman: Stranraer-Larne; Short Sea Route	LMS DR: 1930

Chapter 9 Will Ye no Come back Again!

Poster	Artist and Title	Vintage
279	SPENCER, E.H: England-Scotland in Comfort by Train	BR (ER) DR: 1952
280	WARREN, F.H: LNER Advertisements Compel Attention	LNER DR: 1920s
281	PURVIS, Tom: Dine Well by LNER	LNER QR: 1930
282	PURVIS, Tom: Cruden Bay by East Coast Route	LNER QR: 1928
283	SHEPHERD, Charles: LNER for Fish: Catch East Coast Fish	LNER DR: 1930s
284	GAWTHORNE, G.H: Over the Forth to the North	LNER QR: 1920s
285	UNKNOWN: LNER Results for 1929	LNER QR: 1929
286	CLARK, Christopher: Ecosse; Passez vos vacances	LNER/LMS DR: 1935
287	UNKOWN: Great News! Bonnie Scotland	LMS DR: 1920s
288	UNKNOWN: LNER Golf	LNER DR: 1924
280	NICOLSON, W.C: The Clyde Coast and Loch Lomond	BR (ScR) QR: 1955
290	NEWBOULD, Frank: Scotland by East Coast Route	LNER DR: 1926
291	HOWARD, Norman: Scotland Straight as the Crow Flies	LMS DR: 1924
292	NEWBOULD, Frank: Flying Scotsman; 392 Miles Non-stop	LNER DR: 1920s
293	SECRETAN, Murray: Your best way to Scotland	LMS DR: 1920s
294	de GRINEAU, Bryan: Glasgow Edinburgh by Coronation	LMS/LNER DR: 1938
295	BRIEN, Stanilaus: Scotland It's quicker by Rail	LNER/LMS QR: 1930s
296	JACK, Richard RA: British Industries – Steel	LMS QR: 1923
297	CAMERON, Sir David RA: Scottish Highlands	LMS QR: 1923
298	WILKINSON, Norman: Passenger Express	LMS QR: 1920s
299	BARTLETT, Robert: Scotland; The Night Scotsman	LNER QR: 1932
300	MARFURT, Leo: Flying Scotsman Leaves at 10 am	LNER QR: 1928
301	BAGLEY, R: The Flying Scotsman 1862-1962	BR (ER) DR: 1962
302	ANON: Edinburgh-Aberdeen in 3 Hours	BR (ScR) DR: 1962
303	FREIWIRTH: Up to Scotland from Kings Cross	LNER DR: 1930s
304	de GRINEAU, Bryan: Scot passes Scot	LMS QR: 1937
305	PURVIS, Tom: The Four Streamliners	LNER QR: 1937
306	BECK, Maurice: The Flying Scotsman's Cocktail Bar	LNER DR: 1930s
307	ALEXEIEFF, A: The Night Scotsman	LNER QR: 1932
308	NEWBOULD, Frank: East Coast Types No.2	LNER DR: 1931
309	NEWBOULD, Frank: East Coast Types No.4	LNER DR: 1931
310	BUCKLE, Claude: Beauty Abides	LMS QR: 1930s
311	ANON: East Coast Route; a Contrast	GNR/NBR QR: 1914
312	ANON: Travel in Your Pyjamas	Inter-City DR: 1970s
313	ANON: Whatever You're Doing this Christmas	ScotRail DR: 2000
314	GRAY, Ronald: Ready for the 12th; Arrival at Perth	LMS QR: 1925
315	DANVERS, Verney L: Scotland by East Coast Route	LNER DR: 1925
316	ANON: Pitlochry; Things Move Slowly There	ScotRail 1996
317	ANON: See Britain by Train	BR (ScR) D Crown: 1980
318	ANON: There are Two Ways to Scotland	LMS DR: 1920s
319	ANON; England and Scotland: East Coast Route	GNR/NBR DR: 1910s
320	WOLSTENHOLME, A: The Flying Scotsman	BR (ER) DR: 1960s
321	WOLSTENHOLME, A: The Capitals Limited	BR (ER) DR: 1960s
322	WOLSTENHOLME, A: The Mid-Day Scot	BR (LMR) DR: 1960s
323	WOLSTENHOLME, A: The Royal Scot	BR (LMR) DR: 1960s
324	ANON: Motorail 78; The Relaxing Way	BR Exec DR: 1978
325	ANON: You Tak the High Road; I'll Tak the Rail Road	BR Exec DR: 1960s
326	ANON: The Beauties of Scotland	NBR QR: 1978
327	ANON: Newhaven Edinburgh; There's no Gift Shop	ScotRail 1996
328	GAMES, Abram: See Britain by Train	BR Exec DR: 1950s

Appendix A Artists Portraits

| 329 | MACKENZIE, Helen: The Western Highlands by LNER | LNER DR: 1930 |
| 330 | STEEL, Kenneth: The Central Highlands | BR (ScR) DR: 1950s |

Appendix B Poster Database arranged in County Order

| 331 | PATRICK, J. McIntosh: Loch Leven, Kinross-shire | BR (ScR) DR: 1950s |
| 332 | ANON: The Silver Jubilee Leaves Edinburgh at 15.00 | Inter-City DR: 1977 |

Appendix C Further reading and References

Acknowledgements

Many people have made this book possible and it is right and proper to recognize the immense support I have had during the past seven and a half years it has been developing. It simply would not have happened at all without the commitment from both the National Railway Museum at York and the Science Museum in London. At York former Curator of Collections **David Wright** provided an early stimulus, since carried on by **John Clark** and **Helen Ashby**. In London, **Deborah Bloxam** and **Tom Vine** contributed to the style and overall image. Also early in the project, after speaking with several auction houses, easily the greatest encouragement came from **Patrick Bogue** at Onslows. Patrick, as well as being a renowned expert in posters generally, gave me artistic guidance and allowed material from his vast picture and catalogue library to be used. I am honoured he also agreed to write the Foreword.

The database information in Appendix B, the first of its type ever attempted, is down to literally thousands of hours work between **Valerie and Simon Kilvington** and me. We have gone through hundreds of auction catalogues (where we could find them) but also trawled the Internet, and researched the biographies of as many artists as we could find. They have been instrumental in all the support work behind the book. We plan to keep this database updated in real time. My good friend **Greg Norden** also gave help with carriage prints and artists biographies, and if this book is as successful as his classic volume *"Landscapes under the Luggage Rack"*, I will be very pleased. **Alan Young**, who helped with the *"Book of Station Totems"* in 2002, hand-drew all the maps throughout the whole book. His map work is quite superb.

Pictures and information came from many friends in the railwayana and poster world, and I have to mention **Tony Hoskins** & **Simon Turner** at GWRA, **Chris Dickerson** at SRA, and **David Jones** & **Mike Soden** at GCRA. The proof-reading of the entire work, as well as the final checking, was undertaken by **Belinda Brennand**. If anybody wants texts proof-read, I can thoroughly recommend her work. **Richard Cook** & **David Crossland** from Amadeus Press provided me with the best possible help during the final formatting and printing stages. The quality of the book, all the digital image work and the detailed layout is down to **Steve Waddington** of Amadeus Press: a great anchor man to work with.

The final and greatest thanks goes to my wife **Judi**, who has patiently put up with me spending up to 15 hours a day on the computer over several years. Judi's critical eye and background influence was always there, and the book is as much hers as mine! Thank you all most sincerely for first class team-playing.

SCOTLAND'S WONDERLAND BY MACBRAYNE'S STEAMERS

Foreword Patrick Bogue Onslows

My journey with the railway posters began over thirty-two years ago while working at a famous London auction house. In those days bundles of posters, no matter what they were, sold for ten pounds or less each. My earliest recollection of an evocative image was the London Midland Scottish Railway poster by Ronald Gray depicting a grouse shooting party entitled "Ready for the 12th". It sold with some others for a few pounds. Recently the poster reappeared in New York and sold for a remarkable £6500. I was delighted to see it used in chapter 9 of this first volume.

In those early days I was drawn by the wonderful nostalgic works of art that had become the lost masterpieces of the railway platform. The London and North Eastern Railway and other companies commissioned the finest commercial designers of the day, and they were paid handsomely for their work. My love of the British railway poster developed into my future career as the Onslow's poster auctioneer. Over the years I have made some astonishing discoveries of posters in the most unlikely of places – but that will be another story for future volumes – you will just have to wait and see !

I was delighted when Richard Furness asked me to help him with the book. An inspired and infectious project, the first in a series of seven volumes, will I am certain become a 'well-thumbed' work of reference, for professionals and amateurs alike. Readers are taken on a journey around Scotland through some of the many wonderful posters commissioned by the 'Big 4' companies of the Post-Grouping era and those later by British Railways and their contemporaries. This is a must have travel guide for those who would like to rediscover forgotten aspects of the British Isles and the *"Drier Side"*, the slogan used by the LNER to persuade the travelling public their railway would deliver them to the sunniest resorts on the east coast. The exciting challenge for the traveller using the book as a travel guide will be to identify and to compare holiday destinations as depicted by the posters, in some cases a little "artist's license" will be encountered.

Further volumes will cover the whole of the British Isles (and beyond) in a mixture of documentary reference work, historical view, geographic study and artist review. There have been poster books published before, but not in this depth and not devoted to regional areas. They have also tended to focus on the so-called 'Golden Age' in the 1920s and 1930s. However those same artists worked for British Rail and actually produced some wonderful artwork and in a more modern semi-pictorial style. Never have so many railway posters from the same area appeared together in one book.

It has been fortunate that the National Railway Museum at York has given Richard Furness open access to the nation's wonderful archive of posters, paintings and carriage prints. Most have never been reproduced in this form, so this is also an insight into the heritage that the museum has saved for generations to come. Posters from the extensive Onslows Library have added to the breadth displayed.

The following poem (by Robert Louis Stevenson) is about the excitement of a small child on a railway journey. Some readers may remember learning this poem at school but it sums up our travels in this and the following volumes very well! He was a very famous Scottish novelist, poet, essayist and travel writer, who "seemed to pick the right word up on the point of his pen". The poem is an appropriate introduction to this first Poster to Poster travel volume.

From a Railway Carriage – R.L. Stevenson (1850 – 1894)

Faster than fairies, faster than witches,
Bridges and houses, hedges and ditches;
And charging along like troops in a battle,
All through the meadows, the horses and cattle:
All of the sights of the hill and the plain
Fly as thick as driving rain;
And ever again, in the wink of an eye,
Painted stations whistle by.

Here is a child who clambers and scrambles,
All by himself and gathering brambles;
Here is a tramp who stands and gazes;
And there is the green for stringing the daisies!
Here is a cart run away on the road
Lumping along with man and load;
And here is a mill and there is a river:
Each a glimpse and gone forever!

A definitive series of railway poster books that includes many more BR and modern posters is long overdue. Several works are already available on the open market (see references), but these look at limited periods and use images that are most commonly seen. The aim of this series is to explore the world of commercial railway art more extensively, and to write the books as if we are taking journeys around the United Kingdom and through our near neighbours by rail. Work to compile a large database, to correct poster dates and update artist profiles has been going on in the background since 2002, so it is hoped readers and collectors alike will be pleased with the many hours spent defining and listing British Railway posters. The period between 1923 and 1947 is often referred to as *'The Golden Age'*, but this work shows that some equally classic posters were issued right up to the end of the 20th century, though in ever decreasing numbers. Photographic type images became more popular in the 1960s and some of the posters from the 80s and 90s were visually really rather poor. This work includes many of the lovely and seldom seen images from the first 25 years of British Railways.

The decision to start the series with Scotland was taken at an early stage of the project. It is a complete country, a historic country and with some quite magnificent artistic representations of people and places. It whets the appetite well for the other areas. Records show the earliest incorporated Scottish Railway was the Kilmarnock and Troon in 1808. This is well before the Stephensons became active in England, and was only shortly after Richard Trevithick had produced his famous locomotive at Pen-y-darran in South Wales. The early 1950s hand drawing below by R. Bernard Way shows this important 1804 engineering development to perfection.

The Victorian years saw a massive expansion of activity in railway building and the number of companies popping up everywhere was astonishing. In Scotland for example, no fewer than 197 Companies incorporated in the 95 years after the Kilmarnock and Troon by private Acts of Parliament. In the later years and into the 20th century far fewer obtained their powers by Light Railway Order or by means of a Board of Trade certificate. These small companies quickly merged or were swallowed up as the race for commercial passenger and freight traffic grew.

At the end of Queen Victoria's reign, Scotland's railways were dominated by just five players: The North British (NBR), The Caledonian (CR), The Glasgow and South Western (GSWR), The Great North of Scotland (GNSR) and The Highland (HR). The exception was the Forth Bridge Railway Company, which survived right up until the formation of British Railways on 1st January 1948 (though it was part of the LNER from 1923). The section depicted below from a large 1898 poster, shows the extent of the Caledonian lines in the northern part of Scotland. This full poster contains some lovely artwork.

Early 1950s Artwork by R. Bernard Way of Trevithick's Pioneering Locomotive

1898 Poster for Northern Scotland Showing the Caledonian Railway Routes

Also typical of that period is the corresponding poster issued by the Highland Railway. This is far more colourful but also contains vignettes. Notice how small the route network was and how little of northern Scotland had access to railways.

Highland Railway Routes Circa 1905: Artist is Unknown

In 1923, the 'Big Four' Railway Companies appeared. Scotland was split between the London and North Eastern Railway (LNER) on the eastern side and the London Midland and Scottish Railway (LMS) on the western side. Much has been written about railway history and it is really outside the remit of these texts. Some important references are found at the end of the book and readers are urged to contact or visit the National Railway Museum at York to learn more about our historic past. Suffice it to say the Beeching era of the 1960s saw commercial realism dawn and Scotland's railway system was decimated. However, in fairness to Dr Beeching's influence, station closures began well before his appointment, as economic reality started to bite.

The population of the Highlands was falling as the age of industry grew apace and Glasgow became one of the leading industrial centres in the world. Scots settled in huge numbers in the valley area between Edinburgh and Glasgow. A hundred years ago shipbuilding in Scotland led the world and features on several railway posters. Another section from the 1898 Caledonian Railway map shows the extent of railways in the central area at the end of the 19th century and serves to show how important railways were to the economy of Scotland. Beeching's real mistake was not recognizing the social importance of railways to remote and small communities all over Britain.

The Railway System of Central Scotland in Late Victorian Times (Dated 1898)

In order to gain business, the railway companies had to advertise. Marketing a place, a region or indeed a whole country set a real task to the graphic designers of the period. The first posters were purely informative, but the businessmen soon realised <u>visual</u> images sold, so the whole style changed. Examples of the old style and the attempts at more visual images are shown overleaf. Even with these two posters, it is easy to see that they were not so appealing.

1847 and 1897 Victorian Railway Posters from the National Collection

Eventually he became THE major advertising force in France and added railway companies and some manufacturing businesses to his growing client list. Just two of his works are depicted below but notice how vivid and alive the posters are compared to the 'home-grown' efforts alongside. Switzerland also seemed way ahead of the British at this time and some of Swiss Railways very early 20th century posters are true classics of the advertising world today.

Finally the British companies realized they had to involve artists – strange really! Anybody visiting railway stations in the 1870s and 80s could see that the poster had arrived, and passengers were bombarded with information from all over our islands. Lithographed posters such as those alongside were commonplace at this time, but were informative rather than spectacularly visual. Things began to change when, in 1894, an exhibition of posters showed the power of this medium to stimulate sales. Notable early illustrators were involved in the following years, including Beardsley, Hardy and the Bickerstaffs. Early in the 20th century, John Hassall showed the railway companies the potential of his style to gain travel business: the railway poster had finally arrived!

At the same time, developments in lithography and colour printing began to impact in all areas of advertising. Posters were everywhere, publicizing almost everything, and reference to specialised auction houses shows the many areas where they appeared. They ranged from classic art (Toulouse-Lautrec or Alphonse Mucha for example) to the promotion of tobacco and clothes, but especially for travel. France really led the way in artistic posters in the 1890s, and the pioneer was probably Jules Chéret who seemed to use posters as they were really intended: to stimulate.

Chéret was born in Paris in 1836 and was always interested in art. He became fascinated by printing and from the age of 13 started to study and work in this area. Surprisingly he came to London in 1859 to study, even though at that time, Britain was not the leader in printing. He stayed for seven years. On his return to France, more frivolous images greeted him, depicted in the works of Fragonard and other rococo artists such as Watteau. Chéret created vivid adverts for cabarets, music halls and theatres. He was in so much demand that he soon expanded his craft into municipal festivals and concerts, and then into beverages and liquor, perfumes, soaps, cosmetics and pharmaceutical products.

The Work of French Lithographer Jules Chéret at the End of Victorian Era

The first Bank Holidays appeared in the 1870s and work-weary masses poured from industrial towns and cities to the coast for some well needed R+R. Industrial Glasgow moved south-westwards to the Ayrshire coast, west to Dunoon and Rothesay and north towards the Trossachs. As there were no cars, the buses and trains were swamped. There was no real need at this time for highly visual imagery and posters; people just went out! Once this periodic exodus started, it became a torrent within a few years and railways played the major role in the movement. Special trains ran at weekends to the seaside during the latter years of Victoria's reign, and this continued well into the 1960s, before the car and the lure of continental sun changed holiday habits and locations. After this time the whole style of posters changed, as this and the other books in the series will show.

The poster movement began to gather pace and in 1900, The British Poster Academy was formed and quickly tried to garner interest by holding regular poster exhibitions. Posters were really used for the holiday industry at the start of the 20th century. Around the same time Hassall experimented with gouache and his work was quickly recognized as 'ground-breaking'. He was of the opinion that poster artists had to be trained in visual awareness and compositional techniques that were different from conventional painting. Accordingly he founded the New Art School, tailored specially to young artists who were keen to get onto the commercial bandwagon of advertising using the medium of posters. He had a considerable poster output between 1901 and 1915.

Hassall had a major influence in railway circles and his style (shown in the lovely coloured and styled NBR poster below, advertising the South East Scottish beaches for summer holidays before the dark years of WWI) was adopted by other artists.

1908 NBR Poster by John Hassall Advertising Holidays on the Scottish East Coast

A significant advancement occurred in 1905 when the LNWR took the decision to use Norman Wilkinson in their advertising campaign. It was an association that was due to last many years, long after the LNWR was absorbed into the LMS in 1923, when the 'Big Four' Companies were created. Wilkinson was a well-known artist who painted in oils, and to use such a high-profile figure for posters was a radical departure. He was especially known for marine paintings and one of his first LNWR posters advertised the sea crossing to Ireland (shown alongside). It was examples such as the two shown here that allowed the poster to flourish. An almost endless number of evocative and very colourful posters appeared before WWI, as the intensity developed between the railway companies on the advertising front. Artists such as Wilkinson set the 'bar very high', but cluttered and wordy images were still produced by companies not able to afford top people.

Posters Develop into Art: 1905 LNWR Poster by the Famous Norman Wilkinson

Scottish railway companies soon followed this lead and produced some lovely works of art: an example taken from the National Collection appears below.

1910 Caledonian Railway Company Poster Advertising Crieff Perthshire

However, it was seaside locations that attracted the greatest attention. The UK was at its height in terms of industrial, financial and world power. This all generated into wealth that the ordinary people had not seen before. Life was still hard, but the railways offered an escape to relaxation and fun.

Seaside towns all around the British Isles benefited, with the Yorkshire resorts of Bridlington and Scarborough serving the wool towns of Leeds and Bradford; Blackpool plus the North Wales coast serving industrial Liverpool and Manchester, and mid Wales growing from the Birmingham 'invasions'. Indeed it was the railways that were responsible for some towns developing where the locals actually resented 'outsiders'! The peace and tranquillity of many Scottish places such as Rothesay, Saltcoats, Dunbar and Dunoon was lost as the hardworking people descended. Snobbery and resentment appeared, as some resorts tried to counter what was happening and tried to encourage visitors 'selectively'. They wanted the money but not the hordes of people!

A prime example of seaside growth was Skegness. In the 1870s this was a quiet village of 500 people. The railway arrived by the mid 1870s and within 30 years over 300.000 people visited from Derby, Leicester, Nottingham and Sheffield. We will see in the Eastern Region book (volume 5) just how many Skegness posters were produced. The most famous of any of the posters produced for the Great Northern Railway came from John Hassall. Alongside is a later copy, one of many that subsequently appeared.

Hassall's Original 1908 Image for Skegness with a Later BR Derivative

One of the Scottish seaside towns to benefit was Troon. Golf had been played there for many years, so the railway capitalised on this and produced one of the first golfing posters. Alongside is one for the famous Gleneagles course. Throughout this volume, quite breathtaking golfing posters feature regularly.

Edwardian Golfing Posters for Famous Scottish Courses

My Golden Age of Railway Posters

The intense rivalry between the many railway companies could not continue. Some companies were simply not large enough and in the Edwardian period they started to fail. It was clear that the plethora of small, medium and large companies needed rationalisation. By 1922 there were over 120 companies, some national, some regional and some very local. Takeovers and mergers had already started, but in 1923 four new companies, known as *'The Big Four'*, were formed by Government mandate.

These were the Great Western Railway (GWR), the London Midland and Scottish Railway (LMS), the London North Eastern Railway (LNER) and the Southern Railway (SR). Some of these were logical but one still retained intense internal rivalry in the early days. This rivalry involved the London North Western Railway (LNWR) and the Midland Railway (MR), two of the main constituents of the LMS. All the railway companies prior to 1923 had some form of publicity department and after 1923 their styles, duplication and differences all had to be collectively addressed.

Up to now, it has been assumed that the period from the formation of the 'Big Four' to the creation of British Railways in 1948 (when they were merged again) was the *'Golden Age'* of posters. Why is this? The answer may lie in the classic NRM poster book (Durack and Cole) that looked at the period 1923-1947. However this new book and the others to follow in the series clearly show the Golden Age did not end with the formation of BR. In fact some of the best posters ever produced occurred in the early years of British Railways. Fortunately BR decided to carry on the tradition of art and advertising combined. The London Underground, since the days of Frank Pick, has used posters extremely successfully, and more good books about Underground posters have been produced than for any other area of railway travel. It was always the intention of this series to redress this imbalance.

BR carried on using real artists (e.g. Buckle, Merriott, Newbould, Riley, Steel, and Wesson) and some of their best work occurred towards the end of their painting days. Even now, classic posters are appearing, though in far less numbers than in the period 1925-1965. This for me is the Golden Era, the real Golden Era. One could also mention the work of Fix-Masseau in the 1980s, when a series of quite stunning posters was produced for the Venice Simplon Orient Express (VSOE). Other more modern posters came from Reginald Lander, and some of his late 1960s and early 1970s collages are now starting to attract the attention of collectors. It was quite noticeable that during the days of Intercity, Network Southeast, Regional Railways and right up to the recent Virgin, GNER and other contemporary railway companies, photography gradually took over from art. Some of the pictures were quite wonderful in their own right (and some are included in this volume) but generally they are not the same as artwork posters or as evocative as LNER, LMS, GWR, SR and early BR images. In the early days of the 'Big Four' distinctive styles and themes emerged. Some of the best poster artists of all time were active in the 1930s and beyond. Had WWII not occurred, who knows what would have happened to our national railways? Under-investment by the Big Four, war damage and poor maintenance all contributed to changes in the railways' financial status, meaning far less funds for posters and advertising. When real posters died, we all lost a great deal.

Of the Big Four, the database shows that the LNER was probably the most active (and arguably the leader) in graphic design. They had adopted a clear and bold style using Gill Sans Serif graphics. Eric Gill, a leading cartographer of the time, created this font. However it is most interesting to compare the Big Four and show how they merged to form a unified image and style under British Railways. The GWR promoted speed and comfort. The LMS looked at the sheer size of the company with images spreading from London well into Scotland. The LNER promoted the fastest route to the north, and their main theme *'By the East Coast Route'* appeared on a significant proportion of their classic posters. The Southern Region emphasized modern electric trains, whisking Londoners to the south coast and the continent in comfort and quietness. Just one of each shows the wide difference in both style and company message.

This small collage clearly shows the diversity of styles and advertising philosophy. Notice especially the GWR use of a prominent circular logo. The LNER used developments of an elliptical logo, whereas there is no corporate image at all on the LMS and SR posters. They tended to rely on the simple words *'LMS'* or *'Southern Railway'* to market themselves. The real artistic style on the GWR and LNER posters is quite noticeable.

During the Big Four years (1923-1947) some of the truly outstanding artists were most prolific! The names of Tom Purvis, Fred Taylor, Edward McKnight Kauffer, Norman Wilkinson and Charles Shepherd appeared very frequently on a whole range of posters. Some were allied to a single company, whilst others were freelance, being used freely by the 'Big Four'. The LNER and GWR were by far the most prepared. The early poster days for the LMS and the SR were difficult and relatively few of the truly classic images appeared. However by the mid 30s, each of the railway companies were well into their marketing strides and some wonderful posters came from all of them.

When BR formed in 1948, it inherited a tremendous tradition; a tradition that was far too good to lose. Because of funds, they began by simply reissuing some of the better images under the BR banner. The classic example comes from the great poster artist Claude Buckle, who produced a series of superb cathedral posters in the 1930s for the GWR/LMS. BR simply took his artwork, changed the font and put them out again.

Sample Posters from the Big Four (1923-1947) Illustrating Wide Style Variations

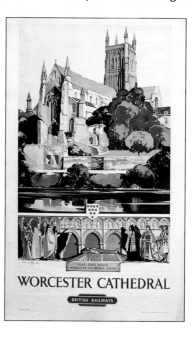

However, it was not long before the better elements of the inherited companies were merged more effectively, resulting in stronger Publicity Departments. Surprisingly, some of the older traditions were still present and some regional influences were apparent well into the 1960s. Once the regional colours started to disappear in the 1960s, when station enamels, totems and even complete stations were no more, the era of B+W BR re-signage ushered in the 'Age of the Train' and other rather tasteless campaigns. The use of classical artists was discontinued as they reduced advertising costs to match lower budgets by producing more abstract and photographic posters, with some featuring celebrities of the day. This for me is when the Golden Age finished.

Today advertising by the re-privatised rail companies is a shadow of its former greatness. Gone are great paintings, the great artists and the collectible images. There is no sense of history or style with the present-day companies, and they seem to have lost the art of commercial graphic poster design. The two examples below are poor substitutes for most images shown in this book. Happily however London Underground still produces fabulous works of art.

The layout of this book

Because of the breadth of posters available and how remarkably few have actually appeared in other books, the main aim of this series is to present as many as possible, arranged by region. In order to show them in a logical sequence, the idea is to take railway journeys, using the power of the poster as the vehicle for travel. This allows us to visit many places, and compare how the various companies tempted us to visit and re-visit. Presenting in random order (as in the past) is a less satisfactory way to gauge the power of posters. The use of railway journeys naturally suggests the title **'Poster to Poster'** (almost a parody of coast to coast) and in this volume alone over 330 works of art show the true beauty that is Scotland. Posters are all about style, visual impression and immediate impact, grabbing the attention of the prospective traveller and wanting him to make the trip. The clever poster below epitomizes these aims.

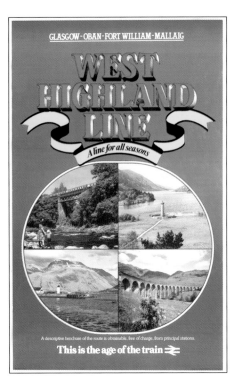

Two More Modern Posters for Rail Travel to Scotland

1950s BR Executive Poster for Rail Travel to Scotland: Artist Reginald Mayes

Here we have the crack locomotive of the day (Sir Nigel Gresley's world speed record holder) running alongside tartans that form the parallel railway track. This early 1950s BR poster advertises the re-introduced *Queen of Scots,* and shows that they did not lose their sense of history or artistic style. The artwork from Reginald Mayes is as fine a piece of eye-catching art as any in the BR era to advertise a railway journey.

Our journey around Scotland has us beginning at the border and in England. Berwick Rangers play in the Scottish Football League and Berwickshire is a Scottish County. However the English purloined the city and made sure it stayed in Northumberland by moving the border. From Berwick we travel through the border country and up the east coast to East Lothian in **Chapter 1**. It is a short journey from there into Scotland's capital in **Chapter 2** and a whole host of posters has been produced over a century featuring the architecture, culture and beauty of the *'Athens of the North'*. It was really difficult to choose what to include and what to leave out, so I hope that readers will approve of my selection. I span more than 100 years of Edinburgh posters but also try to adequately cover this most historic city.

Chapter 3 sees us travelling across the Forth, through the Kingdom of Fife and up to Aberdeen. Here some simply fabulous locations (and posters to match) are presented. Again this was a most difficult area to pick a representative sample of posters from. **Chapter 4** has us in Royal locations, in areas of whisky production and up to Britain's most northerly city, Inverness. Some would say this is the real Scotland and the posters in this chapter reflect the rich culture, majesty and history of the area. In **Chapter 5** we are in the far north and visit remote locations where some lovely artwork has been produced. Travelling on the famous line to the Kyle of Lochalsh we cross onto the Western Islands before landing back at Mallaig to start the journey south. **Chapters 6** and **7** are classical Scotland with a quite superb array of artists and artistic images: a few have appeared before, but most have not, so these are chapters for both the railway buff and the art lover to cherish. Even industrial and smoky Glasgow and the industrial valley produced some fabulous posters. Great artists chose to show steel mills and shipyards in a quite magical way. **Chapter 7** contrasts the beauty of the Trossachs and the Firth of Clyde with the industry of Glasgow and the history of Stirling. The tranquil South-West is showcased in **Chapter 8**. A surprising number of lovely British Railways posters were made for Ayrshire, Dumfries and Galloway, and Kirkcudbrightshire: most presented here will be seen for the first time. The last section, **Chapter 9**, really comes back full circle. The purpose of the these posters was to encourage us to travel and spend money with the railway companies. This chapter tempts us to come back and take the trip again and looks at advertising right through the age of railways in Scotland.

Through the book I have used the real county names, no Highlands, Borders or Strathclyde for me. The real counties are Ross and Cromarty, Roxburghshire and Lanarkshire. These are much more in tune with the theme of railways and railway posters. Small thumbnails of selected artists appear in appendix A, and appendix B lists each of the posters uncovered by research in alphabetical order by real Scottish county.

I know the list is not complete, so any contributions (including correcting errors) are gratefully accepted. For each poster there is a commentary: so as well as a poster book, this is also a travelogue. People intending to visit Scotland could use this as their guide. Scotland has a turbulent history set against a landscape that boasts some of the best scenery anywhere on our planet. I researched the history associated with each poster, adding facts and figures for each place to complement the skill of the artist. Throughout I tried to include posters before and after my Golden Age (those 45 years when artists ruled and collectors today can benefit). Enjoy your journey and appreciate the enormous breadth and artistic skill of the Scottish Railway Poster.

1935 LMS and LNER Artwork by Brian Cook Advertising our Journey to Scotland

1910 Joint LNWR/CR Railway Poster Advertising the Scottish Holiday

Chapter 1 The Journey Begins at Berwick-upon-Tweed

Introduction

Why have we chosen to start the series here in Scotland? One cannot argue that the scenery is not magnificent (so allowing wonderful posters); no one can say the history has lacked turmoil and tragedy (so allowing us to write a colourful background text), and nobody can argue with the distinctive culture, folklore and national identity through tartan kilts, malt whiskies and bagpipes that is recognisable throughout the world. Having spent hundreds of hours poring over the beautiful posters and prints in our National Collection and in international auction catalogues, it is a natural place for us to start. Our poster journey will begin at Berwick-upon-Tweed, having made the journey up from Kings Cross on *"The Coronation"*. Our trusty A4 today has been 60027 - *Merlin* and it is appropriate that the magical powers of the Arthurian character have been put at our disposal as we travel from place to place, around what was the Kingdom of Caledonia for many centuries. These powers will enable us to sometimes move magically as the posters and the prints bring us to the end of the journey at Carlisle.

The journey will take us to most counties of Scotland that existed in the middle of the last century. How much nicer it is for us to use Roxburgh, Selkirk and Peebles instead of Borders, the Kingdom of Fife instead of Tayside Region, or Ross & Cromarty instead of Highland Region. We seem to have lost some of that wonderful heritage through simple name changes. Railways did not cover the entire country – the wonderful landscape and hostile winter storms saw to that. A poster map of Scotland on page 13 shows the natural barriers the builders had to overcome. The gentle uplands of the south and the climb over Beattock give a foretaste of the obstacles further north. Beyond the suburban belt between Edinburgh and Glasgow, we find the Trossachs, Loch Lomond and the new City of Stirling, before we reach the huge granite barriers of the Grampians – the Scottish Highlands proper. Strenuous climbs for our steam engines over desolate and inhospitable purple heather covered moorland makes our journey both romantic and spectacular, with much to see. In a straight line from north to south, Scotland is over 300 miles (475 kilometres long), but the coastline is 20 times this and the many lochs and over 700 islands of the west coast provide sights unique to the British Isles.

In the far north, railways only hug the east coast and the County of Sutherland is best reached today by road, to enjoy the magnificent rolling scenery. Our railway routes, sometimes via steamers and the 'power of Merlin', will take us to those places the railways failed to reach. In our thousand-mile adventure, we will travel to historic cities, to the home of golf, through Glens with turbulent histories, and to places with wonderful names. Consider Blair Atholl, Boat of Garten, Elgin, Glenfinnan and Kyle of Lochalsh, then add in Iona, the Kyles of Bute, John O' Groats and Tobermory: there is no doubt we have a mouth-watering journey in prospect. The poster on page 13 from Montague Birrell Black is almost a view from space as we travel high above northern England towards Scotland. Black was born in London in 1884, but lived part of his life in Liverpool where he painted fine pictures for the White Star Line. His many marine pictures are equally as detailed as this map, one of a series he painted.

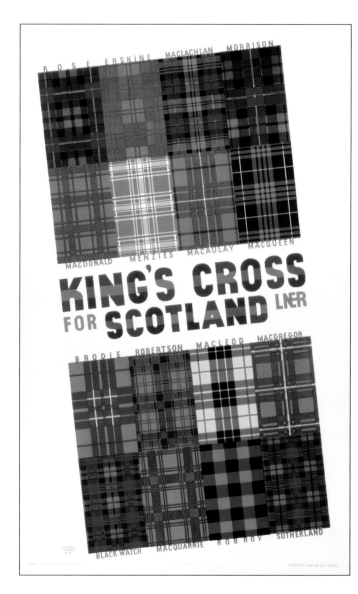

Austin Cooper (1890-1964): Mid 1920s LNER Poster

Mid 1930s LNER Relief Map Poster Used for Joint Advertising: Artist Montague Birrell Black (1884-19xx)

The very large poster database, developed as support for this project, reveals he produced at least 23 posters for six different railway companies. But it is for superbly detailed relief maps (such as this) that he was best known in the railway poster world. This colourful poster allows us to appreciate the geographical and geological features that make Scotland unique. The landscape has been greatly affected by tectonic plate movement and glaciation: it has been covered several times and for long periods during its early history. The poster shows two major fault lines, splitting the country into three main sub-areas. The Highlands and Islands lie to the north and west of the northern fault, which runs from the Moray Firth to Loch Linnhe and the Firth of Larne near Mull. To the south lies the main rift of the Cairngorms, formed by many igneous intrusions and slightly younger than the Highland mountains.

The Central Lowland area is a rift valley and many of the sediments here have had a huge economic influence on the industrial development of the nation. Coal and iron-bearing rocks are found in abundance and largely fuelled Scotland's own Industrial Revolution. From these natural resources, coal mines, shipbuilding and steel developed, which (as we will see) have been used as subjects for some fine railway posters. This area also had volcanoes, the most famous being Arthur's Seat in Edinburgh. This is also found on railway posters (see Chapter 2).

Moving towards the English Border, we come to the Southern uplands, which caused constructional problems when the West Coast Main Line was built through Beattock and into Motherwell in Victorian times. The range of hills is over 120 miles (200km), cut into sections by broad valleys (also featured on posters). The geology here is largely Silurian deposits, laid down some 4500 million years ago. Black's wonderful poster shows many of these features well, and the reader can appreciate the difficulty we face in crossing many parts of Scotland by train. It also shows the railway lines we will follow during much of this journey.

Scotland has a rich history spreading back thousands of years. Its geographical location in the far North of Great Britain has shaped its culture. It is a mountainous and sparsely populated land, but all the railway companies spent a lot of money advertising its beauty and grandeur. Some of the significant historical events have also been depicted on canvas, but it is the scenery that has captured the imagination of artists; look at Merriott's masterpiece on the cover. Apart from the mainland there are almost 880 islands around the coast, and some of these have been depicted on posters and feature in Chapter 5. Today, over 5 million people live in Scotland, but many more ancestors and descendants can be found all over the world. The page 12 poster, dating from the mid 1920s, shows Austin Cooper's artwork for the LNER and gives us a taste of what lies ahead. The 16 clan tartans illustrated typify Scotland's culture: colourful, proud and rich. Scotland has given the world many things we take for granted. The most important two by far are golf and malt whisky! These too are found on our posters.

This book (and all the accompanying volumes that make up the series) has taken considerable research. We began with the NRM in York and then moved through to the Science and Society Picture Library in London, and then to Onslows considerable picture library. We have also looked at poster auctions spanning the last 25 years, where many entries were found to have errors. During our research, we have uncovered a lot of new information. This includes the artists, the location of the painting and the date of the original artwork. Hopefully, therefore, this first volume will enable other researchers in this field to benefit from several years work. The poster database currently lists more than 5700 different posters and careful analysis of all this data reveals much about the commissioning and use of posters to promote railway business.

Our Arrival in Berwick-upon-Tweed

Our early evening arrival in Berwick allows a good night's rest before the Scottish sojourn begins. Many people think Berwick is in Scotland, especially as the football team plays in the Scottish League. The town is actually in Northumberland, but the old county of Berwickshire is in Scotland. Totems from the station showed the colours of the North Eastern Region - tangerine. Berwick is reached on the East Coast Route (frequently used in railway posters as an advertising slogan) via the Royal Border Bridge. As well as Cuneo's famous painting depicted on page 15, the bridge has featured on many posters and works of art.

1930s LNER Poster by Sir Henry Rushbury (1889-1969)

The Royal Border Bridge carries the main East Coast Mail Line between Edinburgh (Waverley) and London (King's Cross). Robert Stephenson's superb viaduct spans the tidal estuary of the River Tweed between Berwick and Tweedmouth, two and a half miles south of the Anglo-Scottish border. It was constructed between 1847 and 1850 under Thomas Harrison's management, using bricks dressed with stone to give a wonderful appearance that befits its Grade I listing. Queen Victoria and Prince Albert opened the 2160 feet (539 metre) long bridge in 1850. It carries the railway tracks almost 140 feet (38m) above the river on 28 arches. 13 of these are above water and the remainder span the land section of the valley: it dwarfs all other bridges in the area.

The bridge underwent its first significant structural refurbishment in 1990 as part of the ECML's upgrading. Cuneo's painting shows a Nigel Gresley '*V2 class*' locomotive struggling across the bridge on a northbound freight. Notice the artist's perspective as he sits outside the line of the parapet. Cuneo was famous for his daring, in order to make realistic paintings. British Railways often co-operated by allowing him unrivalled access to the best areas to paint pictures. Cuneo became 'the establishment artist' for much of the latter half of the 20th century, being the official painter for the 1953 Coronation of Elizabeth II. He is world renowned for his evocative railway scenes, and several appear in this volume.

The Magnificent BR (NER) 1948 Cuneo Artwork of the Royal Border Bridge, Painted Ahead of the Centenary Celebrations.

Berwick is a town that has changed hands many times during the bitter conflicts and battles between the English and the Scots over the centuries. It is a town of many bridges and four cross the Tweed at this point. Even in modern posters, the bridge is heavily used (see Chapter 9). The poster below, from the 1990s, shows the latest East Coast express crossing the River Tweed on its way north. Somehow this does not have the power or artistic flair shown by Cuneo in his masterpiece of 48 years earlier.

GNER Poster from 1996 Showing the Border Bridge in a Modern Stylised Way

The bridge image captured by Sir Henry Rushbury in his LNER poster on page 14, dates from the 14th century, and is equally as famous as the Border Bridge crossing the Tweed. The first of our carriage print artworks by Stanley Roy Badmin shows the panorama around Berwick viewed from the English side of the Tweed.

Carriage Print Artwork of Berwick-upon-Tweed: Artist Stanley Roy Badmin

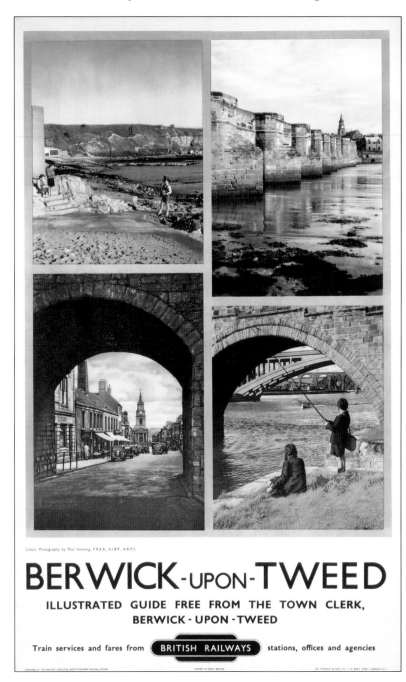

BR Scottish Region Poster from 1950s: Artist Unknown

In front is the old town bridge (shown in more detail in Rushbury's poster on page 14), with the Royal Border Bridge from Cuneo's poster furthest away. They enclose the road bridge shown opposite in Van Jones's poster. The history of Berwick-upon-Tweed is typical of many of the lands in this part of Great Britain. History tells us that between 1147 and 1482 the town changed hands 13 times. King John destroyed Berwick in 1216 and King Edward I also did much damage in 1296 after the Scots surrendered following the Battle of Dunbar. The famous William *'Braveheart'* Wallace had his arms (literally his arms!) displayed here following his execution, as a reminder to the Scots that the English were still in control. After the Battle of Bannockburn (1314) the Scots again took control of the town and during the 15th century the castle was repaired. Berwick was finally taken in 1482 by Richard (Duke of Gloucester) and since then has been administered by the English. History also shows us that the town prospered more under Scottish rule than English. We will not make any comment here, but we are sure that many Scottish readers may have a wry smile and think nothing has really changed!

So why is Berwick in Northumberland and not in Berwickshire? The older, historic part of the town is on the northern side of the Tweed, with the recent expansion to the south. The river had always been the border between England and Scotland, so the lands to the north naturally took their name after the town. When the English took control in 1482, they diverted the historic boundary to include the town, so that today the border is now some 2½ miles (4kms) north of the town boundary. This meant the strategic Berwick Castle was <u>always</u> in English hands, always a good insurance policy in turbulent times! The history of this town is fascinating: it would have made a great documentary film. The Borough of Berwick today has a population of almost 26,000 (2001 census) and on market day it is a bustling place. Our posters show this is a town well worth visiting.

Across the Border and into Scotland

Leaving Berwick we head north, crossing the border with barely a glance. There is a quite famous trackside sign marking the leaving of England and the real start of the journey. To our right is the North Sea and to our left we find the hills rolling away from us towards Coldstream, Kelso and the border abbeys. We will leave the train soon and visit some of these historical places. It is 57 miles (91 kms) from Berwick to Edinburgh, and today's trains make this journey in less than an hour. Below are the famous cross of St. Andrew and the Lion of Scotland.

The Flag and Coat of Arms of Scotland (Rampant Lion dates from 1222)

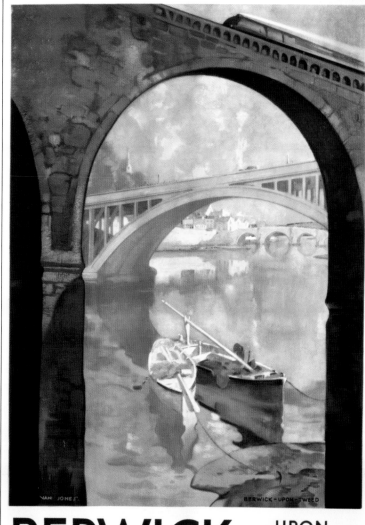

LNER Poster from 1930s: Artist Van Jones

"THE CORONATION"
ON THE EAST COAST ENTERING SCOTLAND
IT'S QUICKER BY RAIL
FULL INFORMATION FROM ANY L·N·E·R OFFICE OR AGENCY

Quad Royal Poster from the Late 1930's Advertising the LNER Flagship "Coronation" Express: Artist Frank Henry Mason

We are now heading due north on *"The Coronation"*. This was *the* crack LNER express that ran from Kings Cross to Edinburgh. This poster shows our northbound express speeding along the coast near St. Abb's Head. Bamburgh Castle, Holy Island and the Farne Islands are shown in the far distance. Note the distinctive 'beavertail' carriage (with its sloping glass observation window) at the rear, so passengers could appreciate the beauty of the journey. There were only two of these saloons ever built. They were part of a specially constructed train to mark the Coronation of King George VI in 1937, after which this express was named.

When this was introduced in July 1937, it created quite a stir with eight coaches articulated in four twin sets (plus the beavertail) to give a 310 tonne train. No. 4491 *"Commonwealth of Australia"* hauled the first service. From an operations perspective, the service was a triumph, but commercially not so, even though the seating and travel was luxurious. This was perhaps because it left London at 4pm and called at York before travelling non-stop to Edinburgh, arriving late in the evening. The poster here demonstrates considerable 'artistic licence' as the sun would not have been in this position when the express was speeding along the coast. Mason's painting seems to make the coaches rather short compared to the locomotive, so maybe this was the real reason the service was not so successful!

1950's BR (ScR) Poster of Neidpath Castle: Kenneth Steel (1906-1973)

We now move magically from the East Coast Main Line inland to see the Borders country. This part of Scotland is a most attractive blend of soft rolling landscapes and wonderful historic houses, castles and abbeys. It has borne the brunt of many conflicts between the traditional 'old enemies' for over 300 years. Edward I of England was the scourge of the Scots, and he took away the Stone of Destiny 600 years ago. It has only recently been returned to its rightful place in Edinburgh. Sadly, many of the castles and abbeys that have been used in posters now only exist as ruins, testament to the bloody conflicts that dated from the late 13th century. The honours were nearly even. Robert the Bruce used guerrilla tactics to beat the incumbent English army at Glen Trool in 1307, but then Flodden Field near Coldstream saw a huge military reverse for the Scots in 1513 when James IV and his army were cut to pieces. The wonderful military history of Coldstream is still shown today, with the Coldstream Guards often being included as part of our National ceremonies. We will see this in Volume 6 when we visit London for Trooping the Colour.

These next few posters are almost history lessons in their own right. The first one shown alongside dates from the mid 50s, and is one of many painted by the superb artist Kenneth Steel for BR's Scottish Region. It shows Neidpath Castle built on a rocky crag above the tranquil River Tweed to the west of Peebles. The castle is an early tower house, fortified to deter local skirmishes rather than repulse a full assault. It is an L-shaped structure dating from the latter part of the 14th century. Its history is interesting, being a stronghold of Charles II. Visitors today can still see the damage in the walls from an assault by Cromwell during the <u>English</u> civil war.

Steel's poster gives us a wonderful view of the upper Tweed in the Borders countryside. He is a favourite poster artist of mine, just because of his wonderful use of colour as here, but his style captured almost everything he painted in a classical way. Steel was born in Sheffield in 1906. He studied art at the Sheffield College under Tony Betts, and was a most prolific poster artist for all the BR regions. He had a fine eye for buildings and some of his quad royal posters are magnificent. I have a book in my collection in which he shows the techniques of watercolour painting.

We soon arrive in Kelso, one of many lovely border towns captured on canvas during the railway era by many artists. The poster alongside dates from the early 1930s, and was produced for the LNER. Kelso has a quite lovely cobbled square in its centre, surrounded by Georgian and Victorian buildings. The Tweed meanders lazily through the town. Nearby is Floors Castle, Scotland's largest inhabited house and there is also a monument to the patriot William Wallace (who we will see again in later chapters). But the main purpose of coming here is to visit the first of our four border abbeys. Founded by King David I of Scotland, Kelso Abbey suffered from the conflicts with England and was severely damaged in 1545, as shown in Tittensor's poster alongside. It was built in the 12th century, making it the oldest of the four we will now visit in rapid succession. James III was crowned as an infant in the abbey. Today's population of Kelso is just over 7000, but being a haunt of Sir Walter Scott, this population swells considerably during the summer months. His first major work *The Minstrelsy of the Scottish Borders* was first published in Kelso in 1802. The lovely town setting, where the River Teviot joins the Tweed is shown to good effect in the second of Badmin's wonderful carriage prints below. This lovely artwork dates from just after WWII. The two Tweed bridges were erected in 1754 and 1800.

Approach to Kelso: Carriage Print Artwork by Stanley Roy Badmin (1906-1989)

The Border Abbeys: a History of Peace and Violence

As we move further inland to the south-west, we come to an area with a violent history and some stunning buildings. The south-eastern Scottish border region shows the scars of the past, but today is a mecca for tourists eager to absorb some of Britain's historical and turbulent past. It is not far to our second abbey.

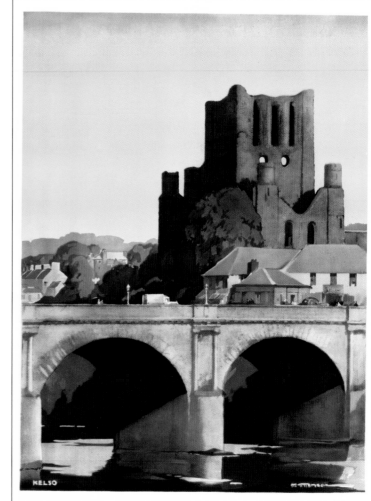

Late 1930s LNER Poster for Kelso: Henry Tittensor

This is Jedburgh and the end of the local branch line from Roxburgh along the Teviot valley. The train journey we have made from Berwick largely follows the Tweed valley as far as Kelso. The village is named after the local river Jed Water. The abbey lies on the north bank of Jed Water and was founded as a priory in 1138. It was given abbey status in 1154. This quite stunning poster shows the abbey around 1930 when Fred Taylor produced his lovely artwork. It is a joint LNER/LMS poster but the style and wording is pure LNER.

History shows us that a church had been established here by 1080, but David I built the priory over a 20-year period. Further building work took place over the next 100 years to give the structure shown in this poster. By 1285 it was complete. The nave is especially long and beautiful and even today some evocative photographs can be taken.

Edward I took lodgings here in 1296 during one of the many skirmishes with the Scots, and destruction started in 1305 when the abbey roof was stripped. Some rebuilding took place, but in 1409, 1410, 1416 and 1464 further attacks occurred. The final death knell rang in 1523 when the Earl of Surrey leading an army, inflicted heavy damage on the abbey. Between 1544 and 1547 the desecration was completed. It really must have been a quite magnificent building in its heyday.

Wonderful Joint LNER/LMS Poster of Jedburgh Abbey, Roxburghshire Painted by Fred Taylor in 1930: Poster Issued 1933

Sir Walter Scott's Tomb at Dryburgh: Original Artwork from 1938 by Ernest William Haslehust (1866-1949)

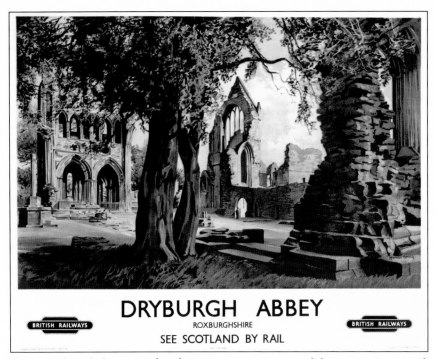

Dryburgh Abbey, Roxburghshire: BR (ScR) 1950s Poster: Artwork by James McIntosh Patrick

The next of the abbeys is Dryburgh, situated within a large bend of the River Tweed just inside Berwickshire. The poster below says Roxburghshire, but this is actually not correct according to OS maps. Many consider this to be the most atmospheric of the abbeys and the location is quite beautiful. It is located only a few hundred yards north of St. Boswells.

Construction (by Scottish Constable Hugo de Moreville) began in 1150, but earlier settlements dating back to 600 AD have been found on the site. The graveyard is the resting place for two famous people from the past: Sir Walter Scott (the eminent novelist) and Field Marshall Earl Haig (the military commander). Tourists flock to Scott's grave (located in the north transept) especially during the summer months. The artwork opposite is by E.W. Haslehust. Below is a BR Poster from the 1950s produced from James McIntosh Patrick's original artwork. It shows the general area of the Abbey and its surroundings, with Scott's tomb over to the left.

The monastery belongs to the White Canon or Norbertine Order (Premonstratensian monks). It too has a turbulent past, being burnt to the ground in 1322 by Edward II, but was later restored by Scottish King Robert I. The English caused further damage in 1385 but it was rebuilt again and enlarged during the 1400s. Along came Henry VIII to raze it to the ground once more in 1545, and it never recovered from this almost total destruction. The general style is Early English, but some parts are much older, dating back to Norman times. Of the whole abbey itself, only the western gable, parts of the transept and part of the choir remain. However, more of the convent area remains, including a stunning rose window. The chapter house has also been well preserved. Visitors often comment on the peace and tranquillity found in the Cloisters. The Earl of Buchan acquired the abbey in 1786 and tried to preserve what he could. The artwork alongside captures the scene today very well.

right) was the first of the symbols used by this railway company after the grouping of 1923. Like the other four abbeys already visited, Melrose suffered from many ransackings during the 14th century. It then took some of the worst destruction by Henry VIII in 1545, from which it never recovered. This was merely a fit of 'pique' by Henry, as the Scots failed to agree to a marriage treaty between his son and the infant Mary, Queen of Scots. He took his anger out on the four border abbeys. There have been several railway posters of this evocative ruin. The quad royal poster (left), dating from the mid 30s, is the work of Fred Taylor. It shows the abbey design well when viewed from the south-west.

1930s LNER Quad Royal Poster Showing the Beauty of Melrose Abbey: Artist Fred Taylor (1875-1963)

**Mid 20s LNER Melrose Abbey Poster:
Artist Frank Newbould (1887-1950)**

Of the four border abbeys, Melrose is possibly the most beautiful. It dates from around 1136 and was built by David I for English Cistercian monks. The stone has a pinkish hue: the poster alongside (right), painted by prolific artist Frank Newbould, depicts the colour of the stonework to good effect. This poster dates from the mid 1920s, as the LNER logo (used bottom

1930 Poster of the Roxburghshire Home of Sir Walter Scott: Artist Walter E. Spradbery

Leaving the abbeys trail we make the short journey to Abbotsford House on our way to Peebles. This was the home of the famous Scottish writer Sir Walter Scott for the final 20 years of his life. The name derives from the abbots of the nearby Melrose Abbey, who used the river crossing spanning the Tweed close to this lovely house. The poster alongside illustrates the rolling countryside that surrounds the gentle setting for his house. The super artwork on this 1930 poster comes from Walter E. Spradbery.

Scott bought the house in 1811 and demolished sections to make way for the turreted design we see today. As his novels were selling well at that time, money for the refurbishment was not a problem. He lavished care, cash and attention on the building to make a wonderful home. The library is almost unique, with some 10,000 rare books about the history of the country and the sheer romance of Scotland. There is also a quite wonderful collection of arms and military memorabilia spanning many centuries of Scotland's turbulent past. The collection includes Rob Roy's famous broadsword (see Chapter 6).

In the early 1950s we could catch the train at nearby Galashiels and travel the upper reaches of the Tweed to reach the border town of Peebles. A Royal Burgh since 1152 under the rule of King David I, Peebles has for many years been a market town cherished by locals and visitors alike for its picturesque and unspoilt character. The Peebles Hydro is an internationally known conference centre and, being only 23 miles from Edinburgh, attracts an international clientele. I have eaten *'neeps and tatties'* with haggis here and very good it was too!

The town is small but quite charming, nestling as it does in the Tweed valley and surrounded by rolling hills. There are many things for the tourist to see, and in common with Edinburgh, the town has festivals and art exhibitions throughout the summer. Our next poster opposite focuses on the tranquillity and peace of the area. This was painted by George Ayling in the early 1930s and captures the area well, even though there is minimal use of colour. Notice all the church spires rising above a 'golden town'. The tallest tower is the parish church and is built in a style identical to that of St. Giles Cathedral Edinburgh but is much later (late Victorian). Standing at the west end of the High Street and overlooking the Tweed Bridge, it occupies the site of Peebles' medieval castle and dominates the town. The distinctive carillon of 13 bells for which Peebles is known today were presented to the church in 1931.

There used to be a train station here (built by the North British Railway) but this is long closed (1962), even before the Beeching cuts started to decimate Scottish rail travel but stemmed the haemorrhaging of financial losses. The train from here would take you into Edinburgh and was a lifeline for the few people who lived in Northern Peebles-shire and South Midlothian. From the carriage windows, there were fine views to the Pentland Hills north of Eddlestone, but usage was very low and the line became an early casualty.

We need to get back to the coast now where our express to Edinburgh has been waiting. The journey takes us over the Waverley route at Stow, across Lauderdale and high over Duns to join the train at Reston. The first written mention of Duns is when a 'Hugo de Duns' signed as a witness to a charter before 1214. The town was frequently attacked by the English, and burned to the ground three times in 14 years, as they headed north to lay waste to the Lothians. Cromwell put a garrison in the town after the Battle of Dunbar in 1650, to keep the locals under control.

Back Along the Coast and into Dunbar

Leaving the tranquillity of the Borderlands we arrive back on our train. *Merlin* accelerates north and we soon come to St. Abb's Head, a jagged series of cliffs running northwards. We have a spectacular view from the train of thousands of seabirds at this important nature site. The line is inland here and follows the Eyewater valley until reaching the coast again at Cockburnspath. Shortly after we enter East Lothian and run parallel to the A1 trunk road, with the sea to our right all the way to Dunbar.

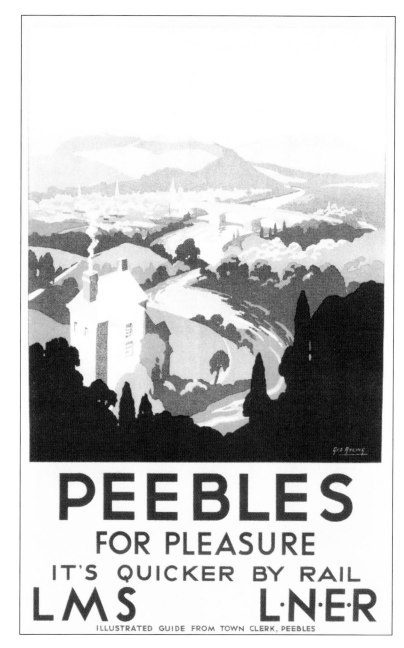

George Ayling's Tranquil View of Peebles: Painted Early 1930s

Because of its strategic coastal location, Dunbar has a long and eventful history. The local tribe resisted Roman incursions and later it was a Pictish fortress until the Scots captured it. The first castle here was built around 900 AD and was unsuccessfully attacked by the English around 1214, but nearly 100 years later King Edward I was triumphant.

It was used by Edward II after the Battle of Bannockburn, and over the next 250 years, was attacked many times before Mary Queen of Scots was brought here in 1567. Ransacking followed shortly thereafter, so the Scots could never again have an impregnable building. The final destruction happened in Victorian times when the harbour was expanded and the outer walls of the castle and the rock on which it stood were removed. Today, access to the ruins is denied following a partial collapse in 1993; barely a stump of wall is all that remains today.

The ruins are seen in the left hand poster. Both posters show different sections of the famous seawater swimming pool, which when built, was the largest in Scotland. It was initially well used but soon fell into disuse when foreign holidays started to become more attractive. Today there is hardly a trace of what used to be there. Dunbar today still has golf and tennis facilities and is worth the short detour as you speed north on either today's high-speed trains or the nearby A1.

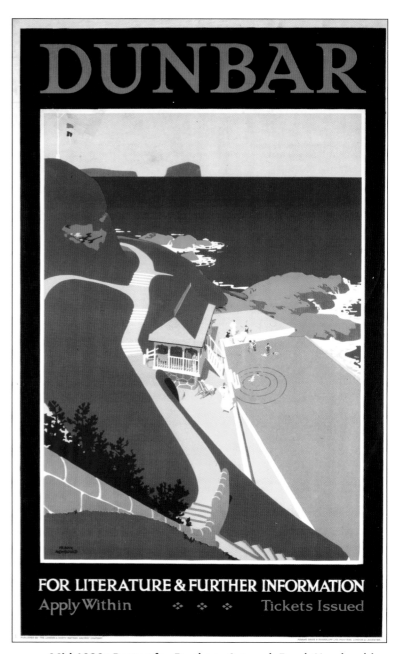

Late 20s Poster of Famous Pool at Dunbar: Artist Eric Lander

Mid 1920s Poster for Dunbar: Artwork Frank Newbould

We finish the first part of our long journey in the small village of East Linton. John Aitken's carriage print below shows the village to good effect, with the River Tyne flowing through the centre. As we alight from the train just 22 miles (36kms) east of Edinburgh, we enter this scene from the left and walk across the lovely 16th century stone bridge.

Carriage Print Artwork of East Linton, East Lothian: Artist John Aitken

There are several houses, pantiled cottages (as shown in the print above), a mill and a kiln from the 18th century. It has remained a charming southern Scottish village for a long time. East Linton had a cattle market and in the 19th century it was an important milling and farming centre, holding weekly hiring markets for migrant labourers. It prospered during this period, through its accessibility by road and later when the railway arrived. Today, commuting into Edinburgh is easy. The artist John Pettie (1839-93) was brought up in East Linton, and the noted civil engineer John Rennie was born in nearby Phantassie in 1761. It is a quite wonderful place to take a pub lunch and reflect on the many sights seen in the Scottish Borders, especially those magical ruined abbeys. The colourful British Railways poster alongside is a final reminder of this peaceful part of Scotland.

1950s BR (ScR) Poster of Jedburgh: Artist Edward Wesson

The Classic 1937 Poster from the LNER Advertising Their New Service: Artist Doris Clare Zinkeisen (1898-1991)

Chapter 2 The Lothians and Edinburgh – Culture, Golf and History

History and Golf

We leave the main railway line to travel a few miles north to see another of Scotland's great castle ruins. Even though it is close to Edinburgh, the peace and tranquillity of this unspoilt area is a million miles from the hustle and bustle of the city. East Lothian has some lovely beaches, rolling hills and cliffs, where we can find military bastions of the past. The early 1920s poster here by Sir Frank Brangwyn of Tantallon Castle, is one example.

Tantallon Castle is built on a rocky headland some three miles south-east of the Royal Burgh of North Berwick. The views from here are stunning, being close to the expansive bird colony on Bass Rock. In its heyday, the castle (with 3.5m thick walls) was a Scottish bastion, but a visit in 1651 by our favourite roundhead - Oliver Cromwell - reduced it to rubble during an artillery bombardment. Brangwyn's poster captures this destruction beautifully, and the reader can only imagine what a fortress this used to be. The eastern towers used to be five storeys high, but all the top sections have now disappeared.

The castle originates from around 1350, when the Douglas family wanted a central fort in their struggle with the Scottish crown, (as they favoured the English). In 1491, the Earl of Angus besieged the castle, because Douglas had tried to betray him to Henry VII. James V besieged it again in 1528, and a year later he acquired it, when the Douglas's fled to England. In 1650, Cromwell's forces occupied it, but repeated Scots attacks caused them to eventually lose control. Cromwell's artillery took full revenge a year later. In 1924 it passed to Historic Scotland. It is a great place to appreciate history.

Mid 1920s LNER Poster of Tantallon Castle, East Lothian by Sir Frank Brangwyn

From Tantallon it is a short westward journey to the Royal Burgh of North Berwick. This is an attractive small seaside resort with good rail links to Edinburgh. The picturesque harbour has been here since the 1100's, and for some 500 years, a ferry ran across the Firth of Forth to Elie in Fife. This proved useful to pilgrims making the trip up to St. Andrews instead of having to go along both sides of the long Firth.

In old English, the name North Berwick means the *'north barley farmstead'* (as *'bere'* is barley). It is 25 miles (40 kms) from Edinburgh and has prospered in recent times because of the superb golf along the shores of the Firth. Several posters have been painted depicting this. The colourful poster alongside (by Andrew Johnson) shows golf fashion in the 1930s, but who do you know who plays golf in designer clothes? This poster has become one of THE classics of all, demonstrating as it does the power of art for promotional purposes. This image has gone around the world as a symbol of Scottish golf, and quite a few may be found in important American collections.

On the next page we show another of Johnson's posters, also depicting golf at this resort, and one that I actually prefer to this more famous one. Sadly research has revealed little about the artist. Maps of the time show four golf courses on both sides of the town, which is served by a short branch line from nearby Drem. This made it easy for city folk to reach the golf links.

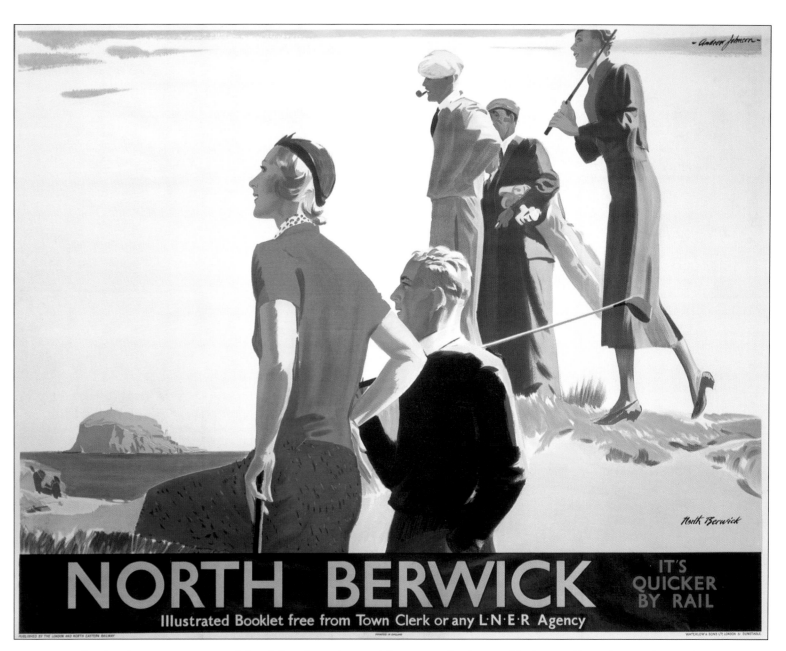

Classic 1930s LNER Poster of the Links of North Berwick, Famous for its World-Class Golf: Artist - Andrew Johnson

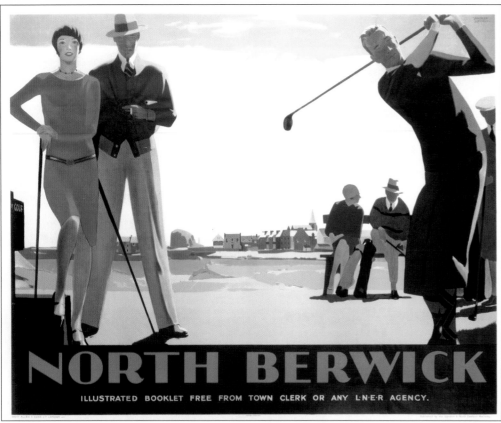

Andrew Johnson's Less Famous Poster of Golf at North Berwick

The database shows well over 100 separate posters published by all the regions but the majority by the LNER. Newbould was a Yorkshireman, born in Bradford in September 1887. Always interested in art, he studied at the Bradford College of Art and in his twenties started to produce posters. During the years between the wars, he established a formidable reputation, which was soon spotted by the LNER publicity department as well as London Transport. It was the style shown in the poster below that won him medals and prizes in several poster competitions. In 1942 he joined the War Office as assistant to Abram Games (who designed the final poster in Chapter 9 of this Volume). Newbould's series of wartime posters under the theme *'Your Britain, fight for it now'* are legendary. His series of *'East Coast Frolics'* and *'East Coast Types'* have been mass-produced as best selling modern day postcards. He died relatively young in 1951 at the age of 64 – truly one of the poster greats.

This poster looks to have been set on the west links, perversely one of two courses on the western side of the town and east of the eastern links! In the centre the reader can see The Sisters Rock, which also features in the first poster of the links near St. Margaret's, on the northern edge of North Berwick. This poster is earlier than the one on the previous page (possibly late 1920s judging by the caption and typeface used), but again the composition is superb and the style quite distinctive.

While in North Berwick we must take advantage of a visit to Canty Bay to the east of the town, where the golf course activity merges with the sun worshippers. This is captured to perfection in Newbould's strong rendering of everything good about the area in the right hand poster. Notice the way he has mirrored the dark blue of the bathing costume in the sky, to highlight the bright yellow of the lady's clothes – wonderful poster art and use of colour. Frank Newbould was a prolific artist for the LNER, and one of the 'Big Five', whose work regularly appeared on posters for the whole region.

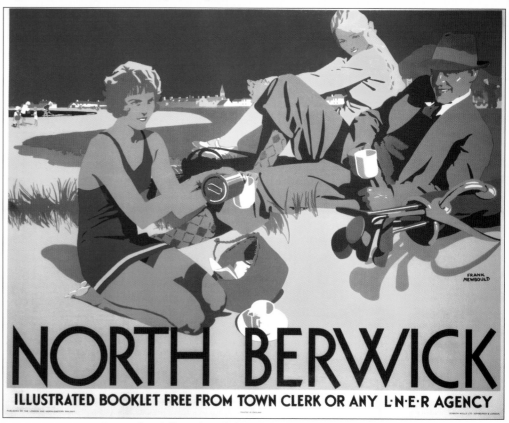

Frank Newbould's Colourful Poster of Relaxation on the North Berwick Golf Links: Issued by the LNER Around 1930

Into Historic Edinburgh

It is time to leave East Lothian and make the short journey to Scotland's capital. When it comes to British history, Edinburgh ranks right at the top, alongside London. The advantage it has over London is the sheer brilliance of its architecture and the city's location, sitting above ancient volcanic cores. On one of these cores sits Edinburgh Castle, and a mile away is Arthur's Seat, captured in another superb railway poster that we will see later in this chapter. The quad royal poster opposite by Kerry Lee is arguably one of the best posters of Edinburgh ever produced by British Railways. The visitor can see at a glance the buildings and key features of an historic city. The Castle, the Royal Mile, the North British Railway Hotel, St. Giles Cathedral, the Scott Monument and Princes Street are all recognizable in a great work of poster art. Also present are famous people from the past; Robert the Bruce, Edward I, Wallace, Cromwell, General Leslie and Mary Queen of Scots.

The historic status of this *'Athens of the North'* is unquestionable, and in recent times the buildings shown opposite have been complemented by the new Scottish Parliament, found near Holyroodhouse at the bottom of the Royal Mile. Edinburgh is the centre of the artistic festival each August, when the famous Military Tattoo and fringe artistic events attract hundreds of thousands of people from all over the world.

Wonderful 1950s British Railways (ScR) Poster, Artistically Stylising the Historic Part of Edinburgh: Artist Kerry Lee

Central Edinburgh Captured in a 1934 Joint LNER/LMS Poster Issued by the LNER: Artist Sir Henry Rushbury

The marvellous city location is captured in our next poster, which views the central features of the capital. In this 1934 image, we are looking west from one of the top rooms in the North British Railway Hotel. This view has changed little in the past 70 years. Only steam-hauled trains have disappeared. Waverley station (where our trusty steed *"Merlin"* now simmers after its efforts) is located in the valley between the Royal Mile and Princes Street, in the bottom left corner of this poster. A local steam train is shown leaving for the short journey to Glasgow. The castle to the left and the Scott Monument and the buildings of Princes Street to the right dominate the whole scene. From this almost 'real' layout the reader can appreciate the artistic licence shown in Kerry Lee's poster, as he moved buildings around to fit his vision on the canvas.

Waverley station is the second largest in Britain and has been the subject of many wonderful railway paintings. Many of these depict Gresley's A4 masterpieces either coming up from London or leaving to go back to the English capital. We can write much about the history and culture of this lovely city, but will restrict ourselves to the following page and let the posters do the talking.

The area has been inhabited since around 1000 BC. However, it was not until nearly 1500 AD that the city became Scotland's capital. Everywhere you look there is history, from the castle and surrounding area of the old city to the new town north of Princes Street. This is a superb example of Georgian architecture. The Romans established a main fort north of Edinburgh around 79 AD when they encountered the Votadinii, a local tribe, which almost certainly used the hill on which Edinburgh Castle now stands as their base.

By 200 AD the Romans had given up on controlling the locals and eventually retreated behind Hadrian's Wall some hundred miles to the south. There were four main Scottish tribes: the Picts to the North, the Scots in the far west, Britons to the south-west and the Angles in the south-east. They struggled amongst themselves for the next few hundred years until Kenneth MacAlpin fought his way to the top in the 9th century. Eventually it was his grandson who became King Duncan I in 1035, and on establishing his kingdom in Edinburgh, so began city development in earnest. It was actually King Malcolm III who began to build the castle and his wife (Queen Margaret) built a chapel within its walls. Today, it is the oldest building in the whole city. Her son David I built the abbey at Holyrood, a mile south of the castle and the main road between these two key buildings was the start of the "Royal Mile".

The Castle itself has had a chequered and bloody history. During the bitter struggles with England around the times of William Wallace and Robert the Bruce it was captured and held by the English until Thomas Randolph and his force scaled the steep sides at night to surprise the holding army. Once Robert the Bruce finally defeated the English to give Scotland its independence, he granted the city a Royal Charter in 1329. The city finally became the capital in the 1500s and its population meant it grew upwards and not outwards. Many of the buildings we see today in the old town date from this time. Because of the overcrowding and the large amount of smoke emanating from domestic fires, it gained the name *'Auld Reekie'. (*An LNER class A1 engine was so named in honour of the city).

In 1603 when James VI became James I of England, everything changed and Edinburgh's importance began to weaken, but the Parliament remained. This ceased in 1707 when the Act of Union was signed, but it was the signal for new city prosperity. It was the start of Georgian Edinburgh, and expansion began in earnest to the north when the loch was filled in and the New City was started below the castle ramparts. This was the time when Princes Street and many classical buildings appeared and the architecture of the city took on a whole new appearance. During the Victorian era the old city around the Royal Mile began to seriously decline and became the habitat of the poor. It was not until a century later that this decline was arrested, and the whole area was cleaned to become today's major tourist attraction. Buildings here have been the subjects of many railway posters and carriage prints.

After the mistakes of the 1960s when precious buildings were torn down, Edinburgh today is the seat of the new Devolved Scottish Parliament with their expensive buildings near the bottom of the Royal Mile. It is home to the world-famous Edinburgh Festival, The Military Tattoo and is full of professionals from many spheres of business (including our failed bankers), the Arts and the Law. The University is very highly regarded worldwide. The Scottish Museum and Academy of Art house treasures from the past and are wonderfully positioned near the station. They have both featured in several classic poster images. The poster alongside, produced by British Railways in the 1960s, shows a classic view from the ramparts. From here we can see the Firth of Forth and the Kingdom of Fife in the distance. Nearer are Calton Hill, The Scott Monument, The Academy of Art, Waverley station and the Princes Street gardens. Almost everything seen in this poster has a special place in Scottish history, and this central area is responsible for some quite wonderful artwork produced by so many artists to lure travellers from all over the world.

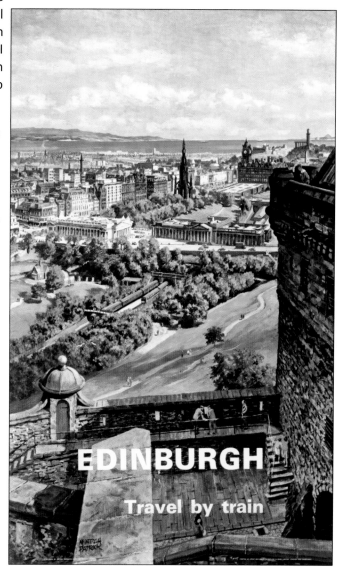

**1960s BR Image of the City Centre From the Castle
Artist: James McIntosh Patrick (1907-1998)**

It is at the castle that we begin to explore Edinburgh. The buildings we see today stem largely from the 15th century. (The exception is St. Margaret's chapel which is early 12th century). It has been a garrison for hundreds of years and is the headquarters of the 52nd Infantry Brigade, the Royal Regiment of Scotland, as well as housing the Royal Scots and the Royal Scots Dragoon Guards museums. It is Scotland's second most popular tourist attraction (behind the Glasgow Kelvinhall Museum and art gallery). The wonderful piece of art from the mid 20s by Anton van Anrooy shows a view from the ramparts.

I love the way the elegantly dressed lady is taking in the history of the city during the afternoon summer sunshine judging by her dress and the shadows. But it is for ceremonial occasions that the castle is best known and several have appeared on posters. The poster below shows ceremonial parading in the castle courtyard; this is simply wonderful to watch.

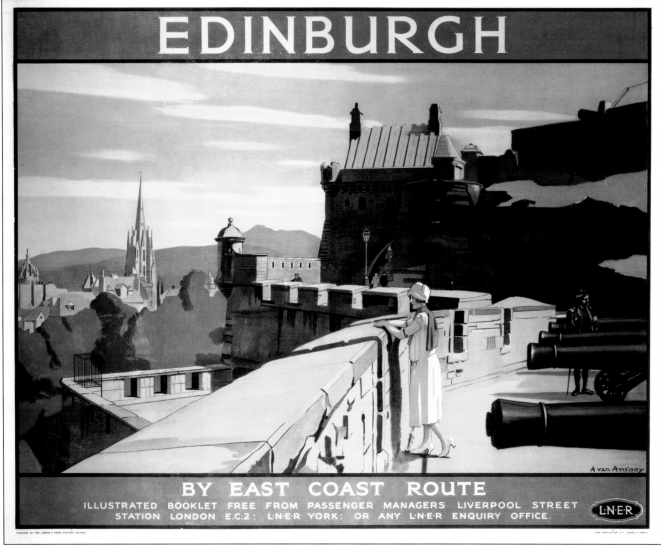

Wonderful 1920s LNER Poster of Edinburgh Castle: Artist is Anton van Anrooy (1870-1949)

1951 BR (ScR) Edinburgh Poster: Artist J. Berry

To the south and west, the castle is protected by sheer cliffs some 220 feet (80m) high, shown in the Kenneth Steel litho-type poster alongside right. This meant that any attacking force would have to come from the east and up via the route of the Royal Mile. One of the historic artefacts found on the ramparts is the 15th century siege gun Mons Meg, shown against elegant designer clothes from the 1930s in Newbould's superb poster below. (An LNER locomotive also carried this proud name). This is a wonderful use of a splash of colour to add some vibrancy to the poster.

1950's BR Poster: Artist Kenneth Steel (1906-1973)

It is time to leave this evocative part of Edinburgh and head off down the Royal Mile on our journey to the Palace of Holyroodhouse. To meander down this most famous of Scottish streets is one of the great walks you can take anywhere in the United Kingdom. It is especially pleasant in early August when the city is alive with Festival visitors from all over the world.

1935 Poster of Edinburgh: Artist Frank Newbould (1887-1950)

The Royal Mile has seen many historic processions, one of which was captured on a poster by William Barnes Wollen, the military artist. It shows Mary Queen of Scots in the city with St. Giles Cathedral behind her. She was a most fascinating monarch, renowned for her beauty and held the crowns of England, France, Ireland and Scotland for a brief period. The colourful artwork below gives us a good impression of the old city buildings and cobbled street.

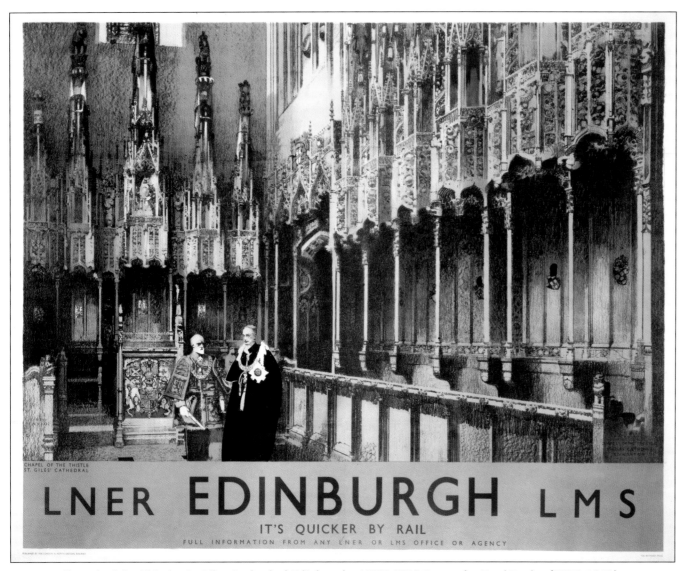

Chapel of the Thistle, St Giles Cathedral Edinburgh: LNER 1930 Poster by Fred Taylor (1875-1963)

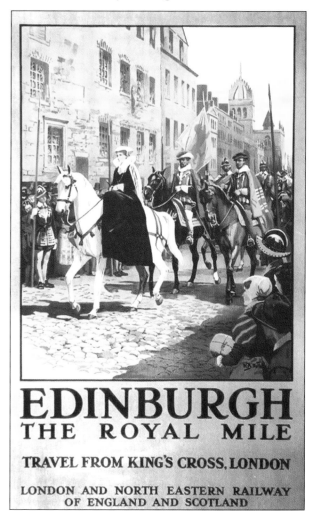

1920s LNER Ceremonial: W.B. Wollen (1857-1936)

Leaving the castle we enter the Esplanade, home to the Military Tattoo, and on into Castle Hill where we are greeted by the city's highest spire on Tollbooth Kirk to our right. Further down the Royal Mile we come to the great Cathedral of St. Giles, easily recognizable by the distinctive hollow crown tower. Very few posters have been made of this building, but a poster has been produced by Fred Taylor to commemorate the Thistle Chapel, the place of prayer for Scotland's foremost order of chivalry. The intricate carving throughout the chapel is captured in the poster, together with the regalia of *The Most Ancient and Most Noble Order of the Thistle*, to give it the full ceremonial title.

Passing down the Mile we come to the house of John Knox, who was the leader of the Reformation in the 16th century and a Minister at St. Giles. He was immensely influential in Scotland around 1540, and his house is one of the few to have survived intact from that turbulent period in Scotland's political and religious history. Today, the house is a museum to his life and work.

At the bottom of the Royal Mile is the famous Palace of Holyroodhouse, built by James IV from around 1500. Today it is the official home of Queen Elizabeth II and is where Scottish ceremonials involving the Queen (such as investitures and banquets) are held. The carriage print (below left) by Sir Henry Rushbury captures the façade beautifully. Buildings on this site date back nine centuries. First there was an abbey and Augustinian monastery, before the palace proper was started. Even before that, the Kings chose to live in the parkland area rather than in the castle at the top of the Mile. Once the towers and west front had been completed in the 1530s, the palace became more as we see it today. It was the home to Mary Queen of Scots for much of her life.

The Carriage Print Depicting Knox's House in Edinburgh's Royal Mile: Artist - Fred Taylor (1875-1963)

The Palace of Holyroodhouse as Taken From the BR Carriage Print: Artist – Sir Henry Rushbury (1889-1968)

It fell into decline during the second half of the 16th century before renovation was made in honour of Charles I. However during the English Civil War, Cromwell's forces were housed there and extensive fire ravaged the palace meaning further restoration was required. Charles II was crowned in Scotland, once the monarchy had been restored, and he began another period of extensive restoration, rebuilding around 1660. There were successive cycles of neglect and renovation for 150 years, until George IV's State visit to Scotland recognized the importance of the Palace and monies were allocated, especially for the apartments once used by Mary Queen of Scots.

It was Queen Victoria who reintroduced the practice of modern-day Royal patronage. Through her interest in the Palace, and the fact that she chose Balmoral for her summer holidays, there developed a renewed interest by Scots people everywhere to ensure Holyroodhouse took its rightful place as Scotland's First Royal Building. King George V and Queen Mary continued this work and the Royal apartments on the upper floor owe much to their efforts. The Great Gallery is well worth a visit.

Holyroodhouse Week occurs at the end of June and into July, when the Queen plays host to thousands of people from all walks of Scottish life at her annual garden parties. This tradition was started by King George and Queen Mary and is immensely popular. In 2002 the new Queen's Gallery was opened to enable artefacts from the Royal collection to go on display.

This quite stunning piece of artwork by Claude Buckle shows the setting around the Royal Palace of Holyroodhouse. The poster was published around 1960 and illustrates the ancient volcanic structure that is Edinburgh. Behind is Arthur's Seat, a volcanic plug dating from the carboniferous period. It was eroded by glaciers, which exposed the rock faces (Salisbury Crags) we see today. This meant silt was swept westwards, towards the sea, forming the landscape upon which this great city is built.

This stunning poster gives a wonderful perspective on both the Palace with its quadrangle design and the ruined abbey on the left hand side of the poster. Buckle's distinctive use of dark colours juxtaposed with bright areas, emphasizes both the building and mountains, but it is interesting to contrast this with Rushbury's carriage print on page 39 that is lighter, softer and far more detailed.

THE PALACE OF HOLYROODHOUSE
EDINBURGH
 SEE BRITAIN BY TRAIN

BR (ScR) 1960 Poster of the Royal Palace of Holyroodhouse: Wonderful Artwork by Claude Buckle (1905-1973)

Edinburgh Princes Street Area

It is now time to explore the central area of the city. This wonderful poster, dating back to pre-BR days, epitomizes the 'Athens of the North' for many people. Again considerable artistic licence has been applied as Princes Street, the Scott Memorial, the Museum complex and Edinburgh castle have all been moved to create a very atmospheric picture. This very rich tapestry of limited colour, but great style, produces one of the most collectible posters of this unique and colourful city.

Very few railway posters carry images of street tramcars, so this is another reason to savour the work of Ludwig Hohlwein. A native of Germany and active in many fields of advertising art, his bold and definitive artwork is quite unlike any other of the artists often used for railway posters. This joint LNER/LMS poster issued by the LNER dates back to around 1933 (when the slogan 'It's *Quicker by Rail*' was adopted) and is one of only a small handful he painted for the British railway companies. The only criticism that could be made is the prominence of the Scottish Crest. This may have looked better in the top right hand corner or not used at all.

Superb 1933 Joint LNER/LMS Poster for Edinburgh: Artist Ludwig Holhwein (1874-1949)

The more modern poster below, dating from the late 50s, shows the pipers of the Scots Guards parading in the almost identical location. Notice here there are no white plumes in the headdress. The Scots Guards do not have plumes as they always parade in the centre of each ceremony. The Coldstream and Grenadier Guards (the other two regiments of foot) do have plumes, which mean they parade on flanks. Ceremonial commanders could easily identify the various regiments within a major ceremony (such as Trooping of the Colour) by the colours of the plumes. All this was introduced around 1830 when ceremonial dress developed. Lance Cattermole, who produced the original painting for this poster, was quite superb in his illustrations of such subjects, and he features again whilst we are in Aberdeenshire visiting the Highland Games.

1933 LNER Poster of Princes Street on a Busy Summer's Day: Artist Arthur Michael

Edinburgh is no stranger to ceremonial processions and here we show two that have appeared on posters at different times. Above is a 1930s poster showing a mounted troop of the Guards on Princes Street in full dress uniform, complete with bearskin caps. Arthur Michael's wonderful artwork also shows fashionable ladies and a proud Scotsman in 'plus fours'. (We will see his classic poster for St. Andrews in Chapter 3). Hardly anybody seems interested to watch the troops pass by! Michael worked mainly in watercolour but this poster was painted in bodycolour (any type of opaque water-soluble pigment of which gouache is probably the most well known example today). SSPL records show seven of his posters are housed in their archives, covering different parts of the UK. He also illustrated 1930s books and periodicals.

BR (ScR) Poster of the Scots Guards on Parade: Lance Cattermole (1898-1992)

BR 1960s Poster – The Scott Memorial by Claude Buckle

These two double royal posters show different parts of the city. Buckle's distinctive style on this poster captures the Scott Monument in Princes Street Gardens to perfection. It was inaugurated in 1846 to commemorate the writings of Scotland's leading novelist, Sir Walter Scott whose house we visited in Chapter 1. For those energetic enough to climb the 287 stairs, the view from the top is well worth the effort. The monument was designed by George Kemp. BR issued the poster in the 1950s and it is one of the posters used in the USA with addresses of several major cities replacing the usual BR lower wording.

Alongside is a 1991 modern poster from the distinguished artist Professor Brendan Neiland RA. This shows the expansive glass roof of Waverley station, with the castle silhouette in the bottom corner. Waverley is built in the area filled in from an ancient loch (the Nor Loch). It covers an area of more than 100,000m^2 (25 acres in old money!). Rival companies built three stations close to each other in the 1840s, but the NBR acquired all three, demolished them and formed the present station in around 1868. Most travellers today overlook the elaborate ceiling of the ticket hall (restored in 2003). The station is made from local Binnie stone – beautiful.

Edinburgh Waverley – Intercity 1991: Brendan Neiland

Nearby is a quite outstanding railway building. The famous North British Hotel stands above Waverley station at the end of Princes Street. It was renamed the Balmoral in the 1980s but the stonework still carries the legacy of its historic past. It opened in October 1902 and the 195 feet tall clock tower could be seen as easily as the Scott Memorial from all over central Edinburgh. The North British Railway Company wanted to make a statement to the wealthy travellers, so installed a private elevator to take guests directly from the arrivals hall at Waverley into the main hotel Reception. The 300 bedrooms were sumptuously fitted to the finest French and Italian tastes. The austere exterior gave no hint of the interior luxury. It can be found on one railway poster that does not do it adequate justice. Fred Taylor's mid 1920s poster is shown below and alongside is Gordon Nicoll's rendition of the vibrant interior. This poster dates from the early 1930s.

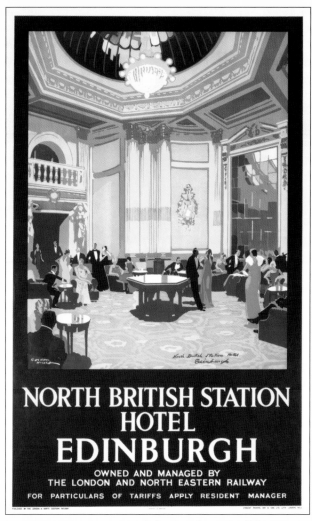

LNER 1924 Poster by Fred Taylor Showing The North British Hotel, With Calton Hill Behind

1930s LNER Poster: Artwork by Gordon Nicoll (1888-1959)

Out of Edinburgh

Close to the centre of Edinburgh is Fettes College, one of 15 schools painted by Norman Wilkinson for a series of posters issued by the LMS. With a proud history, Fettes is one of the finest schools in Great Britain and the artwork below does full justice to the distinctive architecture.

It is now time to start to move outside the main centre of this quite wonderful city. Our train moves slowly westwards out of Waverley station and into the tunnel beneath the Art Gallery. We emerge into Haymarket station and its engine shed complex. Here Gresley's magnificent pacifics used to await their turn to work, or simply rested after working north from Kings Cross. The tracks branch west out of the station and we take the right hand fork, swinging north-west past Edinburgh Airport. We were intending to go directly to see one of the great engineering wonders of Victorian Britain, the Forth Bridge, but first we move away from the railway lines again to visit a famous palace in West Lothian. This features on a quite lovely poster produced by British Railways in the 1950s. Linlithgow Palace is just eight miles from the bridge but well worth the detour.

LMS Poster from Schools Series: Artist Norman Wilkinson (1878-1971)

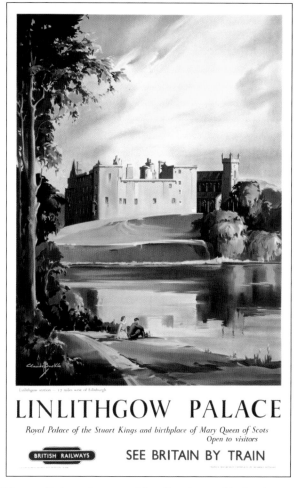

Linlithgow Palace Captured by Claude Buckle in the 1950s

Linlithgow Palace is famous as the birthplace of Mary Queen of Scots. The regal setting midway between Stirling and Edinburgh is sadly now a ruin, but all of the Stuart Kings lived there and each spent time and money in restoration work. There was already a royal manor house here before the many incursions by our favourite English bully – Edward I – at the end of the 1200s. Edward set about fortifying it with ditches and wooden palisades, so at the time of the battle of Bannockburn, he was using it as a garrison and his local base. After the English were beaten at Bannockburn, it reverted back to the Scots.

David II continued its rebuilding but it was not until a devastating fire in 1423 (that also destroyed most of the town) that James I began an ambitious programme to transform it into the large stone castle that we see today. The building lasted almost 200 years, being completed in stages by successive Kings (up to and including James VI in the 1620s).

However it took a woman to really make it famous. Mary Queen of Scots was born here in 1542, but before her first birthday she was taken to Stirling Castle. The English King Henry VIII thought he could unite the two countries by arranging Mary's marriage to his son Edward, but the plan was opposed by pro-French and Catholic Scots alike. As the Scots feared for their Queen, she was then sent to France and did not return for another 13 years. During the time she was in Scotland, Mary visited Linlithgow on numerous occasions. During her captivity in England, and after the succession of her infant son James VI, the palace started to become neglected.

West Lothian used to be called Linlithgowshire until 1921, and the area today is a hive of electronics activity in what is dubbed 'Silicon Glen'. The new town of Livingston took the overspill from the whole of the central urban areas surrounding both Edinburgh and Glasgow. Its development is assured, as it now boasts an SPL premiership football team! Livingston is the second largest settlement in the Lothians (after Edinburgh). Until 1963, the area surrounding the ancient village of Livingston was open farm land.

A year before the decision was taken that the area should be the basis for a new town. It was Scotland's fourth post-war new town and Livingston was chosen to carry the name. The village dated back to the 12th century, when a Flemish entrepreneur called De Leving was granted land in the area. He built a fortified tower (long since gone) and a small settlement grew up around it. This was known as Levingstoun from which the name Livingston evolved.

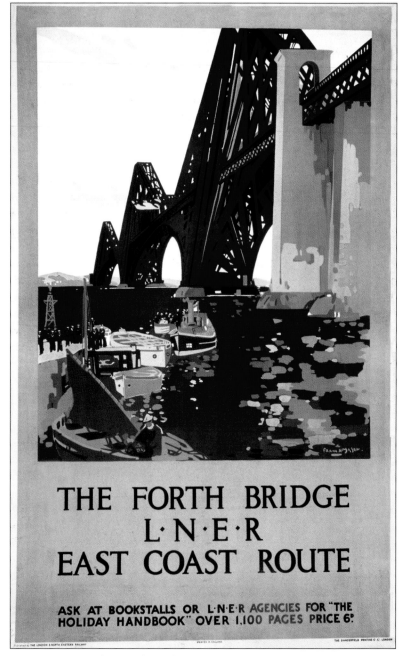

1928 LNER Poster of a Psychedelic Forth Bridge: Artist Frank Henry Mason

 THE SILVER FORTH

SCOTLAND FOR HOLIDAYS

Norman Wilkinson's Superb Painting of the Famous Bridge Used for a 1935 LNER Quad Royal Poster

From Linlithgow Palace it is a short ride to the Firth of Forth and probably the most famous bridge in the world. The previous poster showed an unusually coloured bridge looking across the Forth to the Kingdom of Fife. Comment will be made in the next chapter about **blue** bridges. The 1928 poster from Frank Mason highlights the fact that the famous named express *"The Flying Scotsman"* used this route.

We finish this part of the journey with a quite wonderful poster by Norman Wilkinson showing dawn over the Firth, with the bridge silhouetted against the golden, rather than silver, Forth. Wilkinson features more times in the database than any other artist. His greatest love was marine paintings and his renditions of the sea were quite superb, whether they were in oils or watercolour. It is therefore surprising that in this poster the Forth is just a simple wash of colour. During WWII, Wilkinson painted a record of major sea battles and presented his 54 paintings to the Nation. They are kept at the Greenwich Maritime Museum. However it was with posters that he gained commercial success, painting primarily for the LMS, though this poster was issued by the LNER in 1935. He also illustrated a number of books. This poster is a fitting end to a truly historic journey from North Berwick.

1934 LMS Quad Royal Poster of Edinburgh: View from Calton Hill: Artist George Henry (1858-1943)

Chapter 3: Clackmannanshire, Kingdom of Fife, Kinross-shire Perthshire (East), Angus, Kincardineshire, City of Aberdeen.

Chapter 3	Across the Forth to the 'Granite City'

The Firth of Forth

We have now arrived at one of the wonders of Victorian engineering. The Forth Bridge was conceived to carry the main railway line from Edinburgh north to Aberdeen. Without it trains would have had to travel further along the Firth of Forth to as far west as Kincardine near Falkirk before turning north and proceeding along the north side of the Firth. It has been the subject of many works of art and the problem was deciding which ones show off the scale of the engineering. Gawthorn's red bridge alongside contrasts with Frank Mason's 'blue bridge' on page 42!

At 2.5 km (1.5 miles in old money) this was the world's first major steel bridge. Its twin central spans of 521 m (1710 feet) put it into a different league to anything previously built, and its majestic lines still make it a modern feat of civil engineering. Below the only real engineering data in the whole book is listed. To do otherwise would not do the bridge justice and, as it is one of the principle features of the journey, this must be so.

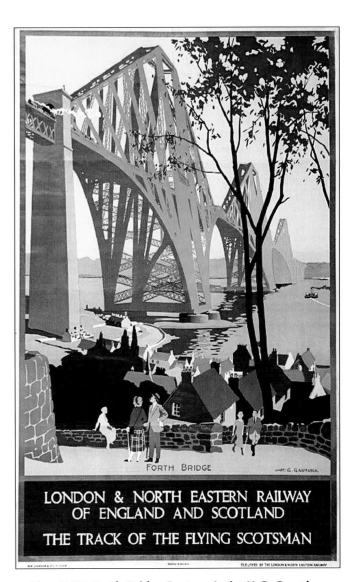

Forth Bridge General Dimensions Built 1883-1890		
	Imperial	**Metric**
Overall length	8296 ft	2528.7 m
South approach	10 spans of 168 ft.	10 spans of 51.2 m
North approach	5 spans of 168 ft.	5 spans of 51.2 m
Length portal to portal	5350 ft	1630.7 m.
Length tower to tower	1912 ft.	582.8 m.
Cantilever length	680 ft	207.3 m.
Simply supported spans	350 ft.	106.7 m.
Main spans	[2 x 680ft.+350ft.] = 1710 ft.	[2 x 207.3 m.+106.7 m.] = 521.3 m.
Height of towers	330 ft.	100.6 m
Rail level above high water mark	158 ft.	48.2 m.
Clear navigation headway	150 ft.	45.7 m.
Weight of 1710 ft. span	11571 tons	11754 tonnes
Total number of rivets	6,500,000 weighing 4200 tons	6,500,000 weighing 4267 tonnes
Total cost	£3.2m [including the cost of foundations £0.8m]	

Each of the double-cantilevered towers is founded on four piers consisting of 90 feet (27m) tall caissons filled with 54 feet of concrete and then topped with a core of Arbroath granite. The foundations alone accounted for over a quarter of the build time. Its conceptual engineering is unbelievably elegant. Gawthorn's LNER poster from the 1930s shows how it towers over Queensferry to the south of the Firth.

Fine LNER Forth Bridge Poster: Artist H.G. Gawthorn

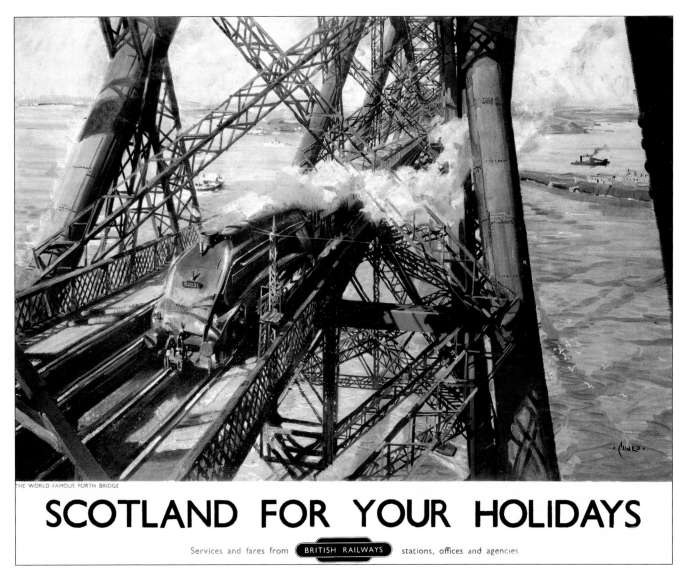

THE WORLD FAMOUS FORTH BRIDGE

SCOTLAND FOR YOUR HOLIDAYS

Services and fares from (BRITISH RAILWAYS) stations, offices and agencies

The Forth Bridge: The Classic BR Poster from the Early 1950s: **Artist: Terence Tenison Cuneo (1907-1996)**

We are now travelling across the bridge and the famous poster from Cuneo captures the sheer scale of the structure. Our trusty steed *"Merlin"* is shown at full flight heading north and looking down the water is almost 150 feet below us. (NOTE: The engine actually shown is 60031 – *Golden Plover*). The cross-bracing of the bridge is shown to excellent effect in this wonderful artwork.

The engineers responsible for this feat were Sir John Fowler and Benjamin Baker (later knighted). The main contractors were Tancred-Arrol with an army of thousands of support staff and workers (up to 4,000 at any one time). They adopted a balanced cantilever principle whereby the load is evenly and smoothly transferred along the entire structure. The main crossings comprise of large tubular struts and lattice girder ties (as in the poster) in three cantilevers, each connected by suspended curved girder spans resting on the ends of the main spans. The whole thing is tied together with giant pins. The northern and southern shore ends carry weights of about 1000 tonnes each to counter balance half the weight of the bridge plus any live loads from the trains crossing.

During the construction 57 men lost their lives, so the bridge was built at quite a cost. Much has been written about the painting of the bridge, since once work is started at either end, by the time they reach the other side the work has to start all over again. I talked with Network Rail and they told me this would soon be a thing of the past! In 1998 a contract was started costing over £40M. The many layers of paint have been blasted back to the bare metal. A zinc-priming coat has been added, and then a layer of glass based epoxy coating measuring only 400 microns thick provides the main protective barrier. Finally a polyurethane-rich coat of gloss paint 35 microns thick will give the traditional 'Forth Bridge Red' colour. Imagine a blue or a black bridge: it just did not look right in the page 42 poster. All these coatings have to be applied on a surface in excess of 400,000m^2. The coatings have been tested in offshore waters to give a life in excess of 20 years. All this means the bridge may be free of painters from 2009 for the first time in over a century – at least for a decade or so. The bridge now carries 180-200 train movements a day and is by far Scotland's largest listed structure.

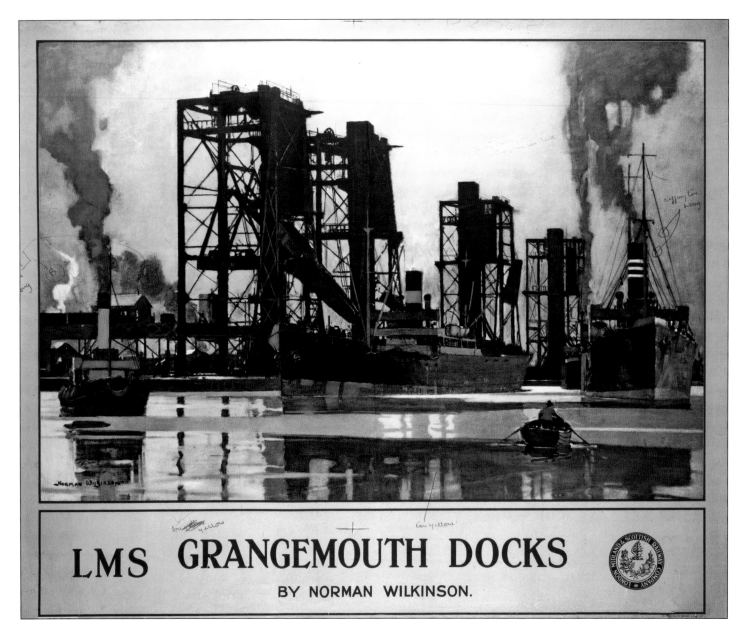

We will be visiting Stirlingshire in more detail later in the journey but from the Forth Bridge area we can see the industrial complex around Grangemouth. The superb industrial poster alongside shows Norman Wilkinson's painting of the docks area in the 1930s. We have included this poster here to contrast industry with the rest of this part of the journey. The Kingdom of Fife, Perthshire and the journey up to Aberdeen are all quite beautiful, so this is a rare chance to put the intrusion of industry into the more traditional Scottish scenery. This LMS poster is actually a final draft as the artist's comments and notes appear on the work. What is quite lovely about this is the use of relatively few colours and the absence of traditional water 'blues' to emphasize the smoke and grime that characterizes man's fingerprints all over our 'blue planet' (to use Sir David Attenborough's phrase). Wilkinson's wonderful treatment of water (as a leading marine artist of his time) is a key feature of this painting.

Some of the normal workings of the port shown opposite seem to have been carried on before the creation of the Forth and Clyde Canal, the building of which in the 1770s is normally associated with the founding of Grangemouth. However history shows buildings and communities going back to before 1100. Unlike nearby Linlithgow with its ancient and interesting history, Grangemouth is a new town with a brief past and a most promising future. The Old Town is the more picturesque part of the port, though some of the old port buildings are really shabby and need refurbishment. In the 1960s the population grew by 25%, and today there are many large companies situated in the town.

LMS GRANGEMOUTH DOCKS

BY NORMAN WILKINSON.

Superb 1930s Industrial Poster of Grangemouth from the Brush of Norman Wilkinson and Painted for the LMS

Into Historic Dunfermline

From Grangemouth and its industry, it is just a short train journey to Dunfermline with a wealth of history to see and enjoy. Dunfermline has a history extending back over a thousand years to the foundation of a Celtic Chapel by a priest. It became even more significant when Malcolm Canmore moved his Court here in around 1065. His Queen, Margaret, established the town as an ecclesiastical centre (see following page) and the world famous abbey was born.

However, it is also the home of Andrew Carnegie, who after spending his early years there, emigrated to the USA to make millions in the Pittsburgh steel industry. Once he had made his fortune, he began to use the wealth to Dunfermline's benefit, as well as New York City's. The famous Carnegie Hall and Carnegie-Mellon University were some of his bequests in the USA, but in Dunfermline, he helped to landscape the town centre. The poster alongside left shows Pittencrieff Park and the famous abbey, wonderfully painted by Kenneth Steel. The town is home to the Carnegie Trust, established in 1903. The cottage where Carnegie was born on 25th November 1835 has been extended to house a museum of his life and work. It depicts the hard life the people had here in the early Victorian years. His wealth was incredible and on his death in 1919 in Massachusetts, he was worth $298.3 billion in today's money!

The 1932 poster alongside right also shows the abbey exterior in Pittencrieff Park, with the softer art of R.G. Praill contrasting beautifully with the boldness of the Steel poster dating from twenty years later.

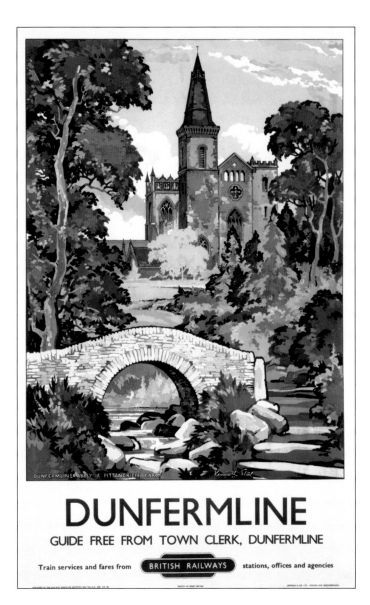

1952 BR (ScR) Poster by Kenneth Steel (1906-1973)

1932 LNER Poster of Pittencrieff Park: Artist R.G. Praill

This lovely image of one of Scotland's most famous abbeys comes from Fred Taylor. He was renowned for his depiction of architecture all over the UK, but it is his work for the LNER for which he is best known. The buildings here began around 800 AD but the nave is later. The central columns, which are identical in design to those found at Gloucester Cathedral, were actually started around 1126. However, the Dunfermline columns are unequal in diameter. This is only one part of the abbey and known as the medieval nave. In 1818 a more modern extension was built, which (whilst being beautiful) does not have the historical atmosphere of the section shown here.

In the South Transept is the Malcolm and Margaret Window. Arresting in size and imagery this magnificent window has, as its principal subject, the marriage of King Malcolm III to Margaret, later Saint Margaret of Scotland. In the new part of the abbey is the equally beautiful McLaren window dating from 1904. Following the Battle of Hastings, the defeated English royal party with Margaret, daughter of Edward Atheling, claimant to the English throne, arrived at Dunfermline at the court of Malcolm III. Following their marriage, they reared a family of eight children and three of their sons Edgar, Alexander I, and David I, became Kings of Scotland. It was David I who was responsible for the development of the abbey.

Successive Kings and Queens of Scotland of this period are buried here, as is Robert the Bruce (plus his Queen, Elizabeth) and also William Wallace's mother, thereby assuring Dunfermline's place in Scottish history.

The Interior of a Most Famous Scottish Abbey: Dunfermline Fife: 1936 LNER Poster by Fred Taylor (1875-1963)

Unusual Industrial Poster by Frank Mason for the LNER: Date 1923

Before we leave Fife's industry, we have the chance to look at another aspect of the Kingdom of Fife rarely seen. Burntisland is east of the Forth Bridge as we make our way by train towards Kirkcaldy. It also gives the chance to show the drawing skills of prolific artist Frank Mason in this rather unusual poster dating from around 1923. This is not the kind of subject to attract tourists but it is informative and it does show exceptional artistic skill. But what was the purpose of such a poster? Maybe the answer was in attracting industrial investment into the area, as the lower portion caption was geared towards extolling the virtues of the coalfield. Mines were sunk as early as the 1820s and as late as the 1950s, but all mines had gone by the late 1980s. The coalfield was inland from Burntisland (centred on Cowdenbeath and Lochgelly) and records show 52 collieries made up the Fife coalfield. At its peak 10 million tonnes per year were extracted from seams up to 5 feet (1.5m) thick, at depths down to more than 900 feet (300m).

The main line hugs the coast after crossing the Forth Bridge up to Kirkcaldy. It then branched with the mainline heading north towards another famous Bridge across the Tay, whilst the branch line (now long-gone) continued along the coast to the world famous City of St. Andrews. Half way on this short detour we come to St. Monance, beautifully captured on canvas by James McIntosh Patrick (1907-1998). It was made into one of the nicest of the carriage prints but would have made a lovely double royal poster. Here we have a 750-year old church with the finest examples of Fife fishing village architecture characterized by red roofs and outside staircases. No wonder it is now an artists' paradise. The whole area is well worth visiting today.

1950s Carriage Print: St. Monance, Fife by James McIntosh Patrick

The Home of Golf

We now journey to possibly the most famous place in Scotland, and certainly for sports fans. St. Andrews is world famous for its golf: indeed it is _the_ home of golf, with the Royal and Ancient (Golf Club) dominating this part of the country.

Falkland Palace, Fife: BR (ScR) Poster from 1955: Claude Buckle (1905-1973)

Claude Buckle painted the Palace of Falkland, home to King James IV. The palace dates from 1500 but suffered at Cromwell's hands in 1645. The south gatehouse (shown above) remains, whilst the eastern and northern sides suffered terrible damage. The Marquess of Bute restored the remains in 1887 and today the National Trust of Scotland maintains it.

H.G. Gawthorn's Depiction of the Famous Golf Links: 1927 LNER Poster

The ancient university City of St. Andrews lies at the extreme end of the Fife peninsula, where the North Sea washes a rocky headland flanked by sandy bays housing the most famous golf course in the world.

The City is a major tourist mecca and used to be the ecclesiastical capital of Scotland but now only possesses a ruined abbey. Its university was, until recently, home to Prince William and has seen much royal activity in recent years. Naturally, being such a famous city, there are many posters. One of the nicest (by Frank Mason) is shown below.

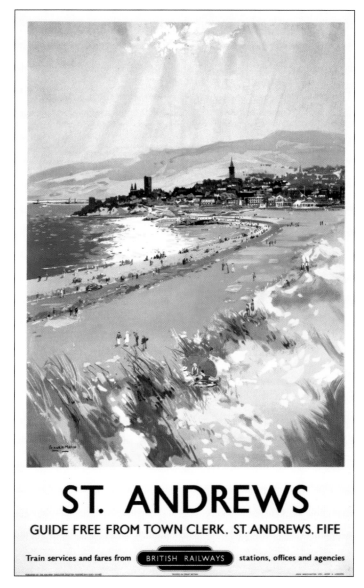

1950s Poster of the City of St. Andrews: Artist Frank Henry Mason

It is worth looking at the history and development of the city both culturally and in railway terms, as today it is a pre-eminent British city with no railway connections. Given its tourism and sporting contributions this is very surprising and shows the complete lack of foresight when railway closures started to bite. The railway that used to serve St. Andrews was a loop off the East Coast Main Line (ECML). It left the main line at Thornton Junction and travelled right around the coastline to such places as St. Monance (page 55), Crail and Anstruther until the 1960s closures. St. Andrews station itself closed in January 1969, so it is almost 40 years since such a mecca for tourists has been rail-linked. The nearest station today is Leuchars to the north-east.

Two Posters Depicting St. Andrews Castle: LNER (left) and BR (ScR) right

Both the castle and lovely cathedral fell into ruin during the reformation years, but two posters of contrasting styles show that the strategic position of the castle remains. Fred Taylor painted them some 30 years apart. St. Andrews is Scotland's oldest University and the third oldest in the UK. For almost six centuries the university has upheld educational excellence, founded upon the classics, geography, history and modern languages as well as theology and natural sciences. It was the first university to enrol women (1862), the first to have a students' union and the first in the world to have a marine laboratory (1882). Carnegie was one of its former Rectors, along with the explorer Nansen and Sir James Barrie (J.M. Barrie) the novelist and dramatist of Peter Pan fame.

The Famous LNER Poster Dating from 1939 Advertising "The Home of Golf": Artist Arthur C. Michael

St. Andrew is the patron saint of Scotland and his cross is the Scottish flag. Scots around the world celebrate St. Andrew's day on 30th November. Legend has it that some of the bones of Jesus' disciple Andrew were brought here for safe keeping.

But it is golf and the R+A (The Royal and Ancient) that is really synonymous with St. Andrews. The quite wonderful poster alongside captures everything about this noble game and makes this poster particularly collectible for golfers all around the world. Arthur C. Michael painted it in 1938 and the LNER issued it a year later. The composition, colouring and style of the work are classic. The club was founded in 1754 as the *Society of St. Andrews Golfers*.

In 1834 King William IV became the Patron and the club took its present title. Towards the end of Queen Victoria's reign, the rules were formalised. In the first part of the 20th century the R+A gradually took control of the running of tournaments at other courses. It is not the oldest golf club: *The Honourable Company of Edinburgh Golfers* based at Muirfield holds that distinction (a name since used by the great Jack Nicklaus for his course). The USGA is responsible for the rules in USA and Mexico, so the R+A is the ruling body in all other countries of the world.

Across the River Tay

From St. Andrews it is a short train ride to the Firth of Tay and the famous railway crossing into Dundee. Its 2.1 mile (3.26 km) length makes it one of Britain's longest. This famous poster from Terence Cuneo shows a view looking north towards Dundee. Cuneo had British Railways position a diesel as he sat atop the lattice structure to create this evocative work. This is actually the second bridge following the destruction of the original cast iron bridge in 1879. The first one, designed by Thomas Bouch, was only open for a year before the catastrophic accident on 28 December 1879. Problems with the bedrock meant the bridge had to have long spans, with no firm foundations in the centre of the river. During a storm the central section collapsed taking a train and 75 lives with it. Bouch had made no wind allowance and the iron was found to be three times weaker than designed. The second bridge, built by Barlow and Arroll, was a twin track structure made from 150,000 tons of iron, steel, concrete and bricks. Fourteen workers lost their lives during its construction. Opening in July 1887, it remains in use today. It was completely refurbished in 2003 when 1,000 tonnes of bird droppings were removed from the structure. The stumps of the original bridge can still be seen as we cross the bridge.

Terence Cuneo's Famous Poster of the Tay Rail Bridge: Issued by British Railways Executive in 1952

We Arrive in Perthshire

We now make a large detour. Instead of going into Dundee, we turn south-west and head into Perthshire. This is a large, almost circular county that only touches the sea at the Firth of Tay. Travelling along the Firth of Tay brings us to Perth, famous as being Scotland's capital in mediaeval times. Its former name was St. Johnstone, a tradition carried to this day by the city's football team.

Perth itself is shown in the expansive 1920s poster alongside, with the River Tay winding its way eastwards to the sea. This is a classic 20s artwork captured by William Miller Frazer's bold style. Perth was an old Roman settlement founded in the first century, and today is a thriving city at the heart of the farming communities that surround it. Marketing itself as 'Scotland's adventure city', Perth is the base for quad biking, abseiling, canoeing, white-water rafting and other outdoor activities. Its rich heritage is reflected in its buildings: Fair Maid House, Balhousie Castle (home of the Black Watch) and John Knox's church of St. John. For the gardening fraternity, Perth is the home of Scotland's National Heather Collection, where a staggering 900 varieties can be seen at Cherrybank Gardens to the west of the city.

1920s Promotional Poster for the City of Perth: Artist William Miller Frazer (1864-1961)

LMS **GLENEAGLES HOTEL** PERTHSHIRE BY NORMAN WILKINSON.

1920s LMS Poster from Norman Wilkinson (1878-1971) of the World-famous Gleneagles Hotel, Perthshire

From Perth we travel back on ourselves taking the line south-eastwards towards Stirling (which we visit in more detail in Chapter 6). We soon arrive at Auchterarder and another mecca for golf. This wonderful and famous poster by Norman Wilkinson shows the world-renowned Gleneagles Hotel in all its splendour. For us this is just as important in the golf world as St. Andrews, and the three championship courses attract players from all over the world. Wilkinson used blocks of colours to give a fine perspective of the landscape and the size of the hotel itself. At that time the hotel was visible from all sides, but today such a view is not possible, as trees surround the magnificent building. The estate itself stretches to 850 rich acres and really is the height of luxury.

Gleneagles was home to the G8 summit in July 2005 and its 850 acres meant many world leaders could get lost – and maybe should have!! It is a member of the *Leading Hotels of the World* (and rightly so). It will host the Ryder Cup in 2014. I had the pleasure of being in Pittsford, New York when we won the cup there in 1996. The village atmosphere is something I will never forget. My wife Judi held the Union Jack high during all the parades and the post-match celebrations were marvellous; the US-Europe camaraderie was never stronger than on that day. A Scottish totem from Gleneagles station proudly hangs in my house: a reminder of the beauty and splendour that is Scotland.

1950s BR (ScR) Poster Painted by C.H. Birtwhistle

From Gleneagles it is a short journey to Crieff. Surprisingly, several posters were painted of this old Perthshire spa town, lying above the River Earn valley to the west of Perth. The Drummond family dominated the area in former times and for a period in the 17th century the town was actually called Drummond. Their castle is south of the town and whilst the castle is still private, the magnificently restored 17th century garden is open to the public periodically.

Two posters are shown from the database we have. Left is C.H. Birtwhistle's modern BR poster, whilst Patrick's later BR but more conventional picture of the town from Cullum's Hill appears right. The mountains all around gave the artists stunning landscapes to paint.

To the north of the town a narrow road leads up Glen Turret to Loch Turret and the lovely waterfalls. Readers who love Scotch will know of Crieff indirectly because Glenturret distillery, home to the *"Famous Grouse Experience"*, is located here. The many visitors to the distillery can glimpse into the world of high volume whisky manufacturing – lovely!!

1957 BR (ScR) Poster from the Brush of J. McIntosh Patrick

From Crieff we can fly magically over the hills to the Tay Valley and Dunkeld. Its tiny 14th century gothic cathedral is dwarfed by the surrounding woodland and hills. Wilkinson's magnificent painting from the 1930s shows this perfectly. After their victory at Killiecrankie, the Jacobites burnt the town but a good part of the cathedral survived intact. The Duke of Atholl rebuilt the town and today the tiny twin-street centre is a model of design and proportion.

In 1809, Thomas Telford built the graceful bridge shown in this poster and the lines complement the architecture of the small town quite beautifully. Wilkinson's composition, block use of colours and exquisite brushwork depicting the river, gives one of the nicest posters in this volume (in our humble opinion). Kenneth MacAlpin, an ancient Scottish King, gave Dunkeld its ecclesiastical importance by bringing St. Columba's bones back here from Iona around 850 AD. The original cathedral choir serves as today's parish church.

The surrounding forest is composed mainly of larch and close to the cathedral is a sign indicating where the 'parent larch' can be found. This tree came from Austria in the 1730s and became the source of most of the trees around the town.

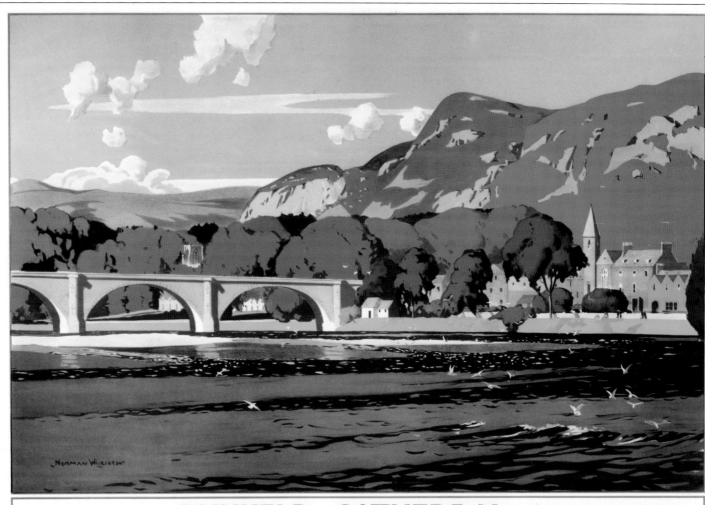

Magnificent 1935 Joint LMS/LNER Poster of Dunkeld Cathedral: Artist Norman Wilkinson (1878-1971)

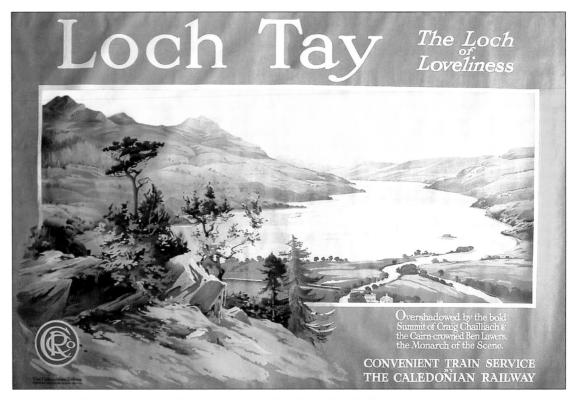

1910 Caledonian Railway Poster of the Upper Tay Valley: Artist is Unknown

1950 BR (ScR) Tay Valley Poster: Artist Jack Merriott (1901-1968)

The Tay Valley area is highly recommended for its scenery and has been responsible for some superb posters. Just two are included here. Jack Merriott's 1950s double royal BR poster focuses on the river, whilst an Edwardian Caledonian Railway Poster above shows just how far railway art had come since Hassall showed the way. The style of the picture creeping into the border was a Caledonian Railway trademark. It somehow leads the eye nicely to the centre of the image. The painting depicts the source of the river – Loch Tay itself – which flows north-east out of the loch, before turning south.

Before we return to the coast to continue the journey to Aberdeen it is worth looking at two posters of the lower Central Highlands. The line from Perth to Inverness winds its way up the only valley where the builders could construct. It passes from Dunkeld to Pitlochry and Blair Atholl via Glen Garry before breasting the summit and following the River Spey down through Kingussie. We will stop on the Perthshire side.

GLEN OGLE
PERTHSHIRE

BRITISH RAILWAYS SEE SCOTLAND BY RAIL

Terence Cuneo's View from the Footplate (BR ScR 1952)

Although on the line from Callander, through Strathyre to Lochearnhead and therefore in eastern Perthshire, these two lovely BR era posters show the beauty of Perthshire directly from the railway. On our left is Cuneo's famous view from the footplate of a 'Black Five' trudging up the glen from Callander. It epitomises our journey. The brushwork and composition makes this one of Cuneo's loveliest posters. Alongside is Merriott's poster of the same area with us now looking up at the old viaduct (which is probably the one at Killiecrankie to the north). The viaduct in Glen Ogle has been heavily photographed and seems to cling tenuously to the side of the mountain. This is located at the head of the Glen and north of Strathyre.

The whole line closed in 1965 and today it is used as a path and cycle track, so you can still enjoy the views that Cuneo and Merriott have painted. The scenery is simply stunning. At Lochearnhead, one line swung back towards Crieff (line closed 1964), whilst the main line carried on north-east to Killin or south-west towards Crianlarach.

Glen Ogle is a popular place for rock climbing today, with some wonderfully named climbs such as The Mirror Wall, The Asteroid, High Noon, The Rave, Far Beyond and The Diamond to name but six.

SEE THE CENTRAL HIGHLANDS
WITH CIRCULAR TOUR TICKETS

BRITISH RAILWAYS

Early 1960s BR (ScR) Perthshire Poster: Artist Jack Merriott

Royal Angus

We now find ourselves magically back at the Tay Bridge, and taking the final curve eastwards we soon arrive in Dundee, Scotland's fourth city and only 14 miles from St. Andrews. It has a population today of around 170,000, well below the peak of 1970 when the census revealed around 200,000 people lived within the urban boundaries. It is famous for its fruit cakes, Keiller's orange marmalade and Robert Scott's Antarctic vessel the *"Discovery"*, which was built here in 1901. This is now berthed in the harbour; a museum to Scott's tragic attempts to cross the Antarctic. The city had a thriving flax and jute industry but all production ceased here in the 1970's as production was lost to India. Dundee is today marketed as the *'City of Discovery'* in honour of the ship and the history of local scientific activities (the Sinclair Spectrum computer was made here and software and biomedical research is also present). The answer to a wonderful *Trivial Pursuit* sports question is found in the City. The two professional clubs Dundee (Dens Park) and Dundee United (Tannadice Park) have the closest two grounds in the world, being right next to each other! Curiously it is Scotland's only south facing city and sadly no posters were made advertising trips there – we wonder why on both counts?

This is the County of Angus, officially known as Forfarshire until 1928. In 1975 the region became Tayside – far less appealing – but happily the name returned in 1996 when Angus was established as a unitary authority. The old county bordered on Kincardineshire, Perthshire and Aberdeenshire. Angus can be split into three sections: Grampian Mountains to the north, rolling Sidlaw hills bordering the sea to the south and the great valley of Strathmore in the centre noted for its potatoes, fruit and wonderful Angus cattle that produce the best tasting steaks and burgers in the world.

Angus also has the famous Carnoustie golf links and Glamis Castle, childhood home to Elizabeth Bowes-Lyon, the Queen Mother. It is featured on our next poster. Glamis is the home to the Earls of Strathmore since 1372 (a long and proud history of more than 300 years exists even before this date). Princess Margaret was born here and Shakespeare's *Macbeth* resided here in the play. Indeed, Glamis has featured extensively in fiction and legend, and the locals say that the castle has more dark secrets than any other castle in Scotland – and there are lots of them. The imposing turreted central section, shown in Cecil King's 1930s poster, will seize your attention first, but the castle houses some wonderful interior design and the curved plasterwork ceilings are a sight to behold. Beautiful gardens swathed in daffodils in the spring and the rich colours of autumn compliment the soft pink stone building, making this an unmissable part of our Scottish journey. Kirriemuir was the nearest station; hence the name on the poster, even though there was another station at Glamis (that closed in 1956).

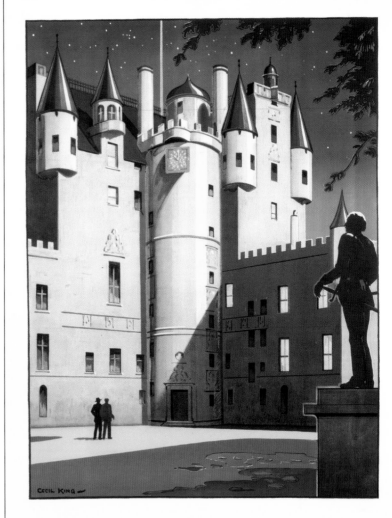

GLAMIS CASTLE

KIRRIEMUIR

LMS **ITS QUICKER BY RAIL** **LNER**

Full information from LMS and LNER Offices and Agencies

Glamis Castle, Angus: Mid 1930s Poster from Cecil King

Glamis station used to be on the loop from Arbroath via Forfar to Perth, but the station closed in 1956 after almost 120 years of service. Kirriemuir station (on the same loop) closed early in 1952. The scenery as we enter eastern Perthshire is beautiful, and the colourful poster alongside captures this to perfection. We will visit western Perthshire and the Trossachs area on our way down the west coast into Glasgow in Chapter 6, but there are some lovely eastern Perthshire posters to enjoy in the meantime as we travel northwards to Aberdeen.

The old County of Perth (to give it its correct title) was abolished in 1975 and its area split between the Central and Tayside regions. In 1996, it reverted back to Perth and Kinross, but some areas remained in Stirling. The county has some very famous places: Blair Castle (no not Tony's home!), Scone Palace and the lovely Dunkeld Cathedral. But it is again golf that figures highly as the lush Gleneagles complex is not far away.

For many golfers (and certainly for the recent G8 summit guests) this is just as important in the golf world as St. Andrews, and the three championship courses attract players from all over the world. When many of the early posters for Gleneagles were painted (such as that shown on page 61), the hotel was visible from all sides, but today such a view is not possible as trees surround the magnificent building. The poster alongside is what the hotel used to look like from the links, but from a different side to that used by Wilkinson on page 61. The estate stretches to 850 rich acres and is the height of luxury.

The Magnificence that is Gleneagles: 1920s LMS Poster by an Unknown Artist

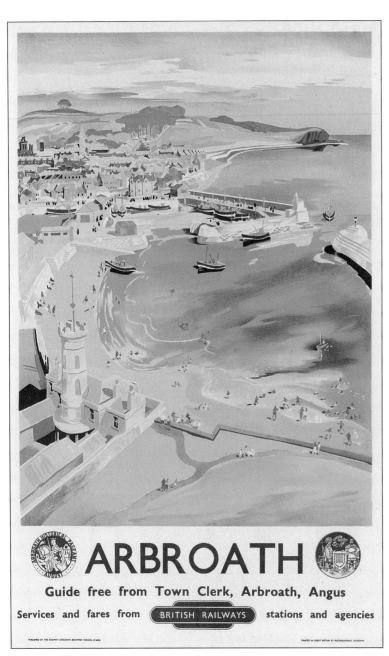

1950s BR (ScR) Poster by Unknown Artist

Northwards Along the Coast

We are now back at the Angus coastline, after our series of sojourns in Perthshire. It will be water to our right all the way to Aberdeen now. Leaving Dundee the line soon passes the wonderful golf links at Carnoustie. This course has hosted Open Championships and is very popular with Americans, keen to test their skills against the seaside links. Arbroath was given Royal Burgh status in 1599. It is especially known for its *'smokies'*, a variety of haddock that is smoked over oak. It has a small but pretty harbour (as the poster left shows) sitting at the mouth of Brothock Burn. In former times it had the name of Aberbrothock. It has a fine 12th century abbey where King William the Lion is buried.

Montrose is 21 miles north-east of Arbroath and is the subject of Austin Cooper's mid 1920s poster for the LNER. Designated a Royal Burgh in the 12th century, the town had historical links to Edward I, so William Wallace destroyed it in 1297. The widest High Street in Scotland is shown in the poster. A *"Princess Coronation"* class locomotive (46232) is named after the Duchess of Montrose.

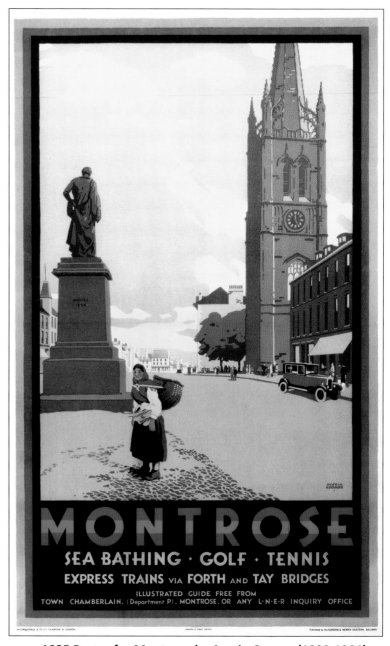

1925 Poster for Montrose by Austin Cooper (1890-1964)

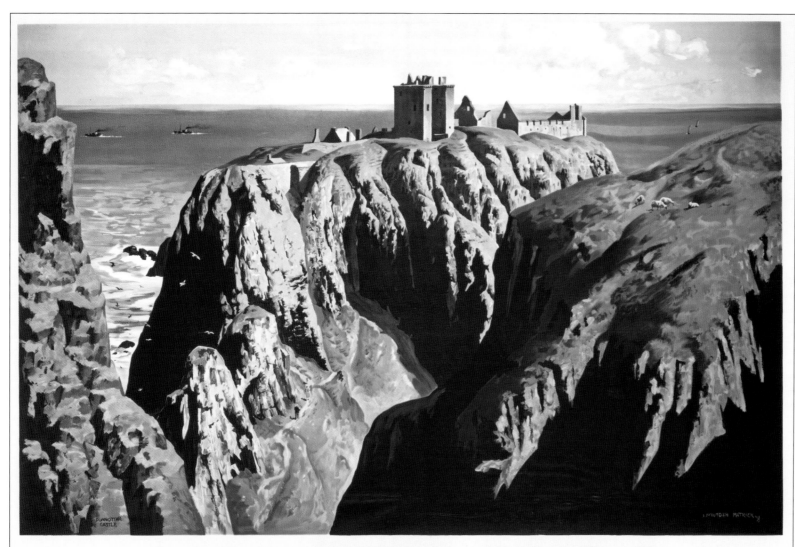

This quite breathtaking poster is of an evocative ruin in a truly stunning setting. The wonderful artwork by McIntosh Patrick really does it justice. For us it is one of Scotland's most impressive ruined castles. It has been graced with the presence of Scotland past: William Wallace, the Marquis of Montrose, Mary Queen of Scots and King Charles II all came here at various times. It goes down in history as the garrison that held Cromwell at bay for eight months and saved the Crown jewels of Scotland from English plunderers. Those jewels (the Scottish Crown, the Sceptre and the Sword) are now rightfully back in Edinburgh castle.

The castle was home to the Earls Marischal (also a famous 'P2' class LNER locomotive designed by Gresley in 1934 and then rebuilt) once one of Scotland's most powerful families. The last Earl was a victim of the 1715 Jacobite rising and the estate was seized. It lay totally neglected until after WWI, when Viscountess Cowdray embarked on a systematic repair of the castle.

It is protected on all sides by steep cliffs down to the sea and access is via a clifftop walkway and fortified gate. It is not difficult to see why even Cromwell had a problem! It is, for me, one of the highlights of this memorable journey, and a tourist must.

1939 LNER/LMS Stunning Poster of the Ruined Castle at Dunnottar, Kincardineshire: Artist James McIntosh Patrick (1907-1998)

LMS "ROYAL HIGHLANDER" APPROACHES ABERDEEN
BY
NORMAN WILKINSON, R.I.

The Rugged Coast of Aberdeenshire Captured by Norman Wilkinson (1878-1971) in this Early 1930s Poster for the LMS

Journeying north from the coast at Stonehaven, we hug the coast with its impressive fall to the sea. We have magically changed to the *"Royal Highlander"*, a former express serving the great City of Aberdeen. This classic poster is yet another from the prolific brush of Norman Wilkinson. The Royal Highlander was an express that ran from London Euston to Inverness up the West Coast Main Line, before crossing to the east coast of Scotland for the final sector. The poster here shows the Midland Railways colours of Crimson Lake synonymous with the LMS and into LMR British Railways days. The train is truly dwarfed by the rugged landscape.

Wilkinson was a superb artist, famous for his marine painting, but here he has chosen to show no sea, sky or cliff detail to match the simplicity of the subject, and juxtaposing our train against the landscape. His composition is just lovely. Today this area is called Grampian Region. If you are interested in watching sea birds, this is the place to be. Seals may be spotted lazing on the beaches of deserted and inaccessible coves and, if you are lucky, out to see can be found bottle-nosed dolphins.

And So to the Granite City

From here it is a short journey into the historic and important City of Aberdeen.

1935 Joint LMS/LNER Poster by Alexander Matheson McClellan (1872-1957) of the Vista of the City of Aberdeen

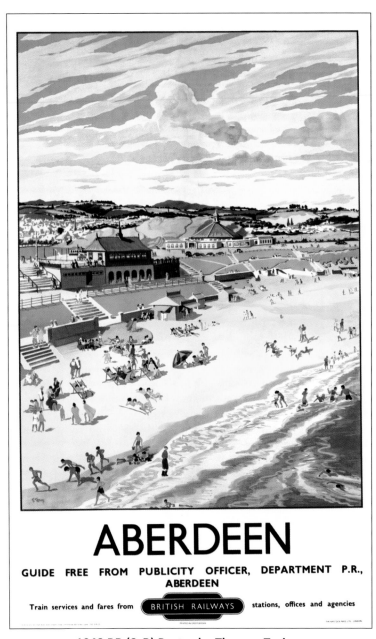

1948 BR (ScR) Poster by Thomas Train

Aberdeen is thought of as a cold and austere place but nothing is actually further from the truth. It has many titles: The Flower of Scotland, The Silver City, Oil City, as well as The Granite City and all are worn with pride. Today it is a prosperous and cosmopolitan place, a centre of culture and learning with a technical presence but a rich historical past.

Our first two posters show the striking skyline that sparkles in the spring after April showers. Here we have Marischal College, St. Machar's Cathedral and His Majesty's Theatre, granite buildings of striking appearance. It was a fishing village but huge oilrigs and drilling platforms have changed that forever. Wherever you are within the Royal Burgh you cannot escape the sea, the influence is everywhere.

The poster right shows streamlined tea clippers from the past arriving with the riches of the Orient, but it is now the riches of the North Sea with its 'black gold' that have brought prosperity. Aberdeen has won the 'Britain in Bloom' competition several times and has a beauty that many British cities do not match, including one hectare of the glass-covered Winter Gardens to provide colour and floral vibrancy in even the coldest of times.

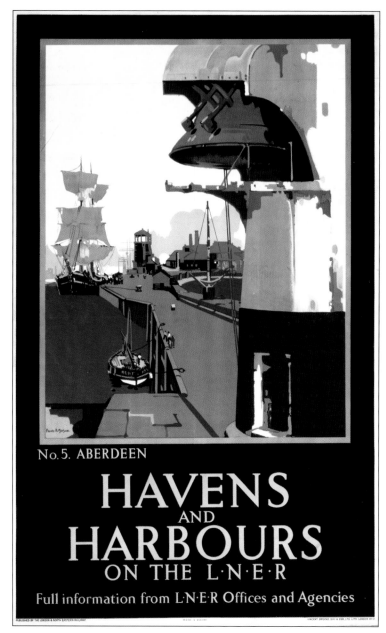

1931 Poster in the 'Harbours Series' by Frank Henry Mason

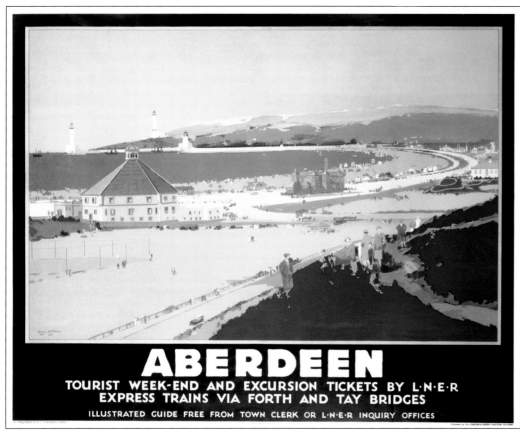

The Seafront Vista of Aberdeen in 1928 Artist: Frank Henry Mason for the LNER

Aberdeen became a Royal Burgh in 1319 from no less than Robert the Bruce, but had been a settlement for at least 8,000 years and in 1179 received its first City charter. It is Scotland's third largest city and, for the economy, the most important. There are two famous universities here (Aberdeen - founded 1495 and Robert Gordon – university status in 1992). The heliport is one of the world's busiest. Aberdeen has seen the traditional industries of fishing, papermaking, shipbuilding and textiles rise and fall and yet it still retains its economic importance through oil and gas. The station where we arrive was rebuilt during WWI, with an architecturally important booking hall and quite magnificent spandrels and ironwork throughout the platform areas. Gresley's masterpiece A4s truly brightened up the place, and it is here we finally say goodbye to our trusty *"Merlin"* who has made the journey possible thus far. However, the spirit of this engine will be with us for the rest of the trip.

Aberdeen has a rich history, being under English rule before the Wars of Independence when Robert the Bruce laid siege and eventually took the town. It was burned by Edward III in 1336 but was then rebuilt and extended with fortifications. The English Civil War saw the city plundered by the Royalists in 1644, and for the next few years it was ransacked by both English and Scots, but over a quarter of the population was wiped out by bubonic plague in 1647. Stability followed and the 18th century saw a Town Hall with the main avenues of George Street, Union Street and King Street all completed around 1800. A century later the development of fishing led to rapid harbour growth and another setback – bankruptcy. It was a few years before prosperity returned and Aberdeen has never looked back. The beautiful poster below is of the 13th century Bridge across the River Don in Old Aberdeen. There is an 1830 bridge some distance downstream but Talmage chose the old bridge for his superb 1928 LMS poster. The 40 feet (12m) granite/sandstone span is now used for people and bicycles only.

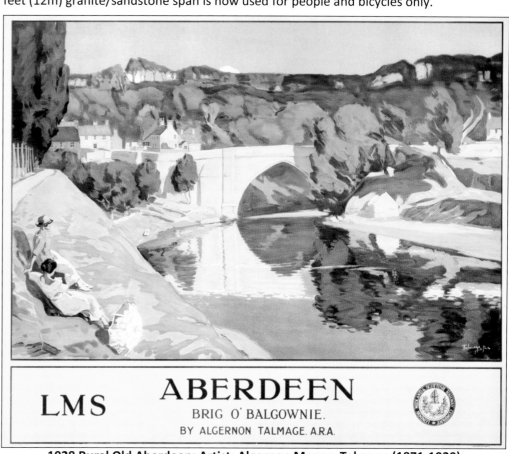

1928 Rural Old Aberdeen: Artist: Algernon Mayow Talmage (1871-1939)

This poster and the one below give clues as to the next part of the journey. We will leave the coastal area and travel inland to some quite breathtaking scenery with posters to match.

The final poster in this chapter, painted by Mason more than 20 years after the panorama alongside, is looking south along the coast with the silver skyline of a mid 30s Aberdeen prominent and glistening after a passing storm. Aberdeen is the Gateway to Royal Deeside and as we leave the city we can look forward to the sights in store in the land of Kings, Queens and Malts.

1914 Poster Painted by Frank Mason (1876-1965) for the Great Northern Railway

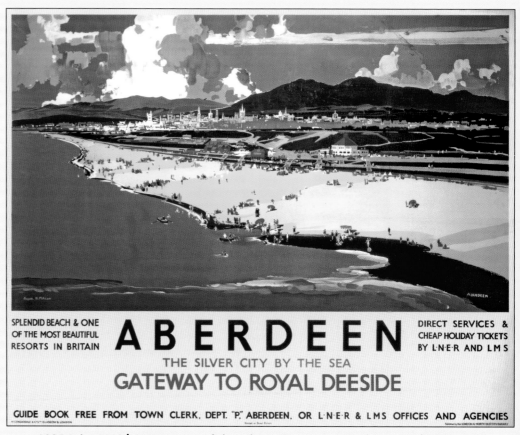

1935 Joint LMS/LNER Poster of the Silver City: Artist Frank Mason (1876-1965)

From the panoramic poster above we can see how Aberdeen lies in relation to the nearby mountains. This poster was painted just before the First World War and at that time, the size of the city was far smaller than it is today. It was one of the prolific Frank Mason's earliest works. However, we can clearly see the harbour is still large and well protected, even at this time, by natural and man-made structures. We can appreciate the extent of the sandy beaches to the north. These were often a feature of 'the tourist side' of Aberdeen, and shown in more detail in some of the preceding posters.

To the north of the city, we can see the River Don and old Aberdeen (or Aberdon as it was originally called). To the south is the city (Aberdeen means between the Dee and the Don) with the Dee coming into the city area itself. The closeness of the Grampian Mountains means citizens, today, do not have to travel far to leave the hustle and bustle of city life behind.

Chapter 4: Aberdeenshire, Banffshire, Morayshire, Nairn, Inverness-shire (East)

Chapter 4 The Land of Kings, Queens and Malts

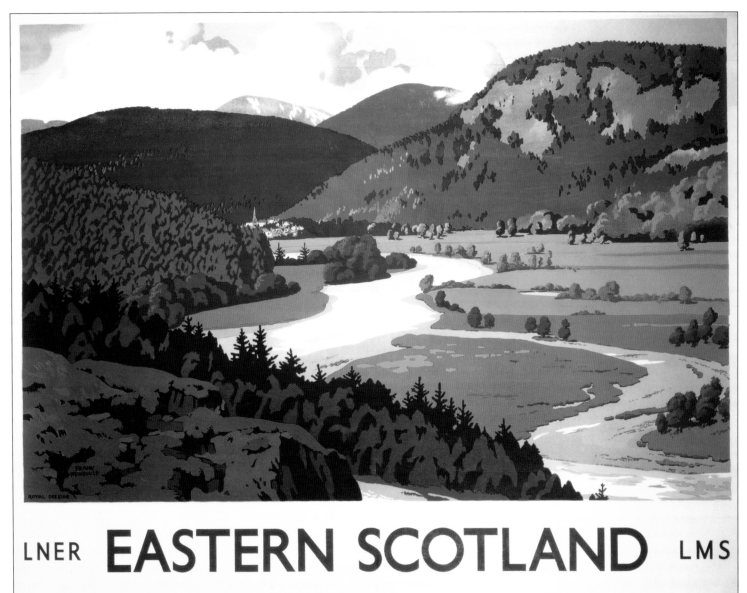

A Classic Poster from Frank Newbould (1887-1950) of the Stunning Dee Valley: Joint LNER/LMS Issued in 1935

In the Valley of the Dee

We begin our journey along the valley of the Dee with a truly wonderful image. This beautifully painted poster comes from one of the 'big four' artists of the golden era, Frank Newbould. Here he captures the serenity of the area in a few colours, but the way they are used shows the mastery of his art. The River Dee rises high in the Cairngorms and flows eastwards to the North Sea. Mountains along almost the entire length, with relatively few passes, restrict its movement north or south. About halfway from source to sea, in the shadow of Lochnagar Mountain, lies Balmoral Castle, the summer home of our Royal Family, so reference is made in the chapter title.

But it is not just the Royal connections we will see in this part of our journey. There is the world famous Highland Gathering and Games at Braemar, world-class distilleries, national parks and breathtaking scenery. The poster artists will do us proud as we travel through Aberdeenshire, Banffshire, Moray and Nairn to end this chapter at Inverness, Britain's northernmost city.

Travelling eastwards from the source of the Dee, we begin at 4000 feet (1250m) on the Braeriach plateau, where waters from many pools join and flow down over the Chest of Dee to White Bridge, the confluence of other burns (Scottish word for small streams). These many burns all merge at Braemar and the Dee is born. We are now on Royal Deeside and the river passes Ballater, Aboyne and Banchory where other burns add to the flow before we reach Aberdeen harbour. We are travelling west, up-river from the city.

Leaving Aberdeen we embark on the Royal route by train, just as the Queen would have done until 1966 when the line from Aberdeen to Ballater closed. The final part of her journey would have been by road. Today it is all by road: a sad loss for international tourism - as well as Her Majesty.

The line passed through Crathes before reaching Banchory some 18 miles from Aberdeen (sorry, according to the EU bureaucrats this will soon be 29 kms). This is a resort town and really marks the start of Royal Deeside. Founded in 1805 and formerly in Kincardineshire, it developed as a resort and latterly as a commuter town for Aberdeen. The local people have a strong musical tradition, and vehemently defend the preservation of Scottish fiddle music associated with James Scott Skinner. Not far away Glen Tanner begins and Lance Cattermole captures this beautiful area in his 1956 carriage print. Rather unusually it is a pastel drawing, contrasting with his normal style of the Aboyne Games alongside.

Glen Tanner, Aberdeenshire: 1956 Carriage Print in Pastel by Lance Cattermole

We soon arrive in Aboyne, a further 16 miles (22kms) west, and the site of the Highland Games since 1867 in September each year. Laid out after 1670 as a resort (after it received Burgh Charter status) its grey granite buildings surround a large central green where the games are held. This event is unmistakably Scotland, as Cattermole shows. The tartans, pipes and traditional sports make this unique to the whole area. The railway actually came here in 1853 and, in the hundred years that followed, the town developed. The original name was superb, Charleston of Aboyne, in honour of the 1st Earl, Charles Gordon, who secured the Charter and rebuilt part of the local castle after 1671.

Aboyne Highland Games: BR (ScR) Poster from the 1950s (Lance Cattermole)

The next poster on our journey is for Ballater, 43 miles (69kms) from Aberdeen. The evocative artwork from Charles Buchel (in this 1927 poster for the LNER) shows the location of this resort town surrounded by Morven and Culblean Hill to the north and the Forest of Glentanar to the south. We are already 700 feet (220m) higher than the start of the journey at the coast. In the early 14th century the area was part of the estates of the Knights of St John, but the settlement did not develop until more than 300 years later. The poster shows a regular street pattern of granite buildings laid to the north of a large bend in the River Dee. The railway did not arrive here until 1866 and lasted 100 years. Once it did arrive, the town grew from its slow 300-year development period from around 1770 onwards. There were mineral wells at nearby Pananich that attracted visitors, but it was the railway that provided the impetus (like so many places on the journey). Many buildings today actually date from Victorian times and the town is a conservation area.

Royal Deeside

Our next artwork is now real Royalty. Just upriver from Ballater is Crathie, possibly the most famous small parish church in the UK. It is a frequent host to all members of our Royal Family when they are in residence at nearby Balmoral during their summer holidays. Each Sunday during this time, family worship takes on a special meaning, and press and visitors descend on the small building. Lawson's well-balanced picture of trees surrounding the church epitomises this lovely place.

Crathie Church Aberdeenshire: 1950s Carriage Print by Edward Lawson

The 1895 church is equally famous as the final resting place of John Brown (1826-1883), Queen Victoria's faithful servant (superbly played by Billy Connolly in the famous film *'Mrs Brown'*). Brown was born in Crathie and worked in Royal service from 1853.

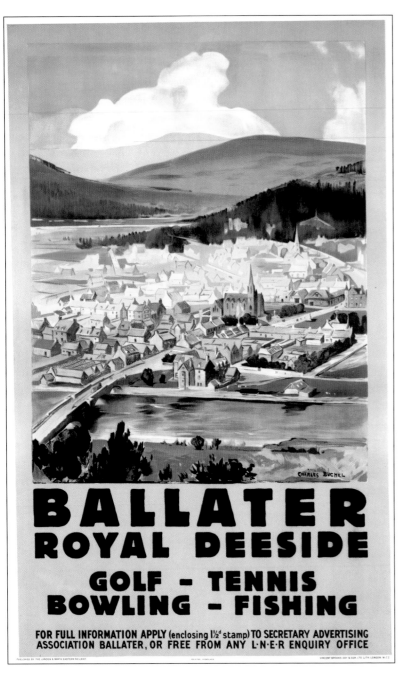

1927 LNER Poster by Charles Buchel of Ballater, Royal Deeside

We soon arrive at the heart of Royal Aberdeenshire: the magnificent estate and castle at Balmoral. Our next poster sets the castle against the autumn tints of the surrounding hills. Kenneth Steel, who also painted a carriage print of the same scene to show the wider panorama, produced the evocative poster artwork alongside in 1951. Even though the Deeside valley has a number of fine castles, there can be no doubt that Balmoral is the finest. It was built for Queen Victoria and Prince Albert in 1854 and it is one of Scotland's most recognized images. Victoria bought the estate in 1852 for 30,000 guineas after seeing the location, but the valley had been associated with Royalty since the times of Robert the Bruce. The Royal estate then was 9700 hectares (around 24,000 acres) situated 8 miles (13 km) east of Braemar in a beautiful wooded area. Today's estate is twice the original size. The construction of this noble building (modern at the time but in traditional Scottish Style) has only enhanced the area. It seems just perfect there.

The architect was William Smith (who was responsible for the City of Aberdeen), but it was clear Prince Albert was a major contributor to both the house and the gardens. He clearly knew what he wanted, and looking at the poster alongside, shows all of us that the finished building encompassed all his wishes. Below is a section of the 1957 Ordnance Survey map to show the Estate environs. Notice just how close the A93 main road is.

The Splendour that is Balmoral: 1951 BR (ScR) Poster by Kenneth Steel

The Location of the Famous Home of our Royal Family: OS Map 41 Seventh Series 1957
(Crown Copyright — licence pending)

The closeness of Crathie church and the surrounding hills are also clear from this map. Notice also the Princess Royal Cairn, the Princess Helena Cairn and Prince Albert's Cairn, all to the south of the Castle itself. The long sweep bend in the river naturally protects on three sides and the mountains do the rest. No wonder it a favoured place for the Queen and Duke of Edinburgh to relax in the late summer months, away from pomp and ceremony - and most people!

BRAEMAR CASTLE

LNER **ROYAL DEESIDE** LMS

IT'S QUICKER BY RAIL

FULL INFORMATION FROM L·N·E·R AND LMS OFFICES AND AGENCIES

Truly Magnificent 1937 LNER Quad Royal Poster of Braemar Castle on Royal Deeside: Artist James McIntosh Patrick (1907-1998)

The poster on page 80 is worthy of a page to itself – so it is rightfully given one. This superb piece of artwork comes from the eminent Scottish painter, James McIntosh Patrick. We have included several of his works throughout this book, but this is undoubtedly one of the finest. It shows the famous Braemar Castle in its magnificent surroundings. Braemar is more than 1100 feet (330 m) above sea level and comprises the villages of Castleton of Braemar and Auchindryne on either side of Clunie Water, which joins the Dee to the north.

Arrival at Braemar

The famous Braemar Highland Games are held in front of the castle in Princess Royal Park each September. It simply epitomises Scotland and the Highlands, and the Royal Family invariably attends. These two 1950s BR posters are by Lance Cattermole. It was impossible to choose between them, so both are included! The castle site originally housed King Robert II's hunting lodge during the late 14th century, and the present day castle was constructed in 1628 by the Earl of Mar. Following the Jacobite rising, it was restored by John Adam. Prince Albert also had a major influence in the development of Braemar around the time when Balmoral was being constructed, and today the town is a thriving tourist centre.

1950s BR ScR Poster of the Braemar Gathering by Cattermole

Highland Games at Braemar: 1950s Poster by Cattermole

LNER **THE DEE** **LNER**

EAST COAST ROUTE FROM KING'S CROSS

ILLUSTRATED BOOKLET FREE FROM PASSENGER MANAGER LIVERPOOL STREET STATION LONDON E.C.2. OR ANY LNER ENQUIRY OFFICE.

1920s LNER Poster of the Upper Dee Valley in Royal Aberdeenshire: Artist Frank Henry Newbould (1887-1950)

Before we leave the Dee Valley we can see how wonderful the place is in early autumn. This early 1920s poster for the LNER by Frank Newbould paints a quite different picture of this valley. Here he has used very little blue and green to produce one of the loveliest of autumn posters ever published, and is characteristic of Frank Newbould's early style.

The river source is above Braemar and is characterized in its early life by rapids and swift currents. The first notable rapid is the Linn of Dee, which is a narrow and twisting waterfall. Looking at the OS maps shows that the mountains really force the course of the river. It is an open yet barren glen where the Victoria Bridge can be found around 3 miles (5km) downstream from the rapids. It is probably this bridge that appears in our poster alongside. A couple of miles west from here is the hamlet of Inverey, and almost the end of the habitable part of the valley. Now the Grampians appear all around and less than 6 miles (10 kms) to the north we find some of the highest peaks (Ben Macdhui at 4296 feet -1320m) and the bleakest winter landscapes.

Not too far to the west is the old county border with Inverness-shire (which we will visit in the next chapter) and where we finish our travels in this chapter.

A Glimpse of the Mountains

Moving north away from the Dee we encounter the grandeur of the Cairngorms. We think of them as wild and bleak but when viewed from a distance they are sheer magnificence. They run (roughly speaking) eastwards from Braemar to the River Feshie, then due northwards up to Aviemore, eastwards past Glen More to the River Avon, and finally south and east again back to Braemar. They are paradise for climbers and trekkers offering, as they do, real challenges to the fit and healthy. However, fortifications are available in the shape of 'wee drams'!

Cairn Gorm mountain itself is located in the centre near Loch Avon. At 4084 feet (1245m), it is high but not the highest: that distinction goes to Ben Macdhui at 4296 feet (1320m). The area is the snowiest, highest and coldest plateau in the British Isles. It is home to five of our six highest peaks and has 13 of the top 20 mountains. Everybody I know who has climbed and roamed there speaks of nothing but peace and beauty.

Thomas Train painted the stunning poster alongside in 1948. The snow capped mountains to the north contrast with the serenity of the foreground Lakeland scene. It is rural and unspoilt Scotland to perfection.

THE CAIRNGORM MOUNTAINS
SEE SCOTLAND BY RAIL

BRITISH RAILWAYS

BRITISH RAILWAYS

Magnificent Poster Issued in 1948 by BR (ScR) of the Southern Cairngorms: Artist Thomas Train

Back to the Coast

We have magically come back down the Dee to the coast, and travelled some 23 miles (37km) north to the location of the next poster. This is Cruden Bay, a quite lovely place with bracing walks along both cliffs and lovely beaches. In former times, it was a popular retreat for the affluent and the railways played a big part in promoting the golf course, which is ranked within the top 100 in the world. The database shows no fewer than six different posters advertised it and two of the best quad royal posters follow.

Just to the north is a ruin that is the focal point for lovers of horror movies. Here is Slain's Castle, the acknowledged inspiration for Bram Stokers "Dracula". But back to the landscape, where Mason's 1928 poster shows a section of the two mile arc of sand that is the Bay of Cruden. To the north is the harbour area (Port Erroll), whilst the village proper is inland. In the distance in the centre of the poster is the Cruden Bay hotel, built by the Great North of Scotland Railway in an attempt to complement the super golf course they had commissioned, and to ensure a good local economy. It also had its own narrow gauge tramway to link it with Port Erroll. The seaside links course can be seen right across the centre of the poster.

1928 LNER Poster of Cruden Bay Aberdeenshire: Artist Frank Henry Mason

Our next poster has an unmistakable style: that of Tom Purvis. Today he is very well sought after with his very bold and minimalist attitude to poster art. This poster of golf at the Cruden Bay Links is typical of his late 1920s work. The wonderful hotel is shown only in silhouette, and the greatest detail is the tartan of the caddie's kilt. It is a simple yet very bold design to promote a quite lovely links course.

It is claimed golf was played here as early as 1791, but today's links were commissioned by the GNSR and designed by Tom Morris (of St. Andrews fame). It was opened in 1899 and offers a unique challenge to even the best players, with its demanding fairways and greens plus the often very difficult pin placements. The full course of today is 6287 yards and par 70 and dates from 1928. Its world ranking just outside the top 50 is justified. At the same time the hotel was constructed with its own railway connections. Built from Peterhead Granite, the 94 rooms rivalled Turnberry for sheer elegance.

The Great Depression of the early 1930s caused a marked downturn in the area's fortunes and the hotel was forced to close in 1932. During the war it housed soldiers but rapidly declined and was sold for demolition in the late 1940s. Fortunately in 1950 the site was bought for only a few thousand pounds. So today in the new clubhouse, the past glories can once more be enjoyed.

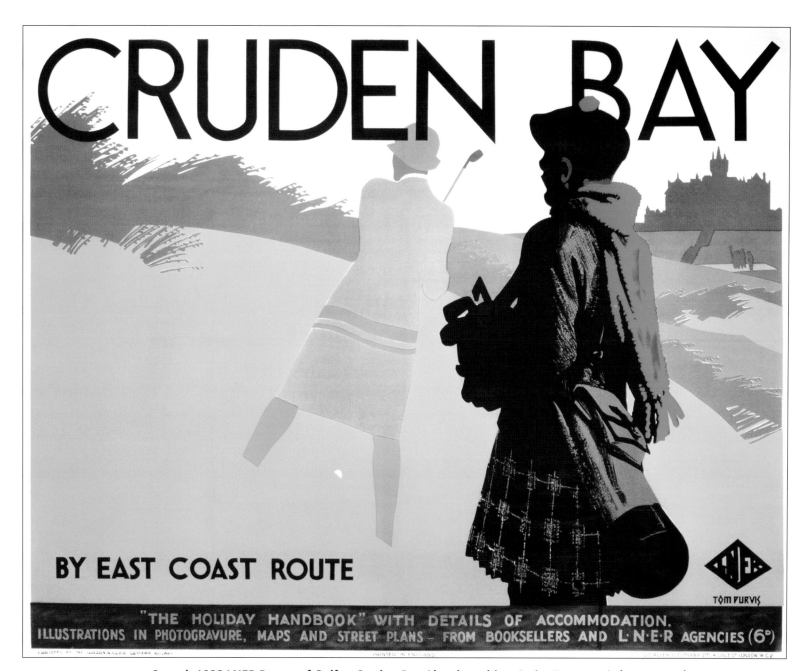

Superb 1928 LNER Poster of Golf at Cruden Bay Aberdeenshire: Artist Tom Purvis (1888-1959)

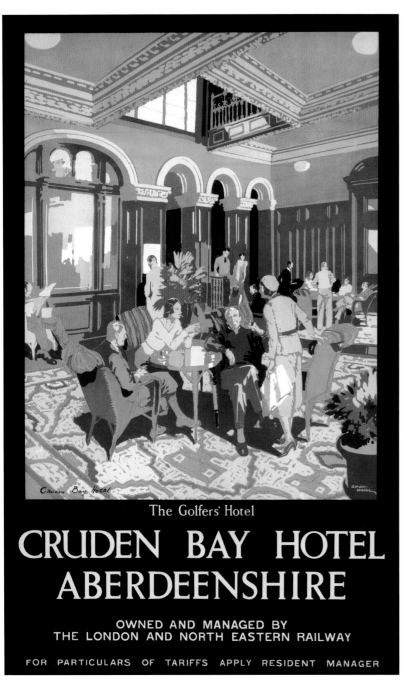

The Golfers' Hotel

CRUDEN BAY HOTEL
ABERDEENSHIRE

OWNED AND MANAGED BY
THE LONDON AND NORTH EASTERN RAILWAY

FOR PARTICULARS OF TARIFFS APPLY RESIDENT MANAGER

1926 LNER Poster Showing Interior of Hotel: Artist Gordon Nicholl

We can now move inside the luxurious golfing hotel. This poster dates from 1926 and the expansive artwork comes from the brush of Gordon Nicholl. When built, the hotel was named the "Palace of the Sandhills". The railway had hoped for the same success as at Gleneagles, but it was not to be, and the fine original hotel was demolished in 1952. The club and course almost went the same way, but today there is a new clubhouse constructed on the site of the original hotel and once more Cruden Bay golf is world-renowned. This beautiful poster can at least give us a glimpse into the elegant past.

Before we leave, we can include a rather different view of the area. Here we still have the golf but in the foreground, a smuggler dating from former times is given pride of place! The caption again advertises the local 'brews'. F.H. Warren painted the poster in 1934 for issue a year later by the LNER. The beautiful pink granite of the old GNR hotel is clearly in evidence in this rather unusual poster.

1935 LNER Poster Showing Past and Present at Cruden Bay: Artist F.H. Warren

North Again to Fraserburgh

From Cruden Bay we travel due north past the fishing port of Peterhead (where we can find yet another golfing poster by artist J.L. Carlisle), and instead we stop in Fraserburgh, the most northerly town in the old county of Aberdeenshire. This is still seaside country, even if it is sometimes on the 'fresh side' facing the rawness of the North Sea. Gawthorne's poster from 1934 shows the dress and style of the period in this beautifully composed work. Henry George Gawthorn was a very clever poster artist and any detail in the sky would draw the eyes away from the seaside activities. The same approach was used for his famous Forth Bridge poster on page 50. I love the use of solid single-colour areas dotted at different places around the poster.

As the name would suggest, the Frasers of Philorth founded Fraserburgh in the early 16th century. Even today some descendants of that famous Scottish clan live in the area. It is locally known as *"The Broch"* and is predominantly a fishing town, the largest shellfish port in Europe. It grew rapidly as the demand for fish escalated in the late 19th and early 20th centuries, and records show more than 1000 vessels were registered here in 1900. Fraserburgh became a "Barony Burgh" in 1546 and within 30 years the Frasers had built Fraserburgh Castle at Kinnairds Head. Strangely by 1787, this had been converted to Kinnaird Head Lighthouse, the first mainland lighthouse in Scotland.

We arrived here by train on the branch line from Dyce, through Ellon and Maud. At Maud another branch would have taken us to Peterhead. It was because of the railway that this poster and the Peterhead poster listed in Appendix B were made. Both towns were important to the economy of northern Aberdeenshire as fish could be sent south very soon after the ships landed. There was also a short branch from Fraserburgh to St. Combs, but all was swept away when economics and Dr. Beeching became involved in 1963 – oh for common sense! However, the line to Dyce remained open until 1979 for freight only (mainly fish), but soon after closure the station area was redeveloped.

The poster shows the outline of churches on the horizon and the town is blessed with at least ten, including Church of Scotland, Pentecostal, Catholic, Episcopal, Baptist and others. Notable residents include Alex Salmond, Leader of the SNP and First Minister of Scotland, who is the town's representative in the Edinburgh Assembly. Others include James Ramsey (1733-89) the anti-slavery campaigner, Sir George Strahan (1838-87) the British Colonial Governor and, sadly, Dennis Nilsen the serial killer who was born in the town in 1945. Today it is more tranquil and (no getting away from golf) it has the fifth oldest club in Scotland and the seventh oldest in the world.

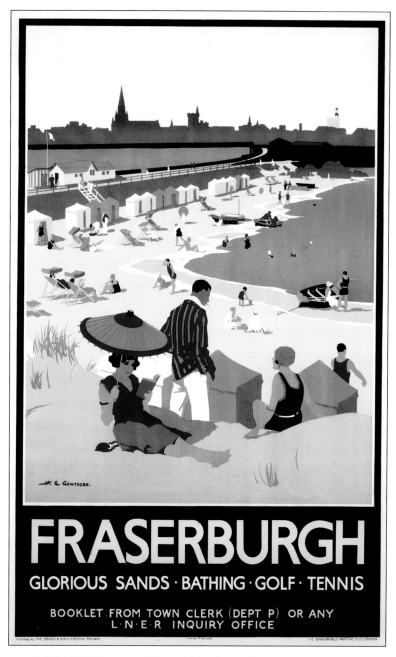

Famous LNER 1934 Poster of Fraserburgh: Artist Henry George Gawthorn

From Fraserburgh it is around 25 miles (40 kms) as the crow flies to Banff, county town of the home of malts – Banffshire. Here we reach an area that has spawned a plethora of wonderful brews. Scotch whisky, but especially malts, are simply Scotland to millions of people and although copied, they are never equalled. Go to any duty free shop at any airport in the world and there is Scottish malt whisky to be found. To make a railway journey from Fraserburgh to Banff used to involve going back to Dyce (well over 30 miles or 42kms) before coming north again through Inverurie and Turriff, a journey of more than 60 miles (almost 100kms). All the lines have long since gone, so today it is a simple drive along the coast. The town (one of a pair) is at the mouth of the River Deveron (shown in the poster). Macduff is to the east and Banff to the west of the river mouth. We are looking westward, therefore, in this lovely piece of art. It has a long history and records show a castle was built here to repel Viking raiders. It was the home to King Malcolm IV by 1163 and Robert II bestowed Royal Burgh status in 1372. The townscape is one of the best preserved in Scotland and it is well worth a visit, with its rich historical past. No wonder the LNER made a poster of this relative outpost. The railways arrived here in 1857 and new stations appeared in 1872. Sadly, all lines had closed by 1964. Rather importantly for our North American cousins, The Banff National Park and Banff Alberta (both in Canada) are named after the town.

Whisky Country Beckons

It is just a short journey to Speyside proper and the home to almost half of the distilleries in Scotland. It must be the water of this river that makes the brews so special, but there are many tastes and flavours within a small area. There are just too many to list but millions worldwide know Aberlour, The Balvenie, Glenlivet, Knockando, The Macallan and Strathisla – wonderful!!

Craigellachie, Spey Valley: Scottish Region Carriage Print by Edward Lawson

1926 Poster of the Entry to Banff: Artist Frank Henry Mason

We are now in the heart of whisky country. The Strathspey Valley runs north-eastwards from Aviemore down past Boat of Garten to Grantown-on-Spey. The Norman Wilkinson poster shows this valley near Aviemore. Painted in the 1930s, this is one of his lesser known works but is another example of the use of colour blocks to show panoramic grandeur.

The railway, which closed in 1965, ran right alongside the river, so from our carriage we see such a sight. The line was re-opened by enthusiasts in 1978 and is today a major tourist attraction. Many know the railway's Broomhill station as Glen Bogle on BBC's *'Monarch of the Glen'*.

Strathspey has the highest concentration of single malt distilleries in the region. Tastes include the smooth Dalwhinnie, as well as the well known brands of Glenfiddich or The Macallan. Tastes can differ and it takes a long time to become a real whisky connoisseur. In the summer months, taking the whisky trail is one of life's greatest pleasures, especially if the weather is hospitable – but fear not: the Scots most certainly are and more than compensate for any meteorological deficiencies!

The Heart of Whisky Country by Norman Wilkinson: Painted for the LMS in the 1920s

The River Spey is, for many Scots, the most valuable treasure in the country. Its water is the key ingredient of most of the world's wonder brews. Data shows us it is the second longest river (at 107 miles, over 170 kms), and also the fastest flowing. The geography in the lower valley ensures speeds in excess of 30 ft/s (10 m/s) in many places. This is ten times faster than most rivers and makes the Spey a rather unusual waterway. As well as whisky it is also a fabulous salmon and trout fishing river, leading us nicely to the next poster. Edward Lawson painted this in the early 1950s and it rarely appears in auctions. Fly fishing was perfected here in a special way, so that fly and line do not travel behind the fisherman. A double handed rod means bushes and trees behind the casting fisherman do not entangle the line. This technique is unique to Speyside.

The river rises at Loch Spey, more than 1000 ft (300m) above sea level and descends through Newtonmore and Kingussie, before crossing Loch Insch to reach Aviemore. This is the start of the Strathspey and from here it is 60 miles (100kms) to the Moray Firth. As it has a large and mountainous catchment area, the river rises and falls very quickly and can be rather treacherous in some places. Peak flows of several hundred tonnes per second are not uncommon. Important railway locations along its course include Boat of Garten, Grantown on Spey, Knockando and Aberlour. It is the malts that make Morayshire and Speyside so world famous. Maps show more than 50 distilleries between Tamnavulin in the south to Glen Moray and Inchgower in the north. Around Dufftown, partakers can find Glenallachie, Glenfiddich, Glendullan, Benrinnes, Balvenie and Macallan. Just to the west are Tamdhu, Glenfarclas, Aberlour and Knockando. Moving a few miles downriver to the Rothes area, the 'brews' are Coleburn (wonderful), Speyburn, Glen Spey and Caperdonich.

The river is fed by melted snow from the upper catchment area for a good part of the year. Some say it is this that makes the water so special. Whether this is true we are not sure, but what we do know is that this area is definitely for the malt whisky connoisseur. Some of the distilleries have a proud history. Macallan, for example, was founded in the 1700s and some would call this the 'Rolls-Royce' of malts: (but I also like lowland malts especially Rosebank, which is superb after a good Angus steak). The process uses oloroso casks from Spain to give a distinctive colouring and flavour, as well as using small handmade copper stills. The process is very traditional. It is nearby Glenfiddich that is reputedly the best selling malt. William Grant founded this distillery in 1887, but it was in 1963 that it really began an intense marketing campaign outside Scotland and the whisky boom really took off. There are many other fine distilleries in this area and Michael Jackson's Guide *(The Malt Whisky Companion)* is suggested for further reading and study.

1950s BR (ScR) Poster of the River Spey: Artist Edward Lawson

1950s BR (ScR) Poster of the Evocative Ruins of Elgin Cathedral: Jack Merriott

It is a short journey to Elgin, where we can also find more distilleries (Benriach, Glen Moray, Linkwood and Mannochmore to name just four). Elgin is famous for its ruined cathedral and the fact that no fewer than 15 US States have an Elgin listed. Indeed Elgin Illinois, a Chicago suburb, has more than 100,000 residents, five times more than the 2001 census gave for the Scottish City. This lovely poster shows the ruined cathedral, painted by the talented Jack Merriott. The first Bishop of Moray was appointed in 1107, but it was a century later before the first cathedral was built. Following a disastrous fire in 1270 it was rebuilt and enlarged: it survived the Reformation only to be vandalised in 1567. In 1637 the choir roof collapsed and steady decay saw the great central tower collapse causing much damage. It was not until 1824 that concern to preserve what was left took hold, and today the ruins remain as one of the finest examples of medieval architecture in Scotland.

The poster below gives a wonderful perspective of the area. Elgin is 5 miles (8 kms) from the coast and is the administrative capital of the old County of Morayshire. This fine GNSR poster dating from around 1910 shows the geography of northern Aberdeenshire, Banffshire and Morayshire which all border on the Moray Firth. The painter is unknown – but it would be great to hear from anybody who does know!

Pre WWI Poster Showing the Panorama of the Moray Firth: Artist Unknown

Morayshire is the county of Macbeth who was born around 1005. In 1040 Macbeth killed the ruling King Duncan I in the battle of Elgin and remained King until his death in 1057. Morayshire is also known for giving the British Isles its first Labour Prime Minister. James Ramsey MacDonald was born at Lossiemouth (the destination of our next poster) in 1866.

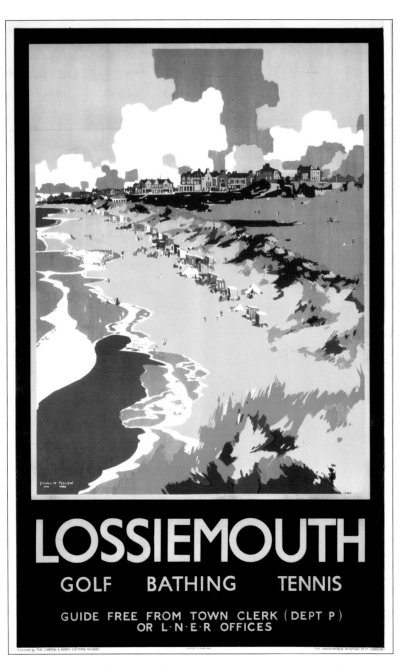

1920s Poster of Approaches to Lossiemouth: Artist Frank Mason

Morayshire had its railways as the borders to its neighbouring counties. The railway line from Aviemore splits at Boat of Garten, with the westerly section going to Forres and the eastern section following the Spey through Rothes to Elgin. As we leave Elgin it is a short 6 mile (10 km) train journey to the coast at Lossiemouth. A cycle track now runs on the former railway trackbed. An early Mason poster shows the port and resort town in the background, as visitors and locals alike enjoy the miles of beaches that front the Moray Firth. Lossiemouth began as a port to help Elgin's trade in the 1760s. The town bisects the sandy coastline: to the east the wonderful dunes are reached by a wooden bridge over the River Lossie. To the west we can find Covesea lighthouse and miles of sand. Today the town is home to RAF Lossiemouth with its Sea King Helicopters and Tornados of the legendary 617 Squadron: *'The Dambusters.'* Nimrods from nearby RAF Kinloss can also be seen here. Just to the west is lovely Findhorn Bay, shown in the poster alongside (right) in a later Mason painting.

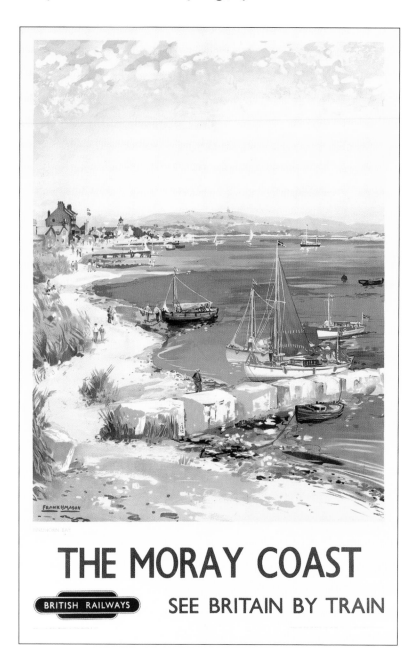

1954 BR Poster of Findhorn Bay, Morayshire: Artist Frank Mason

Before entering the Moray Firth, the River Findhorn flows into Findhorn Bay, a shallow estuary with an outlet to the sea. It was designated a nature reserve in 1949. The village of Findhorn was once home to the busiest port in the area but it declined when the railways arrived in the 1860s. Jack Merriott's prolific brush provides us with the late 1950s poster alongside. The railway from Grantown-on-Spey runs parallel to and sometimes right alongside the river. It is interesting that it states *"On the route from Aberdeen to Inverness"* the subject of this chapter. In reality this isn't the case, as this poster is actually located on the line from Perth to Forres! However we'll let mere details pass and just enjoy the lovely artwork of one of the favoured artists of the time.

The Findhorn is a great salmon fishing river and the poster shows an angler trying his luck at catching dinner. The lower reaches also have good beats of sea trout. The river rises in the Monadhliath mountains and runs north past Tomatin and Forres. At Tomatin we find another 'wonder brew' with the famous distillery taking the magic waters from the Free Burn. The distillery was formally founded in 1897, though drovers had been filling their flasks from the still at the Old Laird's house for hundreds of years before that. It is located some 315 metres (almost 1,000 feet) above sea level, making it one of the highest and remotest of all the many distilleries in the area, and exactly midway between Aviemore and Inverness. The distillery was taken over by the Japanese in 1985 and now operates 12 stills, producing 2.5 million litres per year. This should be enough for the rest of this chapter - Slainthe!

Inverness Castle: 1956 Carriage Print Artwork by Frederick D. Blake (1908-1997)

We are now nearing the end of the chapter and soon the skyline of the great Scottish city of Inverness comes into view. It was given City status in 2000 and is one of the most famous places in the whole journey. We will finish this chapter and start the next at the castle, captured above by Blake in his 1956 painting. It is time now to really partake of some of those Scottish wonder brews before turning in!

Beautiful Findhorn Valley, Morayshire: Artist Jack Merriott

1925 LNER Poster of the Moray Firth, Northern Scotland: Artist John Littlejohns

Chapter 5 The Northern & Western Highlands and Islands

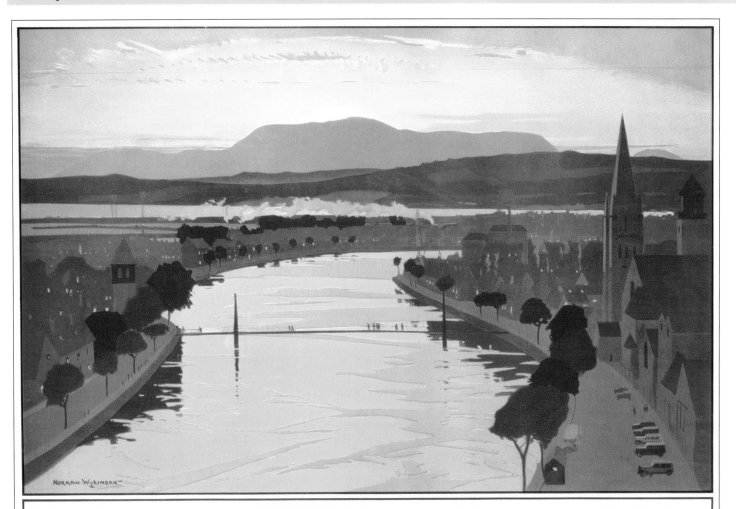

Wonderful 1930s Poster of Inverness Painted for the LMS/LNER: Artist Norman Wilkinson (1878-1971)

The Capital of the North

We awake from a refreshing sleep (boy was that malt good) to a most beautiful sunrise. The whistle of an overnight express arriving from London pierces the stillness, and from the hotel window the sight alongside greets us. This magnificent poster is just the start of a magical journey today (it is actually a sunset scene but fits better into the text by moving forward 12 hours!). We will take in some of the most rugged but stunning sights in Great Britain as we meander through the Northern and Western Highlands to the Isle of Skye, and then across to the islands. Our artists will do us proud, illustrating everything the Scottish landscape offers as a testimony to the beauty of our planet.

Inverness is the capital of the Highlands and, rather interestingly, has no statutory boundaries. It lies on the banks of the River Ness, where the river empties into the Moray Firth. History shows settlements here from the 6th century and that a royal charter was granted in the 13th century. It is just over 150 miles (250 kms) north of Edinburgh and can be accessed today via a scenic railway journey and three main roads from Perth, Aberdeen, Elgin, Thurso and Glasgow.

The railway arrived here in 1855, some 30 years after the completion of the Caledonian Canal. This allowed steamers to link the town with Glasgow from 1824 onwards, and today is still a major tourist attraction. Of course we will come to Loch Ness in due course.

We begin the short tour of Inverness at the Castle. This is not as old as many people imagine, being built in 1835 on the site of an old fortress. In fact there have been successions of castles in this location, from simple wood structures right through to the present day red sandstone. Today it is used as the courthouse. The poster from Lance Cattermole shows the Queen's Own Cameron Highlanders, in full ceremonial dress, marching along Ness Walk with the famous river between the pipe band and the castle behind. This famous regiment has been amalgamated with the Seaforth Highlanders to form the Queen's Own Highland Regiment.

Inverness was designated a city in 2000, but has a history going back to the 12th century, when it was given Royal Burgh status. A major Dominican priory was founded here in 1233. Inverness's location enabled the port and trade to form an essential part of the town and area development. Past industries included textiles and malting. Famous buildings include Balnain House, Abertarff House, The Eden Court Theatre and some of the civic structures. Inverness-shire was the largest county in Scotland and used to include parts of the Inner and Outer Hebrides, before being divided in the 1975 reorganisation.

Before heading north we can look at some of the famous places to the south and west. To the west is Culloden, where the last battle on British soil took place in 1746. Here the Duke of Cumberland finally crushed the Jacobite cause, with the loss of 9,000 souls.

Ceremonial Inverness – Queens Own Cameron Highlanders: 1950s BR (ScR) Poster by Lance Cattermole

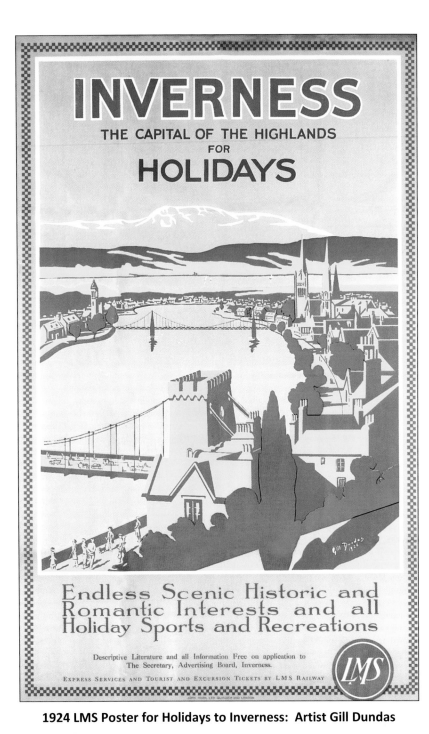

1924 LMS Poster for Holidays to Inverness: Artist Gill Dundas

To the south-west we find Loch Ness, with its worldwide reputation for strange inhabitants. It is smaller in area than Loch Lomond, but contains a greater volume of water due to the depth (which averages almost 600 feet – 182m). It is 23 miles (36 km) long, and at its deepest point (near Urquhart Castle), there is over 750 feet (240m) of water in which 'Nessie' can hide! There is surprisingly little poster advertising for the Loch, but the database does show that Kenneth Steel produced a double royal poster for the Scottish Region of British Railways in the 1950s, advertising visits to Urquhart Castle. This is located on a strategic headland on the western side of the Loch. Just to the south is Invermoriston, where Steel also painted the carriage print below of the falls before the waters enter Loch Ness.

Invermoriston Falls, Inverness-shire: Carriage Print Artwork by Kenneth Steel

At the southern end of Loch Ness we reach Fort Augustus, the site of a 1717 barracks later enlarged by General Wade to hold more than 300 men. It was garrisoned until the 1860s. Waters from Loch Oich, Loch Garry and the canal all join here. These two carriage prints show the beauty of this area.

Fort Augustus, Inverness-shire: Carriage Print Artwork by Sir Henry Rushbury

LMS Poster from the 1920s: Artist is Harry Hudson Rodmell

The Caledonian Canal, dating from the early Victorian era, is a great example of human engineering combined with natural features. It connects the east and west coasts, emerging at Corpach near Fort William after its 62 mile (100 km) meandering from Inverness. Our two posters advertise the benefits of cruising along a natural fault (the Great Glen) to which Thomas Telford added 20 miles (32 km) of actual canal, and 29 locks. Loch Dochfour, Loch Ness, Loch Oich and Loch Lochy form the majority of the length. There are also four aqueducts and ten bridges within the canal's course.

It was built between 1803 and 1822 at a cost of £840,000, but was never a commercial success, as the canal was originally built too shallow, and suffered from poor construction in some places. It was not deepened until the 1850s, by which time the railways had arrived and many of its advantages had disappeared. Today it is used for pleasure cruises (the scenery is quite superb) with MacBrayne and Royal Route Steamers being the main two companies. Both of these posters are not well known, but are good examples of poster art and advertising, especially Rodmell's poster.

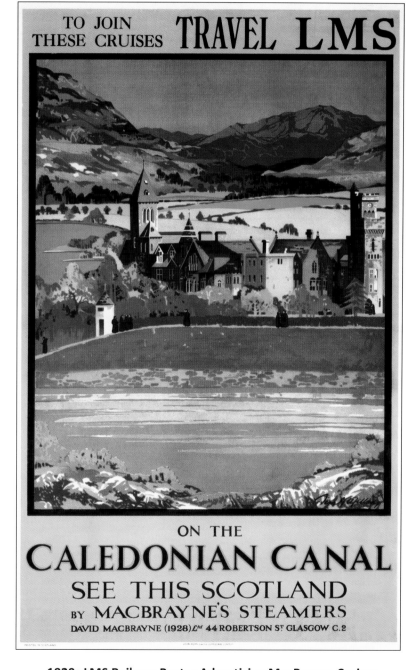

1920s LMS Railway Poster Advertising MacBrayne Cruises

1948 Poster Issued by BR (ScR) of the Superb Inverness-shire Scenery: Artist Edward Irvine Halliday

Leaving Inverness and Heading North: Joint LNER/LMS 1930s Poster by Keith Henderson

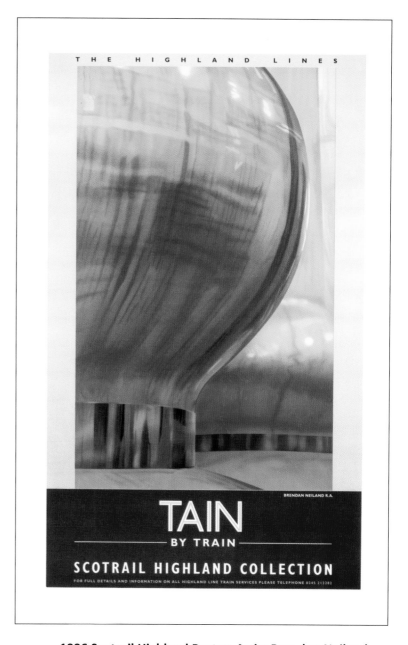

1996 Scotrail Highland Poster: Artist Brendan Neiland

We leave Inverness and travel north. Railways and posters are scarce here and only the brave ventured to the far north (unless you lived there). The former county names were Ross and Cromarty and Sutherland, but today these are just lumped together as the Highland region. Children wave us off as we head north in the lovely poster from artist Keith Henderson (above), which dates from the 1930s. The railway runs all the way to Thurso and Wick, but we hop off to visit places where railways dared not venture. The poster alongside from Professor of Art Brendan Neiland was one of a series of six produced for Scotrail in 1996.

The Northern Outposts

We move magically from the south end of the Loch northwards and up into Sutherland. The poster alongside is the only one so far located from the County of Sutherland, and is the northernmost image found on a poster. This is another of Jack Merriott's wonderful images, painted in the early 1950s for the BR Scottish Region. It shows our train high above a gorge near Invershin. After leaving Inverness and then passing through Tain, the railway line runs along the south side of the Dornoch Firth. The scenery here is breathtaking, and soon after crossing the County border into Sutherland, we come to Invershin. We are in difficult railway building country (as our poster shows). The river shown is the Shin, taking overflow waters from Loch Shin. The railway makes a large loop through Lairg and down to the coast again at Golspie. From here it is 50 miles (80 km) north-east to the termini at Wick and Thurso. The Highland Railway opened the route in sections from Inverness beginning in 1856. It was not completed to the far north for another 20 years. Considering the beauty and tranquillity of the area, so few posters is surprising. There is, however, artwork from a number of carriage-prints to show the rugged and barren landscape of Sutherland. The one below depicts Ben Loyal, a mountain of over 2500 feet (800m) and some 20 miles (32kms) west of the nearest railway line. This is an unusual but great choice of subject and makes a beautiful picture.

Carriage Print Artwork of Ben Loyal Sutherland: Artist Douglas Macleod (1892-1963)

The County town and only Burgh in Sutherland is Dornoch. It is a huge area but very sparsely populated. The 2001 census put the population at just over 13,500. From 1996 the former County name was restored. It is the land of Clan Mackay, a powerful and warlike clan of days gone by. Indeed, the number of people with the name 'Mackay' is still considerable today. We turn south now and head for the coast, magically flying over the landscape as there are no railways here, but we do have the restored engine *"Duchess of Sutherland"* to marvel at.

NORTHERN SCOTLAND

BRITISH RAILWAYS SEE BRITAIN BY TRAIN

BR (ScR) Poster: The Road to the North: Artist: Jack Merriott (1901-1986)

DEER-STALKING IN THE HIGHLANDS

By W. SMITHSON - BROADHEAD

LMS SCOTLAND for HOLIDAYS LNER

IT'S QUICKER BY RAIL

Travel information from any LMS or LNER Station or Agency

Wonderful Joint LMS/LNER Poster from the 1930s of the Far North of Scotland: Artist W. Smithson Broadhead

We are now in the far north but begin to head south, having reached the halfway point of the journey. This wonderful poster epitomises the wild landscape. It is where animals are kings. Eagles fly aloft and red deer roam the hills. This classic poster from Smithson Broadhead evokes the natural beauty that is Scotland. The Red Deer (*Cervus elaphus*) is one of the largest deer species. It inhabits most of Europe, the Caucasus Mountains region, Asia Minor and parts of western and central Asia, but is totally at home in the north of Scotland. Reintroduction and conservation efforts, especially here, have resulted in an increase of deer populations, while many other areas, (such as North Africa and parts of Europe), have continued to show a population decline.

Generally, the average male (stag) Red Deer of Europe is 4ft (1.2m) tall and weighs 650 lbs (295 kg). European Red Deer tend to be reddish-brown in their summer coats. The males of many subspecies also grow a short neck mane during the autumn, so this dates the poster. The Scottish and Norwegian stags tend to have the thickest and most noticeable neck manes, relative to the other subspecies. This specimen with its prized antlers would certainly have made a handsome wall trophy. The antlers are bone and can grow one inch (2.5cm) per day. In the spring they are covered with a velvet protective layer. No time to stay and admire the scenery - we have to be in Strathpeffer by dark.

Sweet Strathpeffer Spa

The Highland Resort

Classic Early 1920s LMS Poster of the Highland Resort of Strathpeffer Spa; Artist Warwick Reynolds

It does not take long to arrive back at the railway and we head west now towards the Kyle of Lochalsh. The line from Inverness to the Kyle of Lochalsh was given maximum publicity in the famous railway journey made by Michael Palin in 1980, as part of the BBC series *"Great Railway Journeys of the World"*. It is a wonderful trip to make. The branch line begins at Dingwall (railway arrived here in 1862) and a few miles south of the line (built in 1885) we find Strathpeffer. This was a popular Victorian Spa resort owing to the discovery of sulphurous springs in the 18th century.

The pump room in the middle of the town dates from 1819. Soon after that, a hotel and a hospital were built. The Pavilion dates from 1880 and provided a venue for the entertainment of visitors. It fell into disuse and disrepair towards the end of the last century, but thankfully has now been restored as a stunning venue for the arts, weddings and events of all kinds. The 1920s LMS poster shows the wonderful setting, with the Grand Hotel's architecture prominent to help attract tourists. Nearby is Castle Leod, seat of the Earl of Cromarty (Chief of the Clan Mackenzie). It is now open to the public several times each year. The annual Strathpeffer Highland Gathering (one of the longest established Highland gatherings) takes place in the Castle Leod grounds each August. In 1486, south of the town, the Mackenzies, led by Chief Kenneth Mackenzie, successfully defeated a large invading force of MacDonalds.

Superb 1930s Joint LNER/LMS Poster of the Western Scotland Scenery: Artist Guy Malet (1900-1973)

Down to the Kyle of Lochalsh

Leaving Strathpeffer, the railway journey to the Kyle of Lochalsh is breathtaking. We pass through some place names that could only be Scottish: Achnasheen, Achnashellach, Strathcarron and Stromeferry to name just four. The line from Inverness to the Kyle is one of the world's most scenic train journeys. Any of the views are worth the train fare over almost the entire 63 miles (101km) of the route. It was opened in November 1897, even though passengers could get as far as Stromeferry a quarter of a century earlier. The last section took years to build because of the construction of 29 bridges and back-breaking work involved in cutting through the hard Scottish rock.

Incredibly, Dr. Beeching had the line earmarked for closure in 1963, but at the last hour it was reprieved. Even more incredibly, the same thing happened in 1974, but the line was saved for a second time. Today it is one of Scotland's most fabulous journeys and a must for this text. Trains run three or four times a day depending on the season. It is a trip well worth taking – and must <u>never</u> close!

Malet's simplistic style and wonderful use of a limited colour palette really does the area justice. The location could be Loch Luichart, where the railway cuts through a valley west of Garve. The LNER really did commission some very collectible posters of this area in the 1930s.

LMS

WESTERN SCOTLAND

By Norman Wilkinson.

LNER

Wonderful 1930s Joint LMS/LNER Poster of the Western Scotland Scenery: Artist Norman Wilkinson

Achnasheen is a very small settlement of only a handful of people. Why it had such a lovely station at all is a mystery, but the buildings are all preserved. The place name in Gaelic means *'field of the storms'*, but quite what this means we do not know. Close by are the flat-topped terraces. These look man-made but in fact were formed 10,000 years ago by glaciers.

Soon we reach Luib summit, the highest point of the line, and it is then downhill past Glencarron and into Achnashellach. This is now an area known as Wester Ross and has also featured in carriage prints as well as posters. This station opened in 1870 and is dwarfed by the nearby Torridon Hills (really mountains), a popular place for walking. However, according to ScotRail figures, use of the single platform is falling. It is a short journey from here to Stromeferry, where the present day road sign says there is no ferry! This service ceased in 1970.

Wilkinson's wonderful artwork alongside really does the area justice. Just notice the way he painted the shadows and cragginess of the rocks in a quite magical way. No wonder he is considered to be one of the top poster artists of all time. The poster might place us at or near Stromeferry: anyway, that is my interpretation for this book! The village is on the south bank of Loch Carron, with Strome Castle on the north bank.

The Torridon Hills (Liathach, Beinn Alligin & Beinn Eighe) and their surroundings must be some of the most scenic of all the Scottish mountains. The lovely carriage print from Douglas Macleod shows the rise from an almost flat landscape, and therefore represents a serious challenge to hill-walkers and mountaineers alike. Liathach, for example, is a seven mile (11km) hike and rises to over 3,400 feet (1055 m). The other two mountains are around the 3100ft mark (970m). The views during the ascents and from the summits are quite breathtaking. These three mountains are entries in the list of *'Munros'*. The highest mountains in Scotland are named after Sir Hugh T. Munro who, in 1891, surveyed all the country's mountains above 3000 feet (914.4 metres). He then produced his famous 'Tables', which catalogued 236 peaks that he deemed to be individual mountains with 'sufficient separation' between each other. Over the years there have been several revisions to Munro's original listing, the latest being in 1997. Currently, there are 284 Munros. Climbing all of these, or *'Munro-bagging'*, is a popular pursuit amongst the climbing and hill walking fraternity, so this chapter contains a good proportion of this list.

Carriage Print Artwork of The Torridon Hills: Artist Douglas Macleod

We now magically fly south, crossing over the railway line north of Loch Carron and arrive at Dornie. Here three lochs meet: Loch Alsh, Loch Duich and Loch Long, and we find the subject of our next poster. Romantic Eilean Donan Castle can be found on a small island close to Dornie. It is captured superbly in Kenneth Steel's 1950s image. It has a wonderful history, dating from 1220, when Alexander II used it as a defence against the Vikings. In the late 13th century, it became a stronghold of MacKenzie of Kintail (later Earl of Seaforth) and numerous local battles saw it change hands. In 1719 it was occupied by the Spanish, attempting to start yet another Jacobite uprising. Royal Navy frigates were dispatched to re-capture it. Large sections were demolished before the Spaniards were defeated at Glen Shiel. It was restored between 1919 and 1932, when the arched access bridge, shown in the poster, was added. It has a left hand spiral staircase, one of only two in Great Britain, because Alexander II held his sword in his left hand. The staircase was made for his exclusive advantage during times of battle. Fascinating!

1950s BR (ScR) Poster of Eilean Donan Castle: Kenneth Steel

The final section of the train journey down to the Kyle of Lochalsh takes us along the southern edge of Loch Carron: it is breathtaking. The railway arrived here in 1897 and soon after, the Kyle took over the ferry business to Stornaway in the Outer Hebrides until this too lost out to Ullapool in the 1970s. For station totem collectors, Kyle of Lochalsh is the 'holy grail'. All serious collectors would love to own one, but few do. Rumour has it that many were thrown into the lochs when the station identities changed from Caledonian Blue to unspectacular black and white.

There has been a settlement at the Kyle for over 400 years. A road arrived from Inverness nearly 300 years ago, and it was the main terminus for ferries to the Isle of Skye before the new road bridge changed everything in 1995. Our railway line contributed massively to trips across to the islands, but today it is bypassed, and motorists now miss so much of this lovely town and setting. Just look at the magnificent quad royal right, painted by Norman Wilkinson for the LMS. The depth and colour on this poster makes it a real collector's piece. Pre-1995 queues for the Skye ferry clogged the area, but today the change is for the better now that the ferries are gone. Remember Michael Palin (during his classic BBC railway journey), sitting in the main lounge of the Lochalsh Hotel and gazing across to Skye before he collected his famous sign? Wilkinson's poster shows a ferry departing in front of the striking hotel and it is easy to imagine Palin making some *'Monty Pythonesque'* quip about it!

KYLE OF LOCHALSH
By Norman Wilkinson. R.I.

Through Glencarron, and along the shores of mighty Loch Carron, the LMS brings you to Lochalsh. All around is scenery of indescribable majesty, and only the narrow waters of the Kyle separate you from Skye. Among the islands of the western Scottish coast, and in the sea lochs of the Highlands, MacBraynes steamers offer you a choice of many fascinating tours, from the Clyde in the south to the Hebrides in the north. And as a headquarters, what could be more desirable than the LMS Lochalsh Hotel, recently rebuilt and charmingly modern, yet in complete harmony with its surroundings.

For particulars of Steamboat Services apply to Messrs. David MacBrayne, 44, Robertson Street, Glasgow.

Hotel Tariff and further information obtainable from Arthur Towle, Controller, LMS Hotel Services, St Pancras N.W.I.

Classic 1930s Poster from a Famous Railway Location: LMS Poster from Norman Wilkinson

BR (ScR) Poster from 1960s: Artist Kenneth Steel (1906-1970)

Across to the Islands

We now leave the Scottish Mainland to travel to the north-western Islands. Kenneth Steel gives us a glimpse of the journey in his 1960s poster, painted for the Scottish Region of BR. From a nearby headland we watch the ferry depart to the rugged yet romantic Isle of Skye. This is the largest of the Inner Hebrides and the geology of former times has given the landscape a dramatic look and feel. Climbers and residents are never more than 5 miles (8 km) from the sea. Yet within the sculptured coastline and high mountains there is a peace, beauty and tranquillity that so many visitors crave for. Today's population of just over 12,000 are found in a few small communities. Along with the mountains and sea lochs, here we find another wonder brew. The Talisker distillery can be found on the west coast, under the shadow of the Cuillins, one of Britain's finest mountain ranges. During the journey from the mainland these come into prominent view, as Norman Wilkinson shows us below in this 1930s LMS poster.

LMS Poster of the Cuillins on the Journey to Skye: Artist Norman Wilkinson

The short ferry ride from the Kyle of Lochalsh dropped us at Kyleakin, though after 1995 we access the island more easily by driving across the Skye Bridge. This was the largest building project seen in this area, and the full extent of the bridgeworks runs to 1.5 miles (2.5kms). The main span from the mainland is 770 feet (250m) long, allowing wonderful views today. We are never far from the mountains and these two posters show the beauty and ruggedness of this large island.

1920s LNER Quad Royal Poster of the Skye Mountains: Artist Austin Cooper

They come from different eras, but show the Cuillins in all their glory. Alongside is an early Scottish Region poster, issued by British Railways in 1960. Above is the much earlier Austin Cooper LNER poster promoting access to Skye from the southern community of Armadale. This is connected to Mallaig by another short ferry journey. With an area of over 600 sq miles (1600 sq. km.) the mountains rise to almost 3,300 ft (1000m), with Sgurr Alasdair being 3,255 ft (992m) and named after resident Alasdair Nicolson.

Wonderful BR (ScR) Poster of Skye from 1960: Artist Clegg

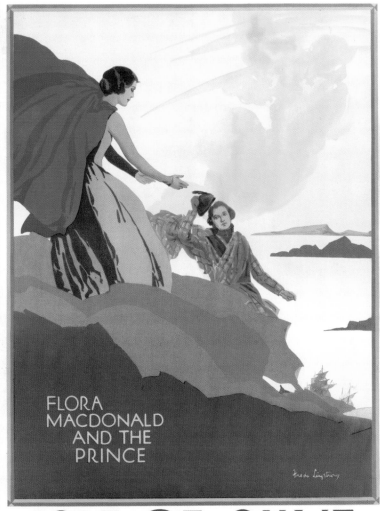

1932 LNER DR Poster of Flora and the Prince: Freda Lingstrom

The classic 1932 LNER poster by Freda Lingstrom (left) contrasts sharply with the stunning modern image produced by ScotRail in 1996 to the right. Bonnie Prince Charlie (Charles Edward Stuart) was the last of the Stuart claimants to the Crown. He came from France in 1745, and reached as far south as Derby, before being driven back to Culloden where his army was slaughtered. The Prince escaped and, after being hounded for several months, he fled to Skye disguised as Flora MacDonald's maidservant. Flora was a loyal supporter from Uist. He sailed to France in 1746 and finally died in Rome. Flora herself was buried at Kilmuir on the northern tip of Skye in 1790, wrapped in a sheet from the Prince's bed. Lingstrom's poster has Bonnie Prince Charlie out of disguise and in the Royal Stuart tartan. The poster colours and style are quite lovely.

The starkness of the geology of Skye is illustrated to perfection in Neiland's poster. These are the remains of long-extinct volcanoes that helped form the Atlantic Ocean more than 60 million years ago. To the east are the Red Cuillins, made of granite, but the Black Cuillin Hills to the west are composed of coarse crystalline Gabbro rocks.

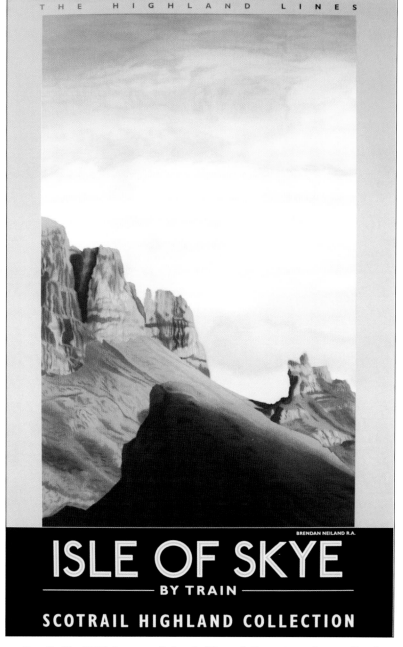

ScotRail's 1996 Poster of the Cuillins of Skye: Brendan Neiland

Early and Late LNER Posters Advertising the Beautiful Island of Skye: Schabelsky (left) and J. Torrington Bell (right)

Before we leave the Isle of Skye, it is worth showing two more posters depicting contrasting parts of the island. The poster far left dates from 1923, the early days of the LNER, and comes from the brush of Schabelsky. The poster near left is just pre-WWII, appearing in 1939 and painted by J. Torrington Bell. They also show the south-west and centre of the island. Here we again have the peaks of the Cuillins, contrasted with the more rolling scenery of the central northern part of the island. The main 'metropolis' is Portree on the east coast. Many people will have seen colourful images of small houses along Scottish quaysides: the chances are the images would be of Portree. It was visited by James V in 1540 and the name means 'Port of the King'. The main ferry harbour in the north of the island is Uig, from where tourists could take the MacBrayne ferry to North Uist and Harris in the Outer Hebrides.

Harris allows travellers to go north to Lewis where we find Stornaway: the main port of the Outer Hebrides. From here ferries could take us back to Ullapool on the mainland. North Uist allows us to take a wonderful drive south along the spine of Benbecula to Lochboisdate harbour and ferries to Barra or back to the mainland at Mallaig. The dominant ferry company for many years has been Caledonian MacBrayne. Like the railway companies, they also commissioned a number of posters of island locations to advertise their considerable network. Without the ferries carrying people and goods, the islands would be sadly depleted. The ferries are the life-blood of the islands, and the 50,000 or so people that inhabit them today. The coastal views on any of the islands are well worth the long trip.

Off Staffa - One of the Magnificent Posters Commissioned by Caledonian MacBrayne in the 1950s: Artist Tom Gilfillan

1930s Quad Royal Poster from Highlands and Islands Series: Treshnish Islands, Inner Hebrides by Tom Gilfillan

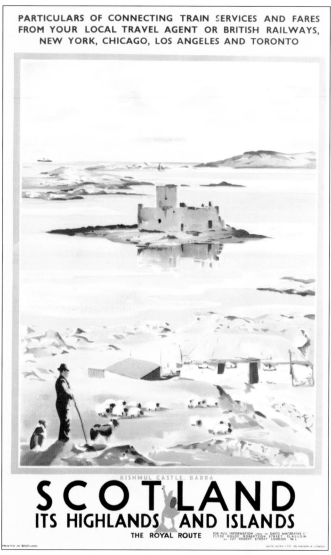

1930s Poster of Outer Hebrides: Barra by Tom Gilfillan

Tom Gilfillan was commissioned by the LMS and MacBrayne's to produce a series of artworks of locations in the Inner and Outer Hebrides. Just two have been selected here, from the main database that lists nine (so far!). The beaches and landscapes are unspoilt in this whole area, as shown by the lovely Treshnish Isles, off Mull. Lazing in the summer sun or watching a winter storm are both great ways to pass the time here! The poster on the right is from Barra, the southerly island in the outer western chain. The only way to reach these outer islands is by ferry and small boats.

The Castle of Kishmul, dating from 1120, was restored some 70 years ago. It was home to the MacNeils, famed for their piracy. For botanists, Barra is a paradise of rare and beautiful flowers, with the Gulf Stream being responsible for the island's temperate climate.

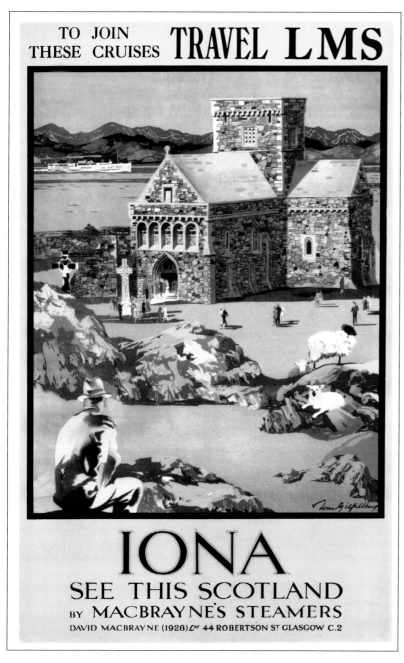

Iona Cathedral: 1932 LMS/MacBrayne's Poster: Tom Gilfillan

Iona is one of the most visited of all island locations. This three mile (five km) long island is at the south-west tip of Mull and is famous as the cradle of Scottish Christianity. St. Columba built a monastery here in 563 AD, and the island is the burial home to no less than 48 Scottish Kings. Our poster from Tom Gilfillan shows the 13th century cathedral, which was restored between 1938 and 1959. The oldest surviving relic on Iona is the 10th century Cross of St. Martin, which is covered with intricate Celtic carvings. Just to the north is Staffa and Fingals Cave, and to the east is Duart Castle, the MacLean stronghold in the 13th century, and close to the port of Craignure that links to Oban back on the mainland.

The poster on the right is a quite wonderful piece of poster art. It shows the heritage of the islands, with highland warriors, the Scottish Standard, the Cross of St. Andrew & the MacBrayne pennant against the backdrop of the islands (and not forgetting the island ferry). This is what poster advertising is all about: stylish, colourful, and full of interest, with great composition. This is a poster rarely seen in auction. It clearly shows the steamship company's use of art: what a collectors' item!

The Epitome of Scotland: Wonderfully Patriotic MacBrayne's Poster

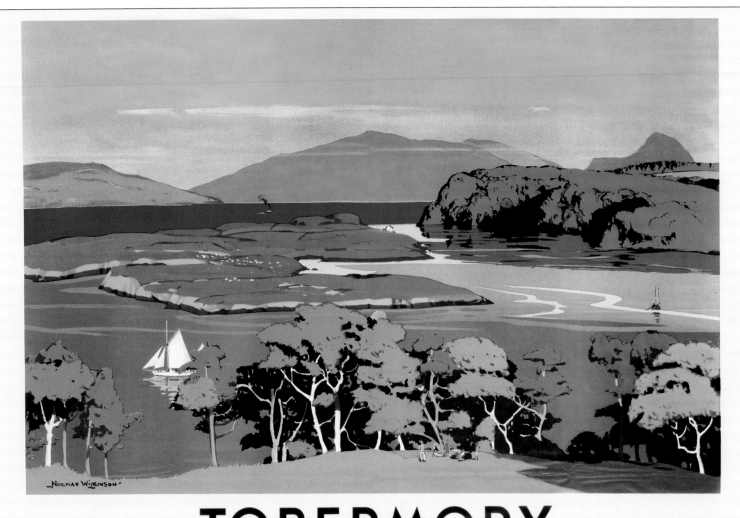

LMS

TOBERMORY
IN THE WESTERN ISLES
BY NORMAN WILKINSON R.I.

LNER

TRAVEL VIA OBAN AND MACBRAYNES STEAMERS

Wonderful 1930s Joint LMS/LNER Poster of Tobermory and the Isle of Mull Scenery: Artist Norman Wilkinson

We finish the trip around the Islands with another magnificent Scottish poster by Norman Wilkinson. This was painted in the early 1930s and issued jointly by the LMS and LNER Companies. Tobermory is on the north coast of Mull, and is Mull's largest resort and harbour, with natural shelter and a quite wonderful aspect. In the distance we can see the Ardnamurchan Mountains. Rather interestingly, MacBraynes appears in small lettering at the bottom and the steamer is also correspondingly small. Even the limited colour palette has vibrancy and depth and, for such a simple poster, it is truly evocative. Our database has other posters listed for Mull and we also have posters listed for several other locations around the Western Isles. Reference to the database will show how many posters have been produced for this area over the years. Today few new travel posters appear, even though the beauty has not changed: food for marketing thought?

It is now time to use our magical powers and fly back to Mallaig on the western coast. We could take the ferry from Armadale on the southern end of the Isle of Skye, (after all Michael Palin did this in his famous 1980s BBC Great Railway Journey). Caledonian MacBrayne also published a poster of the ferry leaving Armadale (see the database), but we just magically re-appear in Mallaig harbour. This chapter has been a real joy, and a visit to the Western Highlands and Islands should be on all travellers' agendas.

Chapter 6 Southwards in Historic Railway Country

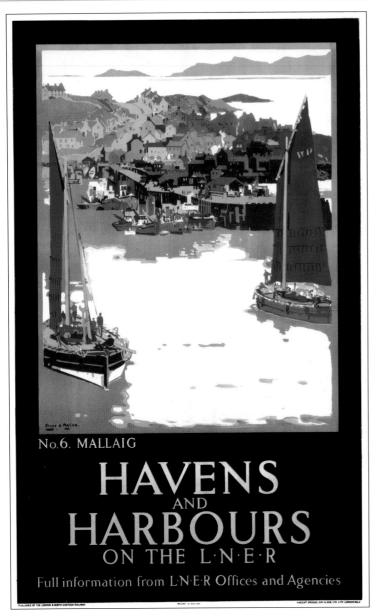

No.6. MALLAIG

HAVENS
AND
HARBOURS
ON THE L·N·E·R
Full information from L·N·E·R Offices and Agencies

LNER Poster of Mallaig Harbour, Inverness-shire: Frank Henry Mason (1876-1965)

The Start of a Famous Journey

Today we are making a great railway journey. The West Highland Line is truly a tourists' paradise and arguably one of the best train journeys you can make in the 21st century. It has always held a mystique and fascination for railway passengers and re-creations today using steam locomotives *('Black 5'* and *'K2'* classes) transport us back to the 'Golden Age of Posters'. This was a time when the many posters depicted in this chapter were in use to tempt tourists onto the route we are now taking back towards Glasgow.

Having crossed from the Islands we are now in Mallaig, the northern terminus of the 'Road to the Isles'. This is a busy fishing and ferry port, and the opening poster from Frank Mason is one of his series developed for the LNER. The ferries run from here to Skye (Armadale), Barra (Castelebay) and to the islands of Canna, Eigg, Muck and Rhum. Mallaig's development is traced to the herring industry that started in Victorian times. When the railway arrived in 1901 things really took off: fresh fish could now be transported more quickly to market. It used to be Europe's largest herring port, but has suffered a steep decline. In recent times, white fish has been the catch, with Scottish prawns and lobster being the main species landed. Today, it is Scotland's most important prawn centre. Bonnie Prince Charlie came here during his flight from the English.

The line was authorized in 1889 and the first sod was cut near Fort William in October of that year. It was built in sections but the barrenness and inhospitality of Rannoch Moor gave rise to considerable construction problems. The first sections were opened four years later but the Mallaig section was not even started until 1897, and proved to be one of the last great rail building projects of the Victorian era. Some of the trains from Fort William to Mallaig are still steam hauled in the 21st century. By 1901, when the whole line was opened, sleeping car services also commenced from Fort William and still run today. Using the train and ferries is an easy way for travellers to see the outer Islands.

Mallaig itself is a recent creation, dating from the 1840s, when Lord Lovat encouraged some tenants to move to the coast and start the fishing industry. Car ferries began in the 1930s and by the 1960s Mallaig was a very busy port. This only lasted a short time and in the 1970s the railway was threatened with closure. Happily it has survived and Mallaig is now prospering once again.

Just before Arisaig, we pass the deepest loch on our left (Loch Morar), where another 'Nessie' type monster is believed to dwell. The line then turns east as we approach the famous inlet at Loch Nan Uamh. This is an area steeped in Jacobite history, as (according to the poster below) it is where Bonnie Prince Charlie landed in July 1745. Other websites, however, say the date was 5th August 1745. Frank Mason's evocative image shows his galleon arriving in Scotland for the ill-fated rebellion. Our train takes us past the Prince's Cairn, marking the spot where the Prince left for a life of exile in France, only 17 months after he had landed.

1950s BR (ScR) Poster of Arisaig, Inverness-shire: W.D. Macleod

Leaving Mallaig, the West Highland Line heads south to Morar and onto Arisaig. The poster above was a BR image painted by William Douglas MacLeod and produced for the North American market. The offshore Islands of Rhum and Eigg can be seen from the train.

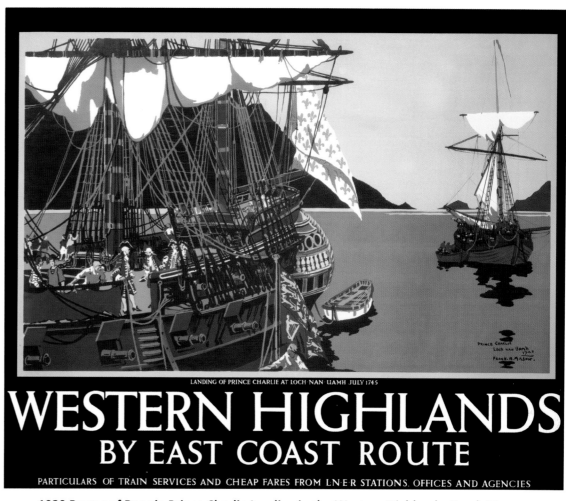

1939 Poster of Bonnie Prince Charlie Landing in the Western Highlands: Frank Mason

The Splendour of Glenfinnan and Loch Shiel

We are soon at Loch Shiel, a magical location, and just ahead of a railway icon. Loch Shiel is a deep and narrow loch with its surface only just above sea level (it used to be a sea loch). Mountains surround it, but none qualify for 'Munro' status. However it has a new claim to fame, as it is the fictional 'Hogwarts Lake' in the Harry Potter films. Our poster appeared in the 1950s, also painted by William Douglas Macleod. The monument in the foreground is where Bonnie Prince Charlie raised his standard at Glenfinnan. Now we approach that railway icon and use the only photograph in the book taken from York's magnificent National Collection (this railway photo collection is also unique). This is Glenfinnan Viaduct, a wonderful curved structure built by 'Concrete Bob', Sir Robert MacAlpine. The 21-arch 100 feet (30m) high concrete structure is not reinforced and took four years to build (it was completed 1901). It also appears in the Harry Potter films and again on the Bank of Scotland's £10 note. The picture shows both the viaduct and Loch Shiel in a quite beautiful setting. Imagine the view as we round the curve and look along the loch – breathtaking!

1950s (BR (ScR) Poster of Loch Shiel: Artist William D. MacLeod

Magnificent Photograph of the Glenfinnan Viaduct: NRM Pictorial Collection, York

In such a historic area we are permitted to 'tarry awhile'. The two modern posters alongside show how Scotrail marketed this wonderful place in 1996. The artwork again comes from Brendan Neiland. Loch Shiel is shown at dusk and the magnificent viaduct from ground level, looking eastwards towards the mountains.

Glenfinnan lies at the head of Loch Shiel and owes its growth to three people: Bonnie Prince Charlie, Thomas Telford and Robert MacAlpine. We have looked at Charlie's landing and leaving spots, but next came Thomas Telford who, in 1810, was asked to build the road from Fort William to Arisaig. It went on to Mallaig and is now known as the *'Road to the Isles'*. The viaduct was late Victorian and is 416 yards (390m) long. When it was completed the general opinion was *'a monstrosity, sufficient in ugliness to take away the charm and beauty of the scene'*. Today time and far greater monstrosities elsewhere have changed the general consensus, and most people now look upon it with awe. A deep cutting to the west of the viaduct allows us to approach Glenfinnan station. The original, untouched building with its mini-museum is well worth a visit.

For lovers of birds and wildlife, there are not many places finer than Loch Shiel. It is an unspoilt treasure and the home to golden eagles, red deer, and other varieties of birds and animals. We could take a cruise down its 20 mile (32km) length but today time does not permit, as Fort William calls. The next poster rightfully deserves a page to itself, showing how we are seeing the wonderful scenery.

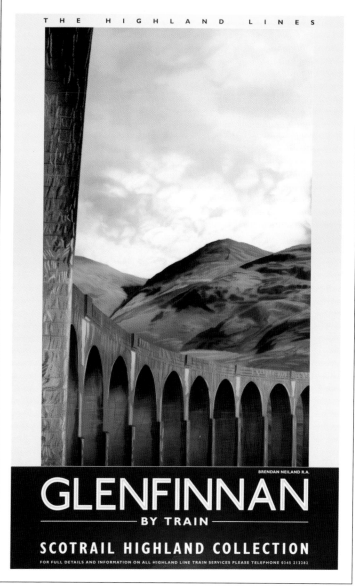

Two Scotrail Posters from 1996 Showing Scottish and Railway History: Artwork by Brendan Neiland

Observation Coach Train at Lochy Viaduct near Fort William

THE WEST HIGHLAND LINE

 SEE BRITAIN BY TRAIN

Travelling on the West Highland Line to Fort William: Superb 1950s BR (ScR) Quad Royal Poster: Artist Jack Merriott (1901-1968)

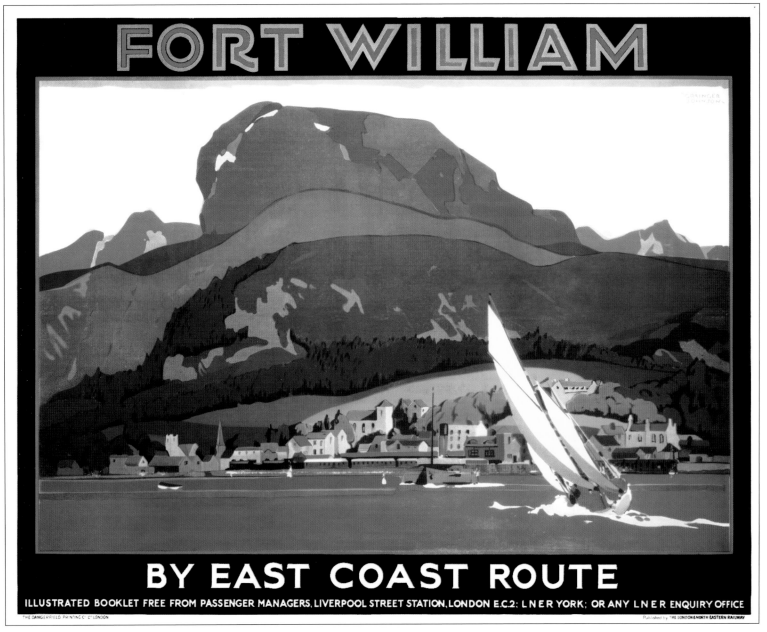

1923 LNER Poster of Yachting at Fort William: Artist Grainger Johnson

Arrival at Fort William

It is not far until we reach our next poster at Fort William. The town lies at the southern end of the Great Glen, on the shores of two lochs, Eil and Linnhe. Grainger Johnson painted the lovely poster alongside in the early 1920s and, rather interestingly, gives references to Waverley station Edinburgh and Aberdeen, both on the east coast. This is the earlier version because in 1925 the whole bottom caption was changed to read simply *'By East Coast Route'*.

General George Monk built the first fort here in 1645 to control the local population after Cromwell's invasion during the English Civil War. He named it Inverlochy. By 1690, the garrison was enlarged and the name changed to Fort William (after William of Orange). Rather interestingly, the fort was demolished to make way for the railway and the station now occupies the site. The combination of the Caledonian Canal, the railway and the increase in west coast steamers all contributed to make Fort William the most important town on the west coast. The terrain was difficult for railway construction, so Glasgow trains arrive from the north-east, then have to reverse before they continue on to Mallaig.

This is Clan Cameron country, and there were several small settlements in the area, so Cameron is a locally common surname.

BEN NEVIS

Britain's highest mountain - 4406 ft.

BRITISH RAILWAYS

BRITISH RAILWAYS

SEE SCOTLAND BY RAIL

Wonderful Quad Royal Poster of Ben Nevis Issued by BR (ScR) in 1955: Artist Clegg

The railway departs from the south end of Fort William station in a north-easterly direction before making a large loop southward through the mountains at Corrour. Just east of Fort William is the massive granite bulk of Ben Nevis, Britain's highest peak. It is at the western edge of the Cairngorms, which allows us to show some more superb mountain posters before we go south. Clegg's masterful view shows the scale of this 'Munro', one of several in the area. The poster (looking from Glen Nevis) shows the huge horseshoe that the mountain forms with nearby Carn Mor Dearg. The north face is for the mountaineers but walkers can ascend to the summit from Glen Nevis up the Old Bridle Path. The 10 miles (16 kms) will easily take you a day. The splash of yellow along the tarn shoreline shows great appreciation of colour to lift the foreground and highlight the buildings.

Weather on Ben Nevis is fickle and many a hill walker has been caught out by the rapid changes that often occur. Blizzard type conditions have been known at all times of the year. The rare view of the summit in this poster is a lucky sight, for often the peak is in cloud. In conditions like this, I have it on good authority that the view is simply stunning.

The following page shows a double royal poster of the mountain, with the vantage point moved to the north-west, so we are now looking along the spine of the long ridge to the summit beyond. This is another of Merriott's wonderful double royal posters.

Highland Wilderness

We have a long climb from Fort William up to Corrour at 1300 feet (400m), passing through Spean Bridge, Roy Bridge and Tulloch before we reach one of Britain's most remote stations. It featured as a location in the 1996 film *'Trainspotting'*. Corrour is in the middle of nowhere, but what a beautiful nowhere! In its 1996 publicity drive, ScotRail produced a great series of small landscape format posters to complement the Neiland series shown here already. Small lochs, high peaks and deep ravines are features of this landscape but, on a day such as this, what a place! From the station that serves the walkers, there are footpaths leading everywhere: to the east is Corrour Forest with Loch Ossian; to the north is Loch Treig; to the west and south are the peaks of Beinn a Bhric and Leam Uillam both close to 3,000 feet (940m).

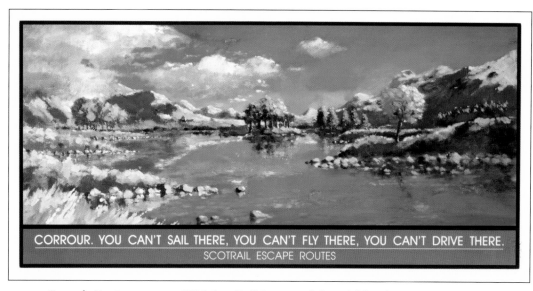

Superb Contemporary 1996 ScotRail Poster of the Highlands Around Corrour

The poster above says it all, but it is not like this in winter when a cold, snowy and inhospitable landscape would greet us on the train. The line is single track throughout and trains must wait at stations with crossing loops for opposite-direction trains to pass. Over much of the Rannoch Moor section, the speed limit is 30 mph to avoid damage to the foundations of the track, which float on top of the boggy ground. More recent posters advertise this line as *'The Line for All Seasons'*. Come in spring, when the air is invigorating and the great glens stir with new life. Travel in summer, when the long evenings bring spectacular sunsets over majestic skylines. Set out in autumn, when the colours flare into purple, gold, yellow and brown, or board the train in winter, when the glinting snow adds a new dimension. The herds of deer come to forage on the moors at most times. It is truly spectacular, even in the rain!

1950 BR (ScR) Poster of Ben Nevis: Jack Merriott (1901-1968)

Coming out of Fort William, the line passes up the Monessie Gorge, beautifully depicted in one of Cuneo's lesser known works. Having passed Corrour, it is a short run up the valley to Rannoch station with its chalet-style building and Swiss birch shingles, accessed only by a single road up from Loch Rannoch. Nearby is Loch Laidon. As the train pulls away from Rannoch, you can see the Black Mount and Glencoe to our left: one of Scotland's premier skiing centres. Rannoch Moor straddles Argyll and Perthshire: more than 50 square miles (125 sq. km.) of wilderness. We are now in Perthshire (for a short spell). It is desolation and emptiness as we soon start to descend towards Bridge of Orchy, and back into Argyllshire. The poster below seems to sum up Black Mount very well. The dark and foreboding sky predicts an infamous local storm is about to strike. To our right, the line from Rannoch has the peaks of the Cairngorms alongside.

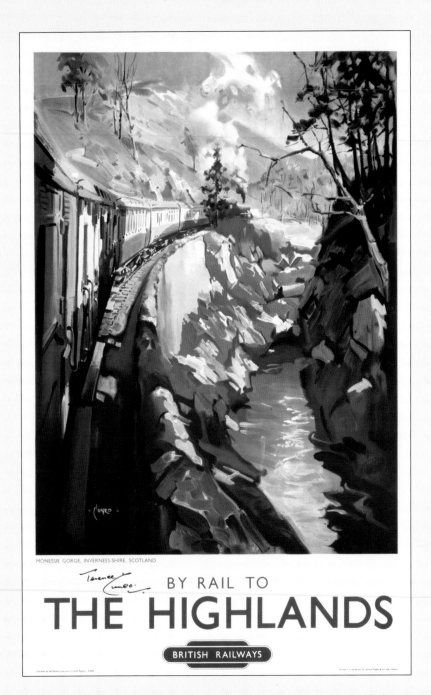

1950s BR (ScR) Poster of Monessie Gorge: Artist Terence Cuneo (1907-1996)

1924 LMS Poster of the Scottish Highlands: Artist Sir David Young Cameron (1865-1945)

The name Glencoe is often said to mean *'Glen of Weeping'*, perhaps with some reference to the infamous Massacre of Glencoe, which took place there in 1692. But the Gaelic name (*Gleann Comhann*) is a reference to the River Coe running down the Glen. The MacDonalds lived here and the Campbells from the south were their traditional rivals. The guests who perpetrated the massacre came from two companies of the Earl of Argyll's Regiment of Foot, commanded by Captain Robert Campbell. Most of the regiment came from Argyll, but few bore the name of Campbell; that did not matter - Campbells were blamed anyway. They had been billeted in true Highland tradition with genuine hospitality and repaid this with bloodshed, killing 38 MacDonalds from the Clan MacDonald of Glencoe, on the grounds that the MacDonalds had not been prompt enough in pledging allegiance to the new King, William of Orange. Another 40 women and children died of exposure after their homes were burned. The King himself was said to have signed the orders, but there was no doubt that it was a high-ranking plot.

1930 LNER Poster of Mountains Around Rannoch: Artist John Edmund Mace

Water runs everywhere, gushing like possessed white fingers down every mountain-side. Even this is the subject of a bold, distinctive painting from John Mace: his posters rarely appear in auctions. This could depict many such locations in Caithness, Ross & Cromarty or Inverness-shire, but it seems appropriate to place it here. Rannoch Moor is very boggy, being composed mainly of peat. These huge deposits posed major difficulties to builders of roads and railways. When the West Highland Line was built across Rannoch Moor, its builders had to float the tracks on a mattress of tree roots, brushwood and thousands of tons of earth and ashes. We are magically going to fly back northwards to be able to take in three posters away from the tracks that the journey simply cannot ignore. They are all of tragic Glencoe, a few miles west of the line, as we descend towards Bridge of Orchy.

Famous LMS/LNER Poster from 1930s: Painted by Norman Wilkinson (1887-1971)

The first poster comes from a painting that hangs in the Glasgow Art Galleries and shows a moody, brooding valley. Contrast this poster with Sherwin's colourful image beneath, and with Wilkinson's lovely view on the previous page. However, the 1924 LMS poster below shows just how beautiful (yet inhospitable) the area can be in wintertime. Life for the MacDonald Clan must have been hard, and to have had their houses burned during the massacre must have exposed the women and children to a terrible demise.

Brooding 1940s Image for the LMS of the Real Glencoe by Horatio McCulloch

1924 LMS Poster Showing the Beauty of the Cairngorms in Winter: Artist George Nichols

BR (ScR) Poster from 1950s of the Pass at Glencoe: Artist: Frank Sherwin

There are many more posters that could easily be placed in this section. Inverness-shire has a rich heritage and this has often been used to entice travellers. Just two appear on the next page as we move back into Argyll and say farewell to the far north.

Bonnie Prince Charlie Lands in Scotland: LNER Poster by Maurice Grieffenhagen

The Grandeur of 'Glen and Ben' by S.J. Lamorna Birch RA

The first (left) is another *'Jacobite'* poster showing Bonnie Prince Charlie landing at Loch Shiel. The poster below is a further tribute to the grandeur of the area around which we have been travelling. Both are painted by Royal Academicians, Maurice Grieffenhagen at the top and S.J. Lamorna Birch beneath.

Oban to Crianlarach

In order to go south, we first have to go back to the coast to pick up the second part of the West Highland Line. This runs from Oban to Crianlarach and also crosses some spectacular scenery. Oban is a coastal resort with a difference - the town and its bay are virtually land-locked, giving it a sheltered setting, as shown in the next poster below. It's a magnificent touring centre, whether you want to cruise to the Isles or explore the lovely Land of Lorne.

The Panorama of Oban: Gateway to the Islands: Artist Alasdair MacFarlane

Contrasting Adverts 50 Years Apart for the West of Scotland: C&OR Poster (Anon) and BR (ScR) Poster (Kenneth Steel)

The two posters above show how advertising changed over 50 years for the same area of Scotland. The left hand poster dates from the Edwardian era, when the Callander to Oban Railway served the far west. What is lovely about it is the wonderful collection of names in the lower half and the detailed vignettes scattered all over the poster. It is, for me, one of the finest of this era and well worth a place in the book and database. The largest image is of Oban itself, showing its sheltered bay from the south, but also featured are the famous Loch Awe Hotel (centre bottom), Fingals Cave and the Western Isles.

The right-hand poster, of the Highlands south of Fort William, is one of the most vibrant images that Kenneth Steel painted. It shows the hills around Ballachulish. His treatment of the mountainside using multiple colours reminds me of the style of Rolf Harris in some of his superb paintings featured regularly on TV. This is how art really works (for me that is). The composition of this poster is also classical and an excellent example that the *'Golden Age'* of posters was not exclusively in the era of the 'Big Four' railway companies.

Oban is an important west coast port. Ferries run today to Mull, Staffa, Iona, Coll, Tiree, Barra and South Uist. Oban is Gaelic for Little Bay and it has been an important harbour for a couple of hundred years. At the last census (2001) its population was just over 8,000 but during the summer season this can treble. Attractions in Oban include the Waterfront Centre, the Cathedral of St Columba, the Oban Distillery (more *wonder brews* here), Dunollie Castle, Dunstaffnage Castle and McCaig's Tower, which dominates the town's skyline.

It is quite a climb for the railway out of the town and up to the summit at Glen Cruitten. It then runs along Loch Etive, a beautiful loch with a narrow entrance to the sea. There is an area here nicknamed 'Australia' as it looks just like some areas of the Aussie Bush. Near Connel Ferry you can see the Falls of Laura, where the tidal waters flow over a ledge of rock at the narrow entrance to the loch. The next poster (one of the very best of the Scottish railway images) shows the beauty of this part of the journey.

Magnificent Railway Poster: Jack Merriott's Superb Image of the Western Highlands: Issued by British Railways (ScR) in 1960

This wonderful painting of Loch Etive would certainly entice the traveller of the day to see the view for oneself. My wife, Judi, had no doubt it should be the choice for the cover. Just look at the palette of colour Merriott used and how he placed the yellows and buff colours at strategic points throughout the canvas. This is masterly poster art, as fine as the very best from the 'Golden Era'.

Loch Etive is almost 20 miles (31.5kms) long and varies between ¾ mile and a mile wide (1.2–1.6 kms). The name Etive is believed to mean '*little ugly one*' from the Gaelic Goddess associated with the loch. It heads east for half its length alongside the main road and rail link to Oban, before heading north-east into mountainous terrain. A road along Glen Etive makes the head of the loch accessible from Glen Coe. The main line from Oban runs along half the length, giving us some breathtaking views. Just seaward of the mouth of the loch is Dunstaffnage Castle. It is believed to have held the Stone of Destiny before its transfer to Scone Palace.

Wonderful Sports Poster: Arthur Burgess's Classical Image of Salmon Fishing in the Western Highlands Issued in 1935.

From one wonderful work of art we move to yet another. Salmon and trout fishing is one of Scotland's great exports and although we featured a poster of fishing on the Spey, here we see Arthur Burgess's exquisite painting of a lone fisherman wader-deep in a swift flowing river. The way he has captured the water is almost magical, with the intermingling of brown, blue, grey and white bringing the water to life. We can feel the current of the river sweeping away down the rocky bed and making 'whitecaps' as it flows seawards.

Scotland has great Atlantic salmon fishing. The more famous rivers are the Spey, Tay, Dee, Tweed, Helmsdale, Nith and more, but hundreds of rivers and burns in Scotland are home to millions of salmon. Some of these swim thousands of miles from as far afield as Greenland and into the mountains to reach their home pools to spawn and start another cycle of life. Lovely tasting trout is also found in many rivers and burns, and experts will doubtless tell me whether this poster shows a trout or a salmon.

The loch turns north-eastwards and the railway line swings south-eastwards inland towards Taynuilt. Now we are really in the Land of the Gael, heading through the Pass of Brander with views of Ben Cruachan to our left. Another of Argyll's magnificent lochs, Loch Awe, swings into view. The railway only runs for a short distance across the northern shore as the loch turns south-west to within a few miles of the sea at the village of Ford. Loch Awe has quite a few posters painted of its shores, spanning more than 50 years. Contrast the early Caledonian Railway poster from 1910 to the carriage print below, painted more than 40 years later. The Caledonian poster is one of the few with the border as an integral part of the whole image. The artist is unknown but it was one of the posters commissioned by the C&OR to illustrate points of beauty along their line.

Loch Awe is the third largest freshwater loch in Scotland, with a surface area of almost 15 square miles (38.5 sq km), and it is the longest freshwater loch at 25.5 miles (41 km) end to end. However, it is a narrow loch, with an average width of around 0.6 miles (1km). The scenery along the entire length is spectacular, as the carriage print below shows.

Carriage Print of Loch Awe: Artist James McIntosh Patrick (1907-1998)

Following on from the previous poster, Loch Awe is renowned for its salmon fishing and a special salmon passageway had to be built at the River Awe barrage when the loch was chosen for a major hydroelectric power scheme. In fact there are two projects. One is a conventional turbine power station, with water extracted from the River Awe at a barrage, fed through underground pipes, and generating electricity as it flows into Loch Etive. The second is a more unusual pumped storage project, using a man-made loch in the hills above the Loch; off-peak pumping allows power generation at times of peak demand.

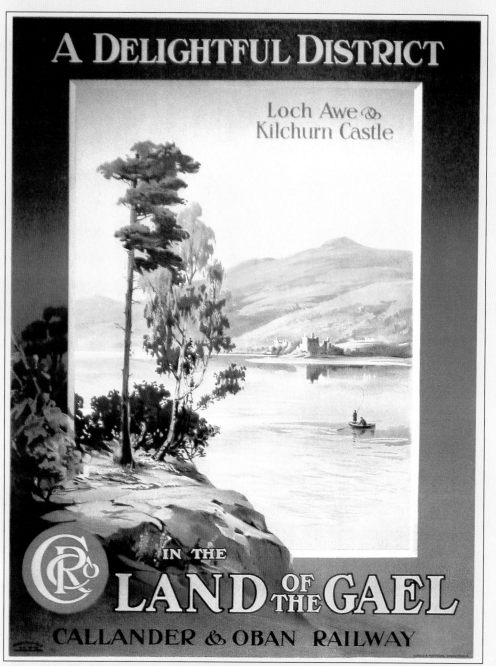

Caledonian Railway Poster of the Beautiful Loch Awe: Artist is Unknown.

Classic Painting from Mid 1930s Issued Jointly by LMS/LNER of Loch Awe, Argyll: Artist Norman Wilkinson

Loch Awe 1950s BR (ScR) Poster: Artist Tom Gilfillan

Here we have two quite different views of this most beautiful of lochs. The bold style of Wilkinson (above) contrasts sharply with the gentle, colour-wash style of Tom Gilfillan. Loch Awe contains several ruined castles on its islands, and at the northern end we find one of the most photographed in Scotland: Kilchurn Castle. This was built about 1450 by Sir Colin Campbell, first Lord of Glenorchy. Towards the end of the 16th century, the Clan MacGregor of Glenstrae was occupying the castle, until it passed back through marriage to the Campbells.

In 1760, it was badly damaged by lightening and quickly abandoned. The remains of one turret from the tower still rests upside-down in the centre of the courtyard, indicating the storm's violence. The ruins are looked after by Historic Scotland and are open during the summer months.

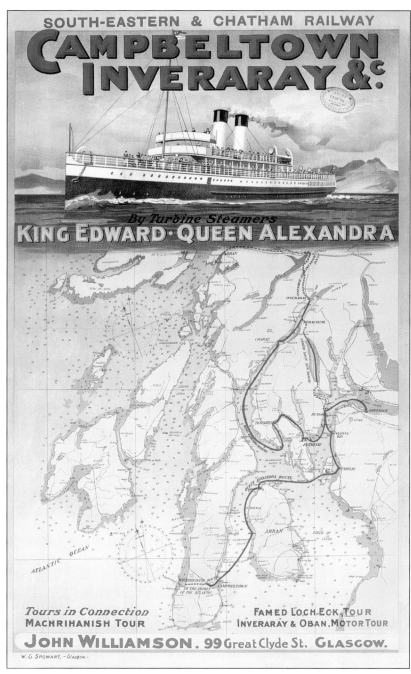

Edwardian SE&CR Poster for Inveraray, Argyll: Unknown Artist

Central Argyll

Our travels have taken us to the centre of Argyll, the second largest county in area after Inverness-shire. Before the border changes of 1975, its area stretched to 3,110 sq. miles (8, 055 sq. Km.). The rather unusual Edwardian poster alongside comes from the South East and Chatham Railway, and shows the amazing amount of coastline this county had. If you include Bute and some of the outer islands, the coastline stretched an equivalent to the distance between Glasgow and New York: more than 3,000 miles (4,800 kms). There is an old Gaelic legend that during the making of the earth, God had some fragments of earth and stone left over. Smiling, he dropped them from his apron and they fell into the sea to form Argyllshire and the adjacent islands. This poster map shows that a very large amount of fresh water and salt water is found within the county boundaries. The capital is Inveraray, right in the centre of the county, and at the sheltered end of Loch Fyne.

Argyllshire is the traditional home to the Clan Campbell; historically one of the largest and most formidable of the Highland clans. History shows they became powerful in the area in the mid 13th century and centred their 'empire' around the shores of Loch Awe. In the Scottish Wars of Independence they were staunch supporters of Robert the Bruce and benefitted from lands and titles after Bannockburn. Sir Niall Campbell eventually married Robert the Bruce's sister, Mary. They were always allied with the Bruces and the Stewarts but became enemies of the MacDougalls. We have already seen the posters of Glencoe where the Campbells were involved in the massacre. They have always been a warrior tribe, being involved somehow in each skirmish and major battle on Scottish soil for centuries.

In 1725 six Independent Black Watch companies were formed: three from Clan Campbell, one from Clan Fraser, one from Clan Munro and one from Clan Grant. These companies were known by the name *Reicudan Dhu*, or Black Watch. Taking advantage of the partisan nature and warrior instincts of the Highlanders, these men were authorized to wear the kilt and to bear arms, thus it was not difficult to find recruits. The regiment was then officially known as the 42nd Regiment of Foot. They fought for the British Government and were involved in the Jacobite rebellion at the battles of Falkirk and Culloden (both 1746). Inveraray itself is an old burgh, and it was made a Royal Burgh in 1753. The castle of the Duke of Argyll was built in the 1750s on the site of the old barony burgh. The town itself developed from linen weaving, herring fishing and in recent times from tourism.

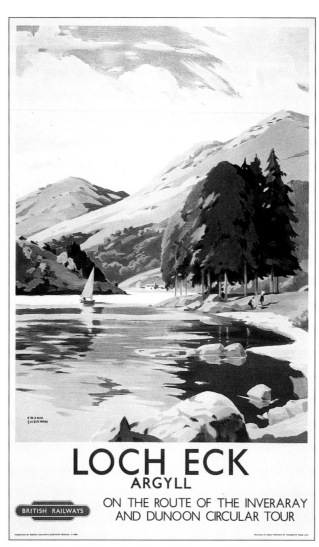

Tourism for Loch Eck, Argyllshire: GNR (Anon) in 1905 and BR (ScR) Poster (Frank Sherwin) in 1955

The waters of Loch Eck are very cold all year round, and the attractive sandy beaches that fringe its shores shelve quickly into deep water. These waters are home to some very special wildlife, and for this reason, it is now protected as a site of special scientific interest. Here anglers will find arctic charr, powan, salmon and trout all in the same waters. Needless to say fishing is tightly controlled and care is taken to ensure protection of the loch water from anything that may pollute. For many years there was a small steamer on the Loch - the S.S. "Fairy Queen". The remains of the pier can still be seen at the head of the Loch. This service ran in the 1800s until the First World War, resuming again in 1918, but ceasing to run in 1926. Loch Eck has supplied the water for Dunoon since 1977.

Loch Long was the boundary between Argyll and Dunbartonshire until the boundary changes during the 20th century put it wholly into Argyll and Bute. It is more than 20 miles (32km) long, extending right into the Firth of Clyde at the south-western end. The Loch was used as a testing ground for torpedoes during World War II and contains numerous wrecks, so today it is a popular destination for divers.

The next wonderful poster by Haslehust shows Loch Long towards the Arrochar and Tarbet end. Here our railway line has come down the valley from Crianlarach via Ardlui, on its way down to Gare Loch and Greenock and into Glasgow. Haslehust shows wonderful artistic skill, with the line and tunnel just appearing at the bottom of the poster.

To the south of Inveraray lie two more lochs that have featured on posters. Lock Eck and Loch Long both take us down towards the Clyde. The two posters above are half a century apart and show how far advertising came from the early days to when BR was most active with recognized artists. The Great Northern Railway ceased to exist when the 'Big Four' were formed in 1923, and this poster advertises not railways but horse drawn travel to see this lovely place. Alongside is Frank Sherwin's exquisite treatment of water and mountains. This poster was issued a few times and each time the caption at the bottom seemed to change.

LOCH LONG

LNER WESTERN HIGHLANDS LMS

IT'S QUICKER BY RAIL

FULL INFORMATION FROM ANY LNER OR LMS OFFICE OR AGENCY

Wonderful Painting from E.W. Haslehust Depicting the Moodiness of Loch Long, Argyllshire: Issued Jointly by the LNER and LMS in the Mid 1930s

Into Dunoon

We finish this chapter, and our short visit to Argyllshire, in the town of Dunoon. This was always a favoured place for visitors from Glasgow, and the poster alongside (painted by William Lee-Hankey) shows the pier, which in summer saw a regular procession of steamers plying across the Firth of Clyde.

Dunoon lies at the southern tip of the Cowal Peninsular and some 28 miles from Glasgow (45 kms). Its location makes it more accessible by sea than by road. Railways therefore came nowhere near the town but it has appeared on several significant railway posters. The castle (built around 1050 but abandoned by 1650) was the seat of the Lord High Steward of Scotland from 1370. A Celtic cross marks the spot where the Lamonts were massacred by the Marquess of Argyll in 1646. Traditionally it has always been a crossing point, and ferries ran to Rothesay until the piers shown in the poster appeared in 1820. Then paddle steamers helped the town develop into a more thriving centre. During the summer months of the 1980s its seawall was thronged with visitors from all over the world, (many from the USA). This was due to the major US Navy submarine base nearby (closed 1992).

Grand villas built from 1820 onwards ring the shoreline and in key places through the town, and people visiting can see the grand centre of this once very prosperous place. However, it has successfully rebranded itself as an alternative *'Gateway to the Isles'*.

Early 1930s Poster of Dunoon, Favoured Destination for Day Trips: Issued by LNER: artist William Lee-Hankey (1869-1952)

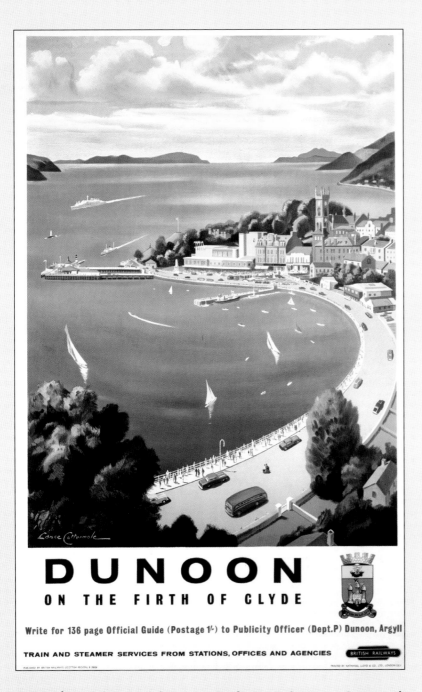

1960 BR/Council Poster of Dunoon Seafront: Artist Lance Cattermole

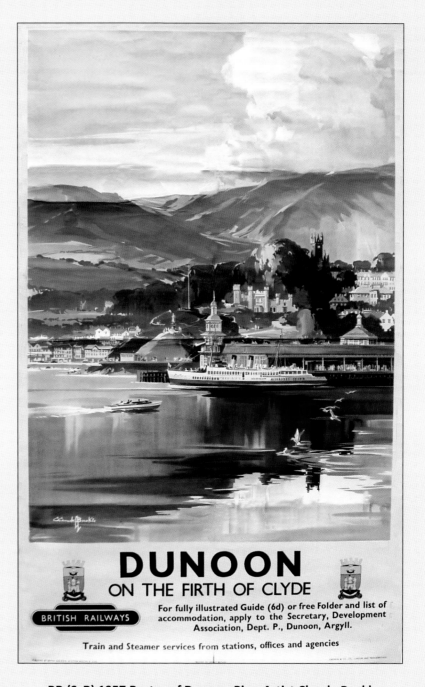

BR (ScR) 1957 Poster of Dunoon Pier: Artist Claude Buckle

The Famous Cowal Gathering at Dunoon: Joint LMS/LNER Poster from 1935: Artist Christopher Clark

Our next poster shows a more ceremonial Scotland. Highland Games are more associated with Aberdeenshire than Dunoon (probably because of the royal connections), but they are also held here and are reckoned to be the largest Highland gathering of all. Competitors come from all over the world, not just Scotland. Christopher Clark's evocative painting shows Highland dancing taking place in the mid 1930s.

The first gathering occurred here in August 1894 and they have been held every August ever since (except for a break during WWII). It is advertised as the Cowal Gathering and in 2008 attracted more than 3500 competitors, many of them exiled Scots from far-flung reaches of the planet. Many Scots went to Canada, the USA, New Zealand, South Africa and other countries. This event gives them and their families a chance to return home and relive old traditions.

Music and dancing is a major feature, with intense competition to become the champion piper and world champion Highland dancer. The railways always supported such events and trains ran from London and all the major UK ports up to Glasgow, so competitors could make the short journey across the Firth of Clyde.

We close this quite wonderful chapter of travel and art with a panorama of Dunoon looking north towards the mountains. Our historic railway trip from Mallaig actually took us as far south as Garelochhead, but at the start of the next chapter we go north and east again to visit an area that is unmistakably Scotland.

Chapter 7 Beauty, History and Industry – Strange Bedfellows

1930s LMS Poster for the Gateway to the Trossachs – When the Railway Ran Here! Artist Archibald Kay

The Gateway to the Trossachs

We have now re-entered Perthshire and have arrived in Callander. As our poster here shows, this is the Gateway to the Trossachs and marks the start of an incongruous stage of the journey. In this part of Scotland, extreme beauty, history and industry all exist well within a few hours of each other. The Trossachs area crosses three of the old counties: eastern Perthshire, western Stirlingshire and eastern Dunbartonshire. Within the area that is now designated a National Park, we find Loch Lomond, probably the most famous of all the lochs (apart from 'Nessie's home' that is). The interest in Loch Lomond and the Trossachs stems in part from the works of Sir Walter Scott. Much of the charm and romanticism would disappear from Ellen's Isle, Inversnaid and the Pass of Balmaha if *Rob Roy* and the *Lady of the Lake* were not part of English literature classes.

We begin in Callander, which used to have its own railway station on the line from Dunblane to Lochearnhead. This was formerly the route from Stirling across to the west coast, but the swingeing cuts saw this disappear in the 1960s. The town lies 14 miles (22kms) north of Stirling, and road <u>and</u> rail used to form key gateways to the Highlands. Indeed, many people still believe this is where the 'real Scotland' starts.

ROB ROY

LNER WESTERN HIGHLANDS LMS
IT'S QUICKER BY RAIL
FULL INFORMATION FROM ANY LNER OR LMS OFFICE OR AGENCY

Famous Rob Roy Poster: Issued by LNER/LMS in 1934: Artist Doris Clare Zinkeisen (1898-1991)

Callander's history goes back to Roman times, when a fort was built here. The military developed this theme in the 1700s when roads appeared in the 1740s to assist in movements of forces after the 1715 uprising; but they only served to help the Jacobite cause in 1745. The town really grew when the railway arrived in 1860 but the line across to Oban did not appear for another 20 years.

At its centre are the Rob Roy museum and the Rob Roy Way, a 79 mile (126 km) walk all the way to Pitlochry to the north. This famous poster by Doris Zinkeisen captures the style and legend of Rob Roy. Red Robert (Robert McGregor) grew up as a herdsman near Loch Arklet (a harsh area north of Ben Lomond). He took to raiding the richer lowlands to feed his family and clan, much to the annoyance of the Duke of Montrose (his main target). The Duke promptly torched his home and this merely enraged Rob Roy, who quickly became the 'Robin Hood' of Scotland with his successful plundering. He escaped from prison many times and eventually the Duke saw reason, pardoned him and allowed him to spend his last years free in Balquidder, where he is buried. He literally became a legend within his own lifetime and his statue can be found at Stirling. Curiously, his poster is equally well known!

One of the subjects commonly found on posters is Loch Katrine, so it is appropriate that we begin the tour here. This is a short journey west from Callander and will take us to the Stirlingshire border. It is also Rob Roy country and follows naturally from Zinkeisen's famous poster. The two views here are typical of the scenery. Alongside is an LNWR/CR poster dating from around 1910 and below is a section of a waiting room painting some 40 years later by Jack Merriott. The island was immortalised by Sir Walter Scott in his famous poem *'The Lady of the Lake'*, written in 1810. This draws loosely on the English Arthurian Legend, but is located around Loch Katrine. It tells the story of the struggle between King James V and the powerful Clan Douglas.

Jack Merriott's Painting of Ellen's Isle, Loch Katrine, Perthshire Dating from 1950

The loch itself is eight miles (12.5 km) in length, making it one of the largest in the Trossachs, but it is only 500 feet (160 m) deep. In one of the great engineering feats of the Victorian era, the loch was enlarged, and a pipeline built from it to supply the city of Glasgow with water. Nearby Loch Arklet (also of Rob Roy fame) is also a water source for the city.

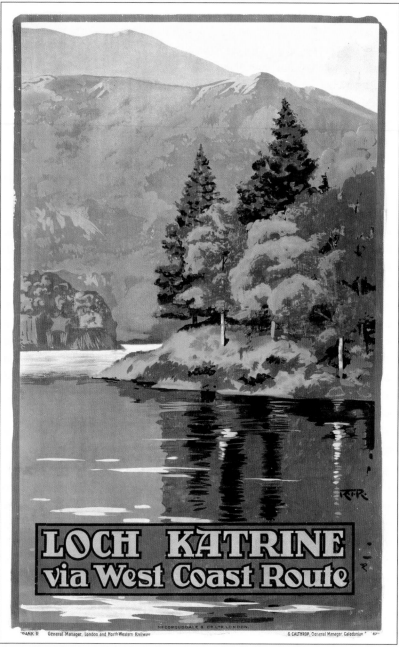

Ellen's Isle, Loch Katrine: LNWR/CR Poster from 1910: Signed by 'RTR'

Probably the most well-known of the posters from here is Tom Purvis's 1926 image. This is brilliant poster art: simple, stylised, colourful and bold. Purvis has several Scottish items included in this volume and all are very collectible. Notice the way he has reduced the bulk of the mountains to a basic grey and contrast this with the two posters on the previous page. A feature of Purvis's work was his use of colour in unexpected ways. Here the sky is yellow and is reflected in the water and onto the form of the hills. The composition is also a classic, with strong vertical and horizontal lines, and the whole poster is beautifully balanced.

Today, the loch is owned by Scottish Water. Because it is a water source, oil powered boats are not allowed. For many years the main mode of transport across the lake was the *SS Sir Walter Scott*. It was a wood burning steamer, but progress has caught up with it and it is being converted to run on bio-fuels that are non-polluting. The steamer features in Merriott's picture on page 144. This runs between Trossachs Pier, at the eastern end, and Stronachlachar at the western end, during the summer months. Loch Katrine (Gaelic *Loch Ceiterein*) is a popular destination for anglers and day visitors from Glasgow and other nearby towns, as the loch is well stocked with trout. Fly fishing is allowed during the summer months only. As well as Ellen's Isle, other islands include Black Isle and Factor's Island.

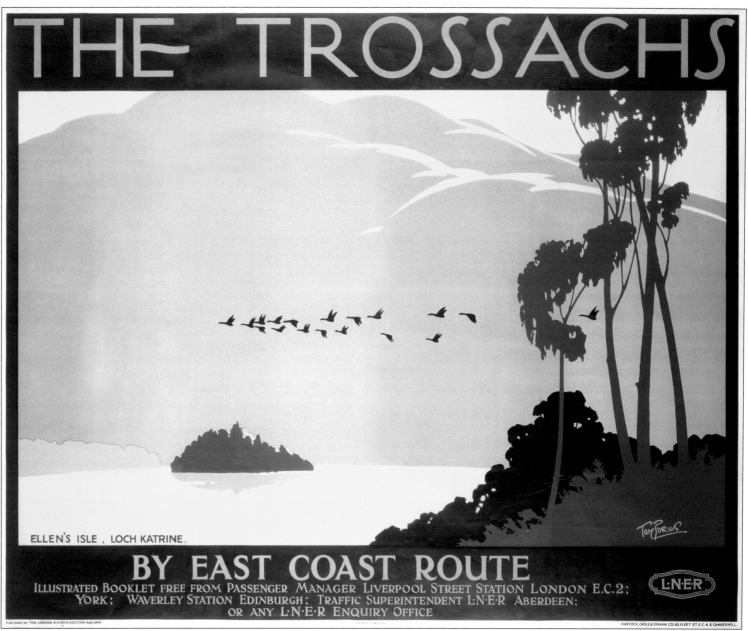

LNER 1926 Quad Royal Poster of Loch Katrine, Perthshire: Artist Tom Purvis (1888-1959)

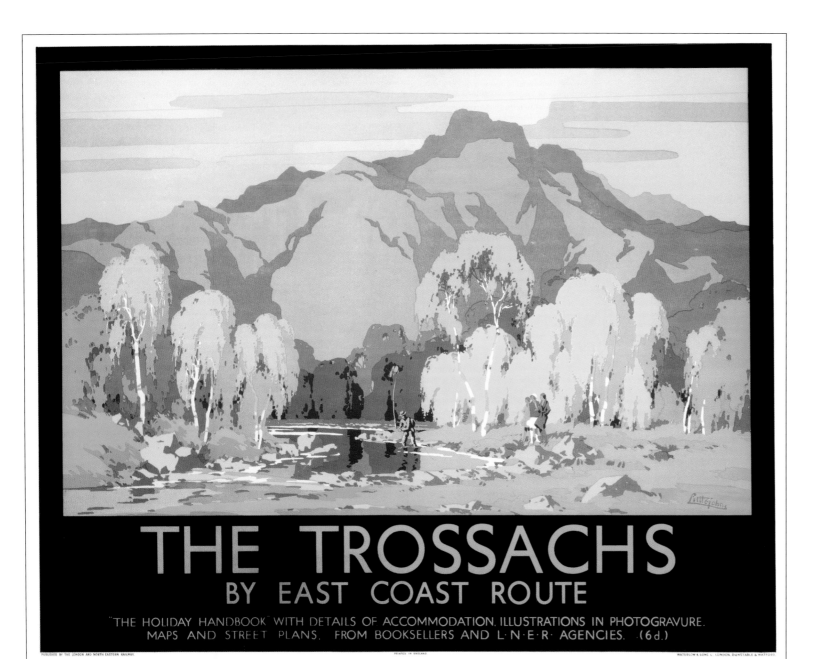

1930s LNER Poster for the Trossachs: Artist John Littlejohns (1874-19xx)

A similar palette of colours was chosen some 10 years later by Littlejohns in his painting for the LNER. This shows a fly fisherman in a stream trying to catch his lunch, while a group of 'townies' look on.

The Trossachs was designated a National Park in 2001. As a result it has seen an upsurge in visitor numbers, but this has always been a popular area, even in early Victorian times. It is the sheer peace and tranquillity that attracts, plus the wildlife of course. Within the park boundaries the patient observer can see capercaillie, red squirrel, woodpecker, blackcock, wood ants, wood wasps, barn owls, and a dazzling array of plants and fungi. It is a land of contrast, ranging from green uplands in the south to towering mountains in the north. What is truly fascinating is the seamlessness of the transition, even though this is thought of as the dividing line, with the Highlands to the north.

In the far north of The Trossachs is the area known as Breadalbane. This name means *'high country'* in Gaelic and is a place of majesty and grandeur: a fitting home for eagles and red deer. Many small villages such as Killin, Tyndrum and Crianlarach depended on the railway in order to develop. The line followed the glacial valley gouged out thousands of years earlier. It runs along the western shore of Loch Lomond from Ardlui to Tarbet, where it swings west to run down Long Loch; the scenery is stunning.

1920 Caledonian Railway Poster of Tarbet Hotel: Artwork by 'DNA'

On the Bonnie, Bonnie Banks

At the north end of Loch Lomond, we find a really grand hotel – a wee dram anybody!? The Tarbet Hotel on Loch Lomond has been a favourite 'watering hole' for many years, and its setting has made it onto railway posters for almost a century. The hotel first appears in records in mid-Victorian times. This lovely old Caledonian Railway poster was published after the end of WWI to entice the traveller back north. Little is known about the poster signatory (DNA), except that today it is an important acronym in biology!

Queen Victoria described Tarbet as 'a small town' with *'splendid passes, richly wooded and the highest mountains rising behind'*. Little has changed and today visitors can also see what captivated those early travellers. It is just two miles (3 kms) from Arrochar, which sits at the top of Loch Long. Arrochar is surrounded by some of the most beautiful mountain peaks in Scotland: it is a magnet for hill walkers of all skill levels. The peaks are often referred to as the Arrochar Alps. The name Tarbet is derived from the Gaelic word for isthmus, which here describes the narrow strip of land separating Arrochar at the head of the sea loch, Loch Long, and the shores of Loch Lomond at Tarbet. This pass, less than two miles (3 kms) long, is the shortest route from the sea to landlocked Loch Lomond. For this reason it has always been a natural approach for anyone wishing to access Loch Lomond from the sea. This was used to good effect by the Vikings who sailed up Loch Long, carried their boats up the pass to Tarbet and then sailed down Loch Lomond which was undefended.

The pier in front of the hotel allows steamers to ply almost the whole length of the loch. This started once the railway station had been completed (opened by the North British Railway in 1894). The station is west of Tarbet and completely by-passes Arrochar along the slopes of Ben Reach, even though the station is called Arrochar and Tarbet. Its station totem is not that common and is always keenly contested in railway auctions. It is a great pity the line did not run down the western side of Loch Lomond, but then I suppose the peace and tranquillity would really have been shattered.

Loch Lomond is stunningly beautiful and it is no coincidence that it features on several railway posters. It has been difficult to choose, and it is hoped the selection does this area justice. In terms of surface area the loch is the largest freshwater lake in Great Britain (at 27 sq. miles – 71 sq km). It is 24 miles long (39 kms) and has a maximum width of 5 miles (8 kms), but the average depth is quite shallow by Scottish loch standards at 120 ft (37m). Many rivers flow inwards so that its catchment area is a whopping 270 sq ml (700 sq km). We can devote a whole page to the next poster.

The Beautiful Loch Lomond, Dunbartonshire: Issued by LNER/LMS Companies in Mid 1930s: Artist James McIntosh Patrick (1907-1998)

1928 LMS/LNER Poster for Loch Lomond, Dunbartonshire: Artist Norman Wilkinson

The poster above is one of the many Wilkinson's to be featured in this series, albeit a lesser known one. It contrasts with the relief map type poster produced by Nicolson in 1953 for issuance a year later. Here many of the features described in the preceding pages are placed firmly into context. Part of the loch is in Stirlingshire and part in Dunbartonshire but, on a surface area basis, the official placement was always Dunbartonshire. Nicolson's detailed poster shows how many islands there are within the loch, some of them quite large, but also we can see the Rob Roy country (in the top right hand corner) where we began this chapter. At the bottom is Balloch Pier, the major terminus for the many ferries that sail up and down this beautiful stretch of water.

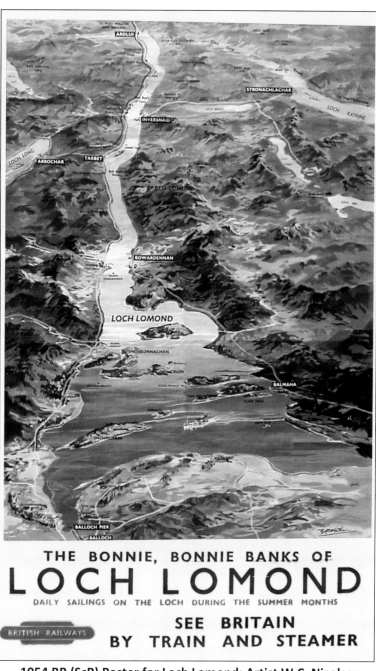

1954 BR (ScR) Poster for Loch Lomond: Artist W.C. Nicolson

History Beckons Again

About a third of Loch Lomond is In Stirlingshire and it is to this county we now travel. In the journey north we had a brief glimpse of the docks at Grangemouth, but Stirlingshire is much more than this. An awful lot of Scottish history has taken place in Stirlingshire over the centuries, and it is regarded as the area where Scotland finally won its freedom from the English. Epic battles were fought here (Bannockburn, Stirling, Stirling Bridge and two at Falkirk) and its strategic location gives Stirling a rich Scottish heritage.

Stirling was created a Royal Burgh by David I in 1130, a status it held for over 800 years until in 1975, Government changes meant Stirlingshire disappeared into Central Region (ugh!). The Queen gave it City status in 2002 and, with a population of just over 41,000, it is the smallest city in Scotland. We are back on railway metals now and from the main station in the 1950s, lines ran south towards Falkirk and Glasgow, east towards Dunfermline and north up to Perth or Oban. It had traditionally been the lowest crossing point for the River Forth for centuries, and only the construction of the Kincardine Bridge changed this in the 1930s. Some wonderful posters have been produced to entice us (and many others) to visit the 'Crossroads of Scotland'.

One of the most famous warriors was surely William Wallace. The recent film *"Braveheart"* gave a vivid picture of events towards the end of the 13th century when Wallace took on the English and won a great victory at Stirling Bridge in 1297. Later captured, tortured and executed, his spirit lives on and is commemorated in the Wallace Memorial that features on both posters and carriage prints. Both are shown here, the poster appearing in the 1930s and the carriage print somewhat later.

The Memorial to the Patriot William Wallace: Carriage Print Artwork by Jack Merriott

The poster alongside is signed ('N' or 'S') but the artist is not known: hopefully readers can assist here.

THE WALLACE MEMORIAL, STIRLING

SCOTLAND FOR HOLIDAYS
LMS ITS QUICKER BY RAIL **LNER**

1930s Poster of the Wallace Memorial: Artist Signature Not Known

Famous 1924 Painting of the Battle of Stirling Bridge in 1297: Artist Maurice Grieffenhagen (1862-1931)

This famous poster was commissioned by the LMS in 1924. It depicts the lovely Stirling Bridge behind the warring Scots and English. This was a major and epic battle in the first Scottish Campaign of Independence. The protagonists were Wallace and Andrew de Moray against the Earl of Surrey and Hugh de Cressingham (the Scottish Treasurer for King Edward I). The scenes in Mel Gibson's film *'Braveheart'* showed the real disadvantage the Scots encountered, both in terms of numbers and military strategy, and yet, sheer courage and will prevailed.

The site of the battle did not favour the English cavalry. The bridge is long and narrow, so few horsemen could cross at a time. Wallace waited for the first wave to cross, after luring the English to him. Once sufficient numbers had crossed he attacked from all sides. Trapped in the small area, the English quickly became disorganised and the bridge meant strong reinforcements were not able to come quickly, effectively severing them from the main army. Many of the knights were cut to pieces (as the poster shows).

Records show that both de Cressingham and de Moray were killed, but the Earl of Surrey, who had remained across the river, made his escape from the debacle. Wallace had won a famous victory. It was another 18 months before he met the English again, this time at Falkirk. On this occasion things did not go so well and the Scottish Infantry suffered a defeat. Grieffenhagen was so taken with this image that it was slightly modified and recycled, appearing again in his poster for the City of Carlisle (see page 185).

Stirling Castle is one of the largest and most important castles in Scotland, both historically and architecturally. The Castle sits atop the Castle Hill, a volcanic crag, which forms part of the Stirling Sill geological formation. It is surrounded on three sides by steep cliffs, giving it a strong defensive position. Its strategic location, guarding what was, until the 1930s, the furthest downstream crossing of the River Forth, has made it an important fortification from the earliest times. The poster alongside gives a clear indication of the strategic position looking out over the River Forth. A more modern rendition below further highlights its location. This stood out as the natural image for the rear cover: a quite wonderful contemporary poster. It is said that *"whoever holds Stirling Castle holds Scotland"*. It is not difficult, therefore, to see why it was the traditional battleground between the Scots and the English.

Magnificent 1996 Scotrail Poster Depicting a Colourful Yet Brooding Stirling Castle

Many of the Castle buildings post-date the epic struggle that took place between William Wallace and Edward I. Most of the structure that we see today was built in the 15th and 16th centuries. A few elements date from the 13th century but much of the frontal defence stonework dates from the 18th century. There have been many sieges here over the years, the last being during the Jacobite rebellion of 1746, when Bonnie Prince Charlie was unsuccessful in his attempts to wrest it from the English.

The Castle is home to the Argyll and Sutherland Highlanders, though they are no longer garrisoned there. The Argylls are one of Scotland's most famous regiments, with a history dating back more than 200 years. Our next poster shows them proudly on parade within the confines of Stirling Castle. Clark's painting captures the colour of their regimental pipe band, with the distinctive parade uniform beyond.

The View from Stirling Castle: BR (ScR) 1950 Poster: Jack Merriott

Ceremonial Stirling: Superb 1930s Painting for the LMS by Christopher Clark of the Argyll and Sutherland Highlanders on Parade.

Caledonian Railway Poster from 1910: Artist Unknown

Bridge of Allan, north of Stirling, lies on Allan Water, a tributary of the Forth. As the poster here shows, it is a spa town with all the amenities one might expect from a small place to relax. It is interesting how this poster positions the town, as the centre for Gleneagles, the Trossachs and Rob Roy's Country. Certainly all these are within easy travelling distance with the convenience of the City of Stirling close by. There was a river crossing point here long before habitation started. The old stone bridge appeared around 1520 and it was used by the Jacobites to raise revenue from crossing the river during their 1746 rebellion. The modern town was laid out by Major Henderson, the local Laird, in mid-Victorian times. Grand houses and hotels sprang up along wide streets and the spa town was born. Among the many visitors was Robert Louis Stevenson, who visited annually during his youth. As with Dunoon, each August in Bridge of Allan the Strathallan Highland Games takes place, where athletes, dancers and pipers all compete. The town is overlooked by the Wallace memorial (as the poster shows) and it is the home to the University of Stirling today.

And Now for Something Completely Different

It is time to leave the history and pageantry of Stirlingshire and move southwards to the 'big city'. The line to Glasgow goes south past Bannockburn and then turns west, by-passing Falkirk, to travel down the central valley and into what was once the heart of heavy industry. This is a far cry from the beauty we have seen, and no wonder that during holiday times there were thousands of people crowded on trains and buses that headed for the coast, to a break from industrial pollution. Glasgow has long been the largest city in Scotland and is the third most populous in the UK today. Famed for its shipbuilding because of the River Clyde, Glasgow City actually did not build many ships. The largest and most famous came from Port Glasgow and Greenock, where the river depth allowed ocean-going giants to be built and floated.

Glasgow's growth owed much to its position and power within the church. St. Mungo founded the church here in the 6th century, and over the next 500 years it rose to become the largest and richest in Scotland. Author Daniel Defoe visited in the 18th century and wrote *"Glasgow was the cleanest, beautifullest and best built city in Britain – London excepted"*. How things were to change during the Industrial Revolution! Scotland developed major trading links with America in the 18th century. Tobacco, cotton and sugar were huge industries. At its peak, half of Britain's tobacco came through Glasgow. Textiles, engineered goods and steel followed, once the Clyde had been dredged, giving access to iron ore and coal to the east. During late Victorian times, 75% of the shipping tonnage and 25% of all railway locomotives were built in and around the city.

Industrial cities do not feature often in posters, and here Glasgow has done far better than Leeds, Manchester, Bradford or Sheffield. The colourful poster shows transportation in the city for the 1938 Empire Games. Local railway and bus companies combined to promote the infrastructure developed for the visitors. However it is shipbuilding that features on several posters. Wilkinson painted four images similar to that shown below. Over the years some very famous ships have been built on the Clyde: *HMS Hood, Lusitania, QE 2*, Royal Yacht *Britannia, Queen Mary* and *the Delta Queen* (famous Mississippi sternwheeler). From its gentle beginnings at the confluence of two small streams in the Lowther Hills of South Lanarkshire, it takes just over 100 miles (160kms) for the River Clyde to wind its way west to the Irish Sea. Can there be another river anywhere in the world as intimately associated with shipbuilding and industry as the Clyde? The answer is: certainly not!

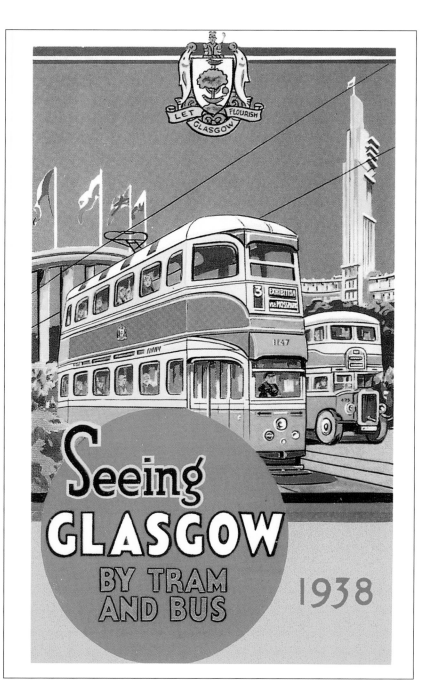

1938 Corporation Poster for Glasgow's Empire Games Visitors

Clydeside Industry: Poster Issued by LMS/LNER in the 1930s: Artist Norman Wilkinson

Baird of Coatbridge made huge quantities of pig iron; Fox and Henderson of Renfrew made cast iron, and several other firms produced tubes, alloys and steel. The railway workshops around Glasgow were vast. There were major sites at St. Rollox (Caledonian Railway), Cowlairs (North British Railway) and at Hydepark (Neilson and Company). Coplawhill was the location for the huge tramcar workshops of Glasgow Corporation. Sadly none of these workshops made it onto posters.

The area between Gorbals and Govan was the site of a large mineral loading and unloading terminal, which did feature on a BR poster (below). Quite why this happened is not clear, as it was certainly not a tourist destination. Iron ore and coal, as well as other materials, were unloaded by huge cranes, and then taken by rail to their destinations. Disused by the early 1980s, these cranes were blown up and the area redeveloped.

Shipbuilding at Port Glasgow: 1950s BR (ScR) Poster by Robert Norman Hepple

The great yard at Govan and the name John Brown are synonymous with shipbuilding on the river. Today Govan yard and the huge Finnieston crane that used to lift boilers and locomotives into giant hulls are all that remains of the grandeur of the yards. Ships continue to be constructed but on nothing like the scale that they once were. The poster above (by Robert Hepple) shows the hive of activity that existed along the whole of the western Clyde up until the 1960s. Then the industry was lost due to a combination of factors: low investment, the emergence of Asian builders, air travel and the failure of Governments to underwrite the construction sector. As a result, a long decline began, leading to high unemployment, urban decay, and a worsening of general health and the quality of life. The city population fell as the new towns of East Kilbride, Glenrothes, Livingstone, Cumbernauld and Irvine all grew. But it was not just shipbuilding that made the name of Glasgow. Engineering and iron trades laid the basis for Glasgow to really industrialise in the 19th and early 20th centuries.

1954 BR (ScR) Poster of the Ore Terminal in Glasgow: Artist Alasdair MacFarlane

Magnificent 1935 LMS/LNER Industrial Poster of the Flemington Steelworks, Motherwell: Artist Norman Wilkinson (1878-1971)

Probably the most unusual subject for a poster appears on page 157. Lanarkshire has been famous for more than a century in steelmaking, and the wonderful painting by Wilkinson of the Flemington works near Motherwell shows that even blast furnaces can produce an evocative poster. The use of colour in the image is superb. Another unusual subject is displayed below. Milngavie is a station just north of Glasgow and the location of an unusual transport system test site. The Railplane invented by George Bennie was almost a monorail, with the car being suspended from one rail while wheels underneath ran on a stabilizer rail to prevent the car from oscillating from side to side. The system was intended to achieve speeds in excess of 100mph, and to allow travel between Glasgow and Edinburgh, but the project never got off the ground – so to speak! However it did make it onto a poster and the test site is still there, all derelict and forgotten.

BR (ScR) Quad Royal Poster from 1960: Artist Terence Tenison Cuneo (1907-1996)

1930s LNER Poster of the Bennie Airplane: Artist: WCN of McCorquodale Studios

Rather more conventional railway technology is shown in Cuneo's poster above. This is shown near Helensburgh on the northern Shore of the Clyde and dates from 1960. Such DMU's were a common site at this time, and lasted for a surprising number of years before being phased out. The older steam locomotive on the left and the tug to the right frame the 'new' mode of transport in Glasgow's modern railway. More then 90 3-car units were built by Pressed Steel at Linwood, near Paisley, from 1959-1961. The first ones came into service in November 1960 and after some transformer problems caused temporary withdrawal (which took almost a year to fix), they went on to become one of the most expansive network workhorses in the UK. The whole system used 25kV for power and the first phase was just over 100 miles in length (165 kms). Today, hundreds more miles serve 2.5 million people each day and Glasgow has far better railway infrastructure than most UK cities. Cuneo's painting is usually sought after when copies come into auction.

Drawing by Frank Mason of the Dalmuir Shipping Basin, Glasgow: NRM Collection York

Although not a proper poster, the drawing above by Frank Mason of the Construction Basin at Dalmuir is in the NRM collection at York and would have made a wonderful poster. It is our final look at the industry and transport of the Glasgow area.

A Return to Tranquillity

Just outside the industrial Clyde is the tranquil Clyde; a few miles distant, but a million miles away in quality of life. It is a fitting place to close out the chapter. As a favoured tourist destination, it is not surprising that many posters are listed in the database. Glaswegians used to use the Firth of Clyde, The Isle of Bute, Rothesay and Dunoon as 'get-away' places, and during the industrial boom the city enjoyed, all the surrounding quieter spots also flourished. However, in the summer months and on Bank Holidays, they were far from quiet! A plethora of ferries, large and small, could be seen travelling between the islands and the main termini at Gourock, Greenock and Helensburgh.

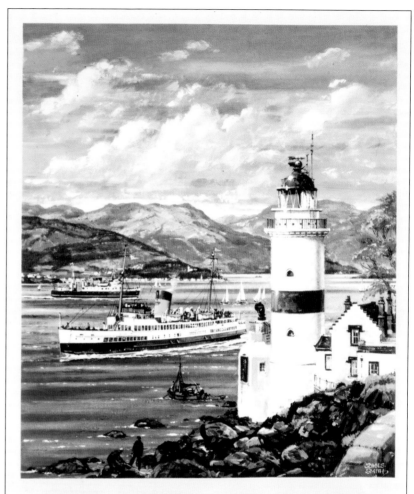

THE FIRTH OF CLYDE

The wonderful estuary of the Clyde, with its islands, sea lochs, mountains and bright resorts, is one of Britain's premier holiday areas.

There are regular sailings between the popular holiday places and day cruises to the many beauty spots by the Caledonian Steam Packet Company's fleet of modern pleasure steamers and motor vessels, all with excellent catering.

Fast and frequent train services connect with the steamers at Gourock, Wemyss Bay, Craigendoran, Ardrossan and Fairlie.

Car ferries link Gourock and Dunoon; Wemyss Bay and Rothesay; Ardrossan or Fairlie and Brodick; and Wemyss Bay and Millport — drive on and drive off at all states of the tide.

1960 BR (ScR) Poster of the Beauty of the Clyde: Artist John S. Smith

THE CLYDE

AT THE ENTRANCE TO LOCH LONG

BRITISH RAILWAYS

1948 BR (ScR) Poster of the US Naval Base Entrance, Loch Long, Argyllshire: Artist Norman Wilkinson (1878-1971).

Here we have a 1948 poster showing a view across the Clyde to the naval base at Holy Loch. For more than 30 years this was a strategic US Navy base, used as a counter to the tensions induced by the 'Cold War' after the end of WWII. Nuclear missile submarines from Squadron 14 of the US Navy, plus fleet auxiliaries, tenders and other support ships used this facility, and at times visitors could be excused for thinking this was the United States! It was the only such base outside the US, and vital because of the limited range of the Polaris missiles. Literally thousands of patrols were begun here as the west sought to counter the might of the Soviet Bloc forces.

What was also most fascinating was that the Polaris Fleet had their own tartan, a wonderful mixture of blues, greens and yellows. The idea came from the Squadron Commander and proved popular on dress and ceremonial occasions. The American presence in Scotland was (and still is) welcomed, especially as they embraced cultural, educational and social facets within the community. A few hundred homes were leased from the Councils around the loch, and one US sailor even boxed for Scotland after winning a national title. The whole exercise is an excellent example of the special relationship enjoyed between the UK and US Governments for many decades.

With the collapse of Soviet power in the 1980s, the need for the base disappeared and the sailors finally left in 1992. This poster is a fitting tribute to their presence in Scotland.

The town of Helensburgh lies on the north shore of the Firth of Clyde. It was built by Sir Neil McKenna in 1776 and laid out in the style of Edinburgh New Town. He named the spa resort after his wife Helen. Once he began the ferry across to Greenock, Helensburgh really started to grow. Its aspect, with the mountains behind (as in the posters) made this a most desirable place to live, and residents used the ferry to commute to work. Once the piers were built, famous ferry boats (*Charlotte Dundas* and the *Comet*) brought people directly from Glasgow.

The town eventually ended up with two ferry piers; Helensburgh itself to the west and Craigendoran to the east. (This had a whole range of posters all to itself – see Chapter 9). There were also two railway stations; the low level going into Glasgow and the higher level on the West Highland Line up to Fort William. Such transportation links gave Helensburgh a unique chance to become a commuter town and it certainly took it. It is a place well worth visiting.

The publisher Walter Blackie had a house designed and built here by Charles Rennie Mackintosh, and Helensburgh is famous as the birthplace of John Logie Baird (inventor of TV), and actress Deborah Kerr.

Templeton's early 1920s poster (L) shows the promenade full of people, and Frank Mason's post-war poster (alongside) shows the main pier with paddle steamers and yachts using the Clyde for the usual boating pleasures. Beyond the mountains in Mason's poster are Loch Lomond and the Trossachs.

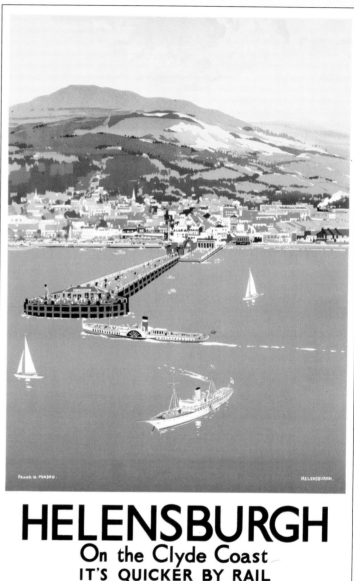

Two LNER Posters for the Resort of Helensburgh: 1920s Poster by Templeton (L) and 1946 Poster by Frank Mason (R)

There are several posters in the database for the Clyde Coast. Before package holidays and the trips from airports to the sun, this area hosted many locals who wanted a break from the industrial centres. The old County of Buteshire came under the Clyde Coast for advertising purposes. MacFarlane's lovely poster below shows the Kyles of Bute, a narrow sea channel between the Island of Bute and the Cowal Peninsula on the mainland. The drive around this area takes in the villages of Tignabruaich and Kames, and is considered by many to be the most scenic short drive in Scotland.

1950s BR (ScR) Poster of the Kyles of Bute, Western Scotland: Artist Alasdair MacFarlane

Of course, no railways came to this part of Scotland, but there were ferries to nearby Rothesay as well as short ferry trips across the Kyles themselves. It is some 80 miles (130km) by road to Glasgow, and today this is a very popular *'day-tripper'*, especially in summer: beauty within reach of the city!

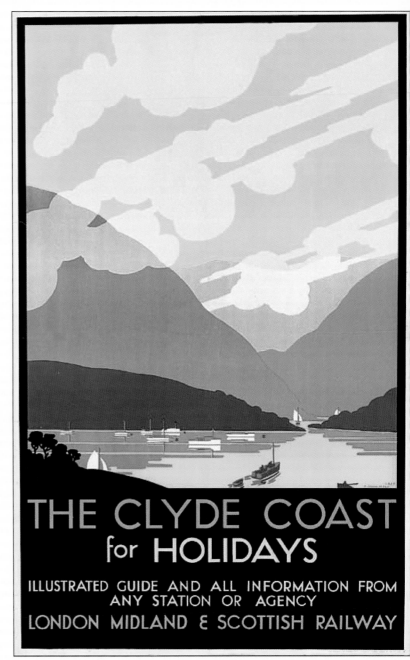

1920s LMS Poster for Clyde Coast Holidays: Artist Unknown

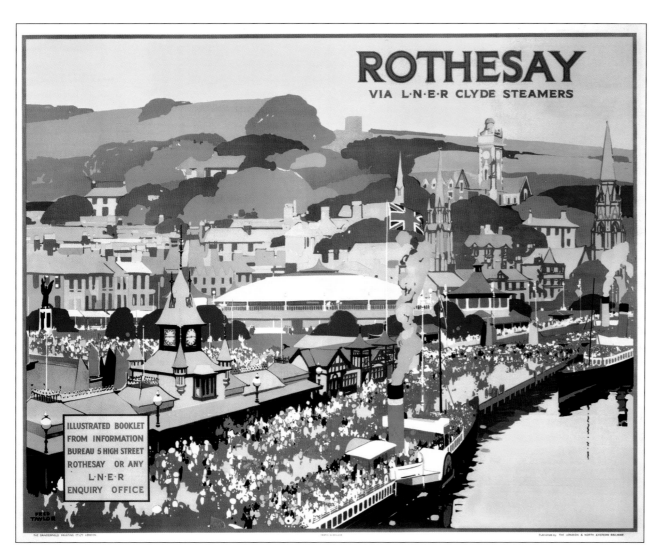

Wonderful LNER Poster from 1926 of the Waterfront at Rothesay Buteshire: Artist Fred Taylor

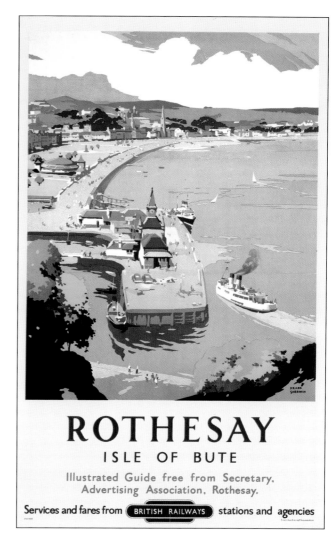

1950s Classic Poster for BR by Frank Sherwin

Across to Bute

Rothesay on the Isle of Bute has always been a popular day-trip destination. Many posters were produced to promote the town and some of the most prestigious artists of the day were asked to paint their view of the resort. It has been very difficult to select Rothesay posters, as all the images are quite wonderful. I have tried to span the time when the power of posters really worked their magic when it came to Rothesay. It was ***the*** prime place that many Glaswegians chose to go *'doon the watter'* for some fresh air. It is still popular today as the beautiful Victorian architecture, the setting and the amenities make it an ideal location for clean Scottish air.

These two posters, published almost 30 years apart, show contrasting styles to tempt the city dwellers to travel. The hustle and bustle in Taylor's work shows Rothesay's popularity in the 20s, whilst visitor numbers are clearly diminished in Sherwin's BR poster. However, the importance as a ferry terminus is evident in both works.

The large number of posters for Rothesay gives us the chance to show one from the National Collection that is rarely seen. This comes from the very early days of the LMS and, although records do not show exact dates or an artist, it has the feel and style of the mid 1920s. The artwork is exquisite and does justice to the lovely panorama that Rothesay affords.

It has an interesting history, being named a Royal Burgh by Robert III in 1400, as home to Industrialists of the Victorian era and as a playground for tourists. The architecture is fascinating with listed buildings, beautiful facades on many mansions, sunken gardens and the ruins of an old castle.

A most interesting place to visit is Ascog Hall. Built around 1870, this is a sunken iron structure that houses a quite lovely Victorian fernery. The surrounding gardens also complement the internal greenery. Mount Stuart House, an outstanding Victorian Gothic mansion, is home to the Marquis of Bute. It was the brainchild of Scottish architect Robert Rowand Anderson. Finally, there is the grade A listed Winter Gardens, which was built in 1924. It has recently undergone very extensive renovation to conserve the unique circular domed cast iron and glass structure: it is well worth a visit.

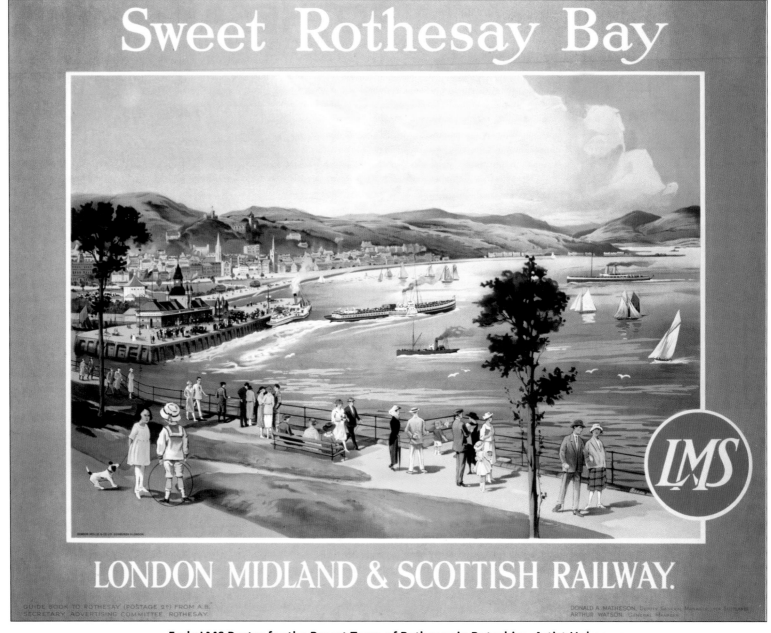

Early LMS Poster for the Resort Town of Rothesay in Buteshire: Artist Unknown.

Cruising *'Doon the Clyde'*

The Firth of Clyde includes other islands. The largest of these is the Isle of Arran, between the Ayrshire coast and the Kintyre Peninsula. Boats used to ply from a dozen locations and some of the old photographs in the NRM show hordes of people in long queues at each of the terminals at peak times. It is therefore not surprising that the database contains well over a dozen posters advertising holidays, cruises and day jaunts. Just three are shown here, and even the best artists were used to illustrate quite modest posters. The two quad royals were painted by Frank Mason and the research shows he made almost a dozen of this type of image in the early and mid 1920s. Craigendoran pier was one of the largest on the Clyde, and the LNER devoted a set of posters to their steamers. The LMS was not to be outdone, and Wilkinson countered with some lovely maritime pictures, one of which is shown here. The two Companies used to go head-to-head on who had the luxury AND the efficiency. Wilkinson was used a great deal to promote this area and although we have featured several of his pictures in this chapter, it is fitting we close with a real classic. This one makes you want to get up and go there: exactly what posters were intended to do.

Two Early LNER Posters for Clyde Coast Holidays: Artist Frank Mason

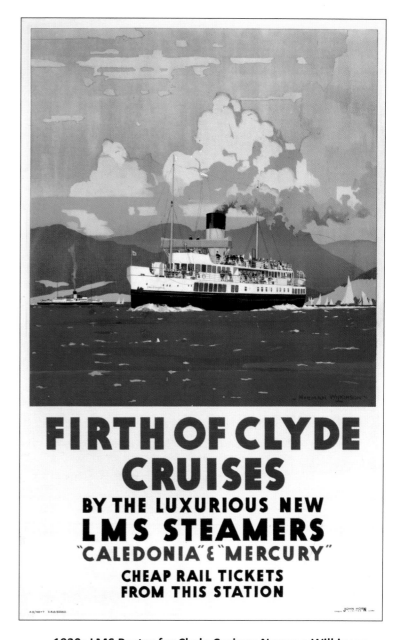

1930s LMS Poster for Clyde Cruises: Norman Wilkinson

Beautiful Firth of Clyde Poster by Prolific Artist Norman Wilkinson: Issued by the LMS in 1925

AEY 4/09

Chapter 8 — Through the Tranquil South-West and Across the Border

To the Ayrshire Coast

In today's journey, we are moving south, back towards the English border and taking in the counties of Ayrshire, Dumfries, Kirkcudbright and Wigtownshire. This is often described as the *"Tranquil South-West"*. In most respects the tranquillity is correct, but you might not think so seeing the first few posters, as we travel out from Glasgow towards the Ayrshire Coast. The railway line takes us westwards through Paisley and Dalry to the seaside at Saltcoats.

Many of the people who live in Saltcoats today remember how busy the town used to be. The Glasgow Fair fortnight saw the town inundated from the 20s to the 50s, as popular stage entertainers played to packed audiences at the Beach Pavilion. The local pool was always crowded and has been captured in this first poster by Tom Gilfillan. Looking at the faces of the bathers, which are reminiscent of cartoon types in 1950s American comics such as *Mad*, maybe they should be captured too! The tidal pool depicted here was rebuilt from an old pond and became the largest of its type in Scotland. The poster is a lively and colourful start to the journey.

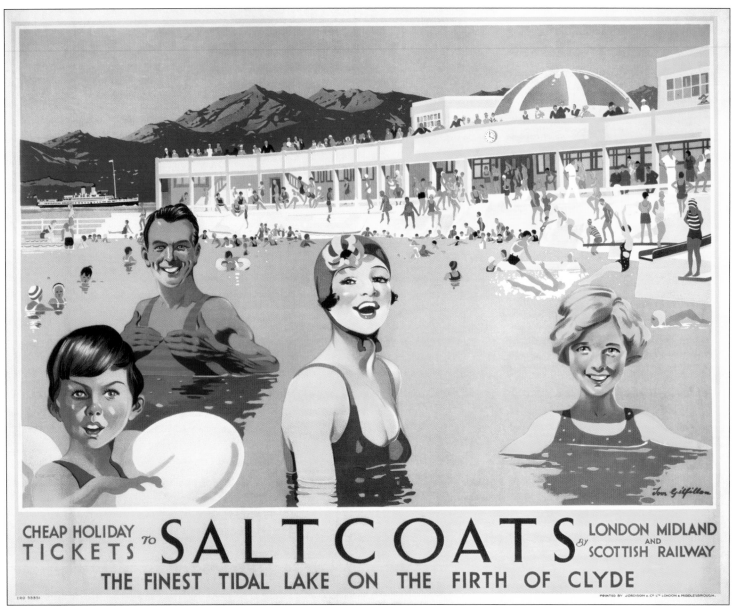

1935 LMS Poster Advertising Travel to Bathing on the Ayrshire Coast: Artist Tom Gilfillan

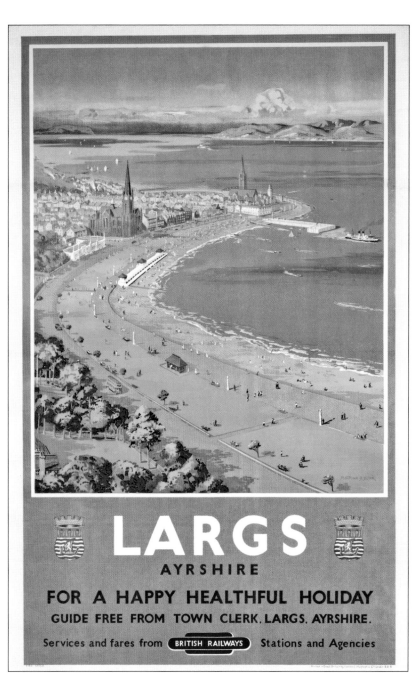

1950s British Railways Poster for Largs: Artist Montague Birrell Black

There are seaside towns like Saltcoats all along the Ayrshire coast, from Wemyss Bay in the north to Girvan in the south. For walkers, the newly created Ayrshire coastal path allows a leisurely look at one of the most panoramic of Scottish coasts. Here, against the stunning backdrop of Ailsa Craig, you see the Islands of Arran, Cambrae and Bute, and right across the lovely Firth of Clyde. For golfers there are world-class courses.

Ayrshire is a curious mix of agriculture, industry and playground. Of the four south-western counties visited in this chapter, it is by far the most populous, serving as it does as part dormitory and part industrial employer. Geologically, Ayrshire is also a mixture, with rich coal seams, sandstones, shales and granite (such as Ailsa Craig), with additional volcanic intrusions from its distant past. Iron ore and coal workings have all but finished, but there are scars to be seen in the north of the county, a testament to man's interference. But along the coast and to the south, things are quite different; the many posters made for the county show the rural aspect rather than the industrial side.

Beginning in the northern coastal resorts we find Largs, just 33 miles (52 kms) from Glasgow and another location for seaside days out. The lovely poster from Montague Black shows the seafront, town and pier with the Firth of Clyde beyond. He was extremely good at aerial and panoramic posters; this one was painted earlier and re-issued by BR in the 1950s. Largs was part of the Cunninghame Estate and from its small beginnings as a village, it grew during the 19th century, first with a small pier and then with larger and larger houses. Once the railway arrived in 1885 (the station was built by the Glasgow and South Western Railway), the town's popularity really increased and it wasn't long after that the first of the railway posters appeared.

Some notable people began to live there, the most famous being William Thompson – Lord Kelvin - the eminent physicist and engineer. It is also the birthplace of Sir Thomas Brisbane (the Governor General of Australia and from whom the City of Brisbane takes its name). For the more sporting types, Ryder Cup winning golfer Sam Torrance is also an Ayrshireman from this most attractive of resorts.

The beaches are pebble, making it less of an attraction to sun worshippers, but unusually it does have an annual Viking festival. In former times there were ancient settlements here, but in 1263, the invading Viking army was forced to beach at Largs during storms. Skirmishes took place with the locals (called the 'Battle of Largs' – but not really a full blown battle) and from this, an interesting local tradition began, which has now been elevated to an annual tourist attraction.

These three posters show the enduring attractions of the north Ayrshire coast for almost a century. These posters span the first 50 years of the 20th century, but even before such posters appeared, visitors to the Ayrshire coast had begun their regular jaunts. Notice how the town was marketed in the 1930s and the complete difference in style only 25 years later. In both the Largs posters, the Steamer *Waverley* is featured. This is the last of the old paddle steamers, and one of the last surviving pleasure vessels of its type anywhere in the world. The pier that Waverley operates from is the subject of a refurbishment so that ferries across to Cambrae can continue. Nearby Troon is famed worldwide for sport. It is home to the Royal Troon Golf Club, that every seven or eight years plays host to *The Open Championship*, golf's most prestigious tournament.

It has the shortest and longest holes in championship golf and is considered by many to be the finest of the seaside links courses. The club has two courses, the older being the championship course and the newer one for the club itself. Nearby is the international airport at Prestwick, but in pre-flying times, it was the railways who carried the tourists and players alike. The GWSR built a station here in 1839 and then a second larger one in 1892. Troon is also a port, with both freight and ferry services. It is actually surprising that so few golf posters were produced to advertise the town, considering that North Berwick, St. Andrews, Gleneagles and Cruden Bay all did so well. The name Troon derives from the Gaelic *'An t-Sron'*, meaning 'the bill' or 'the nose' and a look at the map shows why it was so nicknamed: quite simply, the nickname stuck!

Lively Largs: 1930s LMS Poster: Artist: Chris Meadows

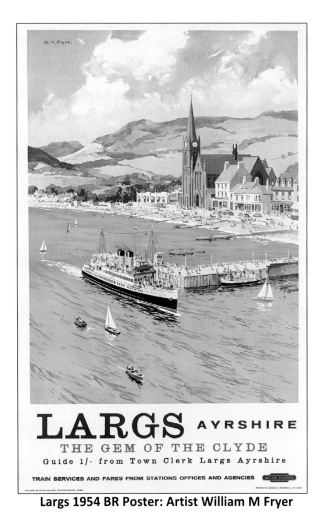

Largs 1954 BR Poster: Artist William M Fryer

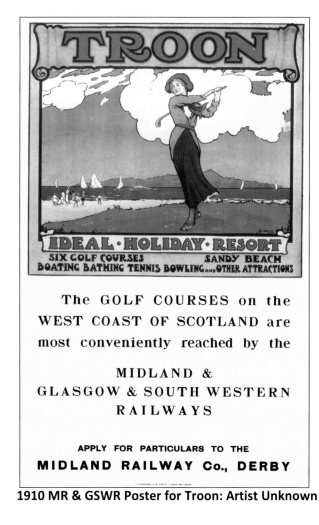

1910 MR & GSWR Poster for Troon: Artist Unknown

Coming south from Troon we soon reach Ayr, where several posters used to promote the town as a seaside resort. Its strategic location at the mouth of the river meant fortifications from the late 1100s. Soon after, William the Lion made it a Royal Burgh. It has a special place in Scottish history as Robert the Bruce held his first Scottish parliament there in 1315 after the English had been defeated. During the English Civil War, Cromwell used it as a garrison and constructed fortifications in the form of town walls; they can still be seen today.

During most of the Victorian years, central Scotland industrialised, but Ayr remained the quiet county town, even though small industries flourished. This included small foundries, shipbuilding and the development of the harbour area to export coal and other raw materials. During the 19th century the population grew sixfold, and even the great industrialist Andrew Carnegie made donations, to enable library facilities to grow. There are monuments to both Wallace and Burns in the town. But it is the association with Burns that Ayr is best known for. The history of Ayr's infrastructure development meant it led many towns in the UK, with gas lighting by 1826, piped water by 1840 and sewerage facilities by 1880. The visionary council encouraged trams, railways and good roads; everything to help attract tourism, and this is why many posters have appeared.

Superb 1930s LNER/LMS Quad Royal Poster of the Panoramic Coastline at Ayr: Artist Robert Eadie

 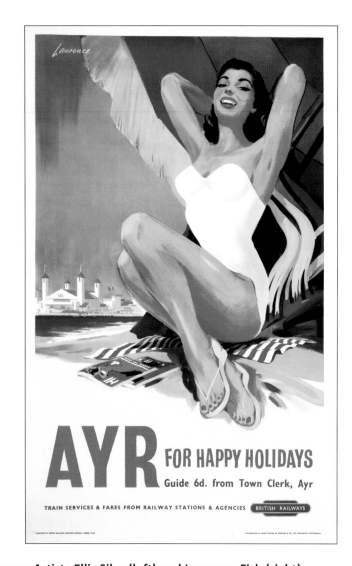

Two 1950s images of Holiday Ayr, Issued by British Railways: Artists Ellis Silas (left) and Laurence Fish (right)

Cup. All in all, it is well served by links, amenities and with a temperate climate. No wonder people have been going there for R+R for well over 140 years.

Beaches and More Golf

So now we look to the beaches and tourist posters and the reason why the economy of Ayr has been so resilient. Its coastal location at the mouth of the river means the town is surrounded by water. The sea air and low position with high ground to the south means rainfall is steady, sea fog is rare and snowfall is also not that common. The wide beaches have featured on several posters and Laurence Fish's bathing belle alongside could be in southern Spain or the eastern part of the Mediterranean!

In the early 50s Ayr, like many towns down the Firth of Clyde, played host to thousands of day and weekend trippers, and all the posters produced in the first half of the 20th century show the beaches being quite busy. The beaches are to the north and south of the river that bisects the town. The northern beaches shield the championship golf courses from the effects of the sea, and to the south, the wide sands stretch down to Doonfoot and the Heads of Ayr. There is more than enough space to accommodate many beachcombers and ensure beauties like the one shown here can get a decent tan – provided the weather stays 'set fair'.

Although it remained a holiday and a market town, Ayr was still a working town with a busy port. The railway came here as early as 1839 but the first station was demolished in 1857, with a second faring little better. That lasted until 1886 when the number of visitors from Glasgow meant the links had to be upgraded; the present day station was built by the Glasgow and South Western Railway. Street trams appeared in 1901, but sadly these were gone by 1931. Ayr has a further association with transportation as the great road builder Robert Macadam was born here in 1756. The town also has a large racecourse, home to the Scottish Grand National and the Ayr Gold

Just down the coast, west of Maybole, is Culzean Castle. This was built by David Kennedy Earl of Cassilis from a stately home that already existed. The famous Robert Adam was the architect, and between 1777 and 1792, he transformed the house into quite a building. The magnificent drum tower, shown in Steel's poster alongside, allows superb clifftop views out to sea. In 1945 it passed to the National Trust of Scotland, with the stipulation that rooms be given to General Eisenhower, in recognition of his service to the UK during WWII. This was the forerunner to the strong US/Scottish connections covered in Chapter 7. Of equal importance to Americans is the famous Turnberry Hotel just down the coast and shown in the colourful poster below. This is a world famous golf course, so to find just three posters is disappointing.

1953 BR (ScR) Poster of the Ayrshire Coast: Artist Kenneth Steel

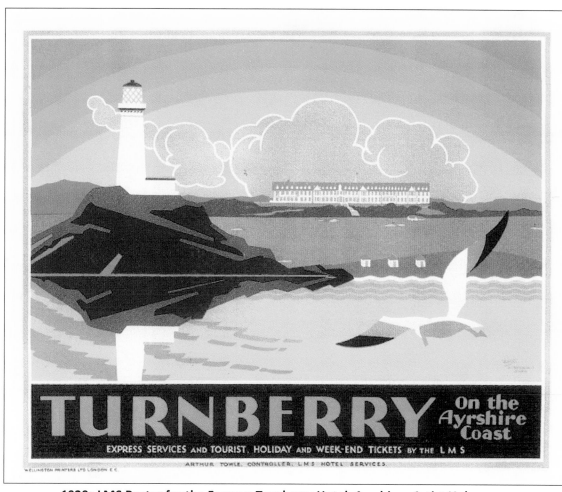

1920s LMS Poster for the Famous Turnberry Hotel, Ayrshire: Artist Unknown

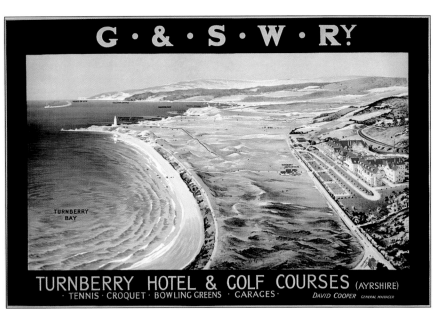

1910 G&SWR Poster Advertising the Renowned Turnberry Course: Artist Unknown

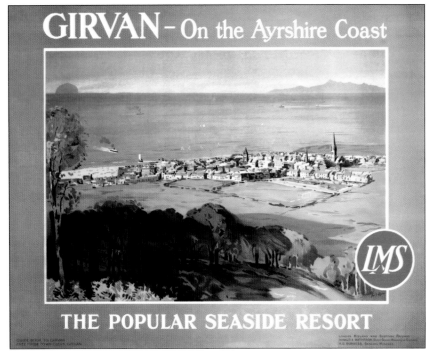

1920's LMS Poster by Artist James Sloane for the Tranquil Town of Girvan, Ayrshire

The hotel opened in 1906 and is remarkable for the foresight shown in building it at that time and in that location. As the Edwardian poster alongside shows, the setting is wonderful. It was built at the height of the British Empire, when golf was becoming the 'gentlemans' game'. The 1901 course was actually laid out on the land owned by the Marquis of Ailsa (who conveniently was a Director of the G&SWR). By the time he had finished the development planning, you could get on a sleeper in London and by the next morning play a round of golf on his seaside course – wonderful! There was even a railway line built straight to the hotel from Glasgow St. Enoch station, so at weekends the entrepreneurs could leave 'the smoke' and head for the greens. The 'golfing special' train called at Ayr and Turnberry only.

Sadly the line closed in the 1940s, unable to be sustained by golfers alone. The route today would be fabulous, especially with preserved steam engines involved. The majestic hotel survived without the railway and it even survived for a time without the golf courses, because during WWII, the greens were replaced by concrete and an airfield filled the site. The hotel was the home to many Canadian airmen. The two courses were later rebuilt and enlarged, and in 1977, Turnberry was given the ultimate accolade by staging the Open on the Ailsa links. Two more tournaments followed in 1986 and 1994, and in 2009 it will stage its fourth. In many ways the hotel was ahead of its time: a purpose-built resort of unashamed luxury, with electric amenities throughout including lifts, wonderful lighting and special golf facilities (a spa, plunge pools and wave machines). For all golfers, it is one of the top courses in the world.

It is a short journey now by road down to Girvan and our last stop on the coastal tour of Ayrshire. There have been people living in and around Girvan for over 4,500 years, but Invergarvane (later shortened to Garvane and then Girvan) came into existence legally when Charles II granted a charter to form the community. This included building the harbour, having local markets and even yearly fairs. This lovely 1920s LMS poster shows the location of the small Ayrshire town, with Ailsa Craig over to the left and the Isle of Arran to the right on the horizon. For hundreds of years the small harbour was the home to a fishing fleet and a hive of activity, but this has been replaced today by visiting yachts and tourism. The River Girvan flows down the valley, densely wooded in places and home to a host of wildlife. Here Atlantic salmon, sea trout, brown trout and other species make their home with otters and other predators for company. It was the peace and tranquillity that the poster advertised.

1910 Poster of Burns Country Issued by MR/GSWR: Artist is Unknown

The Land of a Great Scottish Poet

However the most famous son of Ayrshire was the poet Robert Burns who was born at Alloway near Ayr in January 1759. He was a superb writer and within his short life (dying in July 1796), he established a national and international reputation. The quad royal poster on the next page commemorates his birthplace and shows the humble background from which he came. He was Scotland's greatest poet and known as the Bard of Ayrshire – or simply as the Bard. He wrote in the Scots language, in light Scots dialect (so people outside his native country may understand) and in plain English, but in all of his works he could be forthright as well as romantic. It is in this latter guise that he is thought of as the pioneer of the Romantic Movement: a complex, artistic and literary movement that rebelled against the political and aristocratic norms of the 18th century, and against the rationalization of nature by science. It developed during the industrial age: railways were seen as 'new fangled intruders' into the landscape. The poster shown alongside shows the area where Burns grew up and has the great man standing guard over his beloved Ayrshire. As well as his original works, Burns collected folk songs from all over Scotland and reworked them into his writings. His poem and song *'Auld Lang Syne'* is sung throughout the world at the close of each year, and his other famous song *'Scots Wha Hae'* served for many years as the unofficial anthem for Scotland. He was the eldest of seven children and his real family name was Burness (which he kept until 1786). The house shown in the next poster was built by his father William and it also acted as school, for all the Burness children were family-educated in their early years. His romantic side led him later to father children during different love affairs with several local women, much to the chagrin of the local Kirk Minister. In the 1770s and 1780s his writings became more expansive and prolific, before the combined volume (known as the *Kilmarnock Volume*) appeared in 1786.

It was an immediate success and Burns was invited to Edinburgh to prepare a revised edition. He had finally achieved the pinnacle of literary recognition and success, and was invited to many aristocratic gatherings. At one of these he met a 16-year old Walter Scott, who later heaped great praise on this most gifted of writers. It was in Edinburgh that the development of the *Kilmarnock Editions* was sponsored by the Freemasons Society, and this in turn led to the spreading of the word around Scotland and beyond. He was inducted into the Masons and became Senior Warden in Dumfries and Royal Arch Mason in Berwickshire. His health began to fail when he was only in his 30s, and as this deteriorated, he aged rapidly. His intemperance no doubt aggravated his weakened heart condition, but it was a blood infection caused by a 'botched' dental extraction that finally caused his demise. He died in Dumfries at the early age of 37 – a very sad loss to Scottish literature and the arts. His name lives on in Burns Night, in town names and on locomotives, both steam and modern traction. He really was a 'larger than life' character!

THE BIRTHPLACE of ROBERT BURNS
ALLOWAY – AYRSHIRE
by Norman Wilkinson R·I

LMS LNER

Poster Issued in 1930 by the LMS/LNER to Commemorate the Birthplace in Ayrshire of Robert Burns: Artist Norman Wilkinson

1959 Poster Issued by BR (ScR) to Commemorate Burns Birthday: Artist W.C. Nicolson

The poster above was commissioned by BR in 1958 to celebrate the 200th anniversary of Burns' birthday. It features many of the important people in his life, and the places most associated with the great poet. Jean Armour, first his mistress and later his wife, is in the bottom left, with Tam O' Shanter (seated) also in the front. The small map in the bottom right corner highlights all the places where Burns spent most of his short life.

The poster alongside by Jack Merriott shows the bridge made famous in Burns' poem *'Tam O' Shanter'*. The stone arch is late mediaeval, and lies within the Burns National Heritage Park, about three miles from Ayr. The bridge is used in the climax of the poem as Tam's mare, Meg, makes her bid for freedom, leaving her tail in the hands of Nan the Witch (shown in the top right corner of the poster above). The artwork and wonderful composition in this poster makes it as collectible now as Burns' poems were in their day. It is now time to leave this part of Scotland and move south again.

Evocative 1952 BR (ScR) Poster for Central Ayrshire: Artist Jack Merriott

Back to the Coast and into Wigtownshire

South of Ayrshire is the former County of Wigtownshire (now part of Dumfries and Galloway). These lands are the southernmost extremities of Scotland, with Newcastle and all of Northumberland in England being further north. The county town of Wigtown must have special mention. This most unusual location for literary work has more than 30 book-related businesses, and contains the largest second-hand bookshop outside Edinburgh. There are printers, binders and publishing businesses here. For those interested in collecting antiquarian and rare works, go to Wigtown and browse through the many bookshops. Nearby is another place for Scotland's favourite tipple, the Bladnoch Distillery. This is a small but very traditional farm-based distillery, dating from 1817 and founded by the McCelland family. It used to be part of the Bell Group, but is today privately owned and is Scotland's southernmost distillery. I can personally vouch for the taste of its brew!

Sadly, the county is often seen far too fleetingly, by passengers on their way to the ferry at Stranraer. This is a major port for boats to Northern Ireland and our next poster, dating from the 1960s, shows the ferry being loaded in preparation for the next crossing. Though always a port, because of the sheltered location, the first real harbour was built around 1700. It developed steadily but when the railway arrived in 1861, development was more rapid. A year later the railway was extended right to the quayside and Stranraer's future was assured. The *Caledonian Princess* shown here was built in 1961 by William Debby of Dumbarton. In 1967 it was acquired by BR. At 3650 tons and more than 350ft long (100m), it served the route for many years.

1964 Joint BR/Caledonian Steamship Company Poster of the Stranraer Ferry: Artist Johnson

FISHING IN NEW GALLOWAY
BY NORMAN WILKINSON R.I.

LMS SCOTLAND for HOLIDAYS **LNER**

A WEEKLY HOLIDAY SEASON TICKET. FIRST CLASS 12/6 THIRD CLASS 7/6
IS AVAILABLE IN THIS DISTRICT DURING THE SEASON

1927 Joint Poster Issued by the LMS for the Tranquillity that is Kirkcudbrightshire: Artist Norman Wilkinson

From Stranraer we are now back on the train and travelling eastwards. No time to look at the beauty spots of Luce Bay and Wigtown Bay as we roar through Newton Stewart and on into Kirkcudbrightshire. We are now in the area known as Galloway, with lush green fields and rolling hills stretching northward to the high peak at the Rhines of Kells. Here are small lochs, the best named being Clatteringshaws Loch, where the Galloway Dee enters from Loch Dee and leaves from the south. This superb fishing river is the subject of the next poster, another wonderful rendition from the brush of Norman Wilkinson.

This is where we find our tranquillity, with miles of solitude and only the sound of fast-flowing water for company. A lone fisherman is trying his luck today in the section around Loch Ken, where the Waters of Ken meet the Dee. Wilkinson's skill as a marine artist is evident in this 1927 picture of New Galloway. The combined length of these rivers is more than 50 miles (80 kms), but the Dee was dammed around the time this picture was produced at Tongland, 2 miles (3km) upriver from Kirkcudbright, as part of the Galloway Hydro Project. Here was also the site of one of Thomas Telford's bridges, constructed in 1806. Throughout this series of books we will see examples of his bridgework everywhere.

Tranquil Dumfries and Galloway

We have now entered the quiet final phase of the Scottish sojourn, in deepest Dumfries and Galloway. In former times, before people 'tinkered' with the county boundaries, Galloway covered just the eastern part of Wigtownshire and the western half of Kirkcudbrightshire. The current name includes all the former south-west counties of Scotland, with the exception of Ayrshire. As names go it is infinitely better than Highland or Strathclyde. Some of the older Scottish names were quite romantic.

Historically Galloway has been famous for horse and cattle breeding. One of the well known breeds of cattle is the Galloway, a black hornless breed that produces wonderful steak! The area is ideal for grazing, with rolling hills punctuated by rivers rushing down the mountainsides in the north, and flowing gracefully across the plains to the south. This is beautifully captured in the first of two posters in the final part of this chapter from Charles Oppenheimer.

The scene is probably north of Castle Douglas and looking north towards New Galloway and the Southern Uplands. (It is remarkably reminiscent of my beloved Malvern Hills, viewed from Tirley Knowle). This is the area where the railway runs across to Stranraer, so imagine the stunning views from the carriage windows in former times. This landscape contrasts markedly with the Torridon Hills or the Grampians to the north; it is lush and soft, a most beautiful part of Scotland. For those who like walking and hiking it is almost perfect, especially in Annandale, Eskdale or the area north of Dalry, and known as the Glenkens.

Tranquil Galloway in South West Scotland: BR (ScR) 1950 Poster: Artist Charles Oppenheimer

Northern Kirkcudbrightshire is quite rugged with the peaks of Corsebrine (2669 ft – 815m) and Cairnsmore (2612 ft - 795m) dominating the area. This is depicted in yet another of Wilkinson's lovely Scottish posters. He was most prolific as the leading LMS artist, and as the railway was keen to promote Scotland, he naturally figures highly in this volume. The Galloway Hills north of Dalry are beautifully painted here in the late autumn sunshine. Below is a small section to show Wilkinson's minimalist use of colour for the most dramatic section.

Leaving the train at Dalbeattie, we travel south a short distance to the Solway Firth, or more correctly the small inlet known as Rough Firth. Here is the pretty village of Kippford, superbly captured by Charles Oppenheimer in his 1948 quad royal poster on the next page. Rather interestingly, this was one of the first posters issued by the newly formed Scottish Region of British Railways. It is a surprising choice given the status and history of Edinburgh, but maybe it had been painted a little earlier and intended to be used. The poster has us on the east coast of the Firth looking south. The style and colour usage is stunning and epitomises the tranquillity we have been seeking in this last section of our Scottish journey. The Kirkcudbright coastline is rocky and indented by numerous estuaries, such as at Kippford. Harbours are often shallow, and large stretches of sand are exposed at low tide. These tidal flows are rapid and quite dangerous, but fascinating to watch.

LMS GALLOWAY
THE SOUTHERN HIGHLANDS OF SCOTLAND.
BY NORMAN WILKINSON.

The Southern 'Highlands' in Kirkcudbrightshire as Published in the 1924 LMS Poster; Artist Norman Wilkinson

Magnificent 1948 BR (ScR) Poster for Kippford on the Solway Coast: Artist Charles Oppenheimer

From Kirkcudbrightshire the railway crosses into Dumfries-shire at Maxwelltown, just west of the county town (though in reality it is a suburb of Dumfries). Alighting from the train, it is a five mile (8km) journey to New Abbey south of Dumfries. Here we find the remains of Sweetheart Abbey, captured lovingly in the poster alongside. These are the remains of a late 13th century abbey, founded by the Lady of Galloway, Dervorgilla. Her husband (Lord John Balliol) is far better remembered in academic circles than she is, because an Oxford College is named in his memory. The tale of their love is the story of the abbey itself.

When Balliol died in 1268, Dervorgilla was heartbroken. She had his heart embalmed and it stayed with her until her death in 1289. However, some 16 years prior, she founded the abbey in his memory and both she and Balliol's heart are buried together in the Presbytery. Because of her devotion, the monks there named it *'Dulce Cor'* – Sweetheart, as it is a never-ending testimony to human love. The setting is equally appealing, nestling as it does below the bulk of Criffell and the waters of the Solway Firth. The abbey is made from sandstone, and Wilkinson's poster captures it basking in the late afternoon sunshine.

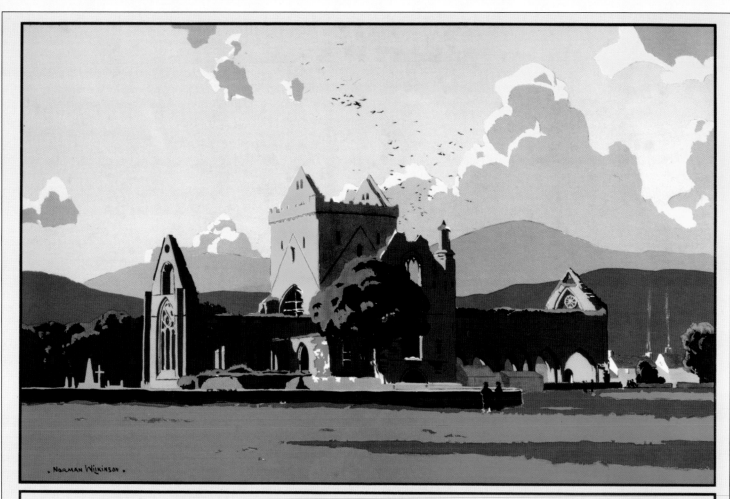

NORMAN WILKINSON, R.I.

Sweetheart Abbey owes its name to the immortal devotion of the Lady Devorgilla, heiress to the ancient Lords of Galloway, for her husband John de Baliol, founder of Baliol College, Oxford. After his death, his heart, enclosed in a silver and ebony casket, lay in a recess above the high altar in the Abbey until at her death it was buried with her. Sweetheart Abbey is near Maxwelltown, in Dumfriesshire, and originally housed the Cistercians. The principal ruins comprise portions of the church, and, some little distance away, the Abbot's Tower.

LMS

SWEETHEART ABBEY

Another Masterpiece of a Famous Border Abbey – Sweetheart Abbey, Dumfries-shire: Artist Norman Wilkinson

The Reformation of 1560 saw an end to the Abbey as a place of religion and worship. By 1600 the whole place was empty and derelict. Over the next 50 years stones from here were used in local village dwellings. In 1779 local people found money to conserve what was left and today it is looked after by Historic Scotland. It is a truly peaceful and tranquil place.

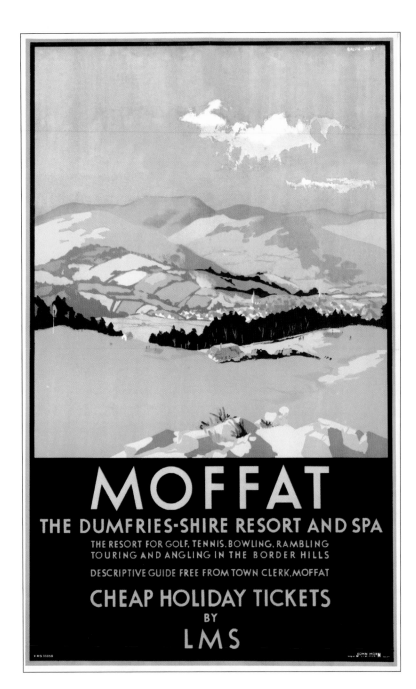

1930 LMS Poster for the Spa Resort of Moffat: Artist Ralph Mott (1888-1959)

From Dumfries we travel northwards again via the branch line to Lockerbie and then the main line towards Glasgow. Moffat is <u>THE</u> Spa and Resort town for the County. Dumfries-shire is the eighth largest county in Scotland (680,240 acres - 2750 sq. km.), but is sparsely populated at under 75,000 people. Moffat itself is a most attractive border town and is considered by many to be the real Gateway to Scotland. It is strategically located in Annandale, the main route from England to the north, and also benefitted from the discovery in the 1630s of sulphurous springs with healing waters. The West Coast Main Line (WCML) was built just two miles to the west through Beattock as early as 1848, but it was another 25 years before the branch line to Moffat appeared, so Victorians could partake of those healing waters. The station there was one Beeching did not have to cull. By 1954 it was already closed.

This poster comes from the prolific studio of Ralph & Mott. This was a firm of artists' agents led by Ralph Mott himself. They used to hire artists to do contract work as required by the various railway companies, but this is an example of Mott's own work. The lovely setting of the town is clearly evident. But it is the waters that attracted the visitors. Sulphurous springs were discovered at regular intervals, and one building that used to be a Spa is now the Town Hall! A large Hydrotherapy Hotel had opened five years before the station, but the railway really made the town. Sadly, a disastrous fire in 1921 put an end to the largest spa, and after that the place never really recovered. That was until the car arrived after WWII. Today this lovely little place is a great place to *'tarry a' while and tak' a few drams'*! This will be good training for the tours of Speyside and the Island distilleries.

Dumfries-shire is actually a surprising county. It has a very short coastline (just over 20 miles – 32 km), and the Southern uplands to the north gradually roll down southwards to the end of the Solway Firth. Most of the scenery is rolling hills and lush areas of farmland: it is great walking country. The county is crossed by three main rivers: the Nith, the Annan and the Esk. The valleys, named after the rivers, are the main routes through the Scottish Uplands that stretch from Kirkcudbrightshire in the west, through Selkirk and Peebles-shire, to Berwickshire in the east. They form a natural barrier to rail and road and some wonderful railway paintings have appeared of heavy express trains struggling up either side of the famous Beattock summit in Dumfries-shire. My own favourite railway painting of all comes from the wonderful brush of artist Norman Elford. It depicts Duchess 'City *of Carlisle'* on a southbound express making the grade up Beattock. This beautiful work appears on the imprint page at the front of this book. I watched him paint the nameplate in under a microscope with a single-bristle brush – incredible! One of the most famous sons of Dumfries-shire had a profound effect on transportation in the early Victorian era. The great engineer Thomas Telford was born in Westerkirk to the north of Langholm.

Back into England

We cross the border back into the *'Land o' the Auld Enemy'*. So far more than 270 works of art have been used to illustrate a beautiful and historic land. In the poster alongside, taking a break in our 'umpteenth' round of golf, we look back across the Solway to see Criffell rising majestically in the background. On a summer's evening, gazing across the Solway Firth into Scotland is amazingly beautiful, especially as the light begins to fade.

We may have reached the journey's end, but one final piece of artwork that links the nearby old City of Carlisle to the historic new City of Stirling is shown below. This is another of Maurice Grieffenhagen's knights, and this painting features on the famous poster we will see in Volume 3. Although these two posters are in England, they remind us of the things dear to Scotland: history, beauty and golf. After our long journey over eight chapters, the next and final chapter reviews general Scottish advertising, and looks at 100 years of Railway Companies attempts to get us to return.

Original 1924 Artwork for a Famous Border Poster: Artist Maurice Grieffenhagen

Looking Back into Scotland: 1930s LNER Poster: Artist H.G. Gawthorne

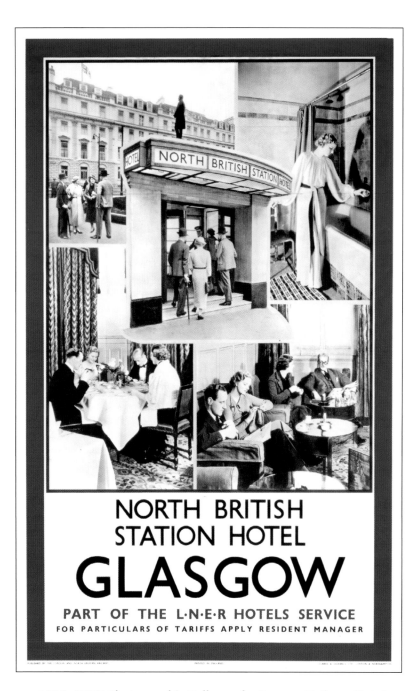

1930s LNER Photographic Collage of a Famous Railway Hotel

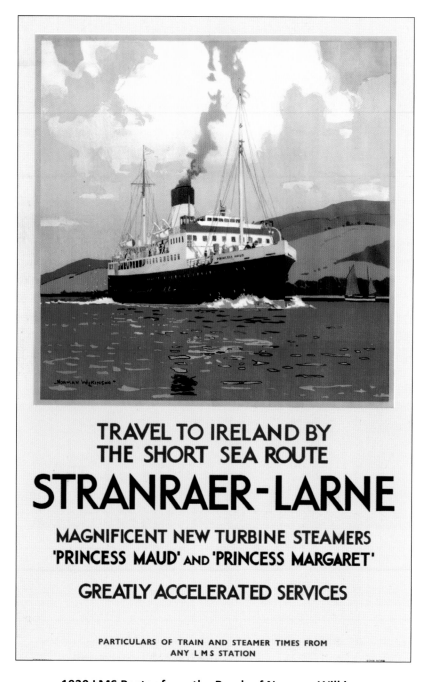

1930 LMS Poster from the Brush of Norman Wilkinson

Chapter 9 Will Ye No Come Back Again

Imagery and Inducement

The chapter title comes from a famous and well known Scottish song written by Lady Carolina Nairne in the first half of the 19th century. After the defeat of Bonnie Prince Charlie at Culloden, there were still many who hoped he would someday return, and in their minds, rightfully claim the Scottish crown. We can say the same thing about travellers returning again and again, because over the past 100 years, many poster adverts of a less visual and more mundane nature were produced by the various railway companies to entice us to return. Having used *'Poster to Poster'* in the previous eight chapters to take our journey, we can use this chapter to study the power of railway posters in more detail, and to examine some more of the images that were created at different times in railway marketing campaigns, with the emphasis being Scotland.

It was stated above that these images were generally less visual, but this first poster is far from that. It is a stunning example of the power of colourful and skillful poster art, using the historic crests of the two protagonists, who have battled each other over many centuries. So powerful is this image that I had, at one stage, considered using it on the cover, but to me it states more about history than railway transportation.

Posters are there to inform but, more importantly, to promote and publicize. They have three major weapons in their armoury: immediacy of impact, composition via colour and subject, and the ability to communicate in few (or no) words. It was solely the visual impact that gave the poster here the potential candidacy for the cover. The best posters are also bold and clear, yet subtle. Note the diagonal line between Kings Cross and Edinburgh Waverley. It is implied by colour and shading, but intermingled with the lions on both shields on the East Coast route only. The West Coast is mentioned, but in BR's time, their preferred route for us to travel between capitals was from Kings Cross. Euston is also tellingly placed second in the 'pecking order'.

The national base colour for England (the red from the cross of St. George) with the lions in gold is reversed for Scotland to match the ancient Scottish coat of arms from 1222, (see page 15). Parts of the shields are more ghostly and less dominant: but the message is precise. This is a wonderful example of imagery and inducement. Note also this was a BR poster and not from the so called 'Golden Age', illustrating that in its infant years, BR was a strong advocate of classical and artistic images. Spencer was one of the best artists to use heraldry in posters. (In Volume 2 we will see his superb poster for the City of York). The result is clear, simple, direct and bold: exactly right!

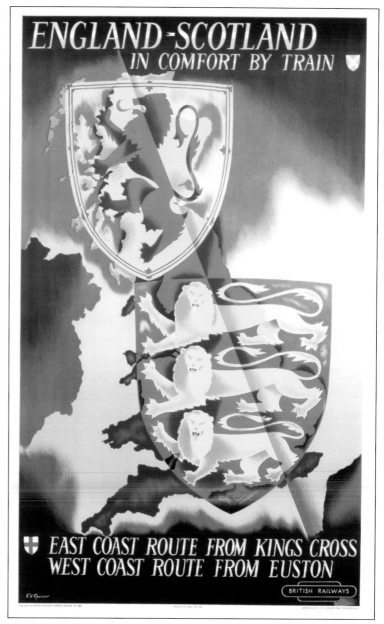

Magnificent 1952 BR (ER) Poster: Artist E.H. Spencer

The poster is meant to catch the eye, to implant seeds into the mind, and to persuade. We have been looking at travel inducement throughout the book, but just look at political or wartime posters to see that they carry a different message. When posters are put together the combined message is amplified. The picture below of the great entrance at Kings Cross shows six quad royal posters in a collage presenting a corporate image, places and information as a set of data. Those six large images means the poster board here is a massive 80" by 150" (2m x 3.75m) with the lovely LNER poster board above that. The whole effect is immediacy of impact and the collage on the next page shows how something like this would have looked using other LNER posters.

If we look at a dictionary, the poster is defined as: *A large sheet of paper announcing or advertising something for display in a public place* (Oxford American Dictionary 1st edition 1986). But it can also be defined as an interchange medium between what the artist has been told to produce and what the railway company wants the public to do. It is the ingenuity of the artist that gets the intended message across.

Poster Wall at Kings Cross Station London in the Late 1920s

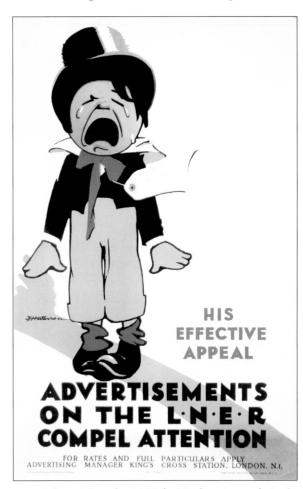

Late 1920s Poster Advertising the LNER's Market Appeal: Artist F.H. Warren

What is interesting in the photo above is the use of the LNER logo to represent the Forth Bridge in the poster shown in the lower centre of this picture. It has not turned up yet in the database, which illustrates that this first attempt at listing all the relevant posters is far from complete. In the many poster exhibitions that started in the 20s, collages and displays such as this were replicated in the studios and exhibition halls of the period.

One of the leading companies in the early days was the LNER and they even advertised their expertise to use this medium for effective marketing (above). On its own it draws the eye, but put colourful images around it, and the message changes: the boy's impact is lessened, as the next page shows. This is poster power: imagery and inducement.

Poster Collage from the 1930 Era Illustrating the Combined Power of Posters (All Posters from the NRM York or Onslows Poster Library)

In order for the poster impact to be increased, railway companies quickly learned that they had to 'mix and match' so that information, maps, destinations and other messages could reach the eye in a pleasing way. Posters had eventually started to appear aimed at every sector of society, and railways had to develop their own stamp of identity to be easily recognized. Logos appeared, slogans were used, and styles evolved so that in that fleeting instant, the message in the poster was already in the mind of its intended 'victim'. This led to standardization of the size of posters so that the collages of pages 188 and 189 could be used in railway entrance halls, on outside hoardings and in public places generally. There is nothing worse than a random collection of odd sized pictures for jarring on the brain. The posters had to be large enough to be effective and yet not too large, as the cost of printing from the original artwork became prohibitive. I suppose the companies looked at paintings and determined what aspect ratio was eye-catching. A 3ft by 2ft image in portrait format is almost ideal and so evolved the double royal (40" x 25" – 1015mm by 635mm) and its big brother the quad royal (40 "by 50" – 1015mm by 1270mm). This meant that posters of different sizes could be grouped together to give a larger visual effect, as on the previous page. But even when posters were the same size, putting them in sets, as opposed to single items, is far better. For Scotland there are instantly recognizable images completely unique to the country, as with the trio below.

The Marketing of Scotland

Throughout this volume, well over 300 images of Scotland are used. I suppose putting them together is almost the perfect way of showing everything that is Scottish. Just imagine the modern Kings Cross station concourse with a dazzling display of 20 quad royal images arranged in a four poster-high by five poster-wide array! I just wonder if today's railway companies would even consider this as a focused marketing campaign. Using some of the images from our National Heritage would be a wonderful way to promote tourism to Scotland and fill those trains. Go to Kings Cross today and the impact is not the same, and the thrill and romance of railway travel is definitely not the same. The railway companies could therefore go back to basics and market a country. But why not use a colourful map to do the same thing? We saw the map of Scotland on page 13, but BR did it just as well in the 1950s, with a quite stunning map of the area highlighted at the end of Chapter 7 and the start of Chapter 8. Do we see this today – NO!

The Marketing of Scotland in Three Simple Posters

Here the pipes, the tartan and a golf course leave the tourist in no doubt about the destination. Even the lady who is not playing is wearing tartan, so any of these on their own is also Scotland, but put them together and they shout Scotland, irrespective of the words or language used.

1955 BR Poster of the Features of a Beautiful Area: Artist W.C Nicolson

In order to understand why areas, cities and places were marketed, we should go back to basics. Marketing is defined as *"Attendance upon a market: the business of selling goods and services, including advertising, packaging and promotion"*. This literal definition shows that focus and attention to detail is a fundamental part of good marketing. The expectation of the customer must be identified, met and matched. At the time railways were developing, Britain was industrialising. Life was hard and fortunes were made on the backs of mass labour. Those workers who toiled, needed (and really earned) their holidays from time to time. As mass transit systems had developed, so that most places were linked to the industrial centres, it was natural to use the newly refined advertising techniques in a focused way.

A strong poster-led marketing strategy is at its most effective when it is an integral part of a corporate strategy. It must show its customers (and prospective customers) how the Company has advantages over competitors, its services and a clear statement of its intent to gain trust (and therefore sales). The railways used high powered selling to gain mass low cost volume sales – they filled as many trains as they could as quickly as they could. The use of key slogans (*"It's Quicker by Rail"*) allowed a branding image to be established and to show a certain market dominance. The many small railway companies at the end of the Victorian era did not have the vision or finance to put in place an effective marketing strategy, but when the 'Big Four' were established, all the rules changed.

For Scotland, the LNER and the LMS went 'head-to head' initially, before realising co-operation could be beneficial to both parties. The six posters here show confrontation (top) in the 1920s, and then the co-operation (bottom) of the 30s, when it came to marketing Scottish travel.

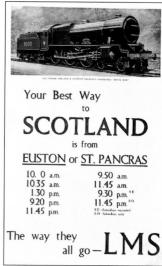

Confrontational 20s and 30s Marketing Between the LMS and LNER: Both Claimed the Quickest & Shortest Routes!

Late 30s Co-operative Marketing of Scotland: Image Interest, Colour and Stimulus Become More Important.

When formed, the LMS inherited many small companies and no clear publicity image, so it had to create one. Norman Wilkinson had been used by the LNWR, and he had a major voice in most planned advertising campaigns that used posters. It was decided to use Royal Academicians as the front line of attack, depicting industries as well as places, to show an all-round LMS service. The two quad royals alongside are examples for Scotland. They depict the huge steelworks at Motherwell, and Cameron's moody painting of the Highlands. Both are powerful works of art and both show the LMS commitment to the arts, but did they really stimulate train-filling? The industrial posters were successful in attracting freight customers, but posters of the type below, depict a rather old-fashioned locomotive in relation to the main rival on the East Coast. The early LMS strategy for Scotland seemed to be places, people and industry in almost equal measures.

Two Early LMS Posters from the Royal Academicians' Series of 1923

Promoting LMS Services in the 1920s: Artist Norman Wilkinson (1878-1971)

In contrast, the LNER was more artistically aware and had employed well known artists of the time, plus some very good and creative young talent. Their publicity office tended to focus for the entire 1923-1947 period on the speed and comfort of its long distance expresses, plus the fact that their restaurant cars and customer support were better than all the rest. They tended to stress the enjoyment of the journey and gave travellers a lot of information about the destination. They even offered for sale copies of the more visually stimulating images (such as the Marfurt image alongside or stunning views of mountains and lochs, of the type shown throughout this volume). The two images shown here were produced in the LNER's truly 'golden patch'. The Night Scotsman highlights the straight-line, comfortable journey by night, with the Flying Scotsman complementing it by day. The LNER had developed wonderful express locomotives such as the 'A3 class', and one engine from the class *"Flying Scotsman"*, became an icon of the time for Scottish rail travel. It is still a very famous engine.

Magnificent 1928 LNER Poster for a Marvellous Train Service: Artist Leo Marfurt

The wonderful piece of poster art shown above is, for me, one of the best posters produced to advertise general rail travel. The *Flying Scotsman* service had started in 1862 when the three main route companies (The Great Northern, The North Eastern and The North British) pooled stock to produce a through service to the north. It ran between the two capitals, taking 10 ¼ hours, including a lengthy stop at York for lunch! However Nigel Gresley designed a locomotive to make the 392-mile (630 kms) journey non-stop in 7 ½ hrs (a 9 ton tender of coal and numerous water trough pick-ups allowed this). This poster was designed to give an artistic stimulus to the service and it worked. They had first grade food, a barber shop and a dependable timetable. It was the forerunner of the *Coronation* (see page 18), and the geography of the line was responsible later for the East Coast electrification scheme to slash journey times. Using posters such as these, plus some beautiful destination posters, was the LNER's strategy, along with their obvious engineering prowess in locomotive design, to woo the punters – superb!

The Classic 1932 Poster for the Scotland Sleeper Service: Artist Robert Bartlett

The *Flying Scotsman* is a jewel for advertising, and has featured on many LNER, BR and now modern era posters. The service from Kings Cross to Edinburgh began in 1862 and is today run by National Express East Coast – which doesn't sound right somehow. It enabled the LNER to really build a powerful advertising model, a service that the rival LMS aspired to, but never quite reached. The *Royal Scot* was famous, but the *Flying Scotsman* was 'Premier League'. Even when diesel hauled, the poster was evocative, as illustrated below. Alongside is a BR poster for the service extension to Aberdeen.

1962 Posters for Scottish Diesel Travel: Artist R. Bagley (L) and Anon (R)

The iconic nature of the service was always going to bring out equally iconic posters, and the LNER produced some beauties. The double royal poster alongside has superb style, colouring and composition, almost reminiscent of a winged mythological creature. Note the LNER fish-eye logo embedded in the wing. This dates the poster from the 1930s. The artist is Freiwirth, about whom little has been found so far. There are three of his posters in the National Collection, of which this is by far the best.

Iconic 1930s Poster for the Flying Scotsman: Artist Freiwirth

The LMS tried to counter with the Royal Scot service. This left London at 10 am each day (as with the Flying Scotsman) and the service began in June 1862 (as with the Flying Scotsman). In 1933, The *Princess Royal* class was specifically designed by William Stanier to take a full load of 500 tons the full 400 miles (640 kms) non-stop, and for a time the LMS had an edge. They hadn't reckoned with Gresley and his streamlining, even though initially such A4s were only used on the *Coronation*. Before 1933, the Royal Scot was hauled by smaller locomotives that required both crew and engine changes. The poster below shows how the LMS approached advertising the journey to Scotland around the time the famous streamliners appeared. This poster artwork has appeared at different times and with different captions. Bryan de Grineau's artwork and brilliant colour palette is absolutely first class. Also on this page is the LNERs advertisement for the new streamliners that appeared at the same time: quite a difference in style and impact.

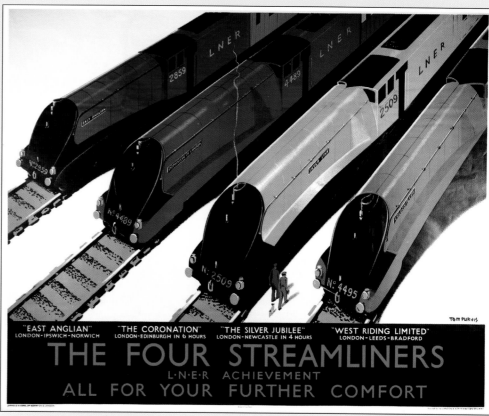

Classic 1937 Poster for the Streamline Service to Scotland: Artist Tom Purvis (1888-1959)

1937 LMS Poster for the Royal Scot Service to Scotland: Artist Bryan de Grineau

When the A4s appeared on the crack Scottish expresses, interest rocketed. The Kings Cross to Waverley journey has always been popular, especially when corridor tenders were introduced that allowed non-stop running. The 392 miles (630 kms) between stations was eaten up by Nigel's Gresley's superb engines. Even before the streamlined A4s, shown in the poster above, had been designed, his A1s and A3s were the stars of the north-south route. They were not the most powerful engines (the GWR King class held that distinction) but boy did they look good, flying along the straight tracks of the East Coast Main Line. Many were appropriately named after thoroughbred racehorses – perfect! The streamlined service advertised above began in 1937 and running times were cut to around seven hours. The regular engine from Kings Cross was 4492 ("*Dominion of New Zealand*"), whilst classmates "*Falcon*" and "*Kestrel*" were shedded at Haymarket for the southern trips. It was the beginning of a magical time for railways, and I really wish I had been there to take the journey.

The Night Scotsman had always been popular for both businessmen and tourists alike. It generated so much passenger traffic that often a relief train was used a short time after the published time. The official naming took place in 1927 and headboards were carried from 1932. Imagine leaving Kings Cross and sitting in the cocktail bar enjoying a 'wee dram' to give a taste of what was to come. The day-time Flying Scotsman also had a famous cocktail bar, the subject of the lovely 'art deco' poster alongside.

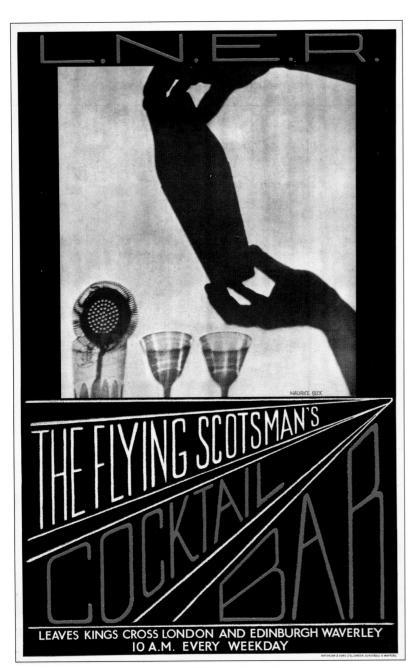

Drinking on the Train: Lovely 1930s Art Deco Poster by Maurice Beck

The Superb Alexeieff Poster from 1932 Advertising the Scottish Sleeper Service

The poster above is a quite wonderful example of commercial art. The way Alexeieff has composed and coloured the work is ethereal, yet bold at the same time. Although the poster says departure at 10.25 p.m., the two trains actually left at 10.15 and 10.30 p.m. The first went north of Edinburgh to Dundee and Aberdeen, whilst the relief went as far as Edinburgh. The trains regularly had 14 or more coaches and over half were sleeping cars; a nice lucrative business for the LNER!

Advertising Scotland in an Unusual Way

Throughout the book we have seen many classical pieces of artwork, showing places and buildings to induce the traveller. However it was not always the classical poster that caught the eye, and in this section some of the more unusual productions are shown. W.M. Teasdale, who was the LNER's brilliant Advertising Manager, had an eye for the modernistic approach, as we have seen with many of the 1920s and 30s posters in this chapter. He had high aspirations and goals, and his choice of artists for the early years was inspirational. Cooper, Mason, Newbould, Purvis and Taylor were among them and time was to show these five became the backbone of the LNR publicity machine using poster art. Many of their images feature in this Scottish book and more will be seen in the regional volumes that follow. By 1926, the LNER was the clear leader of the 'Big Four' companies in poster art. The LNER also came up with sets of posters showing east coast, harbours, people and occupations. The two below from the 'East Coast Types' series painted by Newbould and issued in 1931, depict the Scottish Fisher Lass and The Scottish Fishwife.

Unusual Scottish Posters: 1931 East Coast Types Series by Frank Newbould

BEAUTY ABIDES, NOR SUFFERS MORTAL CHANGE

Unusual LMS Poster Advertising Historic and Beautiful Scotland: Artist Claude Buckle

The LMS had opted for an artistic approach and above is a collage of Scottish historical figures set against the Highland landscape. All the posters on this page seem strange choices, but it was again the LNER images that seemed to make their mark, and even today, seem visually more stimulating (as well as collectible). The original artwork on all these three posters is exquisite; the LNER posters are stylised, crisp and vibrant; the Claude Buckle poster is detailed and quite beautifully painted. They sum up the major differences in the 1930s.

Even before these times of rivalry, some quite unusual posters appeared. The next quad royal is more letter press than colourful poster, but being so large, its intent was to show the progress of travel to Scotland since the days of regular railway services. The comparison in the Edwardian era with coaching times on the East Coast route by the big three companies of the time makes fascinating reading.

EAST COAST ROUTE
A CONTRAST

YORK Four Days Stage-Coach.

Begins on Friday the 12th of April 1706.

ALL that are desirous to pass from *London* to *York* or from *York* to *London* or any other Place on that Road; Let them Repair to the *Black Swan* in *Holbourn* in *London* and to the *Black Swan* in *Conny Street* in *York*.

At both which Places they may be received in a Stage-Coach every *Monday, Wednesday* and *Friday* which performs the whole Journey in Four Days *(if God permits)* And sets forth at Five in the Morning

And returns from *York* to *Stamford* in two days and from *Stamford* by *Huntingdon* to *London* in two days more And the like *Stages* on their return.

Allowing each Passenger 14 lb weight and all above 3d a Pound

Performed By { *Benjamin Kingman Henry Harrison Walter Baynes* }

Also this gives Notice that Newcastle Stage Coach sets out from York every Monday, and Friday, and from Newcastle every Monday, and Friday.

YORK COACHING DAYS
Fac-simile of the Coaching Notice in **1706**

LONDON and EDINBURGH
Daily train Service

ALL that are desirous to pass from *London* to *Edinburgh* or from *Edinburgh* to *London* or any other Place on that Road; Let them repair to the *Kings Cross Station* of the *Great Northern Railway* in *London*, and the *Waverley Station* of the *North British Railway* in *Edinburgh*.

At both which places they may be received in well appointed express trains With Luncheon and Dining Cars in the Day Time and Sleeping Cars at Night, which perform the whole Journey in SEVEN and THREE QUARTER HOURS; And set forth at Convenient times in the Morning and in the Afternoon and at Night.

And run from *London* to *York* in Three Hours and Thirty Five Minutes, And from *York* to *Edinburgh* in four Hours and Ten Minutes more. And the like Stages on their return.

Performed By { *Great Northern Railway North Eastern Railway North British Railway* }

1914

Railways Compared to Stage-coaches: An Unusual Inducement to Travel!

The three railway companies listed here (GNR, NER and the NBR) had been the first group to collaborate as an alternative to the powerful Midland Railway on the western side. This poster appeared just as the dark clouds of WWI were looming, and to a large extent went against the trend of colour usage, visual impact and artists' involvement. Since Hassall and the days of Frank Pick, posters had developed well, so this really is an unusual way to promote Scottish travel. What I like in this poster is *'Ye Olde Englifh'*. *"All those that are desirous to pass from London to Edinburgh ... let them repair to the Kings Crofs station of the GNR"*. This Shakespearian-type call to travel does not appear on any other poster (or anything even close to it for that matter). Just to have the passengers stop and read the words and marvel at the style will bring a wry smile or two – and maybe another few passengers. Here colour and pictures would detract. This is a poster in the old style but with a new message. This poster does not feature very often in auctions (from surveying very many catalogues) but is a real collectors' piece.

But unusual posters for Scottish travel still appear occasionally, and the two below particularly caught my eye. These modern-day images use pyjamas and party frivolity to promote travel to Scotland. The left hand poster below is from the 1970s (the high point of Inter-City) and the right hand one was published by ScotRail, who throughout the 80s and 90s really established themselves as the best user of posters for rail travel. Some of their images are worthy of more space in this volume, but I will return to Scotrail in Volume 7 where general poster advertising is studied in more depth.

The pyjamas poster is actually quite cleverly done. The inducement for me is the 'wee dram' shown in the centre of the image. This is one of the real joys of rail travel: why drive to Scotland when the train can take the strain? I have used sleeper trains several times, and good they are too, especially if you do not want the hassle of airport security. From London to Edinburgh or Glasgow, the train really is best! The right hand image I love. Having the guard lead out the Hogmanay revellers from a party train is just great modern advertising. You have to stop and smile when such large and colourful images are in front of you; well done ScotRail!

Modern Images Promoting Scotland: Pyjamas and Hogmanay - an Interesting Mixture!

Wonderful LMS Poster from 1924 Showing One of the Joys of Scotland: Grouse Shooting in the Highlands: Artist Ronald Gray

Grouse shooting is also typically associated with Scotland and two posters have been produced promoting this aspect of Scottish life. The poster on the previous page is pure LMS 1920s. It was painted when artists held sway, at the time when Norman Wilkinson had maximum persuasive powers within the LMS Publicity department. It shows the arrival of the express from London (Euston or St. Pancras). The grouse shooting season runs from 12th August to 10th December and, as the quarry is endemic to the British Isles only, shoots are usually organised and controlled. The wonderful Ronald Gray poster shows the social nature of the sport, with everything (plus the kitchen sink) being taken by train to Perthshire.

As the mascot of the Scottish Rugby team and an emblem of a famous brand of whisky, the grouse could be thought of as a purely Scottish resident, but reference to the RSPB website shows this is far from the truth. The Pennines, the hills of the Lake District, the Brecon Beacons, parts of Snowdonia and other similar areas are home to grouse. They are more likely to be found in heather covered moorland, where their colouring and plumage gives them added camouflage and protection. The poster on this page from Verney Danvers is one of a series he painted of birds for the LNER in 1925. This one has not been published before, though others from the series have previously appeared.

But why is grouse shooting so popular and so much a part of the Scottish calendar? The answer lies in its ability to fly and accelerate very quickly. It therefore represents the pinnacle of sports shooting. Imagine having to hit a target moving at around 80 miles per hour, either towards or away from you, and at varying and random heights. Clay shooting by comparison is far less taxing. Paradoxically, it is controlled shooting that has ensured their survival, as the moorland habitat is slowly eroded by man's intervention. If during the off season, the population does not come up to a certain density, shooting is suspended. The weak are usually killed first (easier targets) and the number taken per driven beat is also controlled. If you have never tasted grouse, try it; the meat has an excellent flavour. Cooked the traditional Scottish way and washed down with wonder brews (before and after), you have the essence of Scotland.

Returning to these two examples shows the power of posters. They would of course be seasonal and would have appeared in selected locations. They too rarely appear in auction, and when they do, the competition is fierce. Both are unusual, and with the Danvers on this page, notice also the way the artist signed it. Both the style of the picture and the signature exhibit a Chinese-type quality: I wonder if that was the intention? It is what posters should be all about: simple, bold and direct imagery.

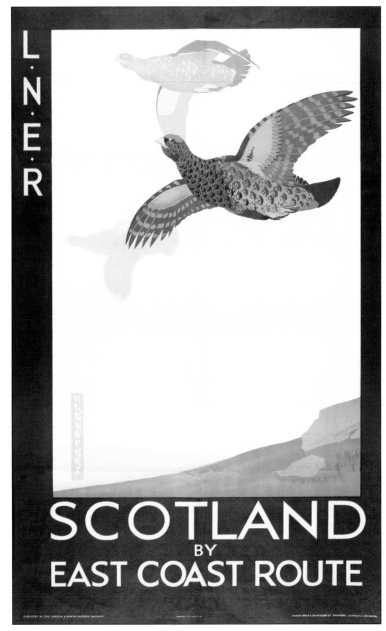

1925 LNER Poster for Scotland in August: Artist Verney L. Danvers

Some of the contemporary posters have gone back to the true intention, to capture attention quickly, and to form a judgement in the customer's mind quickly: *I would like to go there*. I have been looking at late 1990s and early 21st century images and they do seem to be improving. Sometimes real paintings appear in some of the regional posters. The art of marketing was excellent in the 20s through to the early 60s, but this was at a time when world events, business needs and financial systems did not influence travel, as they do today. Few of the Publicity Departments at the BR Regional Centres showed real initiative, preferring instead to follow rather bland and sometimes rather tasteless decisions made at Head Office. I am slowly going through the hundreds of 1970s and 80s posters held at York, and most of these will not make it into this series of books.

Happily the one alongside, which was issued as a double crown size by BR in 1980, was taken from an earlier work. The vibrant poster artwork is spoilt somewhat by the bland top and bottom area, and an ineffectual message. This poster shouts Scotland and what better image to promote the August Festival or a visit to the games at Braemar or Dunoon. Was it used this way – probably not? It is fine to have unusual images, but sometimes a traditional one used in an unusual way has a far greater impact.

For me the 1996 campaign by ScotRail had things right. Here were traditional Scottish scenes, but with modern and punchy messages. Some have appeared earlier and I make no apology for including another below. The reference to the M8, clogged with traffic is excellent marketing, and by the way, a visit to Pitlochry really is recommended.

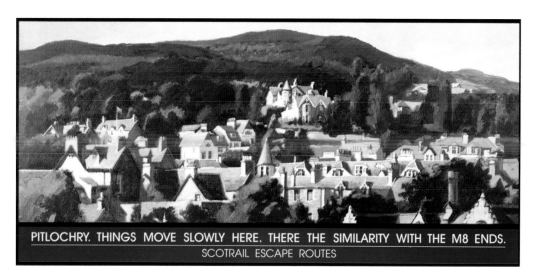

1996 ScotRail Poster Advertising the Tranquillity of Pitlochry

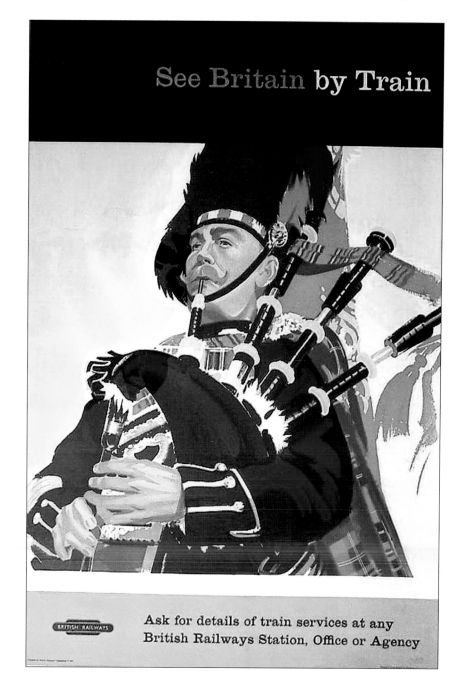

Double Crown BR Poster from 1980: Pure Scotland but Poor Messaging

Speed to the North in Comfort

The journey to Scotland, whether by East or West Coast Mainline routes, has always produced poster advertisements about speed and comfort. From the very early times, the best way to attract passengers was with the promise of a comfortable and speedy journey. Edwardian posters began this theme, and it is still used by the present-day operators. Going back to the days of the rivalry, it is not certain who fired the first shots. What happened as a result, however, was a bitter campaign that lasted 25 years. Right at the start of LMS days, when they had duplicate routes on the western side, both were the best!

 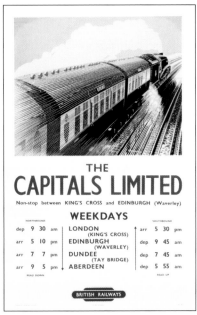

Speed and Comfort Advertisements for the Early 20th Century

Collaboration produced some of the posters shown earlier, and when BR took over in the late 40s, the message was harmonized, ushering in the era of 'The Corporate Message'. Look at the four express poster adverts alongside. Great Eastern blue is used for Kings-Cross to Edinburgh and LMS red is used for Euston to Glasgow. The posters give train times and let the passenger decide. Functionality was the order of the day, but the artwork by Wolstenholme was actually very good and really rather wasted here.

Four BR Posters by A.N. Wolstenholme Advertising Crack Scottish Expresses

Once British Railways had completed their first 15 years or so, the first winds of change began to appear. It was almost as if the older guard slowly retired, and new ideas and fresh marketing vision took over. The locomotives, stations and other images were looking tired, so out went the Scottish Region and all aspects associated with the protectionist past, and in came new slogans, new campaigns and indeed a complete organisational overhaul. The aim was still the same, namely to fill trains and make money, but sadly the train era had already peaked, and the age of the car and the package holiday was here. Railway companies really had to come up with new strategies. Graphics design houses and artistic directors started to take more central roles in advertising campaigns, not just in railways, but in every aspect of marketing.

By the 1970s, creative teams were standard and colour photography was taking advertising generally in many diverse directions. These could be combined, so that instead of trying to get people to abandon their cars, why not include them. The poster alongside from 1978 shows one of the many posters from Motorail, formed to forge the bond between road and rail travel. For the many people who used to travel from the south of England to visit Scotland, this was a great solution. They could miss some of the new bottlenecks created by the fledgling motorway network, and arrive refreshed in Edinburgh or Glasgow to start their holiday. Here was the new speedy and relaxing way to go north.

In the 1980s advertising boomed in all sectors, and some of the advertising agencies grew rapidly on the back of a huge commercial awareness bubble; and as with today's 'credit crunch', some over expanded and fell by the wayside. What was clear was the widespread use of photography either as single images or in collages. British Railways was in fact one of the first public companies to use collages. The poster of Berwick-upon-Tweed on page 16 is an early example, and the pyjamas poster on page 197 a much later but more effective use of this technique. As with many poster campaigns, it is not the image but the way the image is combined with the message that makes for a good poster. The image grabs the attention first and the message should be sharp and punchy for effective market penetration. The poster alongside had a great message to give, but the way it is given gets a generous five out of ten: Inter-City could have done better! The best campaigns to sell the product always have key slogans or unforgettable images. This one has neither.

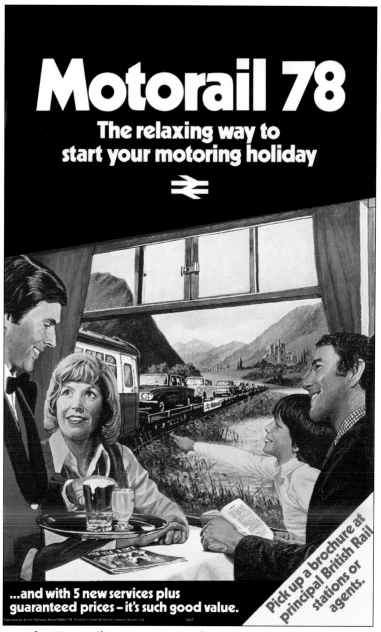

1978 Poster for Motorail Journeys to Scotland: Inter-City Poster: Unknown Artist

Poster campaigns should be colourful, witty, and clever, but above all carry a clear and memorable punch-line. Look at the example alongside from the mid 1960s. The expressions on the 'Popeye-type' characters reinforce the written message of 'rail over road'. Compare this with the previous Motorail ad, and the clarity and directness of poster campaigns is never more sharply contrasted. Today graphic artists, photographers and computer image wizards are the new artists of the poster world. It is because of the new breed that some of the recent punchy posters really have changed the advertising landscape.

Posters are still an important ingredient of contemporary life, but in the railway area today, are not as important as they were. Poster hoardings around stations in the Edwardian period and early days of the House of Windsor (such as on page 188 for example) are not seen today. Since the world has become faster and smaller via the Internet and air travel, so in the railway world, posters have taken a lower profile than they used to. However, they can also cause conflict: some images appeal and others certainly do not. This has been the case since the Victorian Age. I contrast the cartoon-type poster alongside with the traditional way most of the railway poster collectors think of Scotland. It is amazing to think the poster below is almost 100 years old.

Pre WWI Poster for Travel to Scotland: Issued by North British Railway in 1912.

Literally thousands of British railway posters have been published and why was this? It is because some appeal and some do not; it is almost a love-hate type relationship, especially when listening to collectors' comments at railway or poster auctions: *"I don't like that"* or *"I would not have paid that for that poster"* are often heard. These are strong statements to match strong feelings about (usually) powerful images.

1960s Departure in Poster Advertising for Scotland

Closing Remarks

Whatever you feel about posters, they do represent a powerful visual medium for communication, and with respect to railway posters, they actually changed most of our seaside towns forever. I am not sure if the people of Saltcoats, Skegness or Southend would approve of this! The popularity of all types of posters, (railway or otherwise), with collectors shows no sign of diminishing, and hopefully this first volume contributes to a better understanding of Scottish posters throughout the 20th century. Whatever one's feelings, there is no denying that the poster is an integral part of the modern and ever-changing landscape.

I close our visit to Scotland with two contrasting images. Below we have the modern approach and alongside the classical approach. They show that both schools of marketing, when well executed, can have a profound influence to entice us to go back. The poster alongside was also a strong contender for the cover: Scottish counties showcased from a railway carriage. This was exactly the message required to match the title I had chosen. The artist, Abram Games, was an absolute master of poster art, as this image shows. We will see more of his iconic work in other Volumes. Below is another Scotrail poster from the 1990s. I just feel that this is excellent imagery and even better messaging: the very essence of a great poster. Enjoy Scotland everybody!

1996 ScotRail Poster Illustrating the Power of the Modern Poster

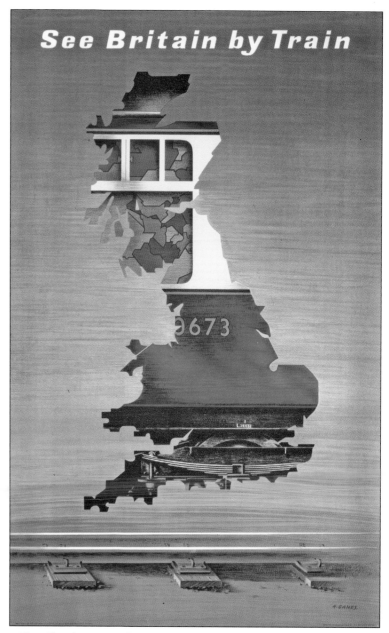

The Classic Poster for Travel to Scotland: Artist Abram Games

Classic Scottish Railway Posters: Argyllshire by Helen Mackenzie (left) and Perthshire by Kenneth Steel (right)

ARTIST PORTRAITS

Thumbnail sketches of the lives of the more important and influential poster artists who will appear throughout this series of books are given in this section. Greg Norden has been of great help in assisting with this. Data from his definitive book on carriage prints **"Landscapes under the Luggage Rack"** forms part of the information presented here (see page 236). Other information was received from many sources, via research at the NRM and on the Internet.

Adrian Paul Allinson (1890-1959)

He was born London 9/1/1890, the son of a doctor. He was educated Wycliffe & Wrekin College, Wellington, and studied art at the Slade School under Tonks, Steer, Brown and Russell from 1910-12, and won the Slade scholarship. Allinson worked for a time in Munich and then Paris. He was a teacher of painting and drawing at Westminster School of Art. Whilst living in London, he became a notable landscape painter, sculptor and poster designer. He died on 20/2/1959, having produced posters for GWR, SR & BR. We will see his work in Volumes 4 and 6.

Bruce Angrave (1914-1983)

Born In Leicester, Angrave studied at the Chiswick School of Art and London's Central School of Art. He worked as a freelance illustrator, designer and sculptor. Heavily influenced by both Eckersley and Games, his poster work is distinctive and sometimes a little bizarre.

His concept was *'follow or discard'* after 2 seconds! He felt a good poster could be looked at time and time again, thus almost forcing the message home. After WWII, he undertook many commissions and his work was displayed at the 1951 Exhibition.

Stanley Roy Badmin (1906-1989)

Badmin was noted as a detailed landscape watercolour artist, a lithographer and an illustrator & engraver. He was born Sydenham, London 18/4/1906, the son of a schoolmaster and studied art at Camberwell School of Art and at RCA. He was art teacher and lecturer at Central School of Arts and Crafts, and was elected to the Royal Water Colour Society in 1939. He illustrated several books including 'British Countryside in Colour', 'The Seasons', 'Shell Guide to Trees and Shrubs' etc. Very elaborate in style. He lived at Bognor, Sussex for some time, and produced posters and carriage prints, two of which are included in this volume.

John Francis Bee (1895-19xx)

Designer of stage settings, posters and show-cards. Born at Wolverhampton. Studied art for four years in Europe and the Near East. Exhibited in Manchester and worked at Loughborough and Liverpool. His work was illustrated in 'Commercial Art' and 'Posters and Publicity'. His posters bore a distinctive capital 'B' monogram, but his carriage panel artwork carried his normal signature.

Samuel John 'Lamorna' Birch (1869-1955)

Samuel Birch was born in Egremont, and educated at the Academie Colarrossi in Paris from 1896. His mother encouraged his art from an early age, and at 15 he exhibited at the Manchester City Art Gallery. He had moved to Cornwall in 1892 and, despite no formal training at that time, he became a professional artist. He was a keen fisherman, and his love of water always inspired his work. His nickname came from the fact that he lived at Newlyn in the Lamorna Valley. He is known for his expansive painting.

Montague Birrell Black (1884-19xx)

Poster artist & illustrator, he was born Stockwell, London 29/3/1884. Educated Stockwell College, he first did military and naval artwork, and was artist war correspondent for Toronto Star 1939-45. Black lived West Derby, Liverpool and Harrow, Middlesex. Was a White Star Line artist and was renowned for his map posters for the railways over many years. He produced posters for LNWR, M&GN, LNER, LMS, SR & BR. Interestingly no information seems to be available about his later years as an artist or information about his date and place of death.

Sir Frank William Brangwyn (1867-1956)

Brangwyn was a Welsh artist, virtuoso engraver, water colour specialist and a truly progressive designer. Born in Bruges, where his father had been commissioned to decorate the Basilica, he returned to England in 1875 and received artistic guidance from both his father and the architect William Morris. With no formal training, his work was accepted for an RA summer Exhibition and he was determined to become an artist. Initially he used limited palettes in his posters, so they appeared dark and gloomy: later this changed as 'Orientalism' swept the art world. His work softened and brightened in his later years. Brangwyn received extensive

commissions from the East and from Africa. His work is very collectible.

F. Gregory Brown (1887-1948)

Began his artistic career as a metal worker but turned to magazine illustration. He undertook work for all four of the main railway companies in addition to ICI, Empire Marketing Board and MacFisheries. Gold Medal winner at 1925 Paris Exhibition of Art for textile design. Produced many posters for the London Underground.

Claude Buckle (1905-1973)

Painter in oils & watercolour, particularly marine subjects, poster designer. Born London 10/10/1905. Trained as an architect, specialising in industrial drawings, but turned to art in 1928. Was a member of Savages Art Club in Bristol. Produced commissioned artwork for the new nuclear power stations around the country. Close friend of Terence Cuneo. Achieved a prolific output of artwork for the railways. Painted many of his later subjects around the coast in France. Lived near Andover, Hampshire. Died in 1973. Produced posters for GWR, LMS, SR & BR.

Lance Harry Mosse Cattermole (ROI 1898-1992)

Painter in oils & watercolour. Born 19/7/1898, son of Sydney Cattermole, an artist, and grandson of George Cattermole (1800-68) - illustrator of 'The Old Curiosity Shop' and other Charles Dickens works. Educated Worthing, Sussex and Odiham, Hants. Studied at Central School of Arts & Crafts 1922-23 and at the Slade School 1923-26. Lived near Worthing for many years. Represented in many museums and collections.

Christopher Clark (1875-1942)

Lived in London and better known initially as a historical and military subject painter (hence his wonderful Stirling Castle on page 153)He worked for the LNER and LMS and several posters were reissued by BR.

Austin Cooper (1890-1964)

Born in Canada he trained and practised in Britain. He studied at the Cardiff School of Art from the age of thirteen, before winning a scholarship to the Allan-Frazer Art College, Arbroath from 1906 until 1910. In 1910 he moved to London, studying in the evenings at the City and Guilds School. He returned to Canada as a commercial artist, although this was interrupted by war service during the First World War in Europe. In 1922 he settled in London and received the first of many poster commissions from London Underground. Over the next two decades he established his reputation as a top poster designer. After the 1920s his work became increasingly pictorial, and he produced work for the Empire Marketing Board, LNER as well as the London Underground. In 1943 he turned from his career as a poster artist to become a full time painter.

Charles Ernest Cundall (1890-1971)

He was born in Stretford, Lancashire and studied at the Manchester School of Art, and then the Royal College of Art 1912-14. His studies were interrupted by WWI but he returned to RCA in 1918. Further studies at Slade Fine Art School and in Paris followed. He travelled widely and his paintings were extremely good panoramas. Cityscapes and portraiture characterized his work, though he strayed into poster art and produced

some good 'Big Four' and LT items. During WWII he was in Quebec as an official War Artist.

Terence Tenison Cuneo OBE (1907-1996)

One of the most famous of all poster artists, Cuneo was the son of Cyrus and Nell Cuneo, well respected artists. He studied at Chelsea and Slade Art Schools. Known for railway subjects, he was also an accomplished portrait painter (including Royal and VIP subjects). Some of his engineering and technical work is also excellent. He was appointed as official painter to Queen Elizabeth for her Coronation in 1953.

Francis Murray Russell Flint (1915-1977)

Landscape & coastal painter in oils & watercolour. Born 3/6/1915, son of Sir William Russell Flint, the famous artist (who also produced posters for the railways). Educated at Cheltenham College and HMS Conway. Studied art at Grosvenor School of Modern Art, at the RA Schools and in Paris. Was art master at Lancing College. Lived at Burgess Hill in Sussex and Coffinswell, South Devon and London W8. Was Vice President of RWS. Died accidentally in Spain in 1977. Produced artwork for LNER Post-War, W Region series.

Abram Games (1914-1996)

Games learned his art at evening classes from 1932 onwards. He went to St. Martins School London, but left after two terms to pursue art. Worked in photography for his father and then in a commercial design studio. In 1936 he won the London Olympic Games poster competition and became a freelance artist full-time, securing commissions from Shell, London Transport and the Post Office. He was official War Office Designer

during WWII. He had a sixty-year career as an influential poster artist.

Henry George Gawthorn (1879-1941)

He was born in Northampton and studies at Regent Street Polytechnic. He trained as an architect but later turned to painting and art. He was a prominent LNER poster artist and wrote widely about poster design. He used to included himself in his posters and 20 of his works are found at the NRM in York.

John A Greene (ARCA)

Artist in oil and watercolour and lecturer. Studied art at the RCA. Lecturer at the Architectural Association School from 1946. Produced work for I.C.I. and the British Transport Commission. The detail in some of his posters was astonishing. Lived at Bordon, Hants.

Norman Hepple (1908-1994)

Born in London, Robert Norman Hepple produced posters for both BR and London Transport. He was educated at Goldsmiths College and the Royal Academy. His father and uncle were both well known artists of their day. His work is owned by the Royal Family and during WWII he was attached as artist to the National Fire Service. Suffering ill health during his later life, he was killed in a road accident shortly after undertaking his commissions for London Transport.

Ernest William Haslehust (1866-1949)

Landscape painter chiefly in watercolour, illustrator. Born Walthamstow 12/11/1866. Educated Manor House, Hastings and Felsted. Studied art at Slade School under Legros. Represented in several public collections. Principal works include The Bridge nr Arundel and A Devon Estuary. He illustrated the 'Beautiful Britain' series of books and produced posters. President of Midland Sketch Club and vice president Kent County Chess Association. Lived in South London for many years. Died 3/7/1949. Produced posters for LMS & LNER in a most detailed style of painting.

Rowland Hilder (1905-1993)

Landscape & marine painter, illustrator, author. Born 28/6/1905 at Great Neck, Long Island, USA, of British parents. Educated at Morristown, New Jersey. Settled England 1915 and studied at Goldsmiths College School of Art under E.J.Sullivan 1922-25. His work was first selected for RA in 1923 when only 18. He married Edith Blenkiron, also a painter. Represented in several public collections here and abroad and is renowned for his paintings of Kentish oast houses. Was President of RI 1964-74. He illustrated many books incl. 'Moby Dick' 1926, 'Treasure Island' 1930, 'The Shell Guide to Flowers of the Countryside' etc. Designed National Savings and Shell Oil posters and illustrated the Army Manual on Camouflage. Hilder wrote books on watercolour technique and an autobiography 'Rowland Hilder, Painter & Illustrator'. He lived in Blackheath, London for many years, and died April 1993.

Ludwig Holhwein (1874-1949)

Born in Wiesbaden, Holhwein also lived in London, Paris, Munich and Berchtesgaden. He trained as an architect but began produced posters as early as 1906. Some of his early works are quite superb (restaurants, pavement cafes and buildings) and he was asked by the LNER to undertake some commissions. The superb Edinburgh on page 41 is an example). He worked as an illustrator for the Third Reich during WWII where his bold style was suited to the messages required.

Eric Hesketh Hubbard (1892-1957)

Landscape & architectural painter, etcher & furniture designer. Born 16/11/1892 in London. Educated Felsted School. Studied art at Heatherleys, Croydon School of Art and Chelsea Polytechnic. Member of many art societies. Represented in many public collections, home and abroad. Published a number of books including 'Colour Block Print Making' and 'Architectural Painting in Oils'. Founder and director of Forest Press. Lived Croydon, Surrey; Salisbury, Hants and later in London. Died 16/4/1957. Produced posters for LMS, SR & GWR.

Edward McKnight Kauffer (1890-1954)

Born in Great Falls Montana, Kauffer became a most prolific and well known poster artist in Europe after studying first in San Francisco and then in Paris in 1913. WWI saw him move to London, becoming a London Transport artist for over 25 years. One of the most influential poster artists, he used surrealism, cubism and futurism in his work. Significant posters were produced for the GWR, Shell, Empire Marketing Board and the Post Office.

Ronald Lampitt (1906-)

Painter of landscapes in oils & watercolour, poster designer, book illustrator including children's books. Worked for Artists Partners Agency in London. Lived Hampstead, London. Produced posters for GWR, LMS and SR as well as many for BR.

William Lee-Hankey (1869-1952)

Painter and etcher of landscapes and portraits. Born 28/3/1869 at Chester. Studied at Chester School of Art under Walter Schroeder, at the RCA and also in Paris. Served with Artist's Rifles 1915-19. Exhibited at most principal London galleries. President of London Sketch Club 1902-4. Represented in many public collections, home and abroad and was a considerable contributor to RWS exhibitions. Won gold medal at Barcelona International Exhibition and bronze medal at Chicago. Lived and worked in France for some time then London. Became member of RWS in 1936, aged 67 and vice president in 1947. Died 10/2/1952. Produced posters for LNER. He had a lovely style of painting.

Reginald Montague Lander (1913-xxxx)

Born London 18/8/1913. Freelance commercial artist in gouache and watercolour, poster designer. Educated Clapham Central School and studied art at Hammersmith School of Art. Chief designer and studio manager at Ralph Mott Studio (1930-9). Worked for Government Ministries and British Transport Commission. Lived New Malden, Surrey. Produced very many posters for all regions of BR and the Post Office. Famous for his bold style, almost modernistic.

Alan Carr Linford (1926 -)

Alan Carr Linford is an eminent poster artist. He studied at the Royal College of Art 1943-47, gaining professional qualifications in art by the age of 20, and winning several prestigious scholarships. A student of Sir William Halliday, his work was seen in 1949 by the then Princess Elizabeth at Clarence House. Over the years Queen Elizabeth II has collected several of his drawings.

He has painted for Royalty all over the world. One of my favourite posters of all is his depiction of High Street Oxford; it has quite superb artwork, depth and movement.

Freda Marston (1895-1949)

Born Hampstead 24/10/1895 (nee Clulow). Painter & etcher of landscapes & figures. Educated, Hampstead, London. Studied art at Regent Street Polytechnic, in Italy and under Terrick Williams 1916-20. Married Reginald St Clair Marston in 1922. Represented in several public collections. She was the only woman artist commissioned by the railway for carriage prints. Lived Amberley, Sussex and later at Robertsbridge. Died 27/3/1949. Produced posters for LMS & BR.

Alasdair Macfarlane (1902-1960)

Born Ballymartin, Tiree 26/9/1902; Gaelic speaking, later bilingual, he was a self-taught artist. Moved to Glasgow 1922. Worked on ships for P Henderson & Co.. Joined Clyde Navigation Trust in 1929. Drew ships for Evening Citizen newspaper, Glasgow from 1929. Exhibited 1932-7. Served with Ministry of War Transport in London 1940-45 and re-joined Clyde Navigation Trust. Produced private and commercial work latterly and ship drawings for Glasgow Evening Times 1950-60. Died from heart attack 1960. Produced posters for BR and Caledonian MacBrayne of Scotland.

Frank Henry Mason (1875-1965)

Marine painter in oil & watercolour, etcher, illustrator, author & poster designer. Born Seaton Carew, Co Durham 1/10/75. Son of a railway clerk. Educated at HMS Conway and followed sea for a time as a ship engineer. Later engaged in engineering and shipbuilding at Leeds and Hartlepool. Travelled abroad extensively and painted many subjects in watercolour. Served 1914-18 as Lieutenant in the RNVR in N.Sea and Egypt. Studied under Albert Strange at the Scarborough School of Art. Member of RBA 1904, RI 1929. Exhibited at the RA from 1900 and achieved a prolific output of artwork for the railways. Wrote the book Water Colour Painting with Fred Taylor. Lived at Scarborough, then London. Represented in several public collections. Produced posters for NER, GNR, LMS, LNER, GWR & BR.

Jack Merriott (1901-1968)

Landscape & portrait painter in oil & watercolour, poster designer, author. Born 15/11/1901. Educated Greenwich Central School. Studied at Croydon School of Art and at St Martins School of Art. Lectured in Royal Army Education Corps (1945-6). President of Wapping Group of artists 1947-60. Lived at Shirley in Surrey, Storrington, Sussex and later at Polperro, Cornwall. Illustrated some of the 'Beautiful Britain' series of books by Blackies. Lectured widely on watercolour and produced the 'Pitman Guide to Watercolour' and wrote 'Discovering Watercolour'. Was vice president of RI and achieved a prolific output of artwork for the railways. Produced posters for BR.

Claude Grahame Muncaster (1903-1974)

Painter in oil & watercolour; etcher of landscapes, town scenes & marines, lecturer & writer. Born 4/7/1903 at W.Chiltington, Sussex, son of Oliver Hall (RA). Educated at Queen Elizabeth School, Cranbrook. Elected a member of RWS in 1936. In November 1945 he adopted above name by deed poll but had exhibited under that name from 1923, and previously as Grahame Hall. First

one-man show at the Fine Art Society 1926. Wrote book 'Rolling Round the Horn', pub.1933 telling of his 4-month voyage from Australia to Britain. Represented in many public collections. Wrote several books on art. Lived near Pulborough, Sussex. Produced posters for GWR & LMS.

Brandan Neiland (b 1941-)

Born in Lichfield, he studied art at the Birmingham College of Art and then the Royal College of Art in London. After winning numerous prizes and awards he was elected a Royal Academician in 1992 and a Fellow of Fellow of the Royal Society of Arts in 1996. He is currently Professor at the University of Brighton. One of the UK's most distinctive painters, his modern renditions of British stations are real collectors' items. Has exhibited internationally and work is held in major public, private and corporate collections worldwide.

Frank Newbould (1887-1951)

Born in Bradford, he became one of the 'Big Four' poster artists after studying art at the Camberwell School. Joined the war office in 1942 and was assistant under the famous Abram Games. His many posters were undertaken for the LNER, GWR, Orient Line and Belgian Railways.

James McIntosh Patrick (1907-1998)

Landscape & portrait artist in oil & watercolour, etcher. Born 4/2/1907 in Dundee, son of an architect. Studied at Glasgow School of Art under Griffenhagen (1924-8) and in Paris. Worked for Valentines Cards. Received Guthrie award in 1935. Exhibited at the Fine Art Society and represented in many public collections, including the Tate Gallery. Based in Dundee for many years and died 7/4/1998. Produced posters for LNER & BR.

Tom Purvis (1888-1959)

Born In Bristol, the son of famous marine artists TG Purvis, Tom Purvis became one of the most famous poster artists of all. He studied at the Camberwell School of Art and worked for 6 years at Mather and Crowther before becoming a freelance designer. His bold style used blocks of colour in a two-dimensional manner and he largely eliminated detail. Worked under William Teasdale, the Marketing manager at the LNER and then his successor Dandridge, for 20 years and rose to prominence in the poster art field very quickly. Our database shows almost 100 posters, produced at regular intervals over his entire working life. He tended to focus on places and the landscape rather than trains or people. His famous set of stand-alone set of six posters for the LNER could be placed together as a panorama – way ahead of its time.

Gyrth Russell (1892-1970)

Printer, etcher of landscapes & marine subjects. Born Dartmouth, Nova Scotia on 13/4/1892. Son of Benjamin Russell, Judge of Supreme Court, Nova Scotia. Studied art at Boston USA, also in Paris at the Academie Julian and Artelier Colarossi 1912-14. Represented in several public collections including Canada's National Gallery. Was official war artist with the Canadian Army during World War I. Lived at Topsham, Devon and later at Penarth, Glamorgan and Sussex. Died 8/12/1970 in Wales. Produced posters for GWR & BR.

Sir Henry George Rushbury (1889-1968)

Painter in watercolour, etcher & draughtsman of architectural subjects. Born 28/10/1889 at Harborne, Birmingham. Studied stained glass design and mural decoration at Birmingham College of Art 1903-09, later working as assistant to Henry Payne (RWS). Settled London 1912. First one-man show held at Grosvenor Gallery in 1921. Studied Slade School for 6 months under Tonks. Became member of RWS in 1926. Worked home and abroad and represented in many public collections. Created CVO 1955, CBE 1960, KCVO 1964. Lived London, Sussex and Essex. Produced some truly outstanding posters for LMS, LNER & BR.

Charles Shepherd (1892-19XX)

Signed his posters as 'Shep'. He also went under the name Captain Shepherd. He studied art under Paul Woodroofe and later became head of the studio at the Baynard Press. Commissioned to do posters for the Southern Railway and several for London Transport.

Frank Sherwin (1896-1986)

Marine & landscape painter in oil & watercolour, poster designer. Born Derby 19/5/1896, son of Samuel S Sherwin (painter). Educated Derby and studied at Derby School of Art and at Heatherleys School of Fine Art in Chelsea 1920. Exhibited from 1926 to 1940. Served in WWII as camouflage advisor around East Anglian airfields. Lived at Cookham, Berks for many years. Prints were produced from some of his artwork. Achieved a prolific output of art for the railways. Produced posters for GWR, LMS, LNER & BR. Died in Slough in 1986.

Ellis Luciano Silas (1883-1972)

Marine & landscape painter in oil & watercolour, poster and stained glass artist. Born London, son of Louis F.Silas, a decorative artist and founder member of the United Artists; and grandson of Edouard Silas, a composer. Studied art under his father and Walter Sickert. He was war artist for the Australian government 1914-18 and spent three years in Papua painting and collecting curios which he described in his book 'A Primitive Arcadia'. President of the London Sketch Club 1930. Lived in London for many years.

Leonard Russell Squirrell (1893-1979)

Painter & etcher of landscapes & architectural subjects, writer. Born Ipswich 30/10/1893. Educated at British School, Ipswich and studied at Ipswich School of Art under G. Rushton and at the Slade School. Won British Institution Scholarship in engraving 1915. Received gold medals at the International Print Makers Exhibitions in Los Angeles in 1925 & 1930, and silver in 1923. Represented in many collections, home and abroad. Transferred from the RI to the RWS during his career. Published 'Landscape Painting in Pastel' 1938, and 'Practice in Watercolour' 1950. Lived near Ipswich and was founder member of the Ipswich Art Club. His son, Martin, was also a painter (1926-50). There are several fine books on Squirrell by Josephine Walpole.

Kenneth Steel (1906-1970)

Painter in watercolour, engraver & lithographer of landscapes & street scenes; poster designer. Born Sheffield 9/7/1906, son of G.T.Steel, an artist and silver engraver. Studied at Sheffield College of Art under Anthony Betts. Represented in several public collections. Achieved a prolific output of artwork for the railways. Based in Crookes, Sheffield for years. Produced posters for LNER & BR, he was one of the most prolific artists in the early BR days.

Fred Taylor (RI 1875-1963)

Landscape & architectural painter in watercolour, poster designer. Born London 22/3/1875. Educated at St John the Evangelist. Studied art at Paris at the Academie Julian, at Goldsmiths College School (awarded gold medal for posters) and in Italy. Worked at the Waring and Gillow studio. He was a poster artist from 1908 to 40s. In 1930 designed four ceiling paintings for the Underwriting Room at Lloyds, London. Worked on naval camouflage during World War II. Renowned for his topographical accuracy and his prolific output, especially for the railways. Wrote the book 'Water Colour Painting' with Frank H Mason. Represented in several public collections and exhibited at the RA. Lived in London for many years. Produced posters for MR, GWR, LMS, LNER, BR, LT, EMB & several shipping companies.

Norman Wilkinson CBE (1878-1971)

Born in Cambridge. Educated at Berkhamsted School and St Paul's Cathedral choir school, he had little training in art but largely developed his style through his maritime career. Norman's greatest love was painting, his subjects were seascape and landscape in both oil and watercolour. His early career as an illustrator for the Illustrated London News enabled him to develop his talents as both artist and entrepreneur. Norman made a contribution to WWI with the invention and development of Dazzle Painting, a form of ship camouflage. One of the finest marine painters of the century, he is well represented in many public collections, including Greenwich and the NRM York. During WWII he painted a record of the major sea battles and presented the series of 54 paintings to the Nation. They are kept at the National Maritime Museum. Norman's commercial work included the production of many illustrated books and he initiated a revival in poster painting for LMS Railways. Honoured with CBE in 1948.

Anna Katrina Zinkeisen (1901-1976)

Born in Kilreggan, Dunbartonshire, she was a pupil of the Royal Academy School, holding medals from there. Designed posters for the LNER and SR. She won scholarship to the Royal Academy from Harrow School of Art, winning the Landseer Prize in 1920 and 1921. She also worked for Wedgewood as a ceramics designer.

Doris Clare Zinkeisen (1898-1991)

Elder sister of Anna, above, she also studied at the RA Schools. Lived in London: she also undertook theatrical and set design work. Her classic poster of Rob Roy is found on page 143, one of several painters of famous figures from the past.

The Lone Poster from Kinross-shire: James McIntosh Patrick

Intercity Poster from 1977 Advertising Rail Travel the Comfortable Way

Written by the Author with Valerie and Simon Kilvington

The following pages show just the Scottish portion of literally thousands of hours of work put in by all three of us since I (RF) began the database after my first visit to the NRM in the spring of 2002. All three of us were working on it by the end of 2002. The master database contains more than 70,000 pieces of information, but the Scottish portion that follows these research notes has been distilled from this (*ideally in Speyside for example!*). We have also collected digital thumbnails of more than 98% of the Scottish entries, from various sources, all over the world.

The following pages list Scottish posters found during our research work, a mere fraction of the several thousand entries we have recorded. The NRM, SSPL and Onslows have contributed significantly throughout the study and their details are given. Other information has been removed and blank spaces are found on pages 218-233 that are filled in our master database. The poster entries are mainly the classical poster artworks produced by all railway companies in the period 1890-1970. We are still collating and working our way through the many hundreds of modern image and contemporary posters for the period 1970-2009. Some of the better examples have been included throughout this book, but the sheer number of photographic and letterpress-type posters are an obstacle to their careful cataloguing, and this will take another two years or more. The pages that follow, therefore, are only the preamble to future full listings.

We have used the traditional names of Scottish counties; those that relate to the locations of towns and lochs around 1950. This is in keeping with the titles found on many of the posters. When boundaries altered and county names changed, the new names of the early 1970s and other changes subsequently make the poster information seem odd. You can talk about a Lanarkshire Steelworks or Dryburgh Abbey in Roxburghshire, but a Strathclyde Steelworks or Dryburgh Abbey, Borders seems rather incongruous!

The database is presented in eight columns. It has been sorted here by column four (location), so that all the Aberdeenshire, Perthshire and other county posters group together. For the first time, readers can see how many posters were produced for each place, illustrating how the railway company policy of encouraging rail travel was largely influenced by the location, and how each town's development was hugely affected by the railway's presence.

The first column is the artist (where known). When the whole database for all regions is placed together, the prolificacy of some of the artists is immediately clear: Norman Wilkinson for example runs to more than two complete pages.

The second column is the year the poster was issued. Here we have used font type, logo type, slogan type and other tell-tale details to more closely date some of the posters. Getting this as accurate as possible has been responsible for a large proportion of the total time we have spent: checking and then cross-checking is tedious, but essential. Even so, we know that there are almost certainly residual errors. The third column is the title of the poster, and again readers can easily see which towns, events or places figured heavily in travel promotion. The next column is the county, followed by the railway company producing the poster and then the size of the poster.

The remaining columns give details of the source of the information. In the complete database of all regions and companies, plus the source of the data and a copy of all of this is already with the NRM in York for possible inclusion in the Search Engine, so that we can all learn and appreciate more in the future.

The Database Arranged by Location

First in sequence is **Aberdeenshire** (an old Briton name meaning *at the mouth of the Don* and first recorded in 1100). We have more than a page of entries (more than 40 in total), showing that Aberdeenshire was a favoured Scottish destination for advertising purposes. Not surprisingly, Aberdeen itself has ten entries currently, but the Royal connections with this county mean that the Deeside area has almost as many. Cruden Bay figures heavily (nine) and the remainder come from spa town adverts, golfing paradises and sporting events. The Aberdeenshire entries are found on pages 218-219.

Next come obvious Scottish Adverts (some being used in Chapter 9), and generally these encourage and welcome the travellers to this unique land. This section will grow as more letterpress and general posters are added.

The County of **Angus** is on the east coast north of the Firth of Tay. The name comes from the son of an 8th century King of the Picts: Angus son of Fergus. The name seems to have been first used around 1150 and few posters (just four) advertised this part of

Scotland. But the famous Glamis Castle and the Tay Bridge both appear. It has also been named Forfarshire after the county town.

Argyllshire, on the western side, then follows with over 30 entries. There are some stunning posters listed, as readers can see in Chapter 6. Argyllshire is a Gaelic name – Arregaithel - meaning *Boundary of the Gaels* and was first used around 970 AD. Argyll is characterised by lochs, mountains and the sea and all appear on famous posters.

Ayrshire in the tranquil south-west has (surprisingly) many posters with 29 entries. It is a scoop of land bordering the Firth of Clyde and was a favoured playground for the industrial population of Glasgow. However, Its history is significant with Robert Burns, fabulous golf courses and General Eisenhower's home all prominent. The name derives from the main river and records show it appeared about 1175 to denote the whole area. The word 'Ayr' is Pict-Celtic.

We have only one poster for **Banffshire** (so far) and it is found on page 88. The word is also Gaelic and refers to the River Deveron. It is home to the many 'wonder brews' that have made Scotland famous. Chapter 4 includes the names of famous malt whiskies that appear all over the world.

There are only six entries so far for **Berwickshire** (Old English *Berewic = barley farm*). The name appeared in records around 1095. The six entries we have listed on pages 223 and 224 include some absolutely classic and highly collectible railway posters.

Buteshire offers a vision of romantic Scotland. The Firth of Clyde, The Kyles of Bute and a collection of islands make up the county. It was a favoured holiday destination and the database on page 224 has only 15 entries (but some **really** lovely images). The resort of Rothesay (the County town) figures prominently. The county is named after the Island of Bute and is probably an old Gaelic word.

Caithness is in the far north, with a single railway line up to Wick and a branch to Thurso. Its bleakness means nobody wanted to visit, so no posters have been recorded – yet! Similarly the tiny county of **Clackmannanshire** on the east coast also has no entries.

Next in the database is **Dumfries-shire** again in the south-west of the country. Only three posters have been listed from here, but all of them are quite wonderful. The

county name is Gaelic (*Dun* = fort and *phreas* = wood) and is in Scottish records from 1185. The Dumfries-shire entries appear on page 224

Dunbartonshire is north of the industrial conurbation of Glasgow, but contains some magnificent scenery (in the Trossachs and Loch Lomond). The southern sector is industrial, with factories, ports and submarine bases. The Gaelic county name appeared later than many Scottish counties (around 1300), and *means Fort of the Strathclyde Britons – Dun Breatton*). Almost 30 posters are listed (pages 224 and 225), naturally focussing on the Clyde, the Trossachs and Loch Lomond.

Golf comes to the fore in **East Lothian,** with some of the most collectible of railway posters from the town of North Berwick, depicting its many courses. The name Loth appeared in 970 AD (Loth was the grandfather of St. Mungo), and may be the origin of the county name. We have nine East Lothian entries on page 225.

Fifeshire (the Kingdom of Fife) is very prominent on railway posters. Dunfermline and St. Andrews both have rich histories and some of the most evocative Scottish posters come from the eastern part of the county. Fith (from which the county name is derived) was a leader and ruler in the area around 500 AD. Chapter 3 contains some simply magnificent images and the database on pages 226 and 226 shows some 30 posters from all over this ancient kingdom, including ten for the ancient capital, Dunfermline.

The collections of islands, known as the Inner Hebrides, have been lumped together in this database. The Isle of Skye is the most prominent, but Iona, Staffa, and Tobermory (on Mull) have all figured on well known railway posters right throughout the 20th century. We have 24 entries on page 226.

Next is **Inverness-shire**, a staggeringly beautiful and wild county that covers a large expanse of north and west Scotland. Consequently, it has the second highest number of entries (50). As many of these as possible have been used to show the beauty of the land. Two of the world's greatest railway journeys appear in this area: the run to the Kyle of Lochalsh from Inverness and the West Highland line from Mallaig via Fort William to the south. The county name is Gaelic (meaning *the mouth of the Ness* – its most famous loch and river).

We have only one poster from **Kincardineshire** – but what a poster! This eastern county is south of Aberdeenshire and Patrick's magnificent picture of Dunnottar Castle has

pride of place on page 69. The name is old Brittonic – *Cinn Chardain* – meaning the end of a copse or thicket and first used in 1295.

There is also one poster for **Kinross-shire** a small county north of Edinburgh, which we hurried through in Chapter 3. This poster depicts Loch Leven, a favourite spot for R+R, and it can be found on page 211.

Kirkcudbrightshire is slow-paced and tranquil; an ideal place to try to encourage people from the towns to visit, but with few posters. Located on Scotland's south-western coast, the five posters we have listed capture the area's peace and serenity. The name probably originates from the late 13th century and maybe comes from *Caer-Cuabrit* – a derived name of a local tribe. The posters entries are found on page 228.

Industrial **Lanarkshire** is probably the <u>last place</u> to advertise and entice people to visit, but some of the best industrial art appears on Lanarkshire posters. Naturally, as Glasgow was the shipbuilding capital of the world in former times, there are some superb posters of this industry available. The steel works south of Glasgow also figures – a surprising subject to entice travel! However, some of the leading artists of the day were used for posters from this county. We list 12 entries on page 228, a far higher number than many beauty spots. The county name is Brittonic, derived from *Llanerch* – a glade or small forest. Can you imagine Glasgow as a woodland area?

And so we come to Edinburgh and **Midlothian**. The history is so wonderfully rich and the subject matter so enticing that the highest number of entries is made for this county and city (52). Edinburgh Castle, the Royal Mile, Calton Hill, the Scott Memorial, Princes Street and Waverley Station are all prominent subjects. The county has also carried the name Edinburghshire, but *Mid Leudonis* (who or what this was?) appears in records in around 965 AD. Really classic and collectible poster images show the cultural richness of Scotland's capital. The Midlothian entries appear on pages 228 to 230.

Morayshire in the north has eight poster entries on page 230 and all are wonderful. The Gaelic word means *Settlement by the Sea.* **Nairn-shire** in the far north currently has no entries and only four entries characterize **Peebles-shire** to the south of Midlothian. The pre-eminent tourist attraction here is the River Tweed, but the Spa town of Peebles is also represented on page 25. The county name appeared around 1115.

Very surprisingly, we found only one entry for the **Outer Hebrides**, this being a MacBrayne poster for Kishmul Castle on Barra. It is included on page 113. **Perthshire,** in contrast, is very well represented in the database. This is another large and beautiful county and is often labelled *'The Highlands in Miniature'*. The eastern side has the Trossachs, the north has the Grampian outposts and the beautiful River Tay bisects the whole area. We have 44 entries and these are generously scattered through Chapters 3 and 6, the former grouping as we travel north and those in Chapter 6 as we return south. Gleneagles, Crieff, Dunkeld, Loch Katrine and the Tay Valley are all featured.

Renfrewshire to the south and west of Glasgow has eight entries, based around the Clyde (where much shipbuilding activity was centred). The beauty of the Firth of Clyde contrasts very sharply with the industry on the banks of the river itself, to the west of Glasgow's city centre. Renfrewshire entries are found on page 232.

The next area is **Ross & Cromarty**, a wild and desolate place in the far north. Who would want to advertise or visit such a place? The answer is given by ten posters and many walkers, climbers and people who seek peace and quiet. The county name dating from 1100 is composed of two Gaelic words: *Ros* is high moorland and *Crombadh* means crooked bay. These describe the natural landscape very succinctly. All the posters from this county are very collectible and the listing appears on page 232.

We go south now to **Roxburghshire**, home to the wonderful border Abbeys and to the haunts of Sir Walter Scott. It was difficult to leave any of the ten entries out of the journey and many feature prominently in the opening Chapter.

The general category of **Scotland** may have fewer entries that readers might imagine, but the database is still being refined and far more than the 16 existing entries may well appear in the future. Some of those listed appear in the final Chapter, enticing us to return again.

Selkirkshire is a small county in the border region and many of Sir Walter Scott's haunts and writing subjects are found here. The one poster entry we have listed on page 233 reflects this. The County name may have derived from the old English *Sele-Chyrche* – meaning Blessed Church.

Historic **Stirlingshire** has only ten entries. Considering the battles the Scots had with the English over the centuries and the strategic location of Stirling Castle, we consider this to

be fewer than expected. Those that have been produced are quite superb, such as Christopher Clark's Stirling Castle on page 152, and of course the wonderful contemporary rear book cover of the same subject.

Sutherland in the very far north has one entry and this poster appears on page 102. Railways did not venture much into the far north-west, but some carriage prints did feature the untamed beauty of Sutherland. The name first appeared in records as *Sudrland* around 1050 AD. This is a Norse word meaning *South Land* - South land this far north – rather strange we feel!

West Lothian has an iconic tourist attraction - the magnificent Forth Bridge. Surprisingly, it has appeared on few posters, but all of them have been included at the end of Chapter 2 and the start of Chapter 3. The former green and pleasant countryside of West Lothian is slowly being eaten up by developments, but the history of Linlithgow Palace makes it an ideal tourist attraction. The poster advertising the birthplace of Mary Queen of Scots is found on page 45. The West Lothian entries are presented on page 233.

The final series of three entries is for **Wigtownshire**, in the extreme south and west of the country, and a key departure point for Northern Ireland. First recorded as *Wigeton* in 1265, all the poster entries feature shipping. This is quite sad, as the Mull of Galloway and Luce Bay would have made lovely posters, and are worth visiting.

Any New Data Please!

We sincerely hope that once this first volume in the series is published, a flood of new information will be forthcoming. Putting your head 'above the parapet' first is always risky, but our clear intention is to use this work as the basis for developing a definitive list of posters, so we request as many readers as possible to contact us, to add new data or correct the data we have listed here. Sincere thanks are due to former Curator of Collections David Wright at the NRM York, for suggesting such a database might be included for the first time in this form in any poster book, to allow readers and collectors alike to appreciate the sheer breadth and number of posters produced. We have amassed almost 20,000 British railway poster images during our work, so there is still much to document and catalogue.

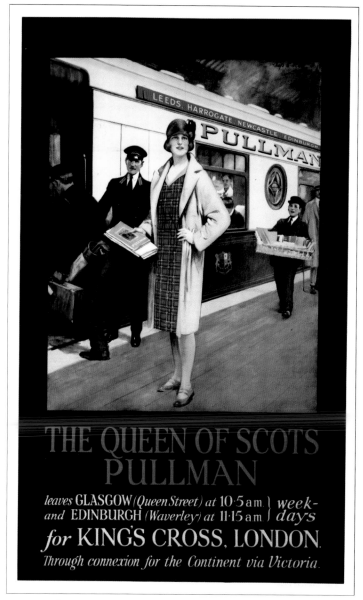

1935 Pullman Company Poster: Artist Septimus Edwin Scott

ARTIST	YEAR	TITLE	LOCATION	COMPANY	SIZE	SOURCE	DETAIL		IMAGE REF	NRM REF
Train, Thomas	1948	Aberdeen Guide free from Publicity Officer	Aberdeenshire	BR(ScR)	DR	SSPL	10170699		Aberdeen05	1991-7014
Mason, Frank Henry	1928	Aberdeen Tourist, Weekend and Excursion tickets by LN	Aberdeenshire	LNER	QR				Aberdeen01a	
Mason, Frank Henry	1928	Aberdeen Tourist, Weekend and Excursion tickets by LN	Aberdeenshire	LNER	QR	SSPL	10173451	Drawer D013	Aberdeen01	1986-9204
Talmage, Algernon Mayow	1924	Aberdeen: Brig O'Balgownie	Aberdeenshire	LMS	QR	SSPL	10173725	Drawer D004	Aberdeen08	1978-9123
Sherwin, Frank	1930	Aberdeen: The Gateway to Royal Deeside	Aberdeenshire	LMS/LNER	QR	SSPL	10173833	Drawer D005	Aberdeen04	1986-9332
Mason, Frank Henry	1935	Aberdeen: The Silver City by the Sea	Aberdeenshire	LNER	QR	SSPL	10173523	Drawer D013	Aberdeen02	1986-9215
McLellan, Alexander Matheso	1935	Aberdeen: The Silver City by the Sea	Aberdeenshire	LMS/LNER	QR	SSPL	10173831	Drawer D004	Aberdeen03	1986-9330
Silas, Ellis Luciano	1950s	Aberdeen: The Silver City with Golden Sands	Aberdeenshire	BR(ScR)	DR				Aberdeen09	
Riley, Harry Arthur	1950s	Aberdeen: The Silver City: beach family scene	Aberdeenshire	BR(ScR)	DR				Aberdeen13	
Buchel, Charles	1927	Ballater- Royal Deeside	Aberdeenshire	LNER	DR	SSPL	10174385	Drawer D077	Aberdeenshire08	1987-8905
Anon	1930	Come and Play at Aberdeen	Aberdeenshire	City Council	DR				Aberdeenshire19	
Lander, Reginald Montague	1957	Come to Aberdeen	Aberdeenshire	BR(ScR)	DR				Aberdeen11	
Anon	1910s	Cruden Bay	Aberdeenshire	GNSR	DR				Aberdeenshire20	
Cooper, Austin	1931	Cruden Bay Golf (blue golf	Aberdeenshire	LNER	QR	SSPL	10173604	Drawer D010	Cruden Bay02	1986-9257
Gawthorne, Henry George	1920s	Cruden Bay Golf (colourful image and pla	Aberdeenshire	LNER	DR				Aberdeenshire16	
Newbould, Frank	1930s	Cruden Bay Golf: fairway shot clubhouse b	Aberdeenshire	LNER	QR	SSPL	10173554	Drawer D014	Cruden Bay03	1986-9228
Purvis, Tom	1930	Cruden Bay By East Coast Route: sand trap 2 people	Aberdeenshire	LNER	QR	SSPL	10173326	Drawer D016	Cruden Bay06	1986-9156
Purvis, Tom	1928	Cruden Bay By East Coast Route: putting with crowds	Aberdeenshire	LNER	QR	SSPL	10173320	Drawer D016	Cruden Bay07	1986-9150
Nicoll, Gordon	1926	Cruden Bay Hotel: The Golfer's Hotel	Aberdeenshire	LNER	DR	SSPL	10176157	Drawer D057	Cruden Bay04	1994-8641
Warren, F.H.	1920s	Cruden Bay: Seekers of Good Spirits from Duty Free	Aberdeenshire	LNER	QR	SSPL	10327705	Drawer D012	Cruden Bay05	1996-7344
Mason, Frank Henry	1928	Cruden Bay: Travel by LNER	Aberdeenshire	LNER	QR	SSPL	10173518	Drawer D013	Cruden Bay01	1986-9213
Wollen, W.B.	1920s	Deeside: Raising the Standard at Braemar 1715	Aberdeenshire	LNER	DR	NRM	LNER Album C11.2-1		Aberdeenshire21	1991/7011/1
Newbould, Frank	1935	Eastern Scotland: Royal Deeside	Aberdeenshire	LMS/LNER	QR				Aberdeenshire9a	
Newbould, Frank	1935	Eastern Scotland: Royal Deeside	Aberdeenshire	LMS/LNER	QR	SSPL	10173703	Drawer D014	Aberdeenshire09	1978-9101
Gawthorne, Henry George	1934	Fraserburgh: Glorious Sands Bathing Golf Tennis	Aberdeenshire	LNER	DR	SSPL	10174398	Drawer D094	Aberdeenshire02	1987-8918
Mason, Frank Henry	1931	Havens and Harbours on the LNER: No. 5 Aberdeen	Aberdeenshire	LNER	DR	SSPL	10172481		Aberdeen07	1983-8334
Cattermole, Lance Harry Moss	1950s	Highland Games Aboyne: 3 girls dancing	Aberdeenshire	BR(ScR)	DR				Aberdeenshire07	
Cattermole, Lance Harry Moss	1950s	Highland Games: See Scotland by Train	Aberdeenshire	BR (ScR)	DR	SSPL	10170647		Aberdeenshire03	
Cattermole, Lance Harry Moss	1950s	Highland Games: Travel by Rail. Gathering at Braemar	Aberdeenshire	BR(ScR)	DR				Aberdeenshire06	
Mason, Frank Henry	1914	Mountain, River and Sea: Aberdeen and Royal Deesside	Aberdeenshire	GNS	QR	SSPL	10173854	Drawer D015	Aberdeenshire04	1986-9353
Carstairs, J.L.	1930	Peterhead: Two 18 Hole Golf Courses	Aberdeenshire	LNER	DR				Aberdeenshire11	
Mason, Frank Henry	1926	Remember Cruden Bay District: Buchaness	Aberdeenshire	LNER	DR				Aberdeenshire17	
Patrick, J. McIntosh	1937	Royal Deeside: Its Quicker by Rail: Braemar Castle	Aberdeenshire	LMS/LNER	QR	SSPL	10173539	Drawer D008	Aberdeenshire05	1978-8984
Lee, Sydney	1930s	Royal Deeside: Its Quicker by Rail: Deeside Bridge	Aberdeenshire	LNER/LMS	QR	NRM	LNER album C11.2 1991-7011/2		Aberdeenshire18	1991-7011/2
Steel, Kenneth	1951	Royal Deeside: See Britain by Train B12551	Aberdeenshire	BR(ScR)	DR				Aberdeenshire10	
Cooper, Austin	1920s	Royal Deeside: Travel by LNER	Aberdeenshire	LNER	QR				Aberdeenshire13	1991-7011/1
Wilkinson, Norman	1930s	Royal Highlander Approaches Aberdeen	Aberdeenshire	LMS	QR	SSPL	10173064	Drawer D007	Aberdeenshire12	1976-9215

ARTIST	YEAR	TITLE	LOCATION	COMPANY	SIZE	SOURCE	DETAIL		IMAGE REF	NRM REF
Wilkinson, Norman	1930s	Royal Highlander approaches Aberdeen	Aberdeenshire	LMS	QR	SSPL	10173802	Drawer D007	Aberdeenshire12a	1978-9168
Anon	1900s	Royal Route Via Aberdeen and Elgin	Aberdeenshire	GNSR	DR				Scotadvert66	
Steel, Kenneth	1962	See Royal Deeside by Battery Railcar and Diesel	Aberdeenshire	BR(ScR)	DR					
Newbould, Frank	1920s	The Dee: East Coast Route from Kings Cross	Aberdeenshire	LNER	QR				Aberdeenshire15	
Cattermole, Lance Harry Moss	1948	The Highland Games: Single dancer and piper	Aberdeenshire	BR(ScR)	DR				Aberdeenshire03a	
Cattermole, Lance Harry Moss	1948	The Highland Games:Single dancer and piper EP192	Aberdeenshire	BR(ScR)	DR	SSPL	10170647		Aberdeenshire03	1990-7158
Anon	1961	All in Holidays: Scotland from 14 guineas	Advert	CTAC/BR	DR					
Anon	1920	Bonnie Scotland	Advert	NER	DR	SSPL	10323228		Scotadvert64	2000-7615
Zec	1920s	By Night Train to Scotland	Advert	LMS/LNER	QR				Night train 1+2	
Anon	1910	Caledonian Railway and its connections	Advert	CalRly	DR	SSPL	10172242		ScotlandMap3	1986-8832
Anon	1910s	Clyde and West Highland Tourist routes	Advert	NBR	DR				ScotlandMap6	
Mace, John Edmund	1930s	Clyde Coast and Loch Lomond: Church	Advert	LMS/LNER	DR				Scotadvert23b	
Mace, John Edmund	1930s	Clyde Coast and Loch Lomond: lighthouse	Advert	LMS/LNER	DR				Scotadvert23a	
Mace, John Edmund	1930s	Clyde Coast and Loch Lomond: orange tree	Advert	LMS/LNER	DR				Scotadvert23	
Nicolson, W.C.	1950s	Clyde Coast and Loch Lomond: Relief map	Advert	BR(ScR)	QR				ScotlandMap04a	
Anon	1920s	Clyde Watering Places and the Western Isles	Advert	LMS	DR					
Zinkeisen, Doris Clare	1937	Coronation	Advert	LNER	QR	SSPL	10172606		LNERadvert1	1983-1412
Anon	1910s	Direct Route to the Clyde Watering Places (map)	Advert	GSWR	Large				Scotlandmap7	
Anon	1913	East Coast Route - Travel from Glasgow Queen st to Lon	Advert	GN/NE/NBR	QR				Advert585	
Anon	1921	East Coast Route Improved Service (tartan border)	Advert	GN/NE/NBR	QR				Advert585	
Anon	1900	East Coast Route: route and colourful collage	Advert	GNR/NER/NBR	DR	SSPL	10172642		Advert543	1983-8448
Anon	1914	East Coast Route: A contrast 1706 to 1914	Advert	GN/NE/NBR	QR	Onslows	25/06/2008 Lot 289		Advert721	
Anon	1900	East Coast Route: Popular between England-Scotland	Advert	GN/NER/NBR	DR	SSPL	10172641		Scotadvert62	1983-8447
Anon	1930s	Ecosse par Les Trains de Luxe LMS	Advert	LMS	DR	NRM	1992-7730 Drawer D092		LMS39	1992-7730
Anon	1900	Edinburgh and the Scottish Borderland	Advert	LMS	DR				Scotadvert20	
Anon	1962	Edinburgh-Aberdeen in 3 hours	Advert	BR(ScR)	DR	SSPL	10171305		Advert044	1992-7784
Anon	1963	Edinburgh-London in six Hours	Advert	BR(ScR)	DR	SSPL	10170670		Advert098	1990-7260
Spencer, E.H.	1952	England-Scotland in Comfort by Train: super heraldic in	Advert	BR(ER)	DR	SSPL	10171396		Scotland10	1994-7195
Anon	1930s	Explore Scotland and the Borders	Advert	LNER	DR				Advert912	
Marfurt, Leo	1928	Flying Scotsman	Advert	LNER	QR				Advert566	
Anon	1985	Freedom of Scotland Rail Tickets: Coast and harbour sc	Advert	Scotrail	DR	NRM	1985-8827		Scotadvert48	1985-8827
Anon	1983	Freedom of Scotland Rail Tickets: Banners and trains	Advert	Scotrail	DR	NRM	1983-8382		Scotadvert47	1983-8382
Anon	2001	From March 24th Bathgate to Edinburgh Just 30 mins	Advert	Scotrail	DR	NRM	2002-8271 Drawer D327		Advert 805	2002-8271
de Grineau, Bryan	1938	Glasgow and Edinburgh by Coronation Scot	Advert	LMS/LNER	DR	Onslows	20/06/06 Lot 363		Scotadvert28	
Anon	1989	Glasgow-Edinburgh-Dundee-Aberdeen etc	Advert	Scotrail	DR				Scotadvert36	
Lingstrom, Freda Violet	1930s	Kings Cross for Scotland	Advert	LNER	DR	Onslows	19/12/06 Lot 279		Scotland05	
Signed EWH		Land of Burns + Scott: abbey ruins	Advert	LMS/LNER	DR				Scotadvert24	

ARTIST	YEAR	TITLE	LOCATION	COMPANY	SIZE	SOURCE	DETAIL	IMAGE REF	NRM REF
MW	1920s	Land of Burns + Scott: River and bridge	Advert	LMS/LNER	DR			Scotadvert24	
MW	1925	LNER Golf: blue green yellow image	Advert	LNER	DR			Advert562	
Newbould, Frank	1926	LNER: The East Coast route to Scotland	Advert	LNER	DR	NRM	1989-7087	Scotadvert11	1987-9087
Anon	1924	Oban and the Land of Lorne	Advert	LMS	DR			Scotadvert20	
Anon	1933	Over the Border: service by Midland route	Advert	LMS	QR			LMS34	
Anon	1990s	Rail Rovers: Freedom of Scotland	Advert	Intercity	DR	NRM	1998-11310 Drawer D042	Scotadvert55	1998-11310
Mayes, Reginald	1945	Railways in War and Peace	Advert	W/M/S/ER	DR			Advert508	
Anon	1929	Road Motor Services: Aberdeen-Braemar	Advert	LNER	Large			Advert652	
de Grineau, Bryan	1937	Scot passes Scot	Advert	LMS	QR			Scotadvert29	
de Grineau, Bryan	1937	Scot passes Scot	Advert	LMS	QR	SSPL	10173367 Drawer D004	Scotadvert29	1978-8850
TCA?	1927	Scotland from Kings Cross	Advert	LNER	DR			Scotadvert42	
Danvers, Verney L.	1930s	Scotland By East Coast Route	Advert	LNER	DR	NRM	1987-8909 Drawer D094	Scotadvert57	1987-8909
Zinkeisen, Doris Clare	1930	Scotland by East Coast Route	Advert	LNER	QR			Scotland07	
Bartlett, Robert	1932	Scotland by the Night Scotsman	Advert	LNER	QR	SSPL	10176065 Drawer D015	Scotland06	1988-8040
Anon		Scotland for Holidays: Walking	Advert	LMS/LNER	DR			Scotadvert16	
Anon		Scotland for Holidays: Waterfall scenes	Advert	LMS/LNER	DR			Scotadvert17	
Anon	1960	Scotland for Ski-ing Ski lift	Advert	BR(ScR)	DR			Scotland09	
Lander, Reginald Montague	1960	Scotland for Sport - Travel by Train	Advert	BR(ScR)	DR			Scotadvert37	
Anon	1980	Scotland for Steam	Advert	Scot. Tourism	DR	SSPL	10173977	Scotadvert65	1987-8822
Danvers, Verney L.	1925	Scotland: From Kings X (art deco style)	Advert	LNER	DR			Scotadvert27	
Gilfillan, Tom	1930s	Scotland: Its Highlands and Islands Loch Scavaig	Advert	MacBrayne	QR	Onslows	02/04/2009 Lot 292	Scotadvert18	
Brien, G. Stanislaus	1930s	Scotland: Its Quicker by Rail: Salmon leeping	Advert	LNER	QR	Onslows	11/6/04 lot 313:	Scotland03	
Howard, Norman	1924	Scotland: Straight as the crow flies	Advert	LMS	DR	SSPL	10172150 Drawer D091	Scotadvert25	1986-8778
Clark, Christopher	1930s	Scotland: The Pipers of the Black Watch	Advert	LNER	DR	NRM	LNER Album C11.2 - 3	Scotadvert58	1991-7011/3
Anon	1910s	Scotland's Golf Courses Pictorial map	Advert	NBR	DR			Scotadvert44	
Cadell, Francis C.B	1925	Scotlands Wonderland by MacBryne steamer	Advert	LMS	QR			Scotadvert26	
Cadell, Francis C.B	1925	Scotlands Wonderland by MacBryne steamer	Advert	LMS	DR	Onslows	02/05/2003 lot 381	Scotadvert59	
Anon	1998	Scotrail Super Sprinter	Advert	Scotrail	DR	NRM	1998-11319	Advert873	1998-11319
Gilfillan, Tom	1930	Scottish Highlands and Islands	Advert	MacBrayne	QR			Scotland12	
Waterlows	1959	Scottish Piper: see Britain by train	Advert	BR Exec	sm.				
Anon	1935	See this Scotland First	Advert	Macbrayne	DR			Inverness-shire04a	
Steel, Kenneth	1963	Service to Industry - steel	Advert	BR(NER)	DR	SSPL	10173159	Advert319	1977-5598
Unger	1980s	Starlight Express: Glasgow-London 85/- return	Advert	BTC	DR				
Anon	1983	Super Scotrail offer: Bargain single to Inverness	Advert	Scotrail		NRM	1983-8585	Scotadvert75	1983-8585
Anon	1952	System Map: Scottish Region	Advert	BR Exec	DR				
Anon	1976	Ten Scenic Reasons for Roundabout Seasons	Advert	BR(ScR)	DR	NRM	1979-7649	Scotadvert43	1979-7649

ARTIST	YEAR	TITLE	LOCATION	COMPANY	SIZE	SOURCE	DETAIL	IMAGE REF	NRM REF
Anon	1920	The Caledonian Railway and its connections	Advert	CalRly	DR	NRM	1986-8832	ScotlandMap3	1986-8832
Anon	1950s	The Clan Lands of Scotland	Advert	BR/MacB	DR			Scotland01	
Anon	1920s	The Clyde Coast and Loch Lomond	Advert	LMS	DR			Scotadvert20	
Anon	1937	The Coronation Hauled by Dominion of Canada	Advert	LNER	DR	SSPL	10406816	London53	
de Grineau, Bryan	1937	The Coronation Scot Euston-Glasgow 6 1/2 Hours	Advert	LMS	DR	SSPL	10172016 Drawer D092	Scotadvert30	1981-7317
Anon	1915	The Countryside Calls You: Come by the Caley	Advert	Cal Rly	DR	SSPL	10170714	Scotadvert63	1990-7095
Cook, Brian	1935	The Face of Scotland	Advert	LMS/LNER	QR	SSPL	10173579 Drawer D004	Scotadvert12	1986-9239
Moffat, Curtis	1935	The Flying Scotsman	Advert	LNER	DR	SSPL	10175998 Drawer D093	Advert413	1988-7973
Thomson, A.R.	1925	The Flying Scotsman	Advert	LNER	DR			Advert512	
Bagley, R	1962	The Flying Scotsman original artwork	Advert	BR Exec	DR	SSPL	10283228	Advert418	1978-1360
Bagley, R	1962	The Flying Scotsman 1862-1962 ref PP5030	Advert	BR(ER)	DR	SSPL	10171762	Advert442	1979-7807
Anon	1930s	The Gateway to the North: Euston and St. Pancras	Advert	LMS	DR	SSPL	10171358 Drawer D092	LMS09	1993-8138
Bell, J.J. (Author)	1935	The Glory of Scotland Guide book artwok	Advert	LNER/LMS	QR	SSPL	10173608 Drawer D010	Scotadvert32	1986-9261
Anon	1920	The Highland Railway: Route map	Advert	HR	DR	SSPL	10172252 Drawer D001	ScotlandMap2	1986-8842
Wolstenholme, A.N.	1950	The Mid-Day Scot	Advert	BR Exec	DR	SSPL	10172635	Advert300	1983-8441
Anon	1990	The New Golden Age of Rail Travel is Arriving	Advert	GNER	Long			Scotadvert15	
Alexeieff, Alexander	1932	The Night Scotsman	Advert	LNER	QR			Kings Cross07	
Mayes, Reginald	1950s	The Queen of Scots Classic poster A4 + tartans	Advert	BR(ER)	DR	SSPL	10173048 Drawer D026	Advert457	1975-8396
Scott, Septimus Edwin	1935	The Queen of Scots Pullman black background	Advert	Pullman Co.	DR	SSPL	10172632	QueenofScots 2	1983-8438
Scott, Septimus Edwin	1935	The Queen of Scots Pullman green background	Advert	Pullman Co.	DR	SSPL	10172633	QueenofScots 1	1983-8439
Wolstenholme, A.N.	1952	The Red Rose: Restaurant Car Express	Advert	BR(LMR)	DR			Advert682	
Taylor, Leonard Campbell	1928	The Refreshment Car	Advert	LMS	QR			Advert674a	
Taylor, Leonard Campbell	1928	The Refreshment Car - original artwork	Advert	LMS	QR	SSPL	10310011	Advert674	1976-9309
Ashford, Colin	1930s	The Royal Scot	Advert	LMS	DR			LMS24	
Brown, P. Irwin	1931	The Royal Scot	Advert	LMS	DR	SSPL	10170737 Drawer D092	LMS38	1991-7119
de Grineau, Bryan	1937	The Royal Scot	Advert	LMS	QR			Scotadvert31	
Brown, P. Irwin	1931	The Royal Scot pictorial timetable	Advert	LMS	DR			Advert669	
Wolstenholme, A.N.	1950	The Royal Scot: Timetable London-Glasgow R51	Advert	BR(ER)	DR			Advert696	
Anon	1910	The Royal, Quickest and Direct Route to the Highlands	Advert	HR	Large	Onslows	20/4/2000 lot 477 Large DR poster	Scotadvert39	
Anon	1977	The Silver Jubilee leaves Edinburgh for Kings Cross	Advert	BR Inter City	DR	SSPL	10173193	Scotadvert03	1977-5632
de Grineau, Bryan	1930	The World Famous Scottish Expresses	Advert	LMS/LNER	QR			Scotadvert18	
Thomson, A.R.	1920s	Then and now: 100 bathing resorts on the East Coast	Advert	LNER	DR	SSPL	10175899 Drawer D077	East Coast23	1987-9173
Thomson, A.R.	1920s	Then and Now: 200 restaurant cars on LNER trains	Advert	LNER	DR			Advert048	
Thomson, A.R.	1931	Then and Now: The Flying Scotsman 1862-1930	Advert	LNER	DR	SSPL	10327513 Drawer D077	Advert479	1999-7536
MW	1933?	Through the Trossachs: Bagpipe player	Advert	LMS/LNER	DR			Scotadvert21	
MW	1933?	Through the Trossachs: Mountain waterfall	Advert	LMS/LNER	DR			Scotadvert21	
MW	1933?	Through the Trossachs: Woodlands	Advert	LMS/LNER	DR			Scotadvert21	

ARTIST	YEAR	TITLE	LOCATION	COMPANY	SIZE	SOURCE	DETAIL	IMAGE REF	NRM REF
Scott, Septimus Edwin	1920s	To Edinburgh by Pullman	Advert	LNER	DR			Edinburgh35	
Anon	1905	To The Coast via Ardrossan, Wemyss Bay And Gourock	Advert	CR	DR			Scotadvert76	
Murray, Andrew	1904	To Scotland and the North of England	Advert	MR	DR			Scotadvert71	
Anon	1950s	Arbroath	Angus	BR(ScR)	DR			Angus04	
King, Cecil	1930s	Glamis Castle, Kirriemuir. Its quicker by Rail	Angus	LMS/LNER	DR	SSPL	10174459 Drawer D077	Angus02	1987-8979
Cooper, Austin	1925	Montrose: Sea Bathing, Golf and Tennis	Angus	LNER	DR	SSPL	10174249	Angus03	1978-9431
Cuneo, Terence Tenison	1957	Tay Bridge: See Scotland by Train B34040	Angus	BR(ScR)	QR	SSPL	10172014 Drawer D024	Angus01	1981-7315
Anon	1914	Cambelltown Inverrary and Co	Argyllshire	SECR	DR	SSPL	10171750	Argyllshire35	1979-7795
Black, Montague Birrell	1955	Dunoon on the Firth of Clyde	Argyllshire	BR(ScR)	DR			Argyllshire26	
Black, Montague Birrell	1950s	Dunoon on the Firth of Clyde	Argyllshire	BR(ScR)	DR			Argyllshire30	
Anon	1950s	Dunoon on the Firth of Clyde Steamer and pier	Argyllshire	BR(ScR)	DR			Argyllshire33	
Buckle, Claude	1957	Dunoon on the Firth of Clyde: ferry at town pier	Argyllshire	BR(ScR)	DR			Argyllshire25	
Littlejohns, John	1925	Dunoon:	Argyllshire	LNER	QR	SSPL	10173771 Drawer D015	Argyllshire28	1986-9300
Cattermole, Lance Harry Moss	1960	Dunoon: On the Firth of Clyde	Argyllshire	BR(ScR)	DR	SSPL	10170650	Argyllshire24	1990-7161
Mason, Frank Henry	1935	Dunoon: The Centre of Clyde Pleasure Sailings	Argyllshire	LNER/LMS	QR	SSPL	10174104	Argyllshire29	1978-9287
Lee-Hankey, W	1920s	Dunoon: The Centre of Clyde Pleasure Sailings	Argyllshire	LMS/LNER	QR	SSPL	10173819 Drawer D015	Argyllshire14	1986-9310
Neiland, Brendan	1996	Glen Coe by Train	Argyllshire	Scotrail	DR	SSPL	10305931	Argyllshire19	1996-7271
McCulloch, Horatio	1930s	Glencoe moody mountain poster: deer foreground	Argyllshire	LMS	QR	SSPL	10171338 Drawer D005	Argyllshire03	1993-8118
Anon	1910s	In the Land of the Gael: Loch Awe and Kilchurn Castle	Argyllshire	C&OR	DR	Onslows	22/11/05 lot 395	Argyllshire27	
Wilkinson, Norman	1928	Loch Awe	Argyllshire	LMS/LNER	QR	SSPL	10171303 Drawer D006	Argyllshire10	1992-7782
Gilfillan, Tom	1950s	Loch Awe, Argyll See Scotland by Rail	Argyllshire	BR(ScR)	DR			Argyllshire21	
Sherwin, Frank	1950s	Loch Eck, Argyll	Argyllshire	BR(ScR)	DR			Argyllshire16	
Merriott, Jack	1950	Loch Etive: Western Highlands B 18318	Argyllshire	BR(ScR)	QR	SSPL	10170760 Drawer D024	Argyllshire12	1991-7143
Anon	1910s	Oban and Loch Awe	Argyllshire	BR	DR	SSPL	10170910	Argyllshire17	1989-7201
Anon	1900s	Oban: The Charing Cross of the Highlands	Argyllshire	CR/C+OR	QR			Argyllshire31	
Sherwin, Frank	1950s	Pass of Glencoe B 18947	Argyllshire	BR(ScR)	QR	Onslows	19/12/2006 Lot 413	Argyllshire02	
Wilkinson, Norman	1950s	RMS King George V at Iona	Argyllshire	BR(ScR)	QR			Argyllshire20	
Wilkinson, Norman	1925	Scotland for Holidays: Glen Coe	Argyllshire	LMS/LNER	QR	SSPL	10173772 Drawer D007	Argyllshire01	1978-9140
Macfarlane, Alasdair	1960s	See Scotland: Oban: Road to the Isles	Argyllshire	BR(ScR)	QR			Argyllshire15	
Anon	1914	The Famed Loch Eck Coaching Route	Argyllshire	GNR	DR	SSPL	10176087	Argyllshire18	1988-8062
Clark, Christopher	1930s	The Highland Games Central Games at Dunnoon	Argyllshire	LMS/LNER	QR	SSPL	10323884 Drawer D004	Argyllshire04	1986-9084
Anon	1914	The Royal Route to the Western Highlands and Islands	Argyllshire	SE & CR	DR	SSPL	10263001	Argyllshire34	
Anon	1930s	The Royal Route: Western Highlands and Islands	Argyllshire	MacBrayne	DR			Argyllshire23	
MacKenzie, Helen	1930	The Western Highlands by LNER	Argyllshire	LNER	DR			Argyllshire09	
Tripp, Herbert Alker	1936	Western Highlands	Argyllshire	LNER/LMS	DR			Argyllshire32	
Anon	1920s	Western Highlands from Kings Cross	Argyllshire	LNER	QR			Argyllshire38	
Steel, Kenneth	1958	Western Highlands near Ballachulish B21876	Argyllshire	BR(ScR)	DR			Argyllshire13	

ARTIST	YEAR	TITLE	LOCATION	COMPANY	SIZE	SOURCE	DETAIL		IMAGE REF	NRM REF
Burgess, Arthur J. W	1935	Western Highlands: Its Quicker by Rail	Argyllshire	LMS/LNER	QR	SSPL	10173440	Drawer D008	Argyllshire07	1978-8905
Haslehust, Ernest William	1935	Western Highlands: Its Quicker by Rail: Loch Long	Argyllshire	LNER/LMS	QR	SSPL	10173730	Drawer D008	Argyllshire06	1986-9275
Zinkeisen, Doris Clare	1934	Western Highlands: Rob Roy	Argyllshire	LMS/LNER	QR	SSPL	10173720	Drawer D009	Argyllshire05	1978-9118
Bore, W. Drummond	1952	Ayr Park forground: beach beyond Ref. B 4799	Ayrshire	BR(ScR)	DR				Ayrshire24	
Black, Montague Birrell	1950s	Ayr Aerial beach view Ref. B 15278	Ayrshire	BR(ScR)	DR				Ayrshire10	
Fish, Laurence	1959	Ayr for Happy Holidays: (white costume bather)	Ayrshire	BR(ScR)	DR				Ayrshire11	
Eadie, Robert	1930s	Ayr: The Land of Burns	Ayrshire	LMS	QR	SSPL	10176001	Drawer D005	Ayrshire04	1988-7976
Silas, Ellis Luciano	1950	Ayr Seafront with pavilion	Ayrshire	BR(ScR)	DR	SSPL	10151597		Ayrshire12	1979-7642
Merriott, Jack	1952	Brig O'Doon, Alloway near Ayr	Ayrshire	BR(ScR)	DR	SSPL	10174299		Ayrshire14	1994-7403
Steel, Kenneth	1953	Culzean Castle: Eisenhower's Scottish Home	Ayrshire	BR(ScR)	DR	Onslows	11/4/02 lot 401		Ayrshire03	
Sloane, James Fullarton	1920s	Girvan on the Ayrshire Coast:	Ayrshire	LMS	QR	SSPL	10176053	Drawer D004	Ayrshire18	1988-8028
Anon	1940	Girvan on the Ayrshire Seaboard	Ayrshire	LMS	QR	SSPL	10327641	Drawer D005	Ayrshire05	2001-7170
Black, Montague Birrell	1950	Largs Ayrshire: for a happy heathful holiday	Ayrshire	BR(ScR)	DR	SSPL	10171594		Ayrshire07	1979-7639
Lander, Reginald Montague	1959	Largs, Ayrshire: Gem of the Coast B25681-59/60	Ayrshire	BR(ScR)	DR				Ayrshire23	
Johnson	1950s	Largs: Ayrshire for Happy Healthful Holidays	Ayrshire	BR(ScR)	DR				Ayrshire26	
Fryer, William Marshall	1954	Largs: Gem of the Clyde B 30654	Ayrshire	BR(ScR)	DR				Ayrshire16	
Fryer, William Marshall	1950s	Largs: original poster artwork	Ayrshire	BR(ScR)	DR				Ayrshire24	
Meadows, Chris	1930s	Lively Largs: Come out of the Work-a-day World	Ayrshire	LMS	DR	SSPL	10175955	Drawer D091	Ayrshire08	1988-7930
Anon	1929	Merchants Holidays at Auchinleck:	Ayrshire	LMS	sm.					
Anon	1910s	Not a Gamble: Select the Ayrshire Coast	Ayrshire	GSWR	DR				Ayrshire19	
WCN	1930	Prestwick: Ayrshires Best Golf and Seaside Resorts	Ayrshire	LMS	QR				Ayrshire17	
Nicholson, W.C	1959	Robert Burns: Bicentenary of the Birth	Ayrshire	BR(ScR)	QR	SSPL	10170683	Drawer D024	Ayrshire15	1990-7274
Gilfillan, Tom	1935	Saltcoats by LMS	Ayrshire	LMS	QR	SSPL	10170879	Drawer D004	Ayrshire13	1989-7115
Anon	1900s	Shortest Route to Coast: Gourock-Wemyss	Ayrshire	CalRly	QR				Ayrshire27	
Wilkinson, Norman	1930s	The Birthplace of Robert Burns: Alloway Ayrshire	Ayrshire	LMS/LNER	QR	SSPL	10170885		Ayrshire01	1988-7121
Wilkinson, Norman	1930s	The Birthplace of Robert Burns: Alloway Ayrshire	Ayrshire	LMS/LNER	QR	SSPL	10173846	Drawer D006	Ayrshire01a	1986-9345
Anon	1910s	To see the Lands of Burns: Travel by MR and GSWR	Ayrshire	MR/GWSR	DR	SSPL	10175077		Ayrshire06	1978-9921
Wright, John Y.	1910s	Troon: Ideal Holiday Resort	Ayrshire	MR/GSWR	DR	SSPL	10311346		Ayrshire20	1995-7129
Anon	1940	Troon: The Popular Seaside and Golfing Resort	Ayrshire	LMS	QR				Ayrshire25	
Anon	1920s	Turnberry	Ayrshire	LMS	DR				Ayrshire21	
Anon	1910	Turnberry Hotel and Golf Courses Ayrshire	Ayrshire	GSWR	QR				Ayrshire02	
Anon	1920s	Turnberry on the Ayrshire Coast	Ayrshire	LMS	QR				Ayrshire09	
Mason, Frank Henry	1920s	Banff: Rail bridge over estuary	Banffshire	LNER	DR				Banffshire1	
Lingstrom, Freda Violet	1930	Border Country	Berwickshire	LNER	DR	SSPL	10171304	Drawer D079	Berwickshire5	1992-7783
Mason, Frank Henry	1932	Coronation on the East Coast entering Scotland	Berwickshire	LNER	QR	SSPL	10173036	Drawer D013	Berwickshire3	1975-8384
Cuneo, Terence Tenison	1948	Royal Border Bridge	Berwickshire	BR(ScR)	QR	SSPL	10170934	Drawer D023	Berwickshire2	1990-7042
Brangwyn, Sir Frank William	1924	Scotlands East Coast Route: Royal Border Bridge	Berwickshire	LNER	DR	SSPL	10170922		Berwickshire1	1990-7018

ARTIST	YEAR	TITLE	LOCATION	COMPANY	SIZE	SOURCE	DETAIL		IMAGE REF	NRM REF
Zinkeisen, Doris Clare	1937	The Coronation	Berwickshire	LNER	QR	SSPL	10176060	Drawer D015	Berwickshire4	1988-8035
Mason, Frank Henry	1923	Tweed to Esk: Salmon and Sea Trout	Berwickshire	LNER	DR	SSPL	10174617		Berwickshire6	1978-9590
Anon	1930s	Arran in Summer: Steamship tree and small boats	Buteshire	LMS	DR				Buteshire14	
Wilkinson, Norman	1930s	Arran: The holiday Isle in the Firth of Clyde	Buteshire	LMS/LNER	QR	NRM	LNER Album C11.2 -3		Buteshire13	1991-7011/3
Merriott, Jack	1956	Isle of Arran: Broddick Bay, Firth of Clyde	Buteshire	BR(ScR)	DR				Buteshire04	
Sherwin, Frank	1950	Rothesay	Buteshire	BR(ScR)	DR	SSPL	10171608		Buteshire06	1979-7653
Mason, Frank Henry	1920s	Rothesay Via East Coast Route	Buteshire	LNER	QR				Buteshire12	
Taylor, Fred	1926	Rothesay via LNER Clyde Steamers	Buteshire	LNER	QR	SSPL	10173364	Drawer D017	Buteshire01	1986-9183
Mason, Frank Henry	1950s	Rothesay: Isle of Bute	Buteshire	BR(ScR)	DR	Onslows	November 2002 Lot 355		Buteshire02	
Russell, Gyrth	1950s	Rothesay: Isle of Bute	Buteshire	BR(ScR)	DR				Buteshire08	
Houston, Robert	1926	Royal Rothesay: Holiday Capital of the Clyde Coast	Buteshire	LMS/LNER	QR	SSPL	10323882	Drawer D005	Buteshire10	1986-9336
King, Cecil	1925	Royal Rothesay: Holiday Capital of the Clyde Coast	Buteshire	LMS/LNER	QR	SSPL	10323885	Drawer D005	Buteshire07	1986-9338
Fryer, William Marshall	1950s	Royal Rothesay: Isle of Bute	Buteshire	BR(ScR)	DR				Buteshire11	
Anon	1924	Sweet Rothesay Bay	Buteshire	LMS	QR	SSPL	10170716	Drawer D005	Buteshire03	1991-7097
Wilkinson, Norman	1950s	The Ardrischaig Mail in the Kyles of Bute	Buteshire	BR(ScR)	DR				Buteshire09	
Macfarlane, Alasdair	1950s	The Clyde Coast: The Kyles of Bute	Buteshire	BR(ScR)	QR	Onslows	20/05/2003 Lot 405		Buteshire15	
Wilkinson, Norman	1934	The Clyde: Approaching Broddick, Isle of Arran	Buteshire	LMS/LNER	QR	SSPL	10173844	Drawer D006	Buteshire05	1986-9343
Anon	1910s	Moffatt: The Holiday Resort of the Lowlands	Dumfries-shire	CalRly	large				Dumfries-shire05	
Ralph & Mott (Pub)	1930	Moffatt: The Dumfries-shire Resort and Spa	Dumfries-shire	LMS	DR				Dumfries-shire04	
Wilkinson, Norman	1930	Sweetheart Abbey	Dumfries-shire	LMS	QR	SSPL	10172186	Drawer D006	Dumfries-shire01	1986-8790
Brown, P. Irwin	1930s	Clyde Coast for Holidays	Dunbartonshire	LMS	DR				Dunbartonshire14	
Mason, Frank Henry	1925	Clyde Coast: Regular Sailings by LNER Steamer	Dunbartonshire	LNER	QR	SSPL	10174063	Drawer D013	Dunbartonshire19	1978-9246
Mason, Frank Henry	1931	Clyde Coast: Sailings by LNER Steamer:	Dunbartonshire	LNER	QR	SSPL	10173379	Drawer D013	Dunbartonshire18a	1986-9191
Mason, Frank Henry	1931	Clyde Coast: Sailings by LNER Steamer:	Dunbartonshire	LNER	QR	SSPL	10174064	Drawer D013	Dunbartonshire18	1986-9191
Mason, Frank Henry	1950s	Cruising on the Firth of Clyde	Dunbartonshire	BR(ScR)	QR				Dunbartonshire13	
Cuneo, Terence Tenison	1960	Glasgow Electric. Travel the Modern Railway B29211	Dunbartonshire	BR(ScR)	QR	SSPL	10171291	Drawer D024	Dunbartonshire09a	1992-7763
Cuneo, Terence Tenison	1960	Glasgow Electric. Travel the Modern Railway B29211	Dunbartonshire	BR(ScR)	QR	SSPL	10324602	Drawer D024	Dunbartonshire09	1989-7134
Templeton	1920s	Helensburgh: Attractive Clyde Coast Resort	Dunbartonshire	LNER	DR	SSPL	10174439	Drawer D079	Dunbartonshire01	1987-8959
Mason, Frank Henry	1946	Helensburgh: on the Clyde Coast: Its quicker by Rail	Dunbartonshire	LNER	DR	SSPL	10174556		Dunbartonshire02	1978-9529
Mason, Frank Henry	1935	Holiday on the Clyde Coast Steamer & Islands	Dunbartonshire	LNER	QR	SSPL	10174087	Drawer D013	Dunbartonshire20	1978-9270
Mason, Frank Henry	1935	Holiday on the Clyde Coast Steamer & Yatchs	Dunbartonshire	LNER	QR	NRM	1978-9272	Drawer D005	Dunbartonshire21	1978-9272
Mason, Frank Henry	1935	Holiday on the Clyde Coast Steamer at the Pier	Dunbartonshire	LNER	QR	NRM	1986-9193	Drawer D013	Dunbartonshire22	1986-9193
Wilkinson, Norman	1928	Loch Lomond	Dunbartonshire	LMS/LNER	QR	SSPL	10171777	Drawer D007	Dunbartonshire06	1979-7822
Macfarlane, Alasdair	1960	Loch Lomond Daily Pleasure Sailings During the Season	Dunbartonshire	BR(ScR)	DR				Dunbartonshire12	
Macfarlane, Alasdair	1959	Loch Lomond: The Maid of the Loch Ref. B 11759	Dunbartonshire	BR(ScR)	QR	SSPL	10170912	Drawer D024	Dunbartonshire07	1989-7203
Patrick, J. McIntosh	1930s	Loch Lomond: Scotland for holidays	Dunbartonshire	LMS/LNER	QR	SSPL	10319223	Drawer D008	Dunbartonshire03	1978-8983
Merriott, Jack	1950s	On the Route of the Trossachs Tour Ben View	Dunbartonshire	BR(ScR)	DR	Onslows	20/06/06 lot 388		Dunbartonshire05	

ARTIST	YEAR	TITLE	LOCATION	COMPANY	SIZE	SOURCE	DETAIL		IMAGE REF	NRM REF
Anon	1920s	Scotland by LMS - Artwork for Tarbet	Dunbartonshire	LMS	DR				Dunbartonshire24	
Anon	1910	Tarbet, Loch Lomond	Dunbartonshire	NBR	DR	SSPL	10170703		Dunbartonshire25	1991-7084
Nicholson, W.C	1954	The Bonnie Bonnie Banks of Loch Lomond	Dunbartonshire	BR(ScR)	DR				Dunbartonshire10	
Nicholson, W.C	1954	The Bonnie Bonnie Banks of Loch Lomond	Dunbartonshire	BR(ScR)	DR				Dunbartonshire17	
Wilkinson, Norman	1948	The Clyde at the Entrance to Loch Long	Dunbartonshire	BR(ScR)	QR				Dunbartonshire23	
McCorquodale Studios	1920s	The Clyde Coast: Scotlands Holiday Playground	Dunbartonshire	LMS/LNER	DR				Dunbartonshire15	
WCN	1929	The George Bennie Railplane	Dunbartonshire	LNER	QR	SSPL	10173073	Drawer D008	Dunbartonshire11	1976-9220
DNA	1920	The Tarbet Hotel, Loch Lomond: Tarbet village	Dunbartonshire	Caledonian	DR	SSPL	10170700	Drawer D001	Dunbartonshire04	1991-7081
Anon	1910s	Trossachs, Loch Katrine and Loch Lomons	Dunbartonshire	Tourist poster	DR	NRM	1986-9136		Dunbartonshire16	1986-9136
Newbould, Frank	1927	Dunbar Pool from cliffs	East Lothian	LNER	DR	SSPL	10170738	Drawer D079	East Lothian04	1991-7120
Simmons, Graham	1924	Dunbar (swimming pool)	East Lothian	LNER	DR	SSPL	10174432	Drawer D077	East Lothian05	1987-8952
Lander, Eric	1920s	Dunbar: Largest swimming pool in Scotland	East Lothian	LNER	DR	SSPL	10174413	Drawer D077	East Lothian06	1987-8933
Newbould, Frank	1923	North Berwick famous golf image	East Lothian	LNER	QR	SSPL	10173537	Drawer D008	East Lothian01	1986-9222
Brangwyn, Sir Frank William	1932	North Berwick for Tantallon Castle	East Lothian	LNER	QR	SSPL	10173567	Drawer D010	East Lothian02	1986-9233
Johnson, Andrew	1920s	North Berwick: golfing party red caption	East Lothian	LNER	QR	SSPL	10173737	Drawer D010	East Lothian08	1986-9282
Johnson, Andrew	1930s	North Berwick: Its Quicker by Rail golf blue caption	East Lothian	LNER	QR	SSPL	10173745	Drawer D010	East Lothian07	1986-9290
Patrick, J. McIntosh	1930s	North Berwick: Its Quicker by Rail Costal view	East Lothian	LNER	QR	NRM	LNER Album c11.2-1		East Lothian09	1991-7011/1
Anon	1910s	The Beauties of Scotland	East Lothian	NBR	QR				East Lothian03	
Mason, Frank Henry	1929	Bo'ness: On South Side of Firth of Forth	Fifeshire	LNER	DR	SSPL	10176117		Fifeshire07	1994-8534
Gawthorne, Henry George	1984	British Open Golf Championship: TV Asahi poster	Fifeshire	TV Asahi	DR	SSPL	10172916		Scotadvert07	1984-8239
Mason, Frank Henry	1923	Burntisland, Near the Rich Fifeshire Coalfields	Fifeshire	LNER	DR	SSPL	10324057		Fifeshire01	1995-7047
Steel, Kenneth	1960	Dunfermline	Fifeshire	BR(ScR)	DR				Dunfermline10	
Patrick, J. McIntosh	1948	Dunfermline Abbey in grey in background	Fifeshire	BR(ScR)	DR	SSPL	10170940		Dunfermline04	1990-7048
Praill, R.G.	1932	Dunfermline Grey foreground Abbey in orange	Fifeshire	LNER	DR	SSPL	10174424	Drawer D057	Dunfermline05	1987-8945
Castle, Tony	1925	Dunfermline Park in foreground - Abbey beyond	Fifeshire	LNER	DR				Dunfermline09	
Taylor, Fred	1936	Dunfermline Abbey	Fifeshire	LNER	QR	SSPL	10173360	Drawer D017	Dunfermline07	1986-9181
Mason, Frank Henry	1931	Dunfermline for interesting holidays	Fifeshire	LNER	DR	SSPL	10174367		Dunfermline06	1987-8887
Blake, Frederick Donald	1950s	Dunfermline: gardens and abbey	Fifeshire	BR(ScR)	DR				Dunfermline08	
Steel, Kenneth	1959	Dunfermline: Abbey and Pittencrieff Park	Fifeshire	BR(ScR)	DR	SSPL	10171596		Dunfermline01	1979-7641
Anon (SIGNED)	1930s	Dunfermline: its Quicker by Rail	Fifeshire	LNER	DR	NRM	LNER Album C11.2 - 3		Dunfermline11	1991-7011/3
Taylor, Fred	1930s	Dunfermline: Its Quicker by Rail	Fifeshire	LNER	DR	SSPL	10174351		Dunfermline02	1987-8869
Carstairs, J.L.	1930s	Elie and Earlsferry	Fifeshire	LNER	DR				Fifeshire09	
Buckle, Claude	1955	Falkland Palace: see Britain by Train B24736	Fifeshire	BR(ScR)	DR	SSPL	10311542		Fifeshire08	1997-9268
Lingstrom, Freda Violet	1930	Fife and Forfar: 3 witches	Fifeshire	LNER	DR	SSPL	10171306	Drawer D079	Fifeshire02	1992-7785
Photographic	1970s	Have you Tried the Snack Bar	Fifeshire	BR Travellers Fare	DR				Fifeshire16	
Gawthorne, Henry George	1920s	Over the Forth to the North famous blue image	Fifeshire	LNER	QR	Onslows	27/6/07 Lot 207		Forth Bridge04a	
McKenzie, Alison	1950	St. Andrews	Fifeshire	BR(ScR)	DR				Fifeshire11	

ARTIST	YEAR	TITLE	LOCATION	COMPANY	SIZE	SOURCE	DETAIL		IMAGE REF	NRM REF
Taylor, Fred	1930s	St. Andrews	Fifeshire	LNER	QR	SSPL	10174066	Drawer D017	Fifeshire15	1978-9249
Mason, Frank Henry	1950s	St. Andrews: Coastline, foliage red beach brolly front	Fifeshire	BR(ScR)	DR	SSPL	10171606		Fifeshire10	1979-7651
Patrick, J. McIntosh	1957	St. Andrews: Golf links clubhouse B28528	Fifeshire	BR(ScR)	DR	SSPL	10170764		Fifeshire05	1991-7148
Taylor, Fred	1930s	St. Andrews: Home of the R+A The Castle	Fifeshire	LNER	QR				Fifeshire12	
Gawthorne, Henry George	1927	St. Andrews: Home of the Royal & Ancient game	Fifeshire	LNER	QR	SSPL	10173408	Drawer D008	Fifeshire06	1978-8877
Michael, Arthur C.	1939	St. Andrews: Home of the Royal & Ancient game	Fifeshire	LNER	QR	SSPL	10173391	Drawer D008	Fifeshire03	1978-8862
Michael, Arthur C.	1939	St. Andrews: Home of the Royal & Ancient game	Fifeshire	LNER	QR	SSPL	10174125	Drawer D009	Fifeshire03a	1978-9308
Anon	1920s	St. Andrews: Home of the Royal & Ancient Golf	Fifeshire	LNER	QR				Fifeshire18	
Taylor, Fred	1930s	St. Andrews: Its quicker by rail	Fifeshire	LNER	QR				Fifeshire15a	
Dunlop, Gilbert	1960s	St. Andrews: the City Gate	Fifeshire	BR(ScR)	DR				Fifeshire13	
Mason, Frank Henry	1954	The Fife Coast: Largo B13737	Fifeshire	BR(ScR)	DR				Fifeshire17	
Thomson, A.R.	1925	Then and Now: 600 Golf Courses on the LNER	Fifeshire	LNER	DR				Scotadvert33a	
Anon	1910s	Ecosse: Loch Coruisk, Skye	Inner Hebrides	LNWR	DR	Onslows	20/06/06 Lot 362		IsleofSkye08	
Anon	1920s	Fingals Cave: The Royal Route	Inner Hebrides	MacBrayne	DR				InnerHebrides12	
Gilfillan, Tom	1928	Iona See this Scotland by Macbraynes steamers	Inner Hebrides	LMS	DR	SSPL	10171774	Drawer D091	Inner Hebrides07	1979-7819
Neiland, Brendan	1996	Isle of Skye by Train: modern mountain image	Inner Hebrides	Scotrail	DR	NRM	1996-7267	Drawer D058	IsleofSkye07	1996-7267
Cooper, Austin	1920s	Isle of Skye First Class Hotels: travel via Mallaig	Inner Hebrides	LNER	QR	SSPL	10173595	Drawer D010	IsleofSkye01	1986-9248
Lingstrom, Freda Violet	1932	Isle of Skye: Flora MacDonald and the Prince	Inner Hebrides	LNER	DR	SSPL	10170735	Drawer D079	InnerHebrides03	1991-7117
Schabelsky	1923	Isle of Skye: First Class Hotels; mountain stream	Inner Hebrides	LNER	DR	SSPL	10174514	Drawer D077	IsleofSkye02	1978-9496
Bell, J. Torrington	1939	Isle of Skye: Its quicker by Rail:	Inner Hebrides	LMS/LNER	DR	SSPL	10174377		IsleofSkye05	1987-8897
Praill, R.G.	1920s	Isle of Skye: Scotland by LMS Via Kyle	Inner Hebrides	LMS	DR	Onslows	17/05/2001 Lot 962		IsleofSkye03	
Clegg	1960	Isle of Skye: Travel by Rail Go north this year	Inner Hebrides	BR(ScR)	DR	SSPL	10171599		IsleofSkye04	1979-7644
Steel, Kenneth	1956	Over the Sea to Skye	Inner Hebrides	BR(ScR)	DR				Inner Hebrides04	
Gilfillan, Tom	1930	Scotland Its Highland and Islands: Iona North End	Inner Hebrides	LMS/MacBr.	DR				Inner Hebrides10	
Gilfillan, Tom	1950s	Scotland: Its Highlands and Islands: Off Staffa	Inner Hebrides	MacBrayne	QR				Inner Hebrides09	
Gilfillan, Tom	1930s	Scotland: Its Highlands and Islands:	Inner Hebrides	MacBrayne	QR				Inner Hebrides11	
Macfarlane, Alasdair	1950s	See Scotlands Western Highlands and Islands:	Inner Hebrides	BR/MacB	DR				InnerHebrides16	
Gilfillan, Tom	1930s	Staffa, Fingals Cave	Inner Hebrides	LMS/MacBr.	QR	SSPL	10322926	Drawer D004	Inner Hebrides06	1996-7353
Macleod, William Douglas	1930s	The Coolins Isle of Skye: via Mallaig or Kyle	Inner Hebrides	LMS/LNER	QR				InnerHebrides15	
Hunt, C.A.	1930s	The Coolins: Isle of Skye	Inner Hebrides	LMS/LNER	DR				InnerHebrides08	
Macfarlane, Alasdair	1968	The Fast Route to Skye: RMS Loch Seaforth at Skye	Inner Hebrides	MacB/BR	DR				IsleofSkye6	
Wilkinson, Norman	1930	The Isle of Skye from the Kyle of Lochalsh	Inner Hebrides	LMS	QR				Inner Hebrides05	
Anon	1920s	The Tour For You: Travel by LMS:	Inner Hebrides	LMS	DR	SSPL	10171391	Drawer D091	InnerHebrides14	1994-7190
Gilfillan, Tom	1930s	The Western Isles: To Join these Cruises Travel LMS	Inner Hebrides	LMS/MacBr.	QR				Inner Hebrides13	
Wilkinson, Norman	1930s	Tobermory in the Western Isles	Inner Hebrides	LMS/LNER	QR	SSPL	10173777	Drawer D007	Inner Hebrides01	1978-9143
Macfarlane, Alasdair	1960s	Tobermory Isle of Mull PD/19/8	Inner Hebrides	MacbBrayne	DR					
Anon	1973	A Line for All Seasons	Inverness-shire	BR(ScR)	DR	SSPL	10171601		Scotadvert46	1979-7646

ARTIST	YEAR	TITLE	LOCATION	COMPANY	SIZE	SOURCE	DETAIL	IMAGE REF	NRM REF
Clegg	1955	Ben Nevis: Britains highest mountain:	Inverness-shire	BR(ScR)	QR			Inverness-shire21	
Merriott, Jack	1950	Ben Nevis: Western Highlands	Inverness-shire	BR(ScR)	DR			Inverness-shire25	
Cuneo, Terence Tenison	1950s	By Rail to the Highlands	Inverness-shire	BR(ScR)	DR			Inverness-shire23	
Anon	1996	Courour: You sail here fly here or drive here	Inverness-shire	Scotrail	Long	SSPL	10326645	Inverness-shire11	1998-9614
Johnson, Grainger	1923	Fort William by the East Coast Route	Inverness-shire	LNER	QR	SSPL	10174119 Drawer D008	Inverness-shire36	1978-9302
Neiland, Brendan	1996	Glenfinnan by Train	Inverness-shire	Scotrail	DR	NRM	1996-7270 Drawer D058	Inverness-shire33	1996-7270
Anon	1960	Glenfinnan Viaduct Original artwork	Inverness-shire	BR Exec	QR	SSPL	10174112 Drawer D024	Inverness-shire08	1978-9295
Mason, Frank Henry	1931	Havens and Harbours on the LNER: No. 6 Mallaig	Inverness-shire	LNER	DR	SSPL	10170736	Inverness-shire01	1991-7118
Wilkinson, Norman	1930s	Inverness sunset river scene	Inverness-shire	LMS/LNER	QR	SSPL	10173403 Drawer D007	Inverness-shire35a	1978-8872
Wilkinson, Norman	1930s	Inverness sunset river scene	Inverness-shire	LMS/LNER	QR	SSPL	10174000 Drawer D006	Inverness-shire35	1978-9183
Cattermole, Lance Harry Moss	1950s	Inverness: Capital of the Scottish Highlands:	Inverness-shire	BR(ScR)	QR			Inverness-shire24	
Dundas, Gill	1924	Inverness:The Capital of the Highlands for Holidays	Inverness-shire	LMS	DR			Inverness-shire31	
Steel, Kenneth	1950s	Loch Ness: Urquart Castle	Inverness-shire	BR(ScR)	DR			Inverness-shire26	
Neiland, Brendan	1996	Loch Shiel by Train modern image	Inverness-shire	Scotrail	DR	NRM	1996-7268 Drawer D058	Inverness-shire34	1996-7288
Macleod, William Douglas	1950s	Loch Shiel: Monument at Glenfinnan	Inverness-shire	BR(ScR)	DR			Inverness-shire19	
Neiland, Brendan	1996	Nevis Range by Train	Inverness-shire	Scotrail	DR	NRM	1996-7269 Drawer D058	Inverness-shire32	1996-7269
Mason, Frank Henry	1926	Remember the Western Highlands:	Inverness-shire	LNER	DR	NRM	LNER album C11.2 -1 1991-7011/1	Inverness-shire50	1991-7011/1
Wilkinson, Norman	1920s	Scotland by LMS: Strathspey and Aviemore	Inverness-shire	LMS	QR			Inverness-shire17	
Nicholls, George	1924	Scotland by LMS: The Highlands in Winter	Inverness-shire	LMS	QR	SSPL	10175960 Drawer D005	Inverness09	1988-7935
Newbould, Frank	1935	Scotland by LNER: Fort William	Inverness-shire	LNER	QR	SSPL	10173395 Drawer D014	Inverness-shire37	1978-8865
Newbould, Frank	1920s	Scotland by LNER: Fort William	Inverness-shire	LNER	QR	SSPL	10174039 Drawer D014	Inverness-shire37a	1978-9222
Broadhead, W. Smithson	1930s	Scotland For Holidays: Climbing in the Cairngorms	Inverness-shire	LMS/LNER	DR			Inverness-shire16	
Anon	1920s	Scotlands Highest Resorts: Spey Valley	Inverness-shire	LMS/LNER	QR			Scotadvert43	
Paton, John	1987	Steam in the Highlands: Aviemore and Boat of Garten	Inverness-shire	Strathspey Rail	DR	SSPL	10173974	Scotadvert04	1987-8819
Train, Thomas	1948	The Cairngorm Mountains	Inverness-shire	BR(ScR)	QR	SSPL	10170889 Drawer D024	Inverness-shire22	1989-7126
Cuneo, Terence Tenison	1950s	The Highlands: Monessie Gorge	Inverness-shire	BR(ScR)	DR	SSPL	10170897	Inverness-shire23	1989-7134
Neilland, Brendan	1996	The Nevis Range by Train	Inverness-shire	Scotrail	DR			Inverness-shire32	
Cameron, Sir David Young	1923	The Scottish Highlands	Inverness-shire	LMS	QR	SSPL	10173495 Drawer D004	Inverness-shire15	1978-8955
Macleod, William Douglas	1950s	The West Highland Line near Arisaig	Inverness-shire	BR(ScR)	DR			Inverness-shire18	
Anon	1970s	The West Highland Line: A Line for all Seasons	Inverness-shire	BR(ScR)	DR	NRM	83/38/354	Inverness-shire28	
Merriott, Jack	1959	The West Highland Line: See Britain by Train: B30521	Inverness-shire	BR(ScR)	QR	SSPL	10173788 Drawer D024	Inverness-shire12	1978-9154
Cooper, Austin	1920s	The Western Highlands	Inverness-shire	LNER	QR			Inverness-shire30	
Lamorna Birch, Samuel John	1939	The Western Highlands	Inverness-shire	LMS/LNER	QR	SSPL	10173813 Drawer D012	Inverness-shire07	1986-9304
Mace, John Edmund	1930	The Western Highlands	Inverness-shire	LNER	QR	SSPL	10324288 Drawer D012	Inverness-shire20	1986-9367
Anon	1950s	The Western Highlands and islands	Inverness-shire	BR(ScR)	DR			Scotadvert19	
Greiffenhagen, Maurice Willia	1930	The Western Highlands by LNER:	Inverness-shire	LNER	QR			Inverness-shire27	
Greiffenhagen, Maurice Willia	1930	The Western Highlands by LNER:	Inverness-shire	LNER	QR	NRM	1978-9095 Drawer D009 + 1978-9121	Inverness-shire27a	1978-9095

ARTIST	YEAR	TITLE	LOCATION	COMPANY	SIZE	SOURCE	DETAIL		IMAGE REF	NRM REF
Gilfillan, Tom	1930	The Western Highlands of Scotland	Inverness-shire	LMS	DR	SSPL	10323864	Drawer D091	Inverness-shire03	1986-8803
Rodmell, Harry Hudson	1920s	The Western Highlands of Scotland:	Inverness-shire	LMS	DR	SSPL	10172216	Drawer D091	Inverness-shire04	1986-8806
Halliday, Edward Irvine	1948	The Western Highlands: See Scotland by Rail	Inverness-shire	BR(ScR)	QR	SSPL	10174128	Drawer D024	Inverness-shire14	1978-9311
Mason, Frank Henry	1935	The Western Highlands: Travel by LNER	Inverness-shire	LNER	QR	SSPL	10173441	Drawer D013	Inverness-shire05	1978-8906
Gilfillan, Tom	1930s	Travel LMS on the Caledonian Canal	Inverness-shire	LMS/MacBr.	DR	SSPL	10172214	Drawer D092	Inverness-shire02	1986-8804
Anon	1983	West Highland Line: A line for all seasons	Inverness-shire	BR Exec	DR	NRM	1983-8590		Inverness-shire28	1983-8590
Anon	1983	West Highland Line: A line for all seasons	Inverness-shire	BR Exec	DR	SSPL	10172813		Inverness-shire39	1983-8590
Photographic	2000	West Highland Line: Days out on the world famous line	Inverness-shire	Scotrail	DR	NRM	2001-8501	Drawer D327	Advert 801	2001-8501
Mason, Frank Henry	1939	Western Highlands by East Coast Route Landing	Inverness-shire	LNER	QR	SSPL	10174103	Drawer D013	Inverness-shire13	1978-9286
Anon	1910s	Western Highlands of Scotland: Ben Nevis	Inverness-shire	NBR	QR	SSPL	10172273		Inverness-shire29	1986-8863
Malet, Guy	1930s	Western Highlands: Its quicker by Rail	Inverness-shire	LMS/LNER	QR				Inverness-shire06a	
Malet, Guy	1930s	Western Highlands: Its quicker by Rail	Inverness-shire	LMS/LNER	QR	SSPL	10173564	Drawer D008	Inverness-shire06	1978-9000
Patrick, J. McIntosh	1939	Dunnottar Castle: Stonehaven Station:	Kincardineshire	LMS/LNER	QR	SSPL	10175950	Drawer D012	Kincardineshire01	1986-9316
Patrick, J. McIntosh	1956	Loch Leven, Swan on loch Ref 17068	Kinross-shire	BR(ScR)	DR				Kinross-shire1	
Wilkinson, Norman	1927	Galloway: The Southern Highlands of Scotland	Kirkcudbrightshire	LMS	QR	SSPL	10173785	Drawer D006	Kirkcudbrightshire04	1978-9151
Wilkinson, Norman	1927	Scotland for Holidays: Fishing in New Galloway	Kirkcudbrightshire	LMS/LNER	QR	SSPL	10173848	Drawer D006	Kirkcudbrightshire02	1986-9347
Oppenheimer, Charles	1950s	South West Scotland: The Galloway Dee	Kirkcudbrightshire	BR(ScR)	QR				Kirkcudbrightshire03	
Oppenheimer, Charles	1955	The Galloway Coast: Sandgreen Bay	Kirkcudbrightshire	BR(ScR)	DR				Kirkcudbrightshire05a	
Oppenheimer, Charles	1948	The Solway Coast: Kippford B211877	Kirkcudbrightshire	BR(ScR)	QR	SSPL	10170772	Drawer D024	Kirkcudbrightshire06	1991-7156
Wilkinson, Norman	1925	British Industries: Shipbuilding	Lanarkshire	LMS	QR				Lanarkshire07	
Jackson, Pilkington	1929	David Livingston Memorial	Lanarkshire	LMS	QR				Lanarkshire11	
Taylor, Fred	1938	Empire Exhibition Glasgow May-October 1938	Lanarkshire	BR Exec	DR	Onslows	3/1/1999 lot 302			
Anon	1976	Inter City: Glasgow shops, coastal lights	Lanarkshire	BR(ScR)	DR	NRM	1979-7660		Lanarkshire10	1979-7660
Wilkinson, Norman	1935	Lanarkshire Steel works	Lanarkshire	LMS/LNER	QR	SSPL	10174012	Drawer D006	Lanarkshire01	1978-9195
Photographic	1930s	North British Station Hotel Glasgow	Lanarkshire	LNER	DR	NRM	1994-8037	Drawer D077	Lanarkshire04	1994-8037
Keely, Patrick Cockayne	1958	Race Specials to Bogside: Jockey cameo	Lanarkshire	BR(ScR)	DR					
Schabelsky	1930s	Rambles around Glasgow	Lanarkshire	LNER	DR	NRM	LNER album C11.2 -3 1991-7011/3		Lanarkshire12	1991-7011/3
WTN	1938	Seeing Glasgow by tram and bus	Lanarkshire	Council Ad	DR				Lanarkshire08	
Macfarlane, Alasdair	1954	Service to Industry: Ore discharge terminus, Glasgow	Lanarkshire	BR(ScR)	QR	SSPL	10171373	Drawer D024	Lanarkshire02	1994-7172
Hepple, Robert Norman	1950s	Service to Industry: Shipbuilding AR 1114	Lanarkshire	BR Exec	QR	SSPL	10174069	Drawer D023	Lanarkshire06	1978-9252
Wilkinson, Norman	1930s	Shipbuilding on the Clyde	Lanarkshire	LMS/LNER	QR	SSPL	10174312	Drawer D006	Lanarkshire03	1994-7416
Anon	1980	Strathclyde Day Transcard	Lanarkshire	Scotrail		NRM	1983-8588			1983-8588
Mason, Frank Henry	1924	The Basin, Dalmuir, Glasgow BEExib. Etching	Lanarkshire	Artwork	DR	SSPL	10418372		Lanarkshire05	1981-0245
Photographic	1920s	The North British Hotel, Glasgow	Lanarkshire	LNER	DR	SSPL	10176152	Drawer D079	Lanarkshire04	1994-8636
DNA	1912	An Outlook from the Caledonian Station Hotel	Midlothian	Caledonian	DR				Edinburgh34	
Taylor, Fred	1930	Chapel of the Thistle, St. Giles Cathedral	Midlothian	LMS/LNER	QR	SSPL	10173459	Drawer D017	Edinburgh08	1978-8921
Clark, Christopher	1935	Ecosse: Passez vos vacances	Midlothian	LMS/LNER	DR				Edinburgh25	

ARTIST	YEAR	TITLE	LOCATION	COMPANY	SIZE	SOURCE	DETAIL	IMAGE REF	NRM REF
Patrick, J. McIntosh	1960	Edinburgh photo-type image from castle	Midlothian	BR(ScR)	DR	SSPL	10171603	Edinburgh06	1979-7648
Henry, George	1934	Edinburgh View from Calton Hill	Midlothian	LMS	QR	SSPL	10173496 Drawer D005	Edinburgh01a	1978-8956
Neilland, Brendan	1991	Edinburgh : modern abstract	Midlothian	Scotrail	DR	SSPL	10308301	Edinburgh29	1997-8436
Anon	1920s	Edinburgh by East Coast Route: Calton Hill Ruins	Midlothian	LNER	QR	NRM	1978-9274 and 9275 Drawer D013	Edinburgh37a	1978-9274
Taylor, Fred	1930	Edinburgh by LNER: The Palace of Holyroodhouse	Midlothian	LNER	QR	SSPL	10173461 Drawer D018	Edinburgh18	1978-8866
van Anrooy, Anton Abraham	1929	Edinburgh by the East Coast Route: The Castle	Midlothian	LNER	QR	SSPL	10324287 Drawer D015	Edinburgh05	1986-9366
Anon	1953	Edinburgh International Festival of Music + Drama	Midlothian	BR(ScR)	DR	SSPL	10174784	Edinburgh32	1987-9099
Mason, Frank Henry	1930s	Edinburgh on the LNER Princes Street gardens	Midlothian	LNER	DR	Onslows	11/4/02 lot 400	Edinburgh13	
Berry, J.	1951	Edinburgh See Scotland by Rail :Pipe Band	Midlothian	BR(ScR)	DR			Edinburgh16	
Praill, R.G.	1930s	Edinburgh Served Directly by LMS	Midlothian	LMS	DR	NRM	1987-9174 Drawer D091	Edinburgh11a	1987-9174
Anon	1910s	Edinburgh Through the Beautiful Waverley District	Midlothian	Midland Rly	QR	SSPL	10170778	Scotadvert13	1991-7253
Taylor, Fred	1929	Edinburgh Travel by East Coast Route The Scottish War	Midlothian	LNER	QR	SSPL	10173463 Drawer D017	Edinburgh22	1978-8925
Taylor, Fred	1930	Edinburgh Travel by East Coast Route: Holyrood Palace	Midlothian	LNER	QR	SSPL	10173511 Drawer D017	Edinburgh20	1978-8968
Taylor, Fred	1920s	Edinburgh: buildings in Royal Mile	Midlothian	LNER	DR	SSPL	10174310	Edinburgh07	1994-7414
Brown, P. Irwin	1930	Edinburgh: Single piper castle behind	Midlothian	LMS	DR			Edinburgh34	
Lee, Kerry	1955	Edinburgh: Pictorial of Castle + Royal Mile B16144	Midlothian	BR(ScR)	QR	SSPL	10172885 Drawer D024	Edinburgh26	1984-8208
Cattermole, Lance Harry Moss	1950s	Edinburgh: Scots Guards along Princes Sreet	Midlothian	BR Exec	Large			Edinburgh15	
Watts, Arthur George	1930	Edinburgh: Athens of the North	Midlothian	LMS	DR			Edinburgh37	
Watts, Arthur George	1930	Edinburgh: Athens of the North waiting room	Midlothian	LMS	sm.			Edinburgh30	
Taylor, Fred	1930	Edinburgh: Inside St. Giles Cathedral (sepia colours)	Midlothian	LNER	QR	SSPL	10173464 Drawer D017	Edinburgh21	1978-8926
Michael, Arthur C.	1934	Edinburgh: Its quicker by Rail Princes Street	Midlothian	LMS/LNER	QR			Edinburgh09a	
Michael, Arthur C.	1934	Edinburgh: Its quicker by Rail Princes Street	Midlothian	LMS/LNER	QR	SSPL	10173862 Drawer D015	Edinburgh09	1986-9361
Michael, Arthur C.	1934	Edinburgh: Its quicker by Rail Princes Street	Midlothian	LMS/LNER	QR	SSPL	10176056 Drawer D015	Edinburgh09	1988-8031
Hohlwein, Ludwig	1933	Edinburgh: Its quicker by Rail superb classic image	Midlothian	LMS	QR	Onslows	05/03 lot 446	Edinburgh02b	
Hohlwein, Ludwig	1933	Edinburgh: Its quicker by Rail superb classic image	Midlothian	LMS/LNER	QR	SSPL	10173210 Drawer D010	Edinburgh02	1986-9085
Hohlwein, Ludwig	1933	Edinburgh: Its quicker by Rail superb classic image	Midlothian	LMS/LNER	QR	SSPL	10173655 Drawer D008	Edinburgh02a	1978-9053
Rushbury, Henry	1934	Edinburgh: Its quicker by Rail superb classic image	Midlothian	LMS/LNER	QR	SSPL	10173619 Drawer D008	Edinburgh03	1978-9017
Rushbury, Henry	1934	Edinburgh: Its quicker by Rail superb classic image	Midlothian	LNER	QR	SSPL	10173699 Drawer D009	Edinburgh03a	1978-9097
Taylor, Fred	1930s	Edinburgh: Its quicker by Rail Edinburgh Castle	Midlothian	LNER	DR	NRM	LNER Album C11.2 - 1	Edinburgh38	1991-7011/1
Rushbury, Henry	1934	Edinburgh: Its quicker by Rail view from NB hotel	Midlothian	LMS/LNER	QR			Edinburgh03a	
Taylor, Fred	1929	Edinburgh: John Knox House	Midlothian	LNER	DR			Edinburgh36	
Hislop, Healy	1930s	Edinburgh: Scotlands Historic Capital	Midlothian	LMS	QR	Onslows	11/6/04 lot 280	Edinburgh12	
Steel, Kenneth	1955	Edinburgh: See Scotland by Rail	Midlothian	BR(ScR)	DR			Edinburgh27	
Buckle, Claude	1950s	Edinburgh: See Scotland by Train: Scott Memorial	Midlothian	BR(ScR)	DR	SSPL	10172224	Edinburgh10	1986-8814
Buckle, Claude	1950s	Edinburgh: See Scotland by Train: Scott Memorial	Midlothian	BR(ScR)	DR	Onslows	19/12/2006 Lot 261	Edinburgh10a	
Praill, R.G.	1930s	Edinburgh: Served Directly by LMS	Midlothian	LMS	DR	Onslows	19/12/06 Lot 393	Edinburgh11	
Wollen, W.B.	1920s	Edinburgh: The Royal Mile and Queen Mary	Midlothian	LNER	DR	Onslows	20/06/06 Lot 386	Edinburgh14	

ARTIST	YEAR	TITLE	LOCATION	COMPANY	SIZE	SOURCE	DETAIL	IMAGE REF	NRM REF
Wollen, W.B.	1920s	Edinburgh: The Royal Mile Travel by LNER	Midlothian	LNER	DR			Edinburgh14b	
Taylor, Fred	1930s	Edinburgh: The Scott Monument	Midlothian	LMS/LNER	DR			Edinburgh28	
Newbould, Frank	1935	Edinburgh: Travel by LNER Mons Meg	Midlothian	LNER	QR	SSPL	10173792 Drawer D014	Edinburgh04	1978-9158
Wilkinson, Norman	1931	Fettes Cottage, Edinburgh	Midlothian	LMS	DR	SSPL	10174163 Drawer D091	Edinburgh24	1978-9346
Anon	1996	Newhaven, Edinburgh	Midlothian	Scotrail	DCr.	NRM	1998-9607 285mm x 610mm	Midlothian2	1998-9607
Nicoll, Gordon	1932	North British Station Hotel Edinburgh drawing room	Midlothian	LNER	DR	SSPL	10316356 Drawer D077	Edinburgh36	1999-7313
Michael, Arthur C.	1930s	North British Station Hotel, Edinburgh dining room	Midlothian	LNER	DR			Edinburgh33	
Mason, Frank Henry	1924	Port of Leith: Scotland's Principal East Coast Port	Midlothian	LNER	DR			Midlothian1	
Schabelsky	1930s	Rambles around Edinburgh	Midlothian	LNER	DR	NRM	LNER album C11.2 -3 1991-7011/3	Edinburgh39	1991-7011/3
Anon	1950s	See Britain by Train series: Edinburgh cas/mon	Midlothian	BR(ScR)	DR				
Cooper, Austin	1933	The Booklovers Britain: Edinburgh	Midlothian	LNER	DR			Edinburgh17	
Cooper, Austin	1933	The Booklovers Britain: Edinburgh	Midlothian	LNER	DR	SSPL	10174213	Edinburgh17	1978-9396
Mason, Frank Henry	1950s	The Flying Scotsman: A4 and Scott Monument	Midlothian	BR(ER)	DR	NRM	1997-9270 Drawer D154	Edinburgh31	1997-9270
Taylor, Fred	1920s	The North British Hotel, Waverley Station	Midlothian	LNER	QR	SSPL	10327659 Drawer D017	Edinburgh19	1996-7352
Buckle, Claude	1950	The Palace of Holyroodhouse ref. B 21874	Midlothian	BR(ScR)	QR	SSPL	10319229 Drawer D024	Edinburgh23	1997-9267
Merriott, Jack	1950s	Elgin Cathedral Ref B. 32992	Morayshire	BR(ScR)	DR			Morayshire05	
Mason, Frank Henry	1920s	Lossiemouth	Morayshire	LNER	DR	SSPL	10174369	Morayshire02	1987-8889
DNA	1910s	Moray Firth Coast (2 posters as panorama)	Morayshire	GNSR	QR			Morayshire06	
Lamorna Birch, Samuel John	1928	Nairn (Moray Firth) All year round Resort	Morayshire	LMS	QR	NMSI	1997-7409-LMS-4470	Morayshire08	
Merriott, Jack	1950s	River Findhorn near Forres Ref. B. 32991	Morayshire	BR(ScR)	DR			Morayshire01	
Mason, Frank Henry	1954	The Moray Coast: Findhorn Bay	Morayshire	BR(ScR)	DR			Morayshire03,3a	
Littlejohns, John	1925	The Moray Firth	Morayshire	LNER	DR	SSPL	10174309 Drawer D079	Morayshire07	1994-7413
Lawson, Edward	1950s	The River Spey	Morayshire	BR(ScR)	DR			Morayshire04	
Gilfillan, Tom	1952	Scotland: Its Highlands and Islands Kishmul Castle	Outer Hebrides	LMS/MacBr.	DR			Outer Hebrides1	
DNA	1920	Peebles for Health, Rest and Recreation	Peebles-shire	Caledonian	DR	SSPL	10170727	Peeblesshire01	1991-7108
Ayling, George	1930s	Peebles for Pleasure: Its Quicker by Rail	Peebles-shire	LMS/LNER	DR			Peeblesshire03	
Merriott, Jack	1950s	The River Tweed: See Britain by Train Neidpath Castle	Peebles-shire	BR(ScR)	DR	SSPL	10174303	Peeblesshire02	1994-7407
Hepple, Robert Norman	1955	The River Tweed: See Scotland by Rail ARO1030	Peebles-shire	BR(ScR)	DR	NRM	1998-11611	Peeblesshire04	1998-11611
Wilkinson, Norman	1920s	Ben More from Killin Junction	Perthshire	LMS	QR	SSPL	10172193	Perthshire24	1986-8794
Kay, Archibald	1930s	Callender: The Trossachs Gateway Best way series 52	Perthshire	LMS	QR	Onslows	20/05/03 Lot 463	Perthshire14	
Birtwhistle, C.H.	1950s	Crieff Perthshire	Perthshire	BR(ScR)	DR	SSPL	10171595	Perthshire03	1979-7640
Anon	1910	Crieff: On the Threshold of the Highlands	Perthshire	Cal Rly	DR	SSPL	10170711 Drawer D001	Perthshire15	1991-7092
Patrick, J. McIntosh	1957	Crieff: View from Cullam's Hill	Perthshire	BR(ScR)	DR			Perthshire20	
Patrick, J. McIntosh	1950s	Crieff: View from the Knock	Perthshire	BR(ScR)	DR			Perthshire28	
Wilkinson, Norman	1935	Dunkeld Cathedral	Perthshire	LMS/LNER	QR	SSPL	10173835 Drawer D006	Perthshire45	1986-9334
Rowntree, Harry	1910	Fore! Gleneagles, the Great Golf Course	Perthshire	Cal Rly	DR	SSPL	10170726	Perthshire17	1991-7107

ARTIST	YEAR	TITLE	LOCATION	COMPANY	SIZE	SOURCE	DETAIL		IMAGE REF	NRM REF
Anon	1924	Gateway to the Highlands: Tay Valley Dunkeld	Perthshire	LMS	QR	SSPL	10170713	Drawer D005	Perthshire44	1991-7094
Cuneo, Terence Tenison	1950	Glen Ogle Perthshire : See Scotland by Train:	Perthshire	BR(ScR)	DR	SSPL	10173154		Perthshire25	1977-5593
Anon	1910	Gleneagles for Golf in the Very He'rt o' Scotland	Perthshire	CR	QR	SSPL	10174841		Perthshire06	1987-9156
Wilkinson, Norman	1932	Gleneagles Hotel Gorse, Links and hotel beyond	Perthshire	LMS	QR	SSPL	10172272	Drawer D006	Perthshire23	1986-8862
Anon	1930s	Gleneagles Hotel Where the Best People Go	Perthshire	LMS	QR	NRM	1986-8875 Drawer D006		Perthshire43	1986-8875
Anon	1924	Gleneagles Hotel: A Palace at the Gate of the Highlands	Perthshire	LMS	QR				Perthshire19	
Anon	1910s	Gleneagles: the hotel motif only	Perthshire	Cal Rly	DR				Perthshire30	
Anon	1920s	Gleneagles: The Scottish Resort	Perthshire	LMS	DR	SSPL	10172146	Drawer D091	Perthshire05	1986-8776
Anon	1905	Highland Railways: via Perth and Dunkeld	Perthshire	HR	Odd				Perthshire31	
Merriott, Jack	1950s	Loch Katrine and Ben Vue - waiting room print	Perthshire	BR(ScR)	small				Perthshire35	
Kir	1910s	Loch Katrine via West Coast Route	Perthshire	LNWR/CR	DR	SSPL	10176023		Perthshire07	1988-7998
Docharty, Alexander Brownlie	1924	Loch Tay and Taymouth Castle Hotel	Perthshire	LMS	QR	NRM	1990-7097		Perthshire27	1990-7097
Anon	1910	Loch Tay: The Loch of Loveliness	Perthshire	CR	DR	NRM	1991-7093		Perthshire38	
Anon	1910	Lovely Loch Earn: Beautiful District of Central Perthshire	Perthshire	CR	DR				Perthshire 39	
Photographic	1987	Luxury Land Cruises: Tyndrum Summit	Perthshire	BR Intercity	DR				Perthshire42	
Frazer, William Miller	1920s	Perth: The Fair City	Perthshire	LMS	QR	SSPL	10172056	Drawer D004	Perthshire08	1981-7357
Photographic	1959	Pitlochry: For Highland Holidays	Perthshire	BR(ScR)	DR				Perthshire37	
Anon	1940	Pitlochry: Pass of Killiecrankie	Perthshire	LMS	QR				Perthshire18	
Patrick, J. McIntosh	1950s	Pitlochry: The Heart of Scotland in Lovely Perthshire	Perthshire	BR(ScR)	DR				Perthshire29	
Anon	1996	Pitlochry: Things Move Slowly Here	Perthshire	Scotrail	sm.	NRM	1998-9610		Perthshire40	1998-9610
Gray, Ronald	1925	Ready for the 12th: Arrival at Perth Station	Perthshire	LMS	QR	NMSI	1997-7409-LMS-3678		Perthshire34	
Merriott, Jack	1960s	See the Central Highlands with Circular Tours	Perthshire	BR(ScR)	DR				Perthshire32	
Anon	1910	Summer Tours via Aberfoyle: Trossachs/Loch Katrine	Perthshire	NBR	DR	SSPL	10173306	Drawer D010	Perthshire46	1986-9136
Docharty, Alexander Brownlie	1924	Taymouth Castle Hydro Hotel Ltd	Perthshire	LMS	DR	SSPL	10170717	Drawer D004	Perthshire16	1991-7098
Cooper, Austin	1927	The Booklovers Britain: The Trossachs	Perthshire	LNER	DR				Perthshire12	
Cooper, Austin	1933	The Booklovers Britain: The Trossachs	Perthshire	LNER	DR	SSPL	10174186		Perthshire12	1978-9369
Steel, Kenneth	1950s	The Central Highlands: Schiehallion + Loch Rannoch	Perthshire	BR(ScR)	DR				Perthshire22	
Merriott, Jack	1950	The River Tay EP190	Perthshire	BR(ScR)	DR				Perthshire04	
Cooper, Austin	1927	The Trossachs	Perthshire	LNER	QR	SSPL	10173572	Drawer D010	Perthshire10	1986-9235
Littlejohns, John	1930s	The Trossachs	Perthshire	LNER	QR	SSPL	10173759	Drawer D015	Perthshire21	1986-9295
Anon	1900s	The Trossachs Tour via Callender	Perthshire	CR	DR				Perthshire33	
Cooper, Austin	1926	The Trossachs: Travel from Kings Cross	Perthshire	LNER	QR				Perthshire36	
Reid, R. Payton	1925	The Trossachs: Its quicker by Rail	Perthshire	LMS/LNER	DR	SSPL	10170688	Drawer D077	Perthshire11	1990-7279
Wilkinson, Norman	1925	The Trossachs: Loch Katrine and Ben Venue	Perthshire	LMS	QR	SSPL	10173770	Drawer D005	Perthshire13	1978-9139
Purvis, Tom	1926	The Trossachs: Loch Katrine Ellen's Isle	Perthshire	LNER	QR				Perthshire09	
Purvis, Tom	1926	The Trossachs: Loch Katrine Ellen's Isle	Perthshire	LNER	QR	SSPL	10173334	Drawer D016	Perthshire09	1986-9163
Anon	1920s	The Trossachs: Scotland by LMS	Perthshire	LMS	DR				Perthshire41	

ARTIST	YEAR	TITLE	LOCATION	COMPANY	SIZE	SOURCE	DETAIL		IMAGE REF	NRM REF
Anon	1930s	Clyde Coast and Scottish Playground	Renfrewshire	LMS/LNER	QR					
Anon	1950s	Clyde Coast Car Ferries: B 26177	Renfrewshire	Cal/BR(ScR)	DR				Renfrewshire02	
Wilkinson, Norman	1920s	Firth of Clyde Cruises by LMS steamers	Renfrewshire	LMS	DR	SSPL	10172217	Drawer D091	Renfrewshire01	1986-8807
Wilkinson, Norman	1930	SS Glen Sannoz on the Clyde original artwork	Renfrewshire	LMS	QR	SSPL	10283092		Renfrewshire08	1977-5797
Wilkinson, Norman	1930s	The Clyde original artwork	Renfrewshire	LMS	QR	SSPL	10282901		Renfrewshire06	1976-9322
Wilkinson, Norman	1920s	The Clyde Text, steamer and lighthouse	Renfrewshire	LMS/LNER	QR	SSPL	10173850	Drawer D006	Renfrewshire06a	1986-9349
Smith, John S.	1960	The Firth of Clyde	Renfrewshire	BR(ScR)	DR	SSPL	10171589		Renfrewshire04	1979-7634
Wilkinson, Norman	1925	The Firth of Clyde	Renfrewshire	LMS	QR	SSPL	10173801	Drawer D006	Renfrewshire05	1978-9167
Wilkinson, Norman	1925	The Firth of Clyde original artwork	Renfrewshire	LMS	QR	SSPL	10283091		Renfrewshire07	1977-5796
Wilkinson, Norman	1950s	The Firth of Clyde: See Scotland by Rail and Steamer	Renfrewshire	BR(ScR)	QR				Renfrewshire03	
Steel, Kenneth	1950s	Eilean Donan Castle, Loch Duich	Ross & Cromarty	BR(ScR)	DR				RossCromarty09	
Steel, Kenneth	1950s	Eilean Donan Castle, Loch Duich	Ross & Cromarty	Original artwork	sm.				RossCromarty10	
Wilkinson, Norman	1930s	Kyle of Lochalsh view of hotel from Skye	Ross & Cromarty	LMS	QR	SSPL	10173063	Drawer D007	RossCromarty03a	1976-9214
Wilkinson, Norman	1930s	Kyle of Lochalsh view of hotel from Skye	Ross & Cromarty	LMS	QR	SSPL	10175912	Drawer D007	RossCromarty03	1987-9186
Broadhead, W. Smithson	1930s	Scotland for Holidays: Deer stalking in the highlands	Ross & Cromarty	LMS/LNER	QR	SSPL	10176050	Drawer D005	RossCromarty05	1988-8025
Anon	1900s	Strathpeffer Spa	Ross & Cromarty	HR	DR	SSPL	10171302		RossCromarty07	1992-7781
Reynolds, Warwick	1920s	Sweet Strathpeffer: The Highland resort	Ross & Cromarty	LMS	QR	SSPL	10322925	Drawer D004	RossCromarty01	1996-7332
Neiland, Brendan	1970s	Tain by Train	Ross & Cromarty	Scotrail	DR	SSPL	10305934		RossCromarty08	1996-7266
Henderson, Keith	1930s	Western Highlands: Its quicker by Rail	Ross & Cromarty	LMS/LNER	QR	SSPL	10175914	Drawer D015	RossCromarty02	1987-9188
Wilkinson, Norman	1935	Western Scotland	Ross & Cromarty	LMS/LNER	QR	SSPL	10173804	Drawer D007	RossCromarty06	1978-9170
Spradbery, Walter Ernest	1930	Abbotsford: East coast for the Border country	Roxburghshire	LNER	QR	SSPL	10171773	Drawer D009	Roxburghshire07	1979-7818
Taylor, Fred	1930s	Dryburgh Abbey: Its quicker by rail	Roxburghshire	LMS/LNER	QR				Roxburghshire05	
Taylor, Fred	1930s	Dryburgh Abbey: original colour lithograph	Roxburghshire	LNER	QR	Onslows	25/06/08 Lot 256		Roxburghshire05a	
Patrick, J. McIntosh	1960s	Dryburgh Abbey: See Scotland by Rail	Roxburghshire	BR(ScR)	QR				Roxburghshire10	
Taylor, Fred	1935	Jedburgh Abbey: Its quicker by Rail	Roxburghshire	LMS/LNER	QR	SSPL	10174078	Drawer D017	Roxburghshire01	1978-9261
Wesson, Edward	1950s	Jedburgh Abbey: See Britain by Train	Roxburghshire	BR(ScR)	DR				Roxburghshire06	
Tittensor, H	1930s	Kelso on the Banks of the Tweed: colourful river scene	Roxburghshire	LNER	DR	SSPL	10174509		Roxburghshire02	1978-8491
Haslehust, Ernest William	1930s	Kelso on the Banks of the Tweed: yellow sky no trees	Roxburghshire	LNER	DR	Onslows	03/11/1999 Lot 304		Roxburghshire09	
Newbould, Frank	1924	Melrose Abbey: First class hotel and hydro	Roxburghshire	LNER	DR	Onslows	19/12/2006 Lot 400		Roxburghshire03	
Taylor, Fred	1930s	Melrose Abbey: Its Quicker by Rail: Abbey ruins	Roxburghshire	LMS/LNER	QR	SSPL	10174073	Drawer D017	Roxburghshire04	1978-9256
Johnson, Grainger	1930	The Cheviots	Roxburghshire	LNER	DR				Roxburghshire08	
Anon	1950s	All in Holidays in Scotland	Scotland	BR Exec	DR	SSPL	10174791		Scotadvert49	1987-9106
Anon	1950s	All in Holidays in Scotland - 2	Scotland	BR Exec	DR	SSPL	10174793		Scotadvert73	1987-9108
Anon	1950s	An all Day in Bonnie Scotland	Scotland	BR Exec	DR	SSPL	10174787		Scotadvert06	1987-9102
Buckle, Claude	1930s	Beauty Abides nor Suffers Mortal Change	Scotland	LMS	QR	SSPL	10173087	Drawer D004	Scotadvert74	1976-9230
Anon	1910s	Come to Scotland for your jolidays	Scotland	CR/LNWR	DR	SSPL	10172222		Scotland08	1986-8812
Rodmell, Harry Hudson	1930s	Cruises from Liverpool to the Scottish Firths and Fjords	Scotland	LMS	DR	SSPL	10175896	Drawer D091	Scotadvert10	1987-9170

ARTIST	YEAR	TITLE	LOCATION	COMPANY	SIZE	SOURCE	DETAIL	IMAGE REF	NRM REF
Cassandre, A. Mouron	1928	Ecosse par les trains de luxe LMS	Scotland	LMS	DR			Scotadvert41	
Black, Montague Birrell	1930	Explore Scotland: its quicker by Rail	Scotland	LMS/LNER	QR	SSPL	10176149 Drawer D005	ScotlandMap5	1994-8633
Fish, Laurence	1950s	Highland Piper (signed original artwork)	Scotland	BR(ScR)	sm.			Scotland09	
Oakley, Harry Lawrence	1920s	LNER Hotels in Scotland	Scotland	LNER	DR	SSPL	10459249	Scotadvert32	
Anon	1905	Route to the Highlands via Perth and Dunkeld	Scotland	HR	DR	SSPL	11074105 Drawer D001	Scotadvert54	1978-1274
Newbould, Frank	1926	Scotland - East Coast Route	Scotland	LNER	DR	SSPL	10174342	Scotadvert05	1987-8862
Anon	1950s	Scotland: Pictorial map with crests	Scotland	Not Known	DR			Scotlandmap3	
Anon	1950s	Scotlands Western Highlands and Islands	Scotland	Macbrayne	DR	Onslows	29/06/2007 Lot 106	Scotadvert53	
Nicholson, W.C	1955	The Clyde Coast and Loch Lomond (Relief map)	Scotland	BR(ScR)	QR	SSPL	10170756 Drawer D024	ScotlandMap4	1991-7139
Maxwell, Donald	1930s	The Lowlands of Scotland	Scotland	LMS	QR	Onslows	18/06/2004 Lot 306	Scan required	
Anon	1926	The Way they all Go: Scotland by LMS	Scotland	LMS	DR	NMSI	1997-7409-LMS-4397 Grouse image	Scotland13	
Thomson, A.R.	1931	Then and Now: 600 Golf Courses on the LNER	Scotland	LNER	DR	SSPL	10327519 Drawer D077	Scotadvert33	1999-7538
Mason, Frank Henry	1926	Tourist Routes in the Scottish Highlands	Scotland	LNER	QR	SSPL	10170952 Drawer D013	ScotlandMap1	1990-7060
Anon	1907	The Home and Haunts of Sir Walter Scott	Selkirkshire	NBR	DR	SSPL	10172204	Selkirkshire1	1986-8800
Anon	1910s	Bridge of Allan, Stirlingshire	Stirlingshire	CR	DR	SSPL	10175892 Drawer D001	Stirlingshire01	1987-9166
Wilkinson, Norman	1930s	Grangemouth Docks Artists final proof	Stirlingshire	LMS	QR	SSPL	10174010 Drawer D007	Stirlingshire02	1978-9193
Wilkinson, Norman	1930s	Grangemouth Docks dark industrial scene	Stirlingshire	LMS	QR	Onslows	25/06/2008 Lot 260	Stirlingshire02a	
Merriott, Jack	1954	River Forth from Stirling Castle	Stirlingshire	BR(ScR)	DR			Stirlingshire07	
Anon	1930s	Scotland for Holidays: Wallace Memorial at Stirling	Stirlingshire	LMS/LNER	DR			Stirlingshire05	
Cameron, Sir David Young	1920s	Stirling	Stirlingshire	LMS	QR	SSPL	10173425 Drawer D005	Stirlingshire03	1978-8892
Cameron, Sir David Young	1920s	Stirling	Stirlingshire	LMS	QR	SSPL	10173620 Drawer D004	Stirlingshire03a	1978-9018
Clark, Christopher	1935	Stirling Castle	Stirlingshire	LMS	QR	SSPL	10173724 Drawer D004	Stirlingshire06	1978-9122
Anon	1996	Stirling Castle: People still flee there	Stirlingshire	Scotrail	sm.	NRM	1998-9612	Stirlingshire09	1998-9612
Greiffenhagen, Maurice Willia	1924	Stirling: Gateway to the Highlands	Stirlingshire	LMS	QR	SSPL	10170900 Drawer D005	Stirlingshire04	1989-7137
Newbould, Frank	1928	Stirling: Historic centre for tourism	Stirlingshire	LMS	QR	NMSI	1997-7409-LMS-4984	Stirlingshire08	
Merriott, Jack	1950	Northern Scotland: Invershin Sutherland	Sutherland	BR (ScR)	DR	SSPL	10174304	Sutherland01	1994-7408
Buckle, Claude	1963	Linlithgow Palace	West Lothian	BR(ScR)	DR	SSPL	10171402	WestLothian01	1994-7201
Cuneo, Terence Tenison	1952	Scotland for your Holidays: Forth Bridge	West Lothian	BR(ScR)	QR	SSPL	10171863 Drawer D024	WestLothian03	1979-7908
Brangwyn, Sir Frank William	1929	The Forth Bridge	West Lothian	LNER	QR	SSPL	10176064 Drawer D015	WestLothian04	1988-8039
Brangwyn, Sir Frank William	1929	The Forth Bridge	West Lothian	LNER	QR	SSPL	10324289 Drawer D015	WestLothian04a	1988-8039
Gawthorne, Henry George	1928	The Forth Bridge	West Lothian	LNER	QR	SSPL	10170905 Drawer D012	WestLothian06	1989-7142
Mason, Frank Henry	1920s	The Forth Bridge	West Lothian	LNER	DR	SSPL	10174620	WestLothian07	1978-9593
Wilkinson, Norman	1935	The Silver Forth	West Lothian	LNER	QR	SSPL	10173794 Drawer D009	WestLothian02	1978-9160
Gawthorne, Henry George	1928	The Track of the Flying Scotsman: Forth Bridge	West Lothian	LNER	DR	Onslows	Oct 2003 Lot 437	WestLothian05	
Wilkinson, Norman	1930	Stranraer-Larne: travel to Ireland by the short sea route	Wigtownshire	LMS	DR	SSPL	10175990 Drawer D091	Wigtownshire01	1988-7965
Wilkinson, Norman	1920s	Travel to Ireland By Stranraer to Larne Route	Wigtownshire	LMS	DR	NRM	1987-8805 Drawer D091	Wigtownshire03	1987-8805
Johnston	1964	TSS Caledonian Princess: Stranraer-Larne	Wigtownshire	Cal Steam Co.	QR	Onslows	19/12/06 Lot 316 ref B 33591	Wigtownshire02	

Posters and Prints

Atterbury, P (2008) *"On Holiday – Remembering Yesterday's Holidays"* AA Publishing, Basingstoke, Hampshire **ISBN 97-807-4955-8048**

Bownes, D and Green, O (Eds) (2008) *"London Transport Posters – A Century of Art"* Lund Humphries (Publishers) Aldershot **ISBN 978-08533-1984-9**

Brodio, L (1992) *"The Posters of Jules Cheret"* Dover Publications, NY USA **ISBN 0-486-26966-3**

Callo, M (1975) *"The Poster in History"* Hamlyn Publishing Group, London **ISBN 0-600-37118-2**

Cole, B (2006) *"It's Quicker by Rail: LNER Publicity and Posters 1923-1947"* Capital Transport Publishing, London **ISBN 1-85414-304-2**

Cole, B and Durack R (1992) *"Railway Posters 1923-1947"* Laurence King (Publishers) **ISBN 1-85669-014-8**

Delicata A, and Cole, B (2000) *Speed to the West: GWR Publicity and Posters 1923-1947"* Capital Transport Publishing, London **ISBN 1-85414-228-3**

Green, Oliver (1990) *"Underground Art: London Transport Posters 1908 to the Present"* Laurence King Publishing **ISBN 1-85669-166-7**

Hillman, T and Cole B (1999) *"South for the Sunshine: SR Publicity and Posters 1923-1947"* Capital Transport Publishing, London **ISBN 1-85414-213-5**

Norden, G (1997) *"Landscapes Under the Luggage Rack"* GNR Publications, Northampton UK **ISBN 0-95296-02-0-6**

Palin, Michael (1987) *"Happy Holidays"* Pavilion Books **ISBN 1-85145-130-7**

Riddell, J (1998) *"Pleasure Trips by Underground"* Capital Transport, London **ISBN 1-85414-200-3**

Shackleton, J.T (1976) *"The Golden Age of the Railway Poster"* New English Library **ISBN 0-450031-168-3**

Timmers, M (Ed) (1998) *"The Power of the Poster"* V+A Publications, London **ISBN 1-85177-240-5**

Wigg, J (1996) *"Bon Voyage – Travel Posters of the Edwardian Era"* HMSO Publications Centre, London **ISBN 0-11-440261-2**

Railways

Atterbury, P (2007) *"Along Lost Lines"* Pages 232-248: Scotland David & Charles, Cincinnati USA **ISBN 13 978-0-7153-2568-1**

Brennand, D and Furness, R (2002) *"The Book of BR Station Totems"* Sutton Publishing Ltd, Stroud, Gloucestershire **ISBN 0-7509-2997-9**

Butt, R.V.J (1995) *"The Directory of Railway Stations"* Patrick Stevens Ltd, Sparkford, BA22 7JJ **ISBN 1-85260-508-1**

Carter, E.F (1959) *"An Historical Geography of the Railways of the British isles"* Cassell and Company, Red Lion Square, London WC1

Chaplin, B: (1987) *"Scotland by Rail"* Railway Development Society: published by Jarrold and Sons Norwich **ISBN 0-7117-0299-3**

Gammell, C.J (1980) *"LMS Branch Lines 1945-1965"* Oxford Publishing Co. **ISBN 0-86093-062-9**

Gammell, C.J (1999) *"Scottish Branch Lines"* Oxford Publishing Co. **ISBN 0-86093-540-X**

Hamilton Ellis, C (1959) *"British Railway History"* George Allen and Unwin, London: also 2nd Edition (1960)

Jowett, A (1989) *"Jowett's Railway Atlas"* Guild Publishing, London **Ref. CN2155**

Morrison, G (1999) *"Scottish Railways Now and Then"* Ian Allen Publishing, Shepperton UK **ISBN 0-7110-2684-X**

Nock, O.S (1982) *A History of the LMS – Volumes 1 and 2"* George Allen and Unwin, London **ISBN 0-04-385087-1** and **0-04-385093-6**

Thomas, J *"The North British Railway Vol 1 (1844-1879) and Vol, 2 (1879-1922)"* David & Charles, Newton Abbott **ISBN 0-7153-4697-0** and **0-7153-6699-8**

Whitehouse, P & St. John Thomas, D (1987) *"LMS 150 – A Century and a Half of Progress"* David & Charles, Newton Abbott **Ref. CN 5916**

Whitehouse, P & St. John Thomas, D (1989) *"LNER 150 – A Century and a Half of Progress"* David & Charles, Newton Abbott **ISBN 0-7153-9332-4**

Miscellaneous

Alexander, K (1987) *"A Thousand Years of Aberdeen"* Aberdeen University Press

Boumphrey, G (1964) *"Shell and BP Guide to Britain"* Ebury Press: George Rainbird Ltd, London W2

Cruden, S (1960) *"The Scottish Castle"* Thomas Nelson, Parkside Works Edinburgh

Donnachie, Hume and Moss (1977) *"Scotland: Historic Industrial Scenes"* Moorland Publishing, Buxton, Derbyshire **ISBN 0-903485-40-0**

Eyre-Todd, G & Geddie, J (1936) *"Beautiful Scotland"* illustrated by paintings by E.W. Haslehust Blackie and Son, Glasgow

Grant, R (1996) *"The Real Counties of Britain"* Virgin Books, London **ISBN 1-85227-479-4**

Hamilton, H (1963) *"An Economic History of Scotland in the 18th Century"* Oxford University Press, Oxford

Lockhart, R. B (1974) *"Scotch: The Whisky of Scotland in Fact and Story"* Putnam Press London

Mullay, S (1996) *"The Edinburgh Encyclopaedia"* Mainstream Publications, Edinburgh

Munro, D & Gittings, B (2006) *"Scotland: An Encyclopaedia of Places and Landscapes"* Royal Scottish Geographical Soc: Harper Collins Glasgow **ISBN 0-00-472466-6**

Simpson, E (1992) *"Discovering Banff, Moray and Nairn"* John Donald (Publishers (Edinburgh)

Poster Sources

Authors Collection	Images	Imprint, 1, 5, 21, 65, 118, 123, 144, 21, 231, 286, 295, 317, 329, 331
Bridgeman Art Library, London	Images	41, 49, 61, 69, 91, 97, 104, 105, 132, 134, 135, 136, 137, 139, 145, 160, 162, 172, 1677, 179, 185, 197, 199, 225, 227, 240
		255, 259, 262, 270, 274
Dover Publications	Images	7
Norden Carriage Print Collection	Images	32, 64, 86, 120, 133, 146, 147, 202
Onslows Poster Library	Images	10, 31, 40, 43, 45, 59, 63, 79, 99, 102, 121, 125, 141, 163, 170, 171, 174, 186, 193, 195, 203, 205, 208, 214, 216, 223, 243
		244, 260, 261, 268, 283, 284, 288, 293, 294, 300, 307, 311, 326, 330
SSPL/NRM National Collection	Images	Frontispiece, 2, 3, 4, 6, 9, 11-20, 22-30, 33-39, 42, 44, 46, 47, 48, 50-58, 60, 62, 66, 67, 68, 70-78, 80-85, 87-90, 92-96, 98, 100,
		101, 103, 106-117, 119, 122, 124, 126- 131, 138, 140, 142, 143, 148-159, 161, 164-169, 173, 175, 176, 178, 180, 181-184
		187-192, 194, 196, 198,200, 201, 204, 206, 207, 209-211, 215, 217-222, 224, 226, 228-230, 232-239, 241, 242, 245-254,
		256, 257, 258, 263-267, 269, 271-273, 275-282, 285, 287, 289-292, 296,-299, 301-306, 308-310, 312-316, 318-325, 327, 328
		332

Authors Note: Strict copyright protection exists for all the images used in this book. Copying and reproduction is expressly forbidden under existing copyright laws. The Author acknowledges the assistance of Benoit Lefere at Bridgeman Art Library, Patrick Bogue at Onslows, Tom Vine at the Science and Society Picture Library and Greg Norden at the Travelling Art gallery in determining the copyright on each image.

Recommended Websites

www.railway-posters.com

www.nrm.org.uk www.scienceandsociety.co.uk

www.onslows.co.uk

www.christies.com www.bridgemanart.com

The Next Volume in the Series
Volume 2 — THE NORTH EAST OF ENGLAND

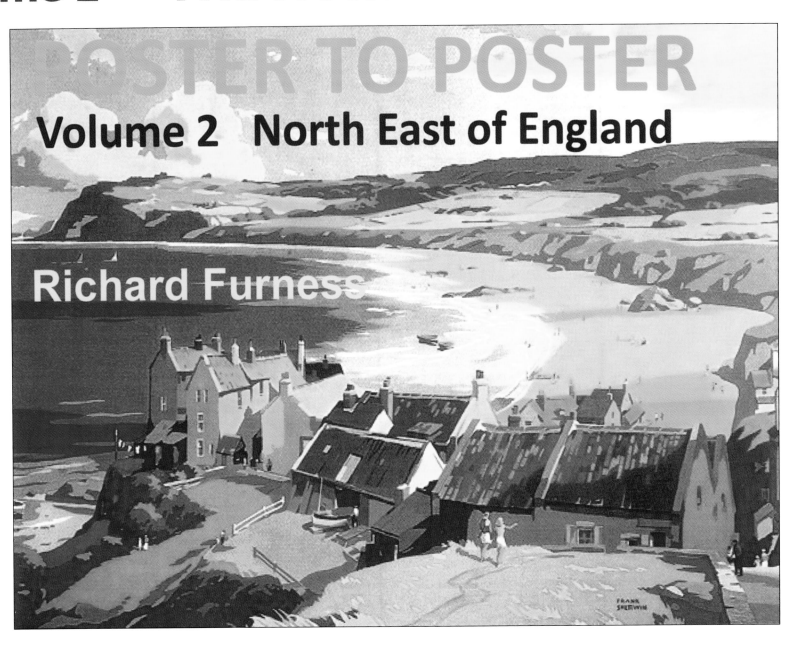

The counties featured are
Durham, Northumberland and Yorkshire

The National Railway Museum at York houses Britain's very large and unique collection of railway posters. This second volume in a series uses our National Collection to take a journey around Northumberland, Durham and Yorkshire using many previously unseen images. The result is a stunning artistic guide to both the "Birthplace of Railways" and its railway poster heritage.

The Third Volume in the Series

Volume 3 — THE BRITISH NORTH WEST

POSTER TO POSTER

Volume 3 The British North West

Richard
Furness

CHESLEY BONESTELL.

The areas featured are
North West England, North Wales,
Northern Ireland and The Isle of Man

The National Railway Museum at York houses Britain's unique collection of railway posters. This third volume in a series uses our National Collection to take a journey around the English North West, North Wales and Northern Ireland using many previously unseen images. The result is a stunning artistic guide to both the area and its railway poster heritage.